Japanese Woodblock Prints

Distributed by Indiana University Press

Roger S. Keyes

with contributions by
Robert L. Feller, Mary Curran and Catherine W. Bailie

Japanese Woodblock Prints

A Catalogue of the Mary A. Ainsworth Collection

Allen Memorial Art Museum
Oberlin College
Oberlin, Ohio
1984

This catalogue has been supported by grants
from the National Endowment for the Arts
and the Ohio Arts Council.

To Edwin O. Reischauer

(Class of 1931)

Distinguished Oberlin alumnus who,
as a teacher, scholar, writer and diplomat,
has made great contributions to modern understanding
between Japan and the West.

Contents

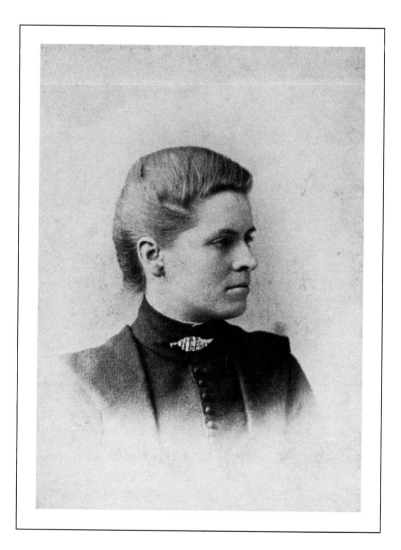

Mary A. Ainsworth, ca. 1890

Preface

WE EASILY THINK OF MUSEUMS as repositories, and museum collections as some kind of fixed, definite entity largely defined by the number of works included and the number and type of artists represented. When we do this, we just as easily forget that all the pieces that are now assembled together were once scattered here and there, and that they were gathered one by one by a particular person guided by particular intentions and tastes. Most important museum collections of Japanese woodblock prints in Europe and America were assembled at the end of the nineteenth and in the first quarter of the twentieth century, between the first discovery of *japonisme* and the period of economic collapse we in America call the Great Depression. By and large, these collections were assembled by people of two persuasions: the aesthetic collectors, who regarded Japanese prints as supremely beautiful works of art, and the ethnographic collectors, who regarded them principally as cultural documentation. The aesthetic collectors were usually successful men of great wealth and discrimination, and they tended to share a taste for certain "classical" artists, and certain "acknowledged" masterpieces. A few of these collectors sometimes strayed outside the boundaries of the known and familiar, but when they did, it was usually with an eye to some special rarity, beauty, or quality that they took justifiable pride in recognizing.

The ethnographic collectors were often men of means, too, but they took a more active interest in historical Japanese culture; and, although many of them had an eye for beauty, subject matter was the main thrust of their collecting interest.

Mary Ainsworth was exceptional among the major collectors of Japanese prints for several reasons. First, she was an unmarried woman; second, she seems to have had rather limited means; third, she had a taste that in many cases ran counter to the collecting conventions of her period; and fourth, she had the idea very early in her collecting career of forming a representative collection of Japanese prints. This does not seem particularly remarkable now, perhaps because most of us see the value of collections formed on an historical basis; and most museums with important holdings of Japanese prints do, in fact, have rather representative collections. This, however, is less the result of design than of accident, the outcome of different generations of collecting, reflecting different tastes, and of numerous bequests.

Mary Ainsworth may have been the first American collector who deliberately assembled an historically representative collection of Japanese prints. She was also possibly one of the first American collectors who intended her collection to be used in teaching the history and connoisseurship of Japanese woodblock prints, deliberately gathering material which she herself found instructive, and which would also illustrate important points of historical development, reveal unrecognized aspects of Japanese culture, and lead to more discriminating taste. Because, for all of her intellectual commitment to collecting, Mary Ainsworth possessed an extraordinary eye, not only for quality of condition and impression, and for the generally accepted beauties pursued by the aesthetic collectors, but she also appreciated the importance of artists like Kuniyoshi and the Primitives, Toyokuni, and the Katsukawa school of actor portraitists who were relatively unadmired at the time she collected.

The present catalogue is more than an illustrated checklist of an important collection of over 1500 Japanese prints. It is an attempt to present the collection in a teaching context, and to show, through a series of essays and extended photographic comparisons, the enormous amount that can be learned about Japanese art, history, and culture and to suggest a number of further questions both general and specific, about art, culture, history, and taste, that can be raised through an imaginative use of the collection.

In the first section of the catalogue is a series of illustrations (PLATES 1–54) of some of the more beautiful, rare, and important prints in the collection arranged in a roughly chronological sequence to recapitulate the history of nearly two centuries of woodblock prints. These illustrations are accompanied by short essays discussing the prints in their cultural and historical context. Following are twenty-four shorter essays with numerous illustrations of some interesting themes that can be traced through the history of Japanese prints (PLATES 55–218). These themes fall into four general categories. Some are concerned with recurrent subject matter: with the *Eight Views of Lake Biwa,* for example, as they have been seen by different artists over a century and a half; with figures like the calligrapher Sugawara Michizane or the religious leader of Nichiren; or with the subjects like rain and wind, as they were envisioned by different artists in one period. Others are concerned with more intellectual aspects of the devel-

opment of prints like the role of classical and modern verse, the use of picture calendars, and the influence of western perspective. Others consider the circumstances surrounding print publication in the Edo period; the introduction and popularity of certain unusual formats like the pillar print and the triptych, the importance of private publication, and the importance of different audiences in the history of prints. Still others are primarily concerned with the physical aspects of prints: repairs, copies, block changes, color variants, and the role of different engravers in the translation of an artist's design into a woodblock print. These topics are not exhaustive—the list could be extended indefinitely—they are simply subjects well-illustrated by examples in the collection that particularly caught the author's interest while preparing the complete checklist of the collection which makes up the second half of the catalogue.

The arrangement of the catalogue section is chronological. Of the over 1500 prints in the collection, nearly 600 are illustrated. A great majority of the genuine eighteenth-century prints, excluding book illustrations, are reproduced because of their general rarity. The other approximately 260 illustrations are drawn from the collection's extensive holdings of nineteenth-century prints. The criteria for choice among these prints were beauty, importance, rarity, and quality of impression. The illustrated checklist is followed by an important essay by Dr. Robert Feller, a conservation chemist, who has performed some critical and essential experiments on the state of fading of certain fugitive organic pigments which are frequently used in traditional Japanese woodblock prints. It has been common knowledge that certain pigments on Japanese prints fade when they are exposed to light, but Dr. Feller has been able to determine the exact rate of this fading. This information will be invaluable both to collectors and to museum curators who are concerned about the effects of light during exhibition of Japanese woodblock prints.

I would like to acknowledge the invaluable assistance on this project of Ms. Chloe Young, who first invited us to Oberlin to catalogue the collection and who edited the catalogue. My thanks go to Richard Spear, the former director of the Allen Art Museum, who gave inestimable support and encouragement to the project; to Christine Dyer, curatorial assistant in the Museum, who helped to install the original exhibition in the fall of 1979 which provided the idea for thematic sections in the catalogue; to Robert Feller, one of the most important American conservation chemists, for his enthusiastic interest in the color fading project; and to my dear wife Keiko Mizushima, for her intelligent critiques, her willing advice, and her loving presence.

ROGER S. KEYES

Foreword

In February 1950 the Office of the President of Oberlin College was notified that the Allen Memorial Art Museum was one of the beneficiaries named in the will of Mary A. Ainsworth, Oberlin Class of 1889. She had left to the Museum her collection of Japanese prints and her entire library of books pertaining to art and history and Far Eastern studies. The bequest was unanticipated and unsought. The College had no knowledge of Miss Ainsworth's activities as a collector—one of the top ones in the field of Japanese prints as it was soon to discover. The coexecutor of her will was Harry W. Getz, a nephew by marriage to Miss Ainsworth, a businessman from Moline, Illinois, where Miss Ainsworth had lived almost her entire life. By late May Mr. Getz had arranged for the entire collection to be packed and shipped to Oberlin. A "token" exhibition of ten prints was hastily arranged in time for Commencement, and a brief note on the bequest appeared in the spring issue of the Museum *Bulletin,* illustrated with somewhat blurred photographs made by the then director of the Museum, Charles Parkhurst, on a flying visit to Moline to examine what turned out to be the most important single bequest the Museum had ever received.

Mary Andrews Ainsworth was born in Geneseo, Illinois in 1867. Her father, Henry A. Ainsworth, had started a mercantile business there after moving from Williamstown, Vermont, in 1853. In 1870 the family moved to Moline, where Henry played a part in the founding of Williams, White and Co., manufacturers of machinery, a firm that is still in the family in Moline today. Mary's brother Harry had preceded her to Oberlin, graduating in 1884. Mary transferred to Wellesley as a junior but returned to Oberlin for her final year. Her mother died the year after her graduation, and Mary returned home to keep house for her father. When he remarried a Miss Sarah Anderson, a niece of his first wife and the current president of Rockford College, in 1905, Mary left the family home and decided to travel to the Orient. According to her old friend from Moline and fellow collector Judson D. Metzgar, she acquired her first prints on this visit, including a number of primitives which are among the finest sheets in her collection. In his foreword to the first (unpublished) catalogue of the Ainsworth Collection prepared by Mr. Metzgar in Oberlin between October 1950 and February 1951, he wrote that "from the very first she had a passion for the primitives, an appreciation that came to most of us, including Mr. Ficke and myself, only after liking the

work of Hiroshige and other late men." Mr. Metzgar wrote fondly of Miss Ainsworth's influence on him as a collector, recalling with pleasure the evenings spent viewing each other's collections. They were occasionally joined by Arthur Davison Ficke, who lived nearby, Frederick Gookin of Chicago, and others. "By consistently maintaining a high standard through the years, and with an ability and willingness to pay high prices," he wrote, "she formed a collection of great importance to collectors and students. The recent weeks of mounting and cataloguing the Ainsworth collection have deeply impressed me with her success in creating and passing on to Oberlin College an adequate working tool for the study of the Japanese print; and, beyond all else, in bringing the truth of beauty to eyes that see and study them, which, after all, is their greatest mission."

Miss Ainsworth collected actively for about twenty-five years. Her niece recalls that she was a "shrewd buyer . . . very capable of recognizing worthwhile prints." She must also have been a very demanding buyer, judging from correspondence in the Museum files between Miss Ainsworth and Sotheby's (then Sotheby, Wilkinson and Hodge) in 1922 and 1924. In a letter of June 12, 1922, Miss Ainsworth found a print by Kiyonaga to be inferior to what she anticipated. ("I am glad that you admit there is something wrong with the Kiyonaga as it is most important that all should recognize what is being done to good prints to make them more saleable. The settlement you propose is not very satisfactory.") And again in 1924, Miss Ainsworth, on the advice of the dealer K. Matsuki from whom she occasionally bought, attempted to return to Sotheby two prints from sales of 1920 that she felt were not made from the original blocks, and one from another sale of that year that to her mind was hand-colored rather than printed. Sotheby's allowed that she might be correct in the second instance and repaid her the £40 it had brought, but stood by, adamantly, on the originality of the prints in the first.

From sales catalogues that accompanied the bequest we know that Miss Ainsworth bought from the following important sales, among others: Appleton in 1910, Blanchard in 1916, Hirakawa in 1917, Ficke and Hamilton Easter Field in 1920 (Field bid for Miss Ainsworth at least once: $510 for the "exceptionally fine Kuniyoshi," he reports to her by letter on May 3, 1919; no. 464 in the present catalogue), Spaulding in 1920, Rouart in 1922,

Haviland in 1923, Gonse in 1926. In the 1930s her buying decreased. She was by then in her sixties, living comfortably in Moline, buying intermittently, but now in possession of a collection that another distinguished collector, Frederick Gookin, found to possess "a high average of excellence."

According to a niece, Miss Ainsworth probably decided some years before her death to leave the collection to Oberlin. "She had great memories of her college days," wrote her niece, who remembered her Aunt Mary as "quite a character," "an intellectual, with strong ideas on all subjects . . . devoted, loyal and generous to her many relations."*

The first large showing of the Ainsworth collection in Oberlin was held from March 11 to April 8, 1951, a selection of about 300 prints (from the 1402 total). Thereafter smaller selections were on view from time to time, according to teaching or other needs. Occasionally groups of prints were sent out on loan, including a selection of forty-eight to the University of Notre Dame and the University of the South at Sewanee (Tenn.) in 1954, and sixty-three to an American Federation of Arts circulating exhibition in 1961–63, an unfortunate occurrence, to say the least, for a number of prints in this circulating exhibition were badly faded upon their return to Oberlin. The Museum now restricts the length of time individual prints are on exhibition, and certain ones are never placed on view.

By the mid-1970s the Museum was encouraged by various specialists to make the collection more widely known. Although Judson Metzgar's catalogue was useful in that it identified and described each print (whereas while in Miss Ainsworth's possession, the collection had not been catalogued), it was now twenty-five years old and contained many errors. The Museum was awarded a Visiting Specialist grant from the National Endowment for the Arts in 1979 to invite Roger Keyes and Keiko Mizushima Keyes to spend a summer at Oberlin to catalogue the collection and make technical examinations and recommendations for conservation. A second grant from the Endowment was awarded in 1980 for publication of this catalogue. A portion of the first grant was further used to underwrite tests on the fading properties of pigments found in Japanese prints. These tests were made by Robert L. Feller and Ruth Johnston-Feller of the Mellon Institute, Pittsburgh in 1980 and their quite extraordinary findings appear in an appendix to the catalogue.

The Museum is honored to have secured the services of Roger and Keiko Keyes. Anyone who has worked with either or both of them will not need to be told that their enthusiasm for this field is infectious, their knowledge immense. Oberlin College and the many generations of students and scholars who will use this catalogue owe them a great debt of gratitude.

Between 1977 and 1982 a number of individuals worked on the project and their valuable assistance is acknowledged, with thanks, particularly former Museum assistants Elizabeth Shepherd and Lise Holst, interns Sandy Goldberg and Wendy Kozol, and Museum administrative secretary Judith Fannin. Color photography is by Lydia Dull and the black and white photography is by Lydia Dull, John Glascock, Joan Anderson, and Roger Keyes. The bibliography was prepared by Barbara Klinger.

The Museum is also deeply indebted to the Ohio Arts Council and to the individuals who placed their trust in the project by committing funds to match grants from the National Endowment: in particular to John N. Stern, Oliver Smith, and Mary Louise Ainsworth, grandniece of the donor.

CHLOE H. YOUNG
Senior Curator

* This and other quotes from "a niece" are from Mrs. Carolyn Ainsworth Getz, '13, wife of Harry W. Getz, to Laurine Mack Bongiorno in letters from 1974 and 1976, when the latter was preparing an article on Oberlin donors for *Apollo* (CIII, no. 168, February 1976).

Introduction

Japanese Woodblock Prints from the Mary A. Ainsworth Collection

IF STUDENTS of *ukiyo-e,* Japanese woodblock prints and genre-painting of the seventeenth to nineteenth centuries, were asked to choose an emblem for their calling, I believe there would be unanimous and immediate agreement on Toshinobu's owl (PLATE 5, CAT. NO. 27). The voyager into the floating world of Japanese prints sets forth with what he accepts as maps and charts and compasses, but before losing sight of shore he knows that he has entered a *terra incognita*. Many travellers scuttle back to port, but those who venture on devise a calculus of astonishment: they learn to expect the unpublished design, the unrecorded state, the ingenious subject. They certainly do not expect to find in a small, mid-Western American college town, an outstanding collection of Japanese prints of every kind.

If you can imagine a Western print-room with an unrecorded Seghers landscape, a unique Dürer engraving and an unknown Rembrandt head; unrecorded prints by two dozen other important Western print-makers; and 1,200 other prints chosen for their rarity, beauty and quality of impression besides, you will have some idea of the quality and importance of Miss Ainsworth's collection of Japanese woodblock prints.

The history of *ukiyo-e* may be thought of as a play in three acts, the first beginning in the tumultuous latter part of the seventeenth century and ending with the death of Okumura Masanobu in 1764. About the first scene, the closing decades of the 1600s, we need only be aware that two distinct styles of figure-drawing developed quite smoothly and naturally out of two distinct traditions of woodblock illustration. One, which derived from the *libretti* of the puppet theatre in the Osaka-Kyoto area, was boisterous and energetic and aptly suited to the vigorous acting of the *kabuki* stage. The other, more svelte and lyrical, found its sources in guide-books to the licensed quarters, and was more appropriate to the robust but elegant female beauties of the day. By the early years of the eighteenth century, actors and courtesans were established as the main subject-matter of woodblock prints, and the theme of Act One, scene Two, is the fusing and gradual alteration of these styles.

* This essay first appeared in *Apollo,* CIII, February 1976, in a special issue devoted to the collections of the Allen Memorial Art Museum, Oberlin College. Plate numbers have been changed to correspond with those in this volume. It is reprinted with the kind permission of the editor of *Apollo*.

No artist contributed more to this development than Okumura Masanobu, a youthful prodigy whose first signed work was an impressive album of courtesans published in 1701, when he was in his sixteenth year. This album was a series of improvements and transformations of a rather dull, but inordinately popular, album that had been designed by Torii Kiyonobu the previous year. Masanobu's gift was to enliven the strong, strikingly decorative early styles with intelligence, wit and spontaneity, and during sixty years as a designer, publisher and occasional author, his inventiveness rarely failed. Masanobu took credit for most of the many innovations of this period: 'perspective' prints, the narrow 'pillar' format, elaborate hand-coloring and two-color printing. And whether or not he deserves the credit, there is no doubt that he served as a powerful catalyst for change.

The Ainsworth collection contains a fine, large, early Masanobu print (PLATE 2, CAT. NO. 11) which, appropriately, combines the vigour of the Torii style with a certain Hishikawa grace. It seems to be unique.

Where one artist showed the way, others were ever on hand to follow. One of the most interesting groups of these, certainly the most puzzling, are the Kaigetsudō. It is a matter of historical record that an artist named Kaigetsudō Ando was a painter in the 1710s, and was exiled from Edo after having been compromised in a political scandal. Several of his paintings have survived, but no prints. It is also a matter of record that there are some twenty-three large black-and-white portraits of courtesans, signed, by four different Kaigetsudō artists, none of them mentioned in the histories, none of them (apparently) the original Ando. On account of the controversy as to the identity of these artists, and because of their rarity and boldness, the Kaigetsudō beauties have been prized by collectors. Miss Ainsworth was the envy of her rivals for owning two. One, signed Dohan, is of a courtesan in a kimono patterned with waves and wheels (PLATE 212, CAT. NO. 8) which is known by other impressions in the Tokyo National Museum and the Vever collection. The Ainsworth impression is sealed Takeuchi, and may be the sixth of the celebrated group that Raymond Koechlin, the French collector, found in a bookstall along the Seine, the other five of which were purchased by the American collector Louis V. Ledoux and are now in The Metropolitan Museum in New York. The Anchi portrait of a courtesan in a kimono patterned with ginko leaves (PLATE 3, CAT. NO.

10) is less fresh, but has not been illustrated since Arthur Davison Ficke's article 'The Prints of Kaigetsudō' in *The Arts*, IV, No. 2, 1923. (Ficke illustrates twenty-two subjects in his article. A twenty-third, signed Anchi, of a courtesan in a kimono patterned with oak leaves, is in the Grabhorn collection in San Francisco.)

In spite of their energetic activity, their diversity and sophistication, and despite the exuberant vitality of their period, artists such as Masanobu, Toyonobu or Kiyohiro lacked a certain form of self-consciousness and historical awareness. These 'Primitives' were improvers, not explorers; their pleasure lay in taking a good design and going one better. Their innovations, for all their variety, were always superficial, for beneath them they shared a vision that had derived in a direct descent from the tributary streams of the earliest period.

A large and unrecorded two-color print by Suzuki Harunobu (CAT. NO. 95) demonstrates this point. On the face of it, this 'armor-pulling' scene between the reckless adolescent Soga Gorō and his well-disposed opponent Asahina is a far remove from the Masanobu beauty with the battledore, but one could easily compose a series joining the two by clear, discrete stages. There are no thundering discontinuities in the first act of our drama. Nor is there any hint of revolution in Harunobu's print.

But revolution was declared. Before two years were out, Harunobu was seized with the conviction that an artist need not be limited to the materials and images of his immediate past. If four colors can be printed, he asked himself, why not six or eight? If a modern Kiyomitsu prompts a variation, why not search out designs of a remoter past? Why, for that matter, couldn't historical and modern themes be joined? The answer from his publishers and patrons was that he should go ahead, and in the six years before his death he designed 1,000 color prints and rifled through older prints and illustrated books for sources, to which he gave a novel interpretation.

Toward the end of his career Harunobu designed a print with the actor-portraitist Ippitsusai Bunchō (CAT. NO. 111). Both figures are intended as portraits, but the design is also an allusion to the 'armour-pulling' incident, mentioned above. Butterflies are the emblem of Soga Gorō and are shown on the courtesan's kimono. The crane of Asahina appears on the screen behind. The mood and the intention of the print, not to mention its technique, constitute a departure from the conventions of Act One. This is the only impression of the print known outside Japan.

Nothing prevented an original artist from being bound by his own form, and one of the themes of Act Two is the spectacle of a series of brilliantly innovative personalities who achieved new visions and extended the scope of *ukiyo-e*, and who ended their careers surrounded by disciples but imprisoned within their own style. Harunobu suffered this fate, as did Shunshō, the actor-portraitist, the stately Kiyonaga, and the more wilfully eccentric artists of the 1790s, Toyokuni and Utamaro.

In the late-eighteenth century, artists were acutely aware of their position as scions of an historical style, and self-consciously they worked at creating ties with their past. Harunobu designed a tribute to Masanobu, for example, and Utamaro drew this fictitious portrait of Harunobu's favorite young beauty, Osen (PLATE 26, CAT. NO. 286), as a respectable middle-aged matron with shaven brows, presenting the secrets of her charm to Ohisa, the reigning beauty of Utamaro's day. In a pendant to this print in the Nelson-Atkins Gallery in Kansas City, Utamaro shows Osen's middle-aged rival, the toothbrush-seller Ofuji, handing a scroll of *her* secrets to Okita, another beauty of the day.

The creation of Japanese prints was not confined to the city of Edo. The original sources of the Torii style are to be found in the Osaka-Kyoto area, and some of the earliest anonymous single-sheet prints seem to have been published there. The balance swung heavily toward Edo in the eighteenth century, but in the 1790s a group of full-color actor portraits were published in Osaka which stimulated the emergence of an entire school with its own style. These were designed by a classically-trained painter-turned-portraitist named Ryūkōsai and show a refreshing candor in the simplicity of designs and accuracy of portraiture. The print by Ryūkōsai (CAT. NO. 316) represents two actors in a scene from a *kabuki* play, the inspiration of nearly all Osaka prints. The print is unique.

Unflattering accuracy was a quality that Ryūkōsai shared as a portraitist with the brilliant and enigmatic artist Tōshūsai Sharaku, whose début in the world of *ukiyo-e* was a colossal series of twenty-four bust-portraits of actors on dark mica grounds for roles from *kabuki* plays performed during the fifth month of 1794. *Ukiyo-e* publishers and designers alike loved sets, but no artist had ever attempted a set on as large, or as costly, a scale as Sharaku, who was then completely unknown. A fine example of one of the rarer portraits from the set (seven other impressions are known) is illustrated (PLATE 30, CAT. NO. 318). There is a tradition that Sharaku was a *Nō* dancer, but recent documents suggest that he may have been the husband of a Shinto priestess who lived in Osaka, but was briefly resident in Edo at the time when Sharaku's prints appeared. Certainly his literal portraits seem 'foreign' when compared with the expressive distortions of similar portraits by Kunimasa, Shun'ei and Toyokuni.

Most artists of the Golden Age died before it passed, and were spared a painful *dénouement* to their moments of glory. Unlike Harunobu, who abandoned tradition for new vision, Utagawa Toyokuni slipped away from the idiosyncratic brilliance of his early 'Actors on Stage' series (PLATE 33, CAT. NO. 323) into a long unresolved struggle with changing taste and circumstance. The villain of the piece was a prosperous economy. In the 1780s Edo had been flattened by fire and economic turmoil, but by 1800 it was enjoying a prosperity it had not known for a century. And just as a generation of designers and craftsmen began

to die out, there was a sudden and insatiable popular demand for woodblock prints. New publishers sprang up overnight like mushrooms after rain and engravers were as popular as Chinese cooks in Manhattan. Artists were suddenly self-supporting, and had to work round the clock to meet demands. Design and craft both suffered. The best engraving was tight and hard, the worst was crude, and the pictures themselves lost in the translation.

The dilemma was resolved. Act Three was another imaginative leap, this time by the son of an Edo fireman, Andō Hiroshige. There was no good reason to limit oneself to endless re-runs of actors and courtesans, he reflected, when there is a boundless natural world around us. Like Harunobu he was able to command or improvise a new technique of engraving and printing so as to accommodate his own sense of poetry to the publisher's requirements of simplicity and speed. Hiroshige was, by any standards a prolific designer. During a career of forty years he designed 10,000 single-sheet prints, and hundreds of book illustrations. His best-known prints are landscapes in the horizontal format, but he designed several hundred delicate studies of birds and flowers (well represented in the Ainsworth collection), and 300 or 400 designs for fans. As these fans were made to be used, few impressions of any one print survive, but the format appealed to Hiroshige as a change from the ordinary landscape format, and his many fan designs are among his most spontaneous and beautiful (PLATE 53).

While Hiroshige was simplifying the grammar of print design in his quest of the serene, his contemporary Ichiyūsai Kuniyoshi was engaged in a similar pursuit of loud fantasy, clutter and visual excess. In the ambivalent, contradictory world of mid-nineteenth-century Japan, there was ample room for visions both of turmoil and tranquility. Hiroshige's prints made it easier to bear the frenetic accelerated urban life, but Kuniyoshi's fantasies, which sprang from the schisms and destructive movements of his time, were a preparation for the inconceivable changes soon to occur. Kuniyoshi died without witnessing the arrival of the foreigners, the dissolution of the Shogunate, and the collapse of three centuries of peace. But like his Soga Gorō (CAT. NO. 574*) and many of his countrymen, he had steeled himself to accept the challenge of a new world and looked forward with high eagerness to the uncertainty ahead and the expanse of the unknown.

An asterisk (*) after a catalogue number reference in text indicates that the work is illustrated in the catalogue section.

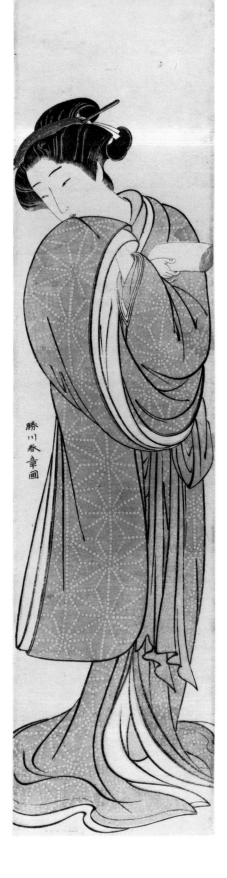

勝川春章画

I. *Selected Issues and Themes*

PLATE I

The Attribution of unsigned prints

THE ATTRIBUTION of unsigned Japanese woodblock prints and illustrated books is difficult because so little is known about the transition between the designer's original sketch and the final engraving. Different engravers translated drawings in very different ways, and the employment of professional draughtsmen to make final drawings for the engravers diminished the personal qualities of the original design even further. The differences between two unsigned prints in similar styles may be the result of different designers, but may equally be a result of different engravers, copyists, or a combination of these.

This portrait of Matsumoto Hyōzō (PLATE I), the Kyoto-Osaka actor of female roles who came to Edo for the first time in the autumn of 1697, is signed Hishikawa Moroshige zu, and is sealed Moroshige. Moroshige was an important pupil of Hishikawa Moronobu, one of the artists in the late seventeenth century who consolidated the *ukiyo-e* style. He was a painter and an illustrator, and designed a few sets of erotic prints. Apart from the signature, however, there is little to link Moroshige to this work. He designed no other actor portraits, and the figures in his illustrations and paintings bear little resemblance to this design. The picture is most closely related to a series published around 1700 of large portraits of actors with conspicuous identifying crests overhead. Early unsigned prints have often acquired exotic signatures in recent times to make them more saleable. The placement of the Moroshige signature, the difference in the color of the ink between the top two characters and the actor's sword hilt, and the slight differences in the patterning of the ink on the signature and the rest of the design on the paper all suggest that the signature is a modern addition. But if we discount the signature and suppose the print were not designed by Moroshige, is there any other more plausible candidate for its designer?

In 1700, an artist named Torii Shōbei Kiyonobu designed an album of over forty vigorous portraits of actors with their identifying crests alongside. Around the same date he designed two large portraits of actors with bold identifying crests overhead. Because of their similarity, several other large unsigned prints in the same format and the same general style have been attributed to Kiyonobu, and most modern writers would have no hesitation in attributing this print to the artist who is credited with founding the Torii style. The patterns on Hyōzō's robe, however, are less broken than comparable patterns in the signed portraits from the group in the Ledoux collection, the Worcester Art Museum, and the Art Institute of Chicago. In addition the trunk of the plum tree is more carefully drawn than the trunk of the Chicago willow. However, the similarities between the prints outweigh the differences; perhaps the portrait of Hyōzō was designed for his first performance in Edo at the Yamamura theater in November 1697. Hyōzō specialized in female roles, but in his debut before the Edo audience, he acted as a *wakashū*, as he is depicted in this print. During the performance as the courtesan Ōiso no Tora in the spring of 1700 he briefly assumed the costume of a *wakashū* once again, but if the print were designed by Kiyonobu in 1700, one would expect it to be signed and closer in style to the portrait of Kichisaburō in Chicago.

If Kiyonobu did indeed design this portrait for a performance in November 1697, and it was published that month or shortly thereafter, it would be the artist's first single-sheet print, and the earliest large single-sheet actor print now known and dated. No other impressions of the print are presently known. Kiyonobu's illustrated theater programs of this period were also unsigned. Thus the signatures on his theatrical prints, and on the above-mentioned album of 1700, may have been an innovation at this time. If so, the other large unsigned prints of actors with bold emblems above may also prove to have been designed by Kiyonobu in the late 1690s, their stylistic differences owing to a difference in engravers or a gradual change which took place in the formation of Kiyonobu's mature style.

1. Attributed to Torii Kiyonobu I, active ca. 1690s-1720s
The actor Matsumoto Hyōzō as a *samurai* beneath a plum tree, ca. 1697.
Sumizuri-e, uncolored woodblock print. Catalogue 4.

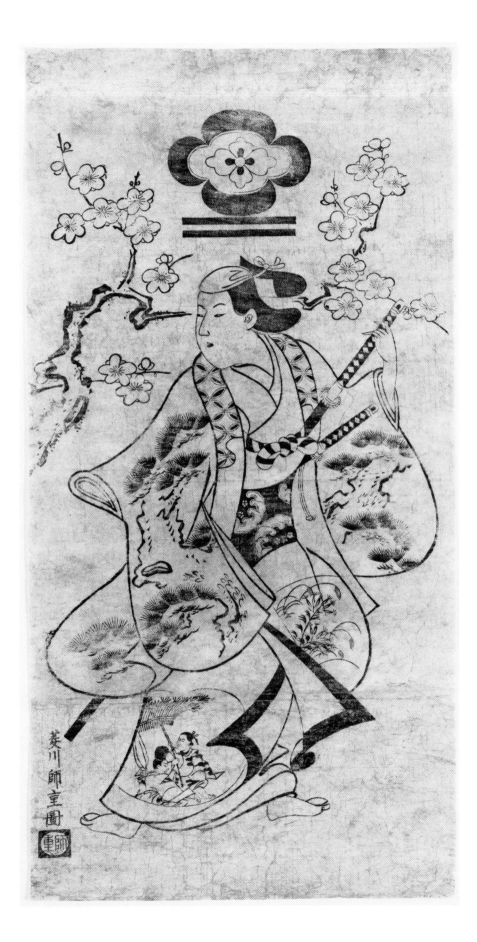

PLATE 2

Early print publishers

COMMERCIALLY PUBLISHED PRINTS in the early eighteenth century seem to have been distributed in two ways. Narrow panel prints of actors and beautiful women were sold by itinerant street vendors, but large prints, like this handsome and probably unique picture of a courtesan by Okumura Masanobu, which could not be hung conveniently from the rim of the street seller's umbrella, were sold on the publisher's premises. Most of the early Edo publishers were located in the central area of Edo around Nihonbashi, near the theater and entertainment quarters. In the early years of the eighteenth century, there were relatively few print publishers, but with the years their number increased, and rather than try to compete with the already well-established central publishers, new firms began to open their shops in outlying districts of Edo. The most important of these were Emiya in the Shiba district, about six kilometers south of Nihonbashi, and Komatsuya near the Tenjin shrine at Yushima, about four kilometers northwest of the city center. These shops were located along the two roads which joined Edo and Kyoto, the Tōkaidō and the Nakasendō or Kisokaidō, and much of both firms' business must have been directed at passing travellers, rather than at local residents or the distant citizens of downtown Edo.

Masanobu began his career in 1701 with an adaptation of Torii Kiyonobu's album of portraits of courtesans, *Keisei Ehon,* which had come out the previous year. The publisher of this set had premises in central Edo, but most of Masanobu's subsequent work, in the next two decades, before he opened his own publishing firm, was published by firms like Komatsuya, Kikuya in the entertainment district of Asakusa, north of the central district along the Sumida River, and Nishimura, a publisher in Komagome. Komagome, even further northwest along the Kiso Road from the central district of Edo than Yushima, was a village best known for its eggplants, its government falconry, and its many nurseries. The signature on this (PLATE 2) and on the two other prints published by Nishimura which are known show that Masanobu was, indeed, catering to travellers who were returning home to Kyoto or the provinces, since he calls himself the Yamato-style painter from Tōbu, the eastern province of Musashi, a euphemism for Edo which would be meaningless to an Edo print collector. Masanobu's choice of subjects may also have been aimed at a Kyoto audience. All three of the Nishimura prints are pictures of standing women. One of the women is a court lady of the Heian court in Kyoto looking down at a bird cage; another is a modern courtesan whose robe is decorated with poem cards bearing portraits of classical poets of the Kyoto area. The courtesan striking a shuttlecock is dressed in a robe decorated with calligraphy, which appears in other prints and paintings of the period but here is quite legible, including many words and phrases redolent of classical verse.

It is difficult to judge the fortunes of the early local publishers from their few surviving prints. Nishimura could hardly have survived on the proceeds of the three prints mentioned above by Masanobu. But the attrition of early eighteenth-century prints was enormous; three of the five surviving large early prints designed by Kiyomasu for the publishing firm of Emiya in Shiba are known only by nineteenth-century impressions and copies and the two remaining prints are known only in unique impressions, like the three Masanobus. Emiya, however, prospered, and eventually moved from Shiba to Bakurochō in the central district of Edo. The fifth-generation descendant of the firm published the copies of the prints whose blocks were discovered in the early nineteenth century (see PLATE 211). It is tempting to imagine that Nishimura also prospered, and eventually moved from Komagome village to Bakurochō himself, becoming the famous firm Nishimura Eijudō who published two-color prints, full-color prints, and many of the finest landscapes by Hokusai in the nineteenth century.

2. Okumura Masanobu, ca. 1686–1764
Courtesan striking shuttlecock with battledore, 1710s. *Kakemono-e,* print in the format of hanging scroll paintings. Catalogue 11.

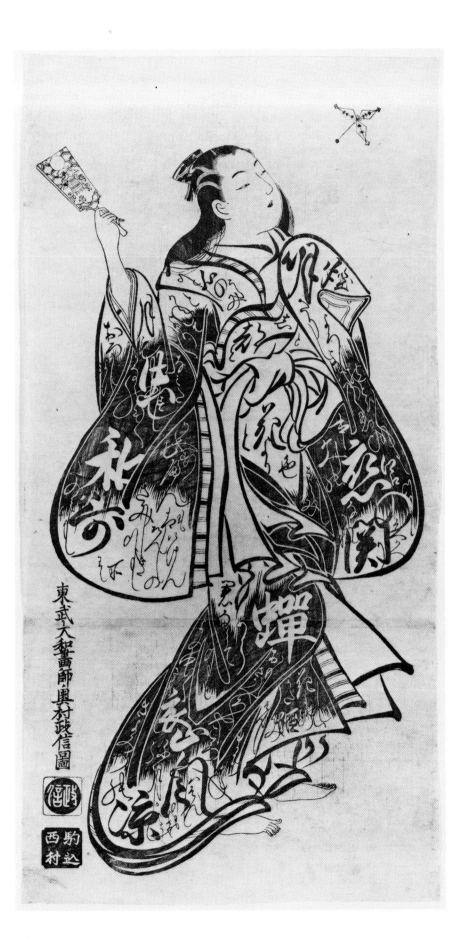

PLATE 3

The Kaigetsudō problem

THERE ARE TWENTY-THREE PRINTS of standing courtesans published at the beginning of the eighteenth century that look very much alike, although they are signed with three different names: Anchi, Dohan and Doshin, who all share the common studio name Kaigetsudō. By whom and when were they designed? Interestingly, each of these artist's names is associated with a different publisher. Eleven prints signed Dohan bear the mark of the major Edo publisher, Igaya. All three prints signed Doshin were issued by a less-important publisher, Nakaya. Five prints signed Anchi were published by Maruya, a firm in the second block of Ōtemmachō in Edo whose trademark of an eggplant with the number eight appears on no other prints. (Maruya, the publisher of the Ainsworth Anchi (PLATE 3), of which no other impressions are known, may have some relation to the Maruya in the third block of Ōtemmachō whose emblem was the number nine in a circle, and who published hand-colored prints from around the late 1710s. This Maruya may, in turn, have become the well-known Maruya Kohei whose early address was in the same block of Ōtemmachō, and whose emblem of the character for mountain in a circle appears on so many two-color prints of the 1740s and 1750s.) There are four exceptions to the rule linking Kaigetsudō signatures with publishers. Two prints signed Dohan and one signed Anchi have no publisher's mark. One print signed Anchi (Higuchi PL. 13.5) has the mark of Igaya, the publisher of the Dohan prints, but is somewhat different from the other Anchi prints and should probably be examined with caution. The Kaigetsudō prints differ slightly among themselves in drawing and style, but how consistently this varies by signature from publisher to publisher and hence from engraver to engraver is as yet unclear, although the carvers seem responsible for much of the variation.

In addition to the prints there are many paintings, early and modern, signed Anchi, Dohan, and Doshin, and there are paintings as well, but no prints, signed Kaigetsudō Ando, the only Kaigetsudō artist who is mentioned in documents of the Edo period. In a manuscript of biogra-phies of *ukiyo-e* artists compiled by the artist Eisen in the 1830s, Ando is described as a painter who lived in Suwachō in the Asakusa district of Edo, active during the Kyōhō period (1716–1735). A brief addition to this note by the historian Saitō Gesshin in 1844 stated that Ando was involved in the Ejima Incident, a scandal involving an actor and a woman of the shōgun's household, and was banished from Edo for a certain period in March of 1714. There is no other verification of this story, and how long Ando was away from Edo, assuming it is true, is unknown. Historians of *ukiyo-e* have all accepted Saitō's story. Those who see differences in the prints explain the absence of Ando's signature by attributing them to his pupils or colleagues in his absence. Those who see similarities suggest they may all have been designed by Ando after his return but were issued under different signatures to escape possible government notice and censure. The large format of the Kaigetsudō prints was abandoned around 1718, so they are usually dated ca. 1715.

The style of the prints themselves, however, suggests they may have been published before the Ejima Incident. Portraits of similar figures by Masanobu and Torii Kiyo-masu seem to date from the late 1700s and early 1710s. Two comparable portraits of actors as courtesans by Kiyomasu which are firmly dated 1715 and 1716—the portrait of Takesaburō in the Vever collection and the portrait of the Kyoto actor Senya in Honolulu and the Metropolitan Museum (formerly in the Ledoux collection)—are far more restrained in their drawing and much more fastidiously hand-colored than the Kaigetsudō prints. It is probably unimportant to know whether or not Ando was really exiled in 1714, and it will perhaps never be clear why his name does not appear on prints (although other important *ukiyo-e* painters of the period, like Miyagawa Chōshun, designed no prints). A careful study of the prints themselves may eventually show that they were the work of one or several artists, and this, in turn, may make it possible to separate more easily the genuine Kaigetsudō paintings from the many forgeries which exist.

3. Kaigetsudō Anchi, active ca. 1710s
Courtesan in a robe decorated with ginko leaves, ca. 1710s. *Tan-e*, picture hand-colored with red lead. Catalogue 10.

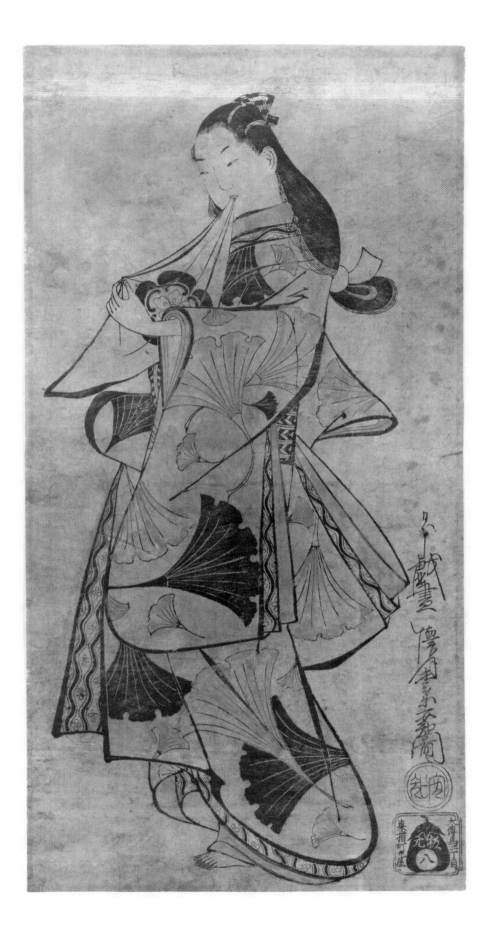

PLATES 4-6

Okumura Toshinobu

NOTHING, apart from what may be inferred from his work, is known about Okumura Toshinobu, but he is, perhaps, the most original, inventive, and interesting designer of the 1720s, a period when the rather crude orange and yellow coloring of the earlier woodblock prints gave way to more careful hand-coloring, using metallic dust to add sparkle to the prints, and a vehicle of glue mixed with certain pigments to give them gloss and luster, as though lacquer had been applied to their surfaces. Toshinobu's first print may have been the large *kakemono-e* published

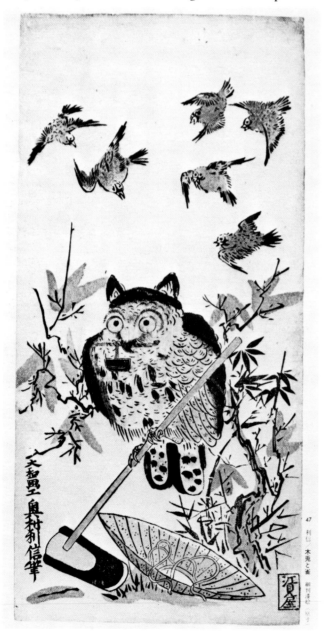

4. Okumura Toshinobu, act. ca. 1717–1740s
Sparrows worrying an owl perched on a mattock, 1720s. *Urushi-e*, picture hand-colored with lacquer, Photo: *Ukiyoe taikei*, vol. 1, pl. 47.

in 1718 of the actor Sanjō Kantarō as young Oshichi arranging her hair before a mirror, although slightly earlier dates have been tentatively proposed for a few portraits of actors in the *hosoban*, or narrow panel format, which was used by Toshinobu for all the rest of his work. Toshinobu uses the name Okumura on his prints, and most writers have supposed that he was a pupil, if not a relative, of Okumura Masanobu, whose firm published some of his work in the 1720s. The greatest proportion of his work, however, was done for outlying publishers like Emiya and Masuya, both in Shiba, several kilometers south of the central district of Edo, where, "at the Sign of the Red Ground," Masanobu published his own work, and it is possible that he was an independent artist who adopted the style of Masanobu because it was congenial, and the name Okumura because it was well-known and commercially saleable. Whatever their personal relations were, Toshinobu's hand-colored prints are nearly always more graceful, more attractive, and more bold than Masanobu's during this period. For all practical purposes, Toshinobu stopped designing prints by the end of the 1720s, although there is one two-color print with his signature in the Art Institute of Chicago which has led writers to say that he was active until 1742.

Masanobu, Shigenaga, Kiyomasu II, and other artists designed many pictures of animals and birds in the 1720s. Toshinobu designed only this one picture of an owl with sparrows (PLATE 4), and its air of mystery sets it quite apart from the others. Two impressions of the print are known. One is the Ainsworth print, which was reproduced in the catalogue of the exhibition of primitive prints at the Musée des Arts Décoratifs in Paris in 1909, in the sales catalogue of the Rouart collection, and in *Ukiyoe taisei*, a Japanese publication. The other impression (PLATE 5), in a Japanese collection, is less carefully colored, and has been reproduced in color in *Ukiyoe taikei* and elsewhere. Everyone who has owned or written about the print has felt that it holds some unexplained, deeper meaning. Gookin thought the print might be a picture rebus; a Japanese writer suggests it might illustrate a proverb. Certainly one wonders why the owl is perched on a mattock, holding a pipe and tobacco pouch in its beak, and why the sparrows are fluttering about above his head. Are they irritated at his presumption in taking the farmer's place? Is he acting as a scarecrow in the farmer's absence? Has the farmer, perhaps, to the sparrows' consternation, changed into an owl? Certainly it is a tribute to Toshinobu that one returns so often to the picture in pleasure and puzzlement.

Another genre that became popular in the 1720s was portraits of actors as itinerant street vendors. Toshinobu designed only a few of these, but this portrait of Ichikawa Danjūrō II in a robe decorated with the crests of other actors (PLATE 6) is a particularly fine and well-colored example. It is the only print in which Toshinobu included an actor's soliloquy. No other impression of the print is presently known.

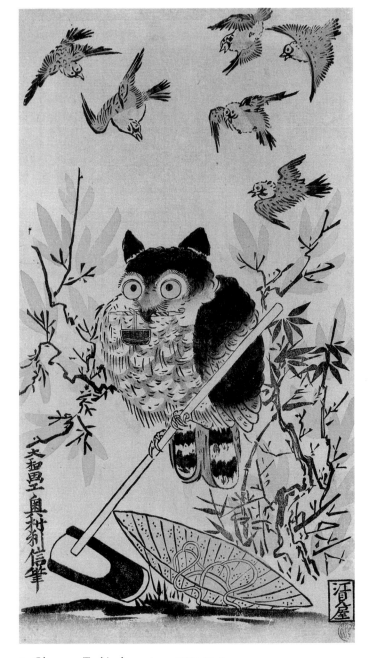

5. Okumura Toshinobu, act. ca. 1717–1740s
Sparrows worrying an owl perched on a mattock, 1720s. *Urushi-e.*
Catalogue 27.

6. Toshinobu
The actor Ichikawa Danjūrō II as Soga no Gorō disguised as a street
vendor, 1720s. *Urushi-e.* Catalogue 28.

PLATE 7

Kakemono-e

WOODBLOCK PRINTS served many purposes and were viewed in many different ways. Some prints were published as sets in albums, others were published separately and were kept loose in boxes or mounted in albums by collectors. In Harunobu's time, and even more in the nineteenth century, prints were pasted on walls and standing screens as decoration. Other prints were used as fans and to decorate boxes, and others were meant to be mounted as scrolls and hung as paintings. The earliest of these large prints were called *kakemono-e,* or prints in the format of hanging scroll paintings. None, to my knowledge, has survived in its original mounting, but some show signs of mounting along the edges. The early *kakemono-e* were larger than the available paper, so large sheets were made by piecing. In 1718 or shortly thereafter, this format was discontinued, and print designers turned their attention to smaller, more brilliantly colored prints, printed on thicker, more durable paper. In the late 1730s large sheets of this paper were used for the first large prints designed in western perspective, and shortly afterwards, hand-colored *kakemono-e* reappeared, narrower than the older prints, but carefully colored, and printed on one sheet of fine, thick paper. The most prolific and successful designers in this new format were Toyonobu and Masanobu, who may have introduced it.

Two impressions of this outstanding portrait of the handsome young *kabuki* actor Sanogawa Ichimatsu are presently known: one in the Ainsworth collection (PLATE 7), the other in the Art Institute of Chicago. The lantern in the actor's hand implies a night rendezvous, and the direction of his gaze suggests that the print may have been published as one of a pair with the picture of a young male prostitute who is carrying a lantern. with Ichimatsu's identifying crest and whose eyes are turned demurely toward the ground. Our portrait of Ichimatsu lacks the mark of the publisher Izumi which appears on impressions of the other print, found in the Vever (Vever 65) and Mann collections, but the two prints are engraved in a similar style and their poses are complementary.

7. Ishikawa Toyonobu, 1711–1785
The actor Sanogawa Ichimatsu holding a lantern and an umbrella, 1740s. *Kakemono-e*, print in the format of a hanging scroll painting. Catalogue 58.

PLATE 8

A Set of pillar prints

KATSUKAWA SHUNSHŌ specialized in paintings of women and woodblock portraits of actors. Most of his portraits of actors are in the narrow upright *hosoban* format, but he designed a few narrow pillar prints of actors around 1770. In the mid 1770s he designed three extraordinarily refined and beautiful portraits of women. The Ainsworth picture (PLATE 8) shows a young girl, the Tokyo Museum print shows a somewhat older woman standing in a loose bath wrapper holding a fan with the crest of the actor Nakamura Nakazo, one of Shunshō's favorite subjects, and facing right. The third print, in the Riccar Museum, shows a courtesan wearing an elaborate robe decorated with flowers, wave patterns, and phoenixes. All three prints are in an unusual wide format which does not seem to have been used by other artists during the period. All show signs along the edges of mounting as hanging scrolls. The signatures on the three prints are similar, although that on the Riccar print is abbreviated, and its colors are less faded. Since paintings were often designed as triptychs, perhaps these prints were also designed together, possibly as a special commission from an enthusiastic patron and print collector (all three prints seem to be unique, and all are fine, early impressions). The three prints depict innocent and worldly women in everyday life set as attendants to the floating, dream-like, nearly celestial figure of the courtesan in her regalia. The Ainsworth impression is from the collection of the Japanese connoisseur and dealer Kihachiro Matsuki, and is illustrated in his sale catalogue.

8. Katsukawa Shunshō, 1726–1793
Young woman with sleeve raised, mid 1770s. *Hashira-e*, pillar print.
Catalogue 163.

PLATES 9–12

Early color printing

SIMPLE COLOR PRINTING was used for the first time in Japan during the Kanei period (1624–1643) and appeared in at least one privately published poetry album in the 1720s. It was not introduced into the world of commercial print production in Edo until the early 1740s, the earliest example presently known being a calendar print by Okumura Masanobu in the Royal Ontario Museum, Toronto, published in the spring of 1742. Hand-colored prints in the narrow *hosoban* and the larger *kakemono* and pillar formats continued to be published during the early 1740s, but the largest number of prints in the 1740s and 1750s were printed in two colors, pink and green (PLATE 9). The pigments used on these prints have not been precisely identified, but they varied over the years, as may be seen in the illustrations. The earliest pictures were printed in a light, very fugitive pink, and a delicate yellow green. Perhaps because this pink, or rose, faded so easily, giving a ghostly, incomplete effect to many of the surviving early prints, it was replaced with a bluer green and a more orange red made from *beni,* or safflower blossoms. A darker, more opaque green was introduced in the 1750s, perhaps because the earlier blue-green pigment was not the same value as the pink and did not balance well (the green on the boy's robe in PLATE 10 seems to recede into the background, giving an effect of transparency, the patterns on his robe seeming to float in mid air). A large number of prints in large and panel formats were published in these colors. When exposed to light or moisture the mineral green did not change, but the organic pink dye would fade, as on the print by Kiyomitsu (PLATE 11). Late in the 1750s, designers began to experiment with a third color block and the effects of over-printing. Three blocks—pink, green and blue—were used in Kiyoshige's print (PLATE 12), the purple stripes on the robe having been achieved by over-printing the pink and blue. The print is particularly fresh in color, although the fugitive dyes have begun to fade on the outer edges. The difference between the pink on the Kiyoshige and the equally fresh Toyonobu print (PLATE 10) may be because the *beni* came from different regions, or because different mordants were used to fix the color.

The squat, conventional figures in the Kiyonobu print (PLATE 9) are typical of the 1740s, and are different enough from the vigorous and graceful hand-colored prints signed Kiyonobu in the 1720s to make an attribution to a third artist using the name at least plausible. Toyonobu designed several large pictures of actors; one of the liveliest is this portrait of the young actor Hikosaburō II (PLATE 10). As the poem says that "the spring pony clears away the morning mist with a drum," the print may have been published to commemorate the actor's first spring performance with this new name at the age of eleven in 1752, even though the actor's name does not begin to appear in the theatrical records until the winter of 1753. One additional impression each of the Kiyonobu III and Toyonobu prints is known, having been recorded in other collections, but neither the Kiyoshige and Kiyomitsu prints are known elsewhere, and both prints may be unique. The Kiyoshige (PLATE 12) is from a group of similar portraits by various artists in a slightly oversized panel format, but the only parallels for Kiyomitsu's picture are in illustrated books of the period, not in single sheet prints.

The Takeda were a clan of craftsmen who manufactured clockwork automata. Originally these devices fell within the purview of the wealthy, but the Takeda opened a theater in Osaka, with interludes of dance, mime and acrobatics performed by children, and exhibited them to the public with great acclaim and success. Occasionally the head of the clan would bring the troupe to Edo and one of these visits is commemorated in Kiyomitsu's print (PLATE 11). The inscription at the left explains that the performance is the Hand Drum Waterfall in the province of Tsu. The two dolls operated a pump which sent a stream of water into a large rock on the table in the background. This water splashed down and turned the waterwheel, and although it is not mentioned, the same action probably caused the bird to sing and drum to sound. The emblem on the table and in the upper corner is the crest of Takeda Ōmi, whose rank seems to have been *daijō* (or *dainojō*) although it is written as *taikyoku* (or *daigoku*) on the print.

9. Attributed to Torii Kiyonobu III, act. 1750s–1760s
The actors Sanogawa Ichimatsu I and Segawa Kikujirō as Ike no Shōji and Kan no Tsubone, 8/1747. *Benizuri-e,* two-color print. Catalogue 48.

10. Ishikawa Toyonobu, 1711–1785
The actor Bandō Hikosaburō II as a pony dancer, early 1750s. *Benizuri-e.* Catalogue 61.

11. Torii Kiyomitsu, 1735–1785
The actor Ichimura Uzaemon VIII as the *ashigaru* Teraoka Heiemon, 1760s. *Benizuri-e.* Catalogue 80.

12. Torii Kiyoshige, act. late 1720s–early 1760s
The actor Ōtani Hiroji (Jitchō) in a male role, late 1750s or early 1760s. *Benizuri-e.* Catalogue 75.

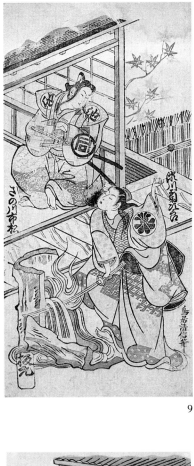

9

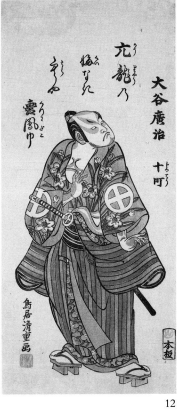

10

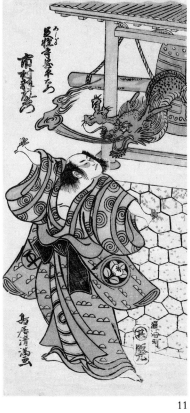

11

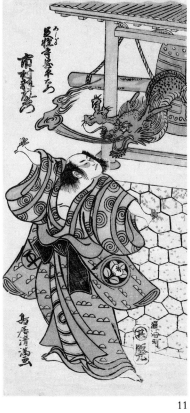

12

PLATES 13–16

Mitate, picture calendars, and early color prints

JAPANESE WOODBLOCK PRINTS and illustrated books were designed for one of two audiences: the general public who bought directly from publishers, shops, or itinerant vendors, and groups of cultivated connoisseurs who commissioned artists to design pictures especially for them, and had them published privately. No written records document this practice, and whatever is known must be inferred from the prints themselves, so the boundaries between these groups are sometimes unclear. But there is no doubt that the great majority of the black and white, hand-colored, two- and three-colored prints published in Edo through the beginning of the 1760s were designed for a commercial audience. It is equally clear that the first full-color prints which suddenly appeared around the spring of 1765 were privately commissioned works produced for groups of poets and were not originally intended for sale. Quite apart from the cost of the careful engraving and printing, the unusual pigments and the fine, luxurious paper, these prints often bore alongside the designer's name the name of some poet in his capacity of inventor of the idea for the print. All of these early experiments in color printing were designed as picture calendars (see PLATES 142–44), and the numerals of the long and short months were concealed somewhere in the design. Since the pictures were being designed for groups of poets, many had a literary interest, using a convention called *mitate,* or modern adaptation.

The principle of *mitate* was that an additional dimension could be added to a picture of a contemporary subject in a modern style by introducing an element of pose, posture, costume, or iconography, which would remind the viewer of some episode from literature or the legendary past. The modern couple in somewhat modern dress is meant to suggest a comparable episode in the *Tales of Ise,* a medieval romance, in which Prince Narihira achieves a rendezvous with a lover by creeping through a wall. The episode was the subject of another, less attractive horizontal print in the Art Institute of Chicago (PLATE 14), which has calendar marks for 1765 and the name of Rigyoku, the poet, who either designed the print himself, or acted as the commissioner and conceiver. The Ainsworth print (PLATE 15) is engraved in the style of, and is printed with the colors characteristic of, the calendar prints of 1765 and 1766. No numerals are visible, but the pattern on the young man's knee is uneven and was altered to remove some numbers. (An earlier impression with calendar marks for 1765 and the seal of the conceiver or designer Gihō is in the Morse collection, Wadsworth Atheneum, Hartford, PLATE 13). This seems to have been a common practice in the 1760s, and may show that after the prints had served their original purpose they were sold commercially or distributed more widely. Unsigned prints in this style are often attributed to Harunobu, but neither the composition nor the couple's faces resembles his work. Many other artists designed

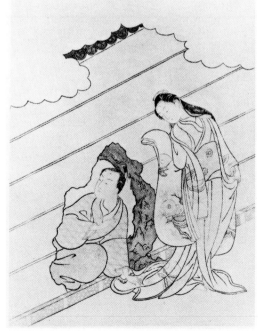

13. Unsigned
Couple escaping through a hole in the wall, 1765. *Egoyomi,* Picture calendar. Wadsworth Atheneum, Hartford.

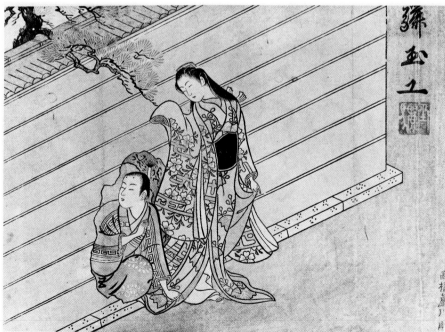

14. Rigyoku
Couple escaping through a hole in the wall, 1765. *Egoyomi.* The Art Institute of Chicago, Clarence Buckingham Collection.

calendar prints, but their work has not been studied carefully enough to offer a convincing attribution for this picture.

Erotic albums and suggestive semi-erotic pictures were designed by many artists during all periods of the history of *ukiyo-e,* and the snow scene belongs to one of these sets which is unsigned but comfortably attributed to Harunobu (PLATE 16). The fact that the entire figure of the seated girl has been reengraved suggests that some erotic albums may have been commissioned privately, and that certain subjects were occasionally altered by the publisher to make them more commercially saleable. In the first state of the print, the girl's pudenda is exposed, she is reading a love letter, and the married woman outside her window is throwing the snowball to cool her ardor—elements which are lost in this contemporary but expurgated version.

A close examination of the two figures shows that the lines on the women's robes are engraved by different hands. Lines which are sweeping and sure on the married woman are wiry and hesitant on the girl, and the technique of engraving details on the wigs and faces also differs. The color of the Harunobu picture is quite fresh but is beginning to fade, noticeably on the man's trousers. The cloud above is printed a pale yellow with a pattern of woodgrain, to contrast with the uncolored but warm white paper of the couple's faces and the girl's undergarments.

15. Unsigned
Couple escaping through a hole in the wall. 1765. Second state, lacking calendar marks. *Egoyomi.* Catalogue 92.

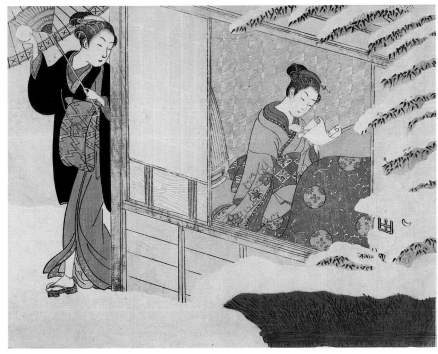

16. Attributed to Harunobu
Woman throwing a snowball at a girl reading a love letter, late 1760s. Catalogue 108.

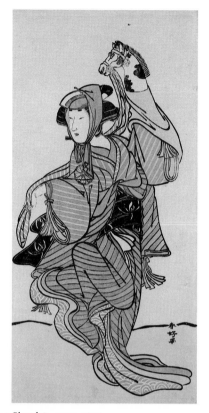

17. Katsukawa Shunkō, 1743–1812
The actor Nakamura Tomijūrō I as a pony dancer in *Kunikaeshi shichiyō kagami*, 9/1778. Catalogue 179.

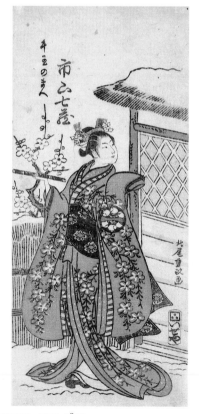

18. Kitao Shigemasa, 1739–1820
The actor Ichiyama Shichizō as Giō no Mae holding a flute, ca. late 1760s. Catalogue 125.

PLATES 17–18

Actor prints

MANY IMPORTANT *ukiyo-e* artists of the late eighteenth century began their careers as designers of inexpensive commercially published three-color portraits of *kabuki* actors. The first half of Harunobu's career was devoted to conventional and unmemorable works of this sort (see CAT. NO. 93*), and Kiyonaga, Shigemasa, Kitao Masanobu, and Hokusai (using the name Shunrō) all designed prints in this genre long after the demand for full-color actor portraits was well established. The typical three-color actor portrait was carelessly engraved and hastily printed on thin, low-quality paper. These pictures almost invariably bear the mark of a publisher, often of obscure firms. Surviving impressions are usually rare (since they were not especially beautiful, they may not have been systematically collected or prized) but they are often late impressions, showing that in their time large numbers were printed. By contrast, full-color portraits of actors were published in great numbers during the same period, but were virtually monopolized by artists like Shunkō of the important Katsukawa school. These pictures, which began to appear in the spring of 1768, were carefully engraved and painstakingly printed, like the full-color prints of Harunobu and his contemporaries, in rich colors on fine, absorbent paper of a larger size than was used for the commercial prints. These qualities, the fact that publishers' marks appear on the prints so rarely, and the relative rarity of late impressions, indicate that they might also have been privately produced prints commissioned by members of the wealthy theatrical patronage organizations of the period or as gifts by individuals, like the owners of the tea houses associated with the theaters which were maintained by these wealthy patrons. The different qualities of design, color and engraving technique in these commercial and possibly private publications may be seen in the two prints illustrated. The Shigemasa (PLATE 18) is outstanding for the quality of its design, its freshness and its fine printing

(continued p. 126)

PLATES 19–22

Fugitive pigments and the fading of color prints

IT IS WELL KNOWN that many of the organic pigments used in full-color Japanese prints are fugitive, and change irreversibly when exposed to moisture and light. There are two different kinds of change. The reds, pinks, and yellows become less and less intense (or paler and paler), but still retain their essential color. Blue, on the other hand, and purple, which is made by mixing blue and red, altogether change their nature, becoming by degrees a light tan and buff respectively. The following group of four prints designed within a period of a few years by Torii Kiyonaga

(continued p. 126)

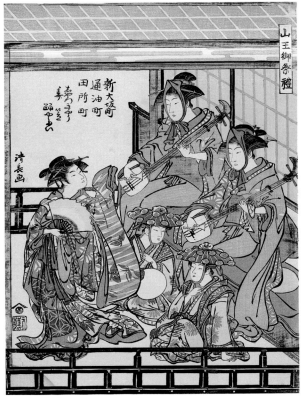

19. Torii Kiyonaga, 1752–1815
Dancers and accompanists on a parade float, 1780. Catalogue 197.

20. Kiyonaga
Evening bell at the end of spring. 1779. Catalogue 194.

21. Kiyonaga
The flower-viewing month, 1784. Catalogue 217.

22. Kiyonaga
Mother, child and attendant with parasol, 1785.
Catalogue 209.

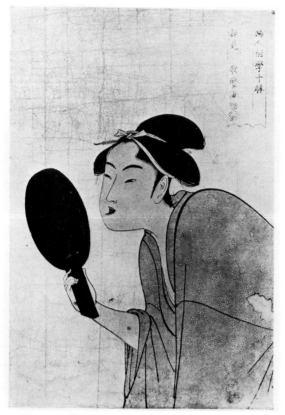

23. Kitagawa Utamaro, 1754–1806
Woman looking in a mirror, ca. 1793–94, first version, second state. Photo: *Japanese Prints . . . Ledoux*, New York, 1948, pl. 46.

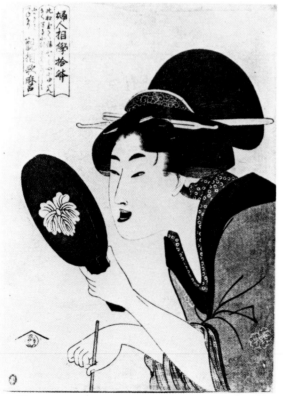

24. Utamaro
Woman looking in a mirror, ca. 1793–94, second version. Photo: *Collection Ch. Haviland*, Paris, Galerie Georges Petit, 1922, pl. XII, no. 305.

PLATES 23–25
Physiognomy

THE JAPANESE believed that people's character could be read from their features, posture, and behavior. *Sōmi*, or professional physiognomists, counseled people and offered personal advice, often with the help of the divinatory *Book of Changes*. The physiognomists' premise that individuals express a certain number of distinct personality types was shared by many artists and entertainers in the eighteenth century. The dramaturgy of the *kabuki* theater was based on a similar notion of role types which the first designers of woodblock prints presented in a series of visual conventions, the actor being identified, not by his features, nor anything individual in his pose, but by an inscription or by his decorative crest. Until the end of the eighteenth century there were no equivalent visual types for women in Japanese prints. After the commercial discovery of full-color printing women became an increasingly popular subject, and housewives, girls, servants, noblewomen, and waitresses appeared as frequently as courtesans. The classes were distinguished by their costumes, wigs and activities, but all the women were equally beautiful and graceful, and even Kiyonaga made little attempt to distinguish different characters or types.

Utamaro, on the other hand, was fascinated with the varieties of women's personalities and moods, and much of his work was an exploration of female types. Utamaro's particular gift was to find visual means of suggesting or conveying the differences that he and his audiences had seen and felt. This led him to a search first for the significant gesture or pose, and then to the suggestive or evocative arrangement of pattern and color. This new way of looking at women gave Utamaro's early prints their extraordinary originality and vigor, and contemporaries like Sharaku, Toyokuni and Kunimasa were quick to look at the male actors on stage with the same fresh eye for the telling pose and striking gesture. In the last twelve to fifteen years of his life, Utamaro designed seventeen sets of prints which examined the range of female types. Six of these sets have the word *sō,* or "type" in their title. The remaining sets have more general or allusive series titles, but the name of each woman's type is given on the prints, often accompanied with a complementary written description of her character. The picture of the woman looking in the mirror (PLATE 25) was designed for the first, and most important of these sets, *Fujin sōgaku juttai,* "A Study of the Physiognomy of Ten Types of Women," which was published by Tsutaya Jūzaburō, probably in 1793 or 1794. Japanese writers have often suggested an earlier date, but there is a similarity in the way in which the white mica on the background adheres to the paper in both the Utamaro series and the half-length portrait of the actor Iwai Hanshirō by Torii Kiyomasa, published by Tsuruya Kiemon to commemorate a performance in the eighth month of 1793.

(continued p. 126)

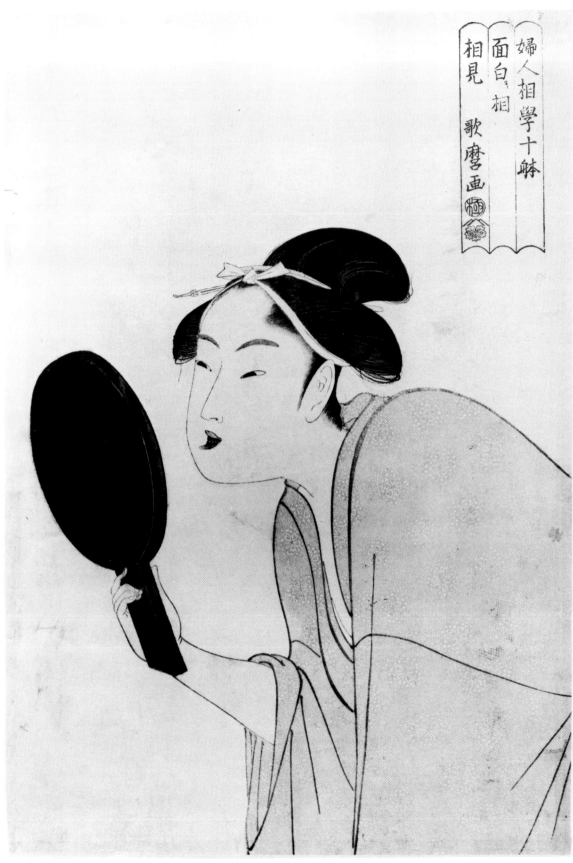

婦人相學十躰
面白キ相
相見　歌麿画

25. Utamaro
Woman looking in a mirror, ca. 1793–94, first version, first state.
From *Ten aspects of the physiognomy of women*. Catalogue 285.

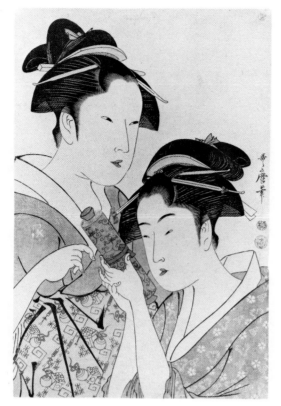

26. Kitagawa Utamaro, 1754–1806
Osen, the former waitress at the Kagiya teahouse, presenting a handscroll to Ohisa of the Takashimaya teahouse, ca. 1794. Catalogue 286.

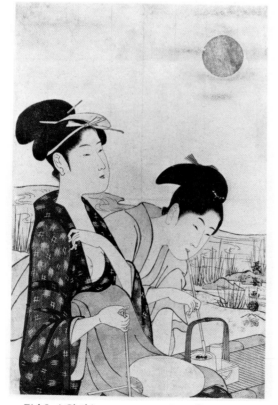

27. Eishōsai Chōki, act. ca 1770s–1800s; fl. 1790s
Courtesan and companion enjoying the summer moon, mid 1790s. *Nigao-e*. Catalogue 274.

PLATES 26–28

Portraiture

OSEN WAS A BEAUTIFUL GIRL in her teens who was a waitress at the Kagiya, or Key Teahouse, on the precincts of the Kasamori Shrine in what is now the Yasaka district of Tokyo. Before her elopement in 1770, and subsequent marriage, she was the subject of popular songs, a *kabuki* play, a novelette, and at least forty woodblock prints, most of them by Harunobu. In this print (PLATE 26) she is shown with the shaven eyebrows of a respectably married woman, presenting a hand scroll to one of the two most celebrated beauties of the early 1790s, Ohisa. A companion print also designed by Utamaro shows Osen's rival, Ofuji, presenting a similar scroll to the other great beauty of the 1790s, Okita of the Naniwaya Teahouse. Ohisa's robe is decorated with her emblem of a triple leaf, and the character Taka, taken from her shop's name. Identifying Osen are the jewel with the fox fire, the tray of the round rice balls called *dango,* which she served, the key and the character for forest, or *mori,* on her sash. The key with the character for *sen* on Osen's robe puts her identity beyond question. This is the only print of Osen published after Harunobu's death in 1770, and is indicative of Utamaro's interest, most obvious in his poetry albums, in history and precedence.

Utamaro may have been the first artist to apply ideas of physiognomy, significant gesture, and personality type to woodblock prints, but Toyokuni carried them much further, exaggerating the drawing and using unexpected color combinations in his portraits of *kabuki* actors, which revealed the drama and variety of their roles on stage (PLATE 28). He particularly enjoyed violent contrasts, as in this print, where the dissolute, impoverished, degenerate Kyujūrō visits his refined and elegant sister.

Around 1794, the artist Chōki designed four pictures with mica backgrounds which were published by Tsutaya Jūzaburō. The two which are best known have dark mica backgrounds: one depicts a woman watching the sun rise over Edo Bay on New Year's Day, the other shows a woman and a child chasing fireflies in an iris garden. A third print represents a woman with an attendant in a snowfall. The lyrical Ainsworth picture of the two women sitting in the summer moonlight is the least common of Chōki's mica prints.

28. Utagawa Toyokuni, 1769–1825
The actors Segawa Kikunojō III and Arashi Sampachi as Mikuni Kojorō and her older brother Kyūjūrō in *Tomioka koi no yamabiraki.* Catalogue 328.

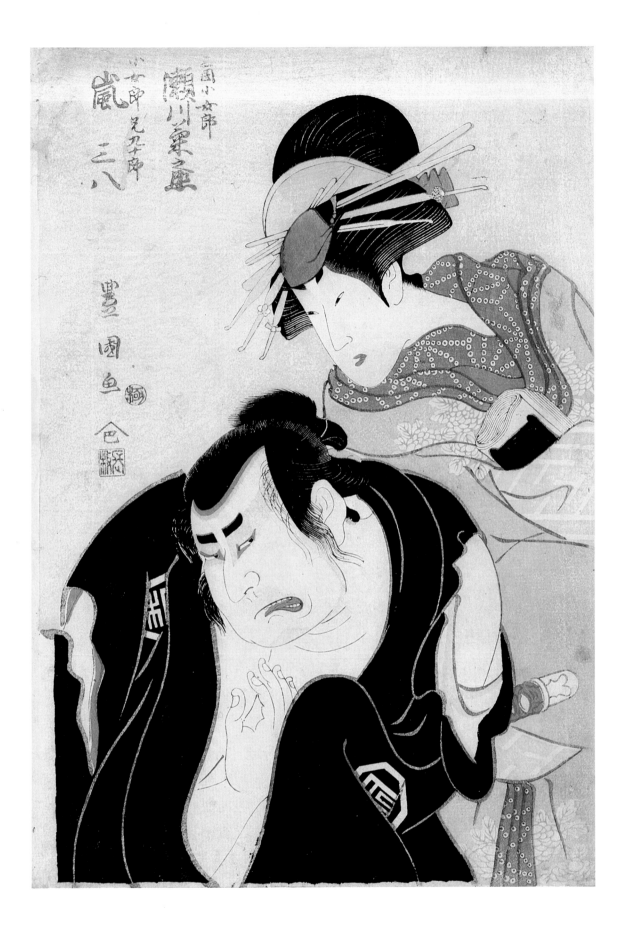

PLATES 29-32

Large heads and restoration

SHARAKU was an artist who suddenly appeared, as did so many Japanese print designers, at the height of his powers, in the middle of 1794, and disappeared just as abruptly the following spring, leaving behind a host of prints, nearly 160 of which have survived to the present day. A brief note written long after Sharaku's disappearance has led most writers to believe that he stopped designing prints because they were unpopular. In fact, he was enormously popular. While he was active he designed more prints than any other artist, with the possible exception of Utamaro. Late impressions show that large numbers of many of them were printed, and the numbers of his large heads that have survived—far more than comparable prints by any contemporary including Utamaro—argues that they were thought worth preserving in their own time. Sharaku's continuing popularity among collectors in the present century set the stage for the alterations visible on this print (PLATE 30). The print is perfectly genuine, but completely faded, and the blue, red and purple blocks have been reengraved and printed to make the print appear unfaded; this type of deceptive facsimile restoration occurred rather frequently around the 1910s, and similar examples may be found in many public collections in America and England. A comparison of these colors with the other contemporary prints reproduced on this page will give some idea of the print's original colors.

Eishō was, to judge from his name, a pupil of Chōbunsai Eishi. But while his teacher specialized in full-length pictures of women and multi-panel compositions, Eishō's most important work was a series of nearly thirty large heads of well-known courtesans done for the firm Yamaguchiya Tōbei. The style of these prints varies, and they were probably published over a period of two or three years, but those with dark mica backgrounds were probably published in 1794 or 1795 when this background was being used by Sharaku, Shunei and Utamaro. The color of this print (PLATE 29) has begun to fade only at the edges, and the mica is in excellent condition. Several large holes on the woman's face and fan have been restored with great skill, the repairs not visible in the reproduction.

The Uemura publications

A large proportion of the over 120 prints known to have been designed by Kunimasa were large bust portraits of *kabuki* actors. The first of these was published at the end of 1795, but many of the finest appeared in 1796 as part of a group designed by Shunei, Kunimasa, and Toyokuni, his teacher. These prints all have grey backgrounds, and the outlines of many of the faces are printed with colored ink. Many, like this one (PLATE 31), have hand-colored eyes. All of the prints have the name of what is supposed to be the publisher, Uemura. However, this

mark appears on so few prints, and on prints of such high quality, that it might be the name of a patron who commissioned the prints privately, and who added his own name since the government required actor prints during this period to have a mark of censorship and the seal of a publisher. This would be analogous, in western practice, to "vanity publications" where a press is engaged to print a book which bears the pressmark of the client or patron.

Shunei contributed three prints to the Uemura group: a portrait of Bandō Hikosaburō as the courtier Kan Shōjō, a portrait of the Osaka actor, Kataoka Nizaemon, as an old man, and this fresh and lovely portrait of the actor Segawa Kikunojō as Osome (PLATE 32). All roles in the *kabuki* theater were performed by men, who were required to shave their forehead and wear a purple silk cap as is seen on the print by Kunimasa. On Shunei's print this is not shown, and only the crest on the sleeve, the pattern of chrysanthemums of the collar, and the tiny butterfly-shaped ornament on the hairpin, indicate that this is a portrait of Kikunojō, and not a graceful young woman. The portrait of Kikunojō was originally designed as the right panel of a diptych; the left panel is a portrait of Matsumoto Yonesaburō in the role of Osome's young lover Hisamatsu. Both prints are presently known by only one impression; the portrait of Yonesaburō, illustrated in the Javal sale catalogue, is now in the collection of Mr. Harry Russell.

29. Chōkōsai Eishō, act. 1790s
The courtesan Somenosuke of the Matsubaya house holding a fan, mid 1790s. Catalogue 266.

30. Tōshūsai Sharaku, act. 1794-95
The actor Morita Kanya VIII in the role of the palanquin bearer Uguisu no Jirōsaku in *Hanashōbu omoi no kanzashi*, 5/1794. Catalogue 318.

31. Utagawa Kunimasa, 1773–1810
The actor Iwai Kumetarō as the *kamuro* Tayori from the Shimabara district in Kyōto in *Modorikago nori no shigayama*, 4/1796. Catalogue 333.

32. Katsukawa Shunei, ca. 1762–1819
The actor Segawa Kikunojō III as Osome, the oil merchant's daughter, in *Hayariuta hiyoku sammon*, 7/1796. Catalogue 315.

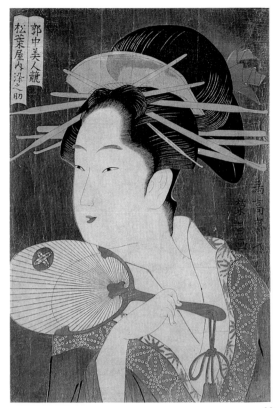

29

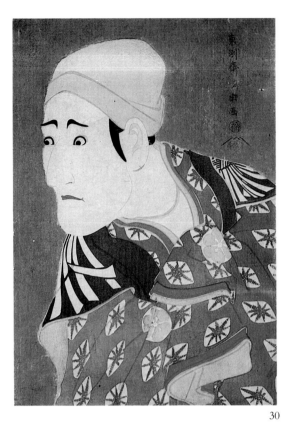

30

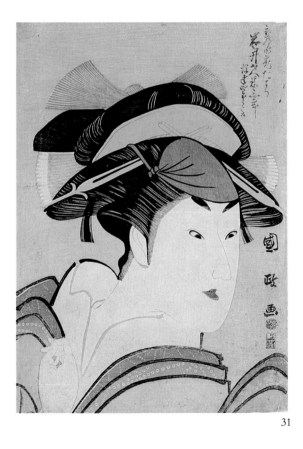

31

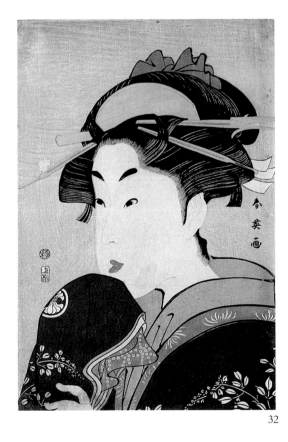

32

PLATE 33

The *Actors on Stage* series

KATSUKAWA SHUNSHŌ and his colleagues began designing recognizable portraits of actors in the late 1760s, but they kept the narrow panel format that had become one of the conventions of actor prints of the earlier Torii school. Shunshō experimented with the larger *ōban* format in pictures of wrestlers and actors in private life backstage in the 1780s, but it was not until Shunshō's death that the monopoly of full-color woodblock portraits by artists of the Katsukawa school was broken, and the narrow panel format gave way to the larger size that had already become standard for figure prints. The artist who was responsible for this change was Utagawa Toyokuni.

In the spring of 1794, a few months before the appearance of Sharaku's first prints, an enterprising new publisher in the Shimmeimae district of Shiba, six kilometers south of the center of Edo, engaged Toyokuni, who was then twenty-five, to design a few full-length portraits of *kabuki* actors which would stand isolated against grey or lightly micaed backgrounds. Toyokuni, who had specialized in pictures of beautiful women until that time and had not designed portraits of actors, took up the project eagerly. The prints were titled *Yakusha butai sugata-e*, "Pictures of Actors on the Stage," and they seem to have been immediately successful, for Izumiya Ichibei, the publisher, continued the series, and during the next two years Toyokuni designed more than fifty prints with the same tile-shaped title cartouche and the same grey grounds. Toyokuni was an innovator. The prints he designed in his late teens and early twenties show a debt to Eishi, Kiyonaga and the figure artists, but once his own popularity was established, the only style that Toyokuni was ever tempted to imitate was his own.

Sawamura Yodogorō was a minor *kabuki* actor in the 1790s. His name appears regularly in the published theatrical records of the period, but he only seems to have been the subject of two prints: this brilliant design by Toyokuni (PLATE 33), and in a double bust portrait with mica ground by Sharaku. The print is rare and only one other impression seems to be presently known. The entire left side of this impression has been restored. The series title, the artist's signature, the publisher's mark and the censorship seal are printed from a woodblock in facsimile, and a light mica ground has been added to the print to conceal the repair.

33. Utagawa Toyokuni, 1769–1825
The actor Sawamura Yodogorō (Kinokuniya) as the lord Ōe no Onitsura in *Zensei azuma garan*, 8/1795. *Yakusha butai sugata-e*, The *Actors on Stage* series. Catalogue 323.

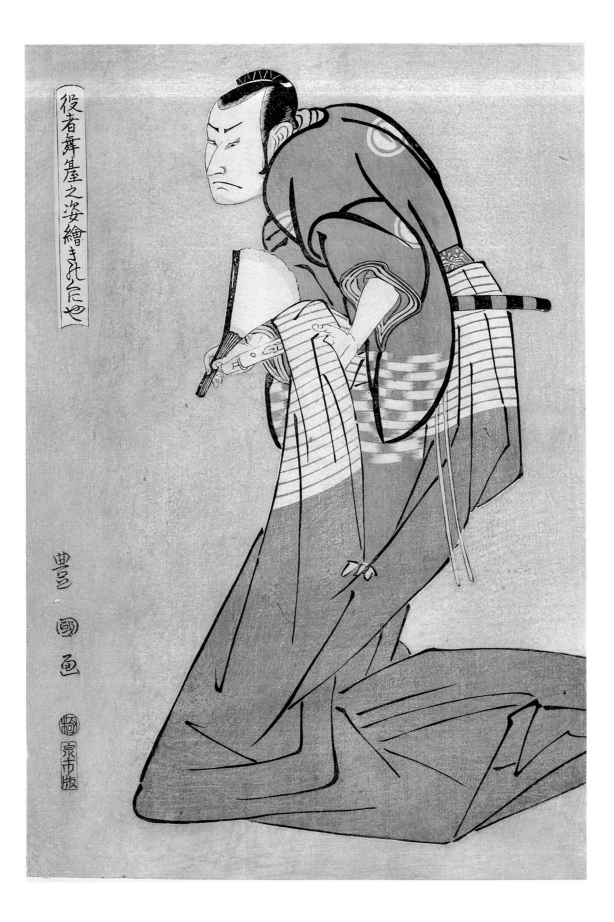

役者舞台之姿絵 きたにや

豊
國
画

泉市版

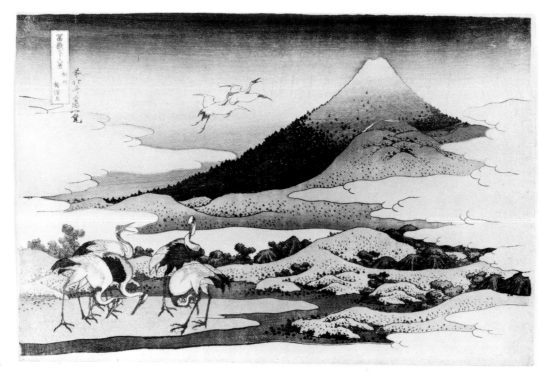

34. Katsushika Hokusai, 1760–1849
Fuji with Umezawa Marsh at the left in Sagami
Province, early 1830s. From *Thirty-six views of Mt. Fuji*.
Catalogue 362.

PLATES 34-36

Prussian blue and Chinese-style landscape prints

THE SETS OF LANDSCAPE PRINTS by which Hokusai is today best known and most admired were all designed during the 1830s when the artist was in his seventies. There is still some disagreement among western writers over the date of the most famous of these sets, the *Thirty-six Views of Mt. Fuji*. The signature on many of these prints, *Zen Hokusai aratame Iitsu hitsu,* indicates that the artist had changed his name from Hokusai to Iitsu. The change occurred in 1820 when the artist, by Japanese reckoning, had reached his sixty-first year. (The Japanese calendar used sixty-year cycles; 61 was the first year of a person's second cycle. Iitsu means "one again.") Edmond de Goncourt, writing on Hokusai in the 1890s, understood this signature to imply that the artist had recently made the name change, and dated this group of prints to the early 1820s, and other writers have repeated this. It seems fairly well established, however, that the deep, permanent blue which is used throughout the set was not introduced into Edo until 1828, and appeared commercially for the first time on fan prints and book covers designed by Eisen in the spring of 1829. A publisher's advertisement for the set of *Thirty-six Views* in a book published by Eijudō in 1832 shows that at that date the set was still in the course of publication, and most Japanese writers tend to think that publication of the set was begun around the spring of 1831, the year after the five ghost prints were published (see CAT. NO. 348). Prussian blue was not first introduced

in Edo. In the 1820s Japan was still closed to foreign trade, and European products all entered Japan through the Dutch settlement in the port of Nagasaki. The first use of Prussian blue on a woodblock print is on the cap of the immortal in a privately published *surimono* printed in Osaka in the spring of 1825 (see CAT. NOS. 439-440).

Hokusai designed eleven prints of bridges in the provinces. Eleven is an unusual number for a set, and it is most likely that Hokusai originally designed ten prints, which were published in the early 1830s, but was asked to design another (PLATE 35) when Mt. Tempō, the artificial hill near Osaka made from the silt uncovered in the dredging of the Aji River, was completed in 1834. The artist's signature reads, "Drawn by special request by Iitsu, formerly Hokusai, after a drawing from Osaka."

Closer to the middle of the 1830s, Hokusai designed a set of views of the Ryūkyū Islands (PLATE 36) based on drawings in a guide book to the area published a few years earlier. The set was published by Moriya Jisuke and is engraved in a freer style than the views of Fuji or the Bridges published by Nishimura Eijudō. The designs were also more Chinese in quality than the other landscapes of the period, and in fine impressions like this are very delicate. Many impressions of Hokusai prints have been framed and have lost much of their pink and yellow pigments, giving the prints a cold, hard quality. These prints are both fresh and unfaded.

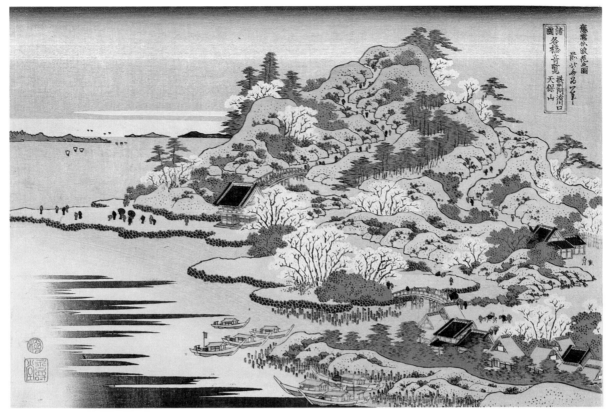

35. Katsushika Hokusai, 1760–1849
Mt. Tempō at the mouth of the Aji River in Settsu Province, early 1830s.
From *Famous bridges of the provinces*. Catalogue 383.

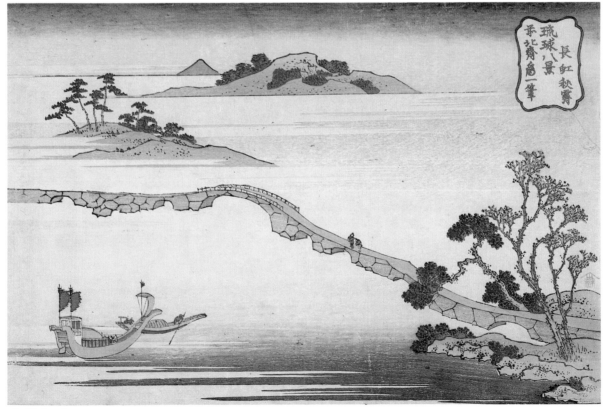

36. Hokusai
The voice of autumn at Chōkō, mid 1830s. From *Eight views of the
Ryūkyū Islands*. Catalogue 390.

PLATES 37-38

Western-style landscape prints

IT IS DIFFICULT to know whether or not these two landscapes were Kuniyoshi's response to the *Thirty-six Views of Mt. Fuji,* but they are certainly among the most moody and unconventional prints in the history of *ukiyo-e* (PLATES 37, 38). The Rendezvous Pine is in the enclosure in the middle distance, but the real subject of the print is the fresh-water crabs, the flowers, the crustacean, and the rocks. Still-life was an unusual subject of commercially published prints, and however startling the picture seemed to its audience, it was popular, and very late impressions are known, missing several color blocks. The Ainsworth impression seems to be the earliest and finest known, with a printed wave pattern, green and pink rocks at the right, green overprinting on the central rock, and before the extension of the cloud below the flower on the left, and the addition of another cloud printed over it.

The Night Attack (PLATE 37) is an extraordinary study in perspective and shading, and a wonderful, if arbitrary, evocation of moonlight. The *rōnin* were samurai who had been in the service of Enya Hangan (to use the fictitious name the historical figure was given in the popular *kabuki* play) but were disenfranchised when Enya was ordered to commit suicide after drawing his sword in the shogun's palace. The *rōnin* swore to avenge their master, and on the night of the anniversary of his death silently attacked the mansion of Lord Moronao, the master of etiquette who had provoked him. Ōboshi Yuranosuke, the leader of the men, stands pointing at the right. As his men begin to scale the mansion's walls, one samurai throws rice balls to the neighborhood dogs to quiet them. This is a very fine, fresh, early impression, but lacks the pink block with the publisher's marks and the rays of the upraised hood lantern at the right.

37. Utagawa Kuniyoshi, 1798–1861
The night attack in act XI of the play *Chūshingura*, ca. 1833. From an
untitled series of landscapes of the eastern capital. Catalogue 455.

38. Kuniyoshi
The pine tree of rendezvous in the eastern capital, ca. 1833. From same
series as pl. 37. Catalogue 456.

Privately published prints

AS MENTIONED EARLIER, Japanese prints may be divided into two broad categories: pictures produced for public sale by commercial publishers, and pictures produced privately for groups or individuals which were not offered for sale. There is no generic word for commercially published prints, although *ukiyo-e* is often used in this sense. The privately commissioned pictures are called *surimono* and are usually distinguished by their unusual formats, heavy paper, elaborate printing, and exquisite craftsmanship. *Surimono* may have been published as early as the 1740s (and may, in fact, have been the impetus for the use of two-color printing), but the genre developed to its height in the early nineteenth century when groups of poets commissioned artists to design pictures to accompany their verses and had them printed with the greatest care and technical skill available. The poets appreciated unconventional designs and subject matter and the *surimono* designers were the first Japanese print designers to explore the possibilities of still-life, as in this picture by Shumman (PLATE 39) which was designed to illustrate a poem by Hasunoya Noriyumi which reads, "The plum tree is in blossom, the world of birds and flowers is spring; the willow branches are jewelled tails, strings of green beads."

The Chinese poet Lin Ho Tsing, or Rinnasei as he was known to the Japanese, is a familiar subject in Japanese art, although the poet's great distinction was that he never wrote his poems down. The poem by Kokuken Shikyō on the print (PLATE 40) says that the fragrance of the plum blossoms is deeper than the garden well from which he draws the first water of the New Year. The well may be suggested by the wine jar at the poet's side. The picture of the plum branch is separated from the picture of the poet as though it were a separate picture mounted on the same album page.

The picture by Hōchū (PLATE 41) is designed and printed in the style of paintings of the Rimpa school, founded by the painter Ogata Kōrin, which had recently been revived by Hōchū and other modern painters. The print was commissioned by the poet Reinichian Baisoku to celebrate his entry into his sixtieth year. His poem says, "I am old enough this spring: fine weather in the plum tree."

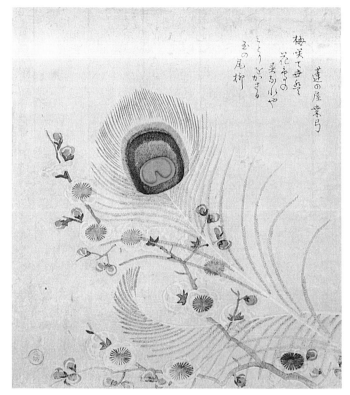

39. Kubo Shumman, 1757–1820
Plum branch and peacock feathers, mid to late 1810s. *Surimono.*
Catalogue 239.

40. Yashima Gakutei, act. 1815–1852
The immortal Rinnasei with wine cup and crane, plum blossoms and
rising sun, mid 1820s. *Surimono.* Catalogue 426.

41. Nakamura Hōchū, act. late 18th to early 19th century
Pine tree and plum blossom, ca. 1810s or 1820s. *Surimono.*
Catalogue 438.

PLATES 42-43

Hiroshige and the Tōkaidō

HIROSHIGE had been designing figure prints and book illustrations for ten years before he designed his first set of landscape prints for Kawaguchi Shōzō, a new publisher in the outlying district of Shiba near the beginning of the Tōkaidō Road from Edo to Kyoto. This first set of ten views of Edo may have been aimed at travellers; the prints were so successful that Hiroshige was invited by Taken-ouchi Magosaburō, the proprietor of the firm Hōeidō, to design a series of views along the Tōkaidō Road to offer to the public in Edo. Hiroshige, who had just returned from a trip to Kyoto and back along the Tōkaidō, accepted the invitation, and the set he designed, *Tōkaidō gojūsantsugi,* or *Fifty-three Stations of the Tōkaidō,* was an immediate popular success; so much so that his views were used as backgrounds for figure prints by Kunisada probably even before the set was completed. Thousands of impressions were taken, to judge from the wear on late impressions and the large number of prints from this set which have survived. Alternate designs were published for several of the early prints in the series, perhaps because the original blocks had literally worn out.

The *Hōeidō,* or *Great Tōkaidō,* set, as it is sometimes called, established Hiroshige's reputation as a landscape print designer. It also linked the artist with a subject that his publishers and his public found impossible to resist, and during the next two decades Hiroshige designed over 25 complete sets of views of the Tōkaidō, ranging from the full size to 1/20th block format. We are so familiar with some of Hiroshige's masterpieces that it is difficult to think of him as a daring innovator or as a revolutionary artist, but many of his designs and color effects were

complete departures from accepted practice in painting and print design during the early nineteenth century and are startling even today in their imagination and boldness. Hiroshige may have designed over ten thousand single-sheet prints (over one thousand of them views of the Tōkaidō), and many have survived, but fine impressions of individual prints are surprisingly rare. A few designs like *Shōno* or *Kambara* from the *Hōeidō Tōkaidō* (see PLATES 49, 180) are striking even in late impressions, but in most cases the effect of the print is lost when the blocks are hastily printed. Most collectors think of *Shimada,* for example, as a rather dull print, because they have never seen an impression of this richness and delicacy (PLATE 42).

The only other *Tōkaidō* set Hiroshige designed in the large horizontal *ōban* format was published by Maruya Seibei around 1850 and is known, from the abbreviation of the publisher's name, or the style of calligraphy in the title, either as the *Marusei* or the *Reisho Tōkaidō.* Like each of the Tōkaidō sets, this one has a distinctive quality: crispness of drawing and a general intensity of color which reflect the habits of Marusei's engravers and the relatively late date of the set. The *Marusei Tōkaidō* is relatively rare and most impressions are early and fine. This indicates that only a relatively small number were printed. This may have been because the set was unpopular, the publisher failed, or the blocks were lost or destroyed. As in the first *Tōkaidō* set, Hiroshige introduced new compositions, and created new effects in the woodblock medium: the focal point of his view of Mishima is three distinctly different types of tree silhouetted against a bold pattern of wood grain on the road before the shrine (PLATE 43).

42. Utagawa Hiroshige, 1797–1858
The Suruga bank of the Ōi River at Shimada, ca. 1833.
From *Fifty-three stations of the Tōkaidō Road.* Catalogue 779.

43. Hiroshige
Mishima, ca. 1850. From *Fifty-three stations of the Tōkaidō Road.*
Catalogue 827.

42

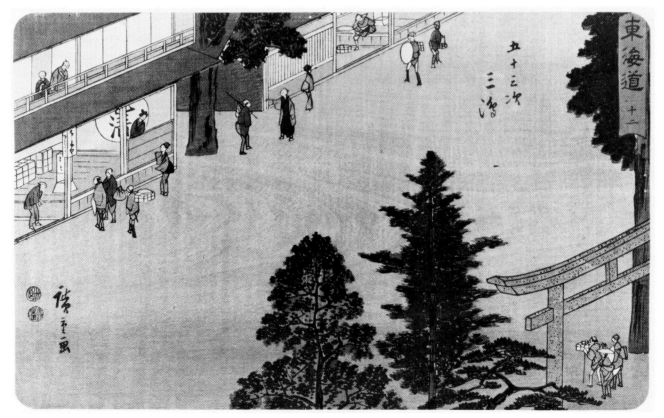

43

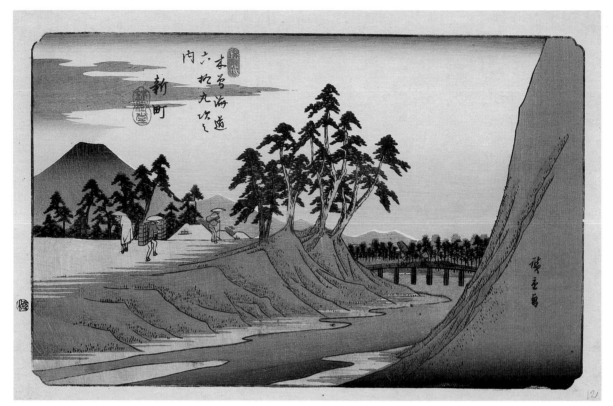

44. Utagawa Hiroshige, 1797–1858
Shimmachi, late 1830s. Pl. 12 from *Sixty-nine stations on the Kisokaidō Road*.
Catalogue 1017.

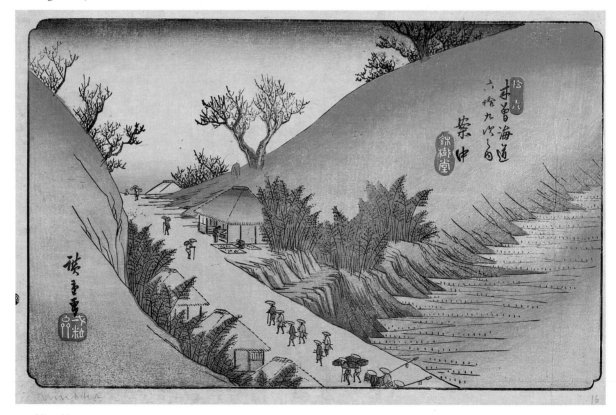

45. Hiroshige
Annaka, late 1830s. Pl. 16 from *Sixty-nine stations on the Kisokaidō Road*.
Catalogue 1023.

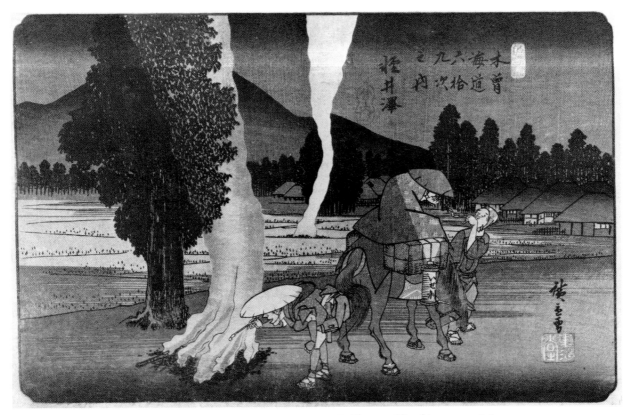

46. Utagawa Hiroshige, 1797–1858
Karuizawa, late 1830s. Pl. 19 from *Sixty-nine stations on the Kisokaidō Road.* Catalogue 1026.

PLATES 44–46

The Kisokaidō Road

PARTLY BECAUSE OF ITS SUCCESS with Hiroshige's *Tōkaidō* series, the publisher Takenouchi Hōeidō began a major set of views along the second, inland route between Edo and Kyoto. The first artist asked to design the set was Keisai Eisen, an erratic, flamboyant, and by his own account (Eisen was the only *ukiyo-e* artist to write his autobiography), somewhat unreliable figure who had specialized in pictures of beauties and erotic prints, but was ready to tackle practically anything from kite painting to landscape, given the proper incentive. Eisen began the series, and his prints are remarkably free and unconventional; Takenouchi's engravers skillfully imitated his loose, ragged and painterly brush-strokes. After designing fewer than one third of the prints, however, Eisen dropped the project. Takenouchi then joined forces with another publisher, Isaya Rihei (Iseri), and engaged Hiroshige to finish the set. Toward the end of the project, the designs, engraving, and printing became rather perfunctory, but Hiroshige's early designs for the set include many of his masterpieces. More like the *Eight Views of Lake Biwa* (see PLATES 48, 76; CAT. NOS. 1207*, 1210*–1212) than the often anecdotal pictures of the *Hōeidō Tōkaidō* set, Hiroshige's *Kisokaidō* views capture the mood and poetry of the seasons and of different times of day. To do this he was greatly dependent on the skill of the printers, who in turn could exercise their imagination in choosing to make a moonlight lighter or darker, or a twilight scene late afternoon or dusk, much as Whistler varied the mood and time of day of certain of his *Venice* etchings, especially the *Nocturnes,* by the way he inked and wiped his plates. Both Whistler and the Japanese artists were attracted by the range of expression latent in a single image.

As with most of Hiroshige's prints, images from the *Kisokaidō* which seem dull in ordinary or late impressions, are vibrantly alive in fine early impressions, as this picture of a sunny day in early spring at Annaka, with the plum trees just blossoming, and the first bright yellow-green flush of grass tinting the hills (PLATE 45), or the picture of twilight near Shimmachi, with light purple clouds in the sky (faded in many impressions) and a golden glow on the horizon (PLATE 44).

The night view of Karuizawa with the travellers lighting their pipes has the marks of both Takenouchi (beside the picture title) and Iseri (on the horse's girth and the rider's lantern), and was one of Hiroshige's first designs for the set (PLATE 46). This may account for the large scale of the figures which is similar to the Eisen prints, and the name the artist chose for his seal: Tōkaidō. The smoke and the light of the fire make the green leaves of the trees distinctly visible.

51

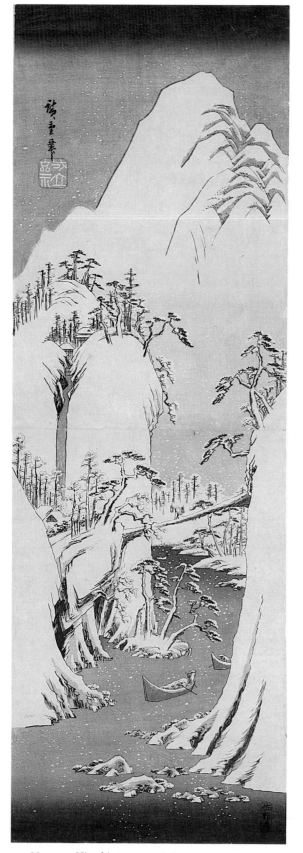

47. Utagawa Hiroshige, 1797–1858
Snow on the upper reaches of the Fuji River, ca. early 1840s.
Catalogue 1206.

Snow

FALLING SNOW is a subject particularly suited to woodblock prints, since the flakes can be engraved in reserve on the color blocks, letting the unprinted paper supply their whiteness, but before Hiroshige this motif seldom appeared in Japanese prints. Hiroshige's first picture with falling snow may have been the picture of three travelers in the village of Kambara, which was part of the first set of views of the Tōkaidō Road published by Takenouchi in the early 1830s (PLATE 49). The earliest impressions of the print are very light, with the sky darkest at the top and small uncleared areas of wood left by oversight on the legs and cape of the figure at the right. When these areas were removed, it was discovered that the picture was more dramatic when printed with darker greys with the sky dark at the horizon. The public preferred the new effect; nearly all late impressions of *Kambara* are dark on the horizon, and Kunisada used this state of the print for the background of his own version of *Kambara*.

Hiroshige had a gift for making the new seem inevitable, the original obvious, and the daring matter-of-fact. Few pictures are more bold or startling than the view of Mt. Hira looming up like an enormous white cloud in silhouette (PLATE 48). And yet the picture is so well-conceived that it seems completely natural, as though the print, like the mountain, is part of the natural order, not just another human artifact. The earliest impressions of Mt. Hira are printed with dark grey at the top of the hills in the middle distance, and with the white mountain extending fully to the left. A pattern of curved lines was engraved on the bottom of the grey block, and on the finest early impressions this pattern is embossed, suggesting a grove of bamboo laden with snow at the foot of the mountain. Later printers seeing this pattern probably assumed that it had been printed in color, and reversed the shading on the hills so they were light at the top and darker on the bottom. This made the separation between the mountain and the foothills indistinct, so an extra grey block was added at the left, along the horizon. Most good impressions of the picture are printed this way; late impressions have more colors, including green and brown, which diminish the print's solemnity and grandeur.

One of Hiroshige's finest snow scenes is the large vertical diptych of a gorge on the Fuji River in Kai Province, which is drawn and composed in the manner of a Chinese painting (PLATE 47). Hiroshige designed only one other landscape in this format: the picture of a crescent moon over the Monkey Bridge in Kai Province which was published around the same time by Tsutaya Kichizō. (An even more Chinese-looking landscape with snow in the same vertical format was designed by Keisai Eisen around this period.)

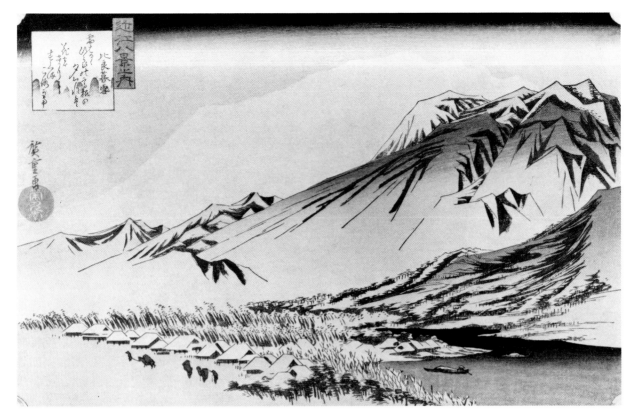

48. Utagawa Hiroshige, 1797–1858
Evening snow on Mt. Hira, early 1830s. From *Eight views of Lake Biwa*.
Catalogue 1208.

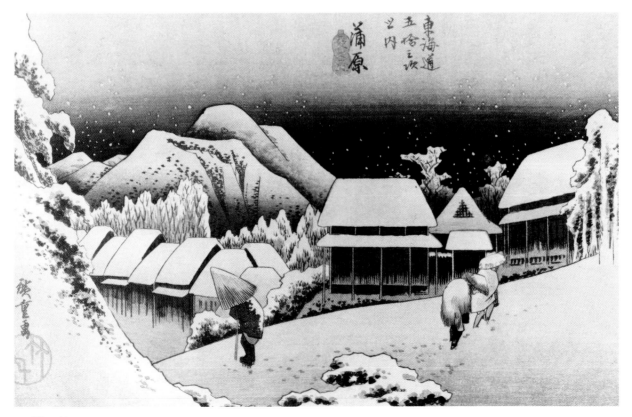

49. Hiroshige
Evening snow at Kambara, ca. 1833. Pl. 16 from *Fifty-three stations of the
Tōkaidō Road*. Catalogue 770.

53

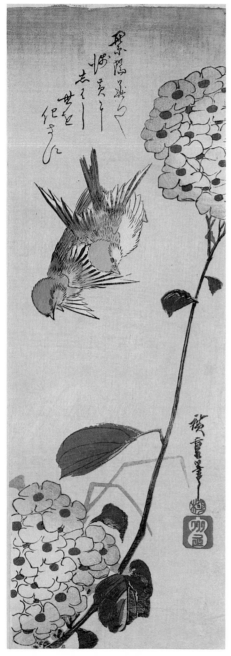

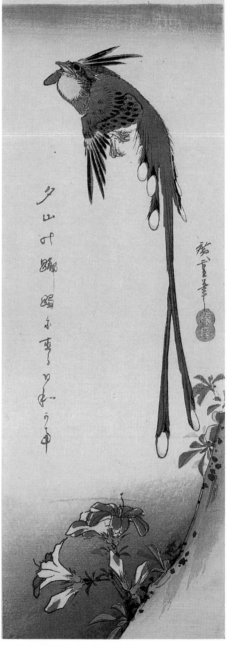

50. Utagawa Hiroshige, 1797–1858
Small green birds and hydrangeas, 1830s.
Catalogue 1307.

51. Hiroshige
Rabbits by stream in full moon, ca. late 1830s.
Catalogue 1325.

52. Hiroshige
Long-tailed blue bird and azaleas, 1830s.
Catalogue 1302.

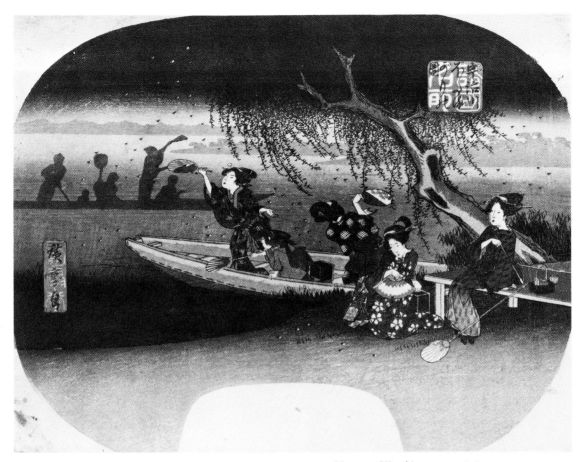

53. Utagawa Hiroshige, 1797–1858
Catching fireflies on the Uji River, ca. late 1830s.
From *Famous places in the provinces. Uchiwa-e*, printed fan.
Catalogue 1205.

PLATES 50–53

Printed fans and pictures in the Shijō style

THE TRADITION of designing woodblock prints for fans seems to have begun in the second quarter of the eighteenth century. The Japanese had two types of fans for everyday use: the folding *sensu*, and the flat, oval-shaped *uchiwa*. *Sensu* were made with stiff paper and were often painted. Woodblock prints used the shape of the folding fan as a decorative border, but nearly all the prints designed for actual use as fans were in the rigid *uchiwa* format. They were printed on horizontal sheets; the color blocks were rounded at the edges and indented at the bottom to accommodate the bamboo ribs of the support which came together there and joined the picture to the handle. During the eighteenth century certain publishers began to specialize in fan prints, which were sold at their premises or by street vendors. Since printed fans were used and damaged or discarded, very few impressions of any particular fan prints have survived. During most of the eighteenth century, artists did not make very imaginative use of the fan format, but nineteenth-century artists, particularly Hiroshige, were fascinated with the odd, irregular shape and used the fan format for sometimes whimsical, sometimes serious ex-periments in design and composition that were not possible in the conventional oblong formats.

Hiroshige probably designed over 500 fans; this picture of fireflies along the Uji River near Kyoto (PLATE 53) is from a set of views in areas distant from the city of Edo. The set was published by Dansendō, a firm which specialized in fan prints in the oval-shaped *uchiwa* format (*Dansen* is the Chinese-style pronunciation of *uchiwa*). There is no distinct feature in the landscape with its beautiful effect of a summer night which identifies its location, but Hiroshige has given the women the flat hair style that was popular in Kyoto at that time. Like so many of the surviving fan prints, this impression was from a fan seller's sample book; this explains why it is such a fine impression, why its color is so fresh, why it has binding holes along the right and has been thumbed in the lower left corner.

Hiroshige was also fond of bird-and-flower prints, since they allowed him to design pictures in the style and format of modern Shijō-style painting. They are well represented in the Ainsworth collection, and their imaginative quality and freshness are clear in these examples (PLATES 50–52).

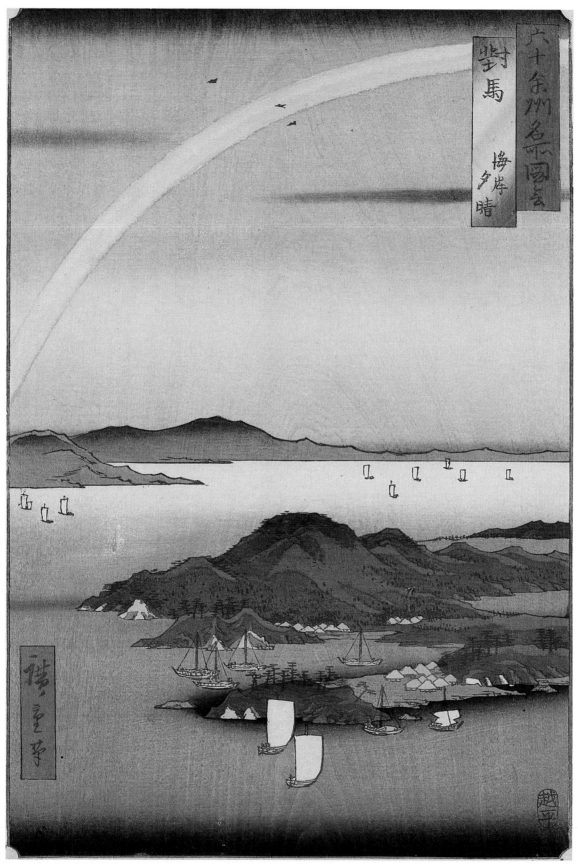

54. Utagawa Hiroshige, 1797–1858
Clear evening with a rainbow over the sea in Tsushima Province, 3/1856.
Pl. 69 from *Famous views of the sixty-odd provinces.* Catalogue 1157.

PLATE 54

Vertical landscapes

IN THE 1840s the Japanese government tried to stabilize the floundering economy by proclaiming sumptuary laws which attempted to regulate many aspects of personal and mercantile life in the cities. The publishing world was drastically affected, since the laws forbade printed pictures of courtesans and actors, and limited the number of colors that could be used on single-sheet woodblock prints. Pictures of courtesans, which had been in decline for nearly a generation, were hardly missed. Actor portraits were replaced with pictures of heroic, historical, or legendary figures. As time wore on, these figures began to acquire the unmistakable features of certain popular actors and before long the actor print was legalized again. During this period, landscape prints, nearly all of them designed by Hiroshige, were published in large numbers.

Gradually, the aesthetic of the woodblock prints began to change. Prints with stronger, deeper, more intense colors, and with more over-printing began to appear. This inclination towards more intense colors was already visible in *surimono* in the late 1820s, and in Hokusai's illustrations for the *100 Poems* in the mid 1830s. Hiroshige first applied this new palette to landscape in the *Marusei Tōkaidō,* which was published around 1850. Soon afterwards, the government seems to have relaxed regulations on the numbers of colors allowed in prints, because in 1853 Hiroshige began to use a wider range of strong colors, along with more over-printing, and a more prominent use of wood grain in a new set called *Pictures of Famous Places in the Sixty-odd Provinces.* The set was also remarkable because the landscapes were designed for the first time in a vertical format. It is commonplace to say that prints by Hiroshige must be judged by early impressions. This is especially true of the vertical landscapes, which can be dull and empty without the effects of color and shading which bring early impressions to life. At their best, Hiroshige's vertical landscapes are like printed paintings, with a clarity, a delicacy, and a richness of both color and texture which is only possible in color woodblock prints. This impression of the rainbow at Tsushima (PLATE 54), one of the last prints Hiroshige designed for the set, is especially fine, with its three-colored title cartouche, the bands of clouds painted on the grey block in the sky, the clear patterns of wood grain in the sky and water, and overprinting on the hilltops, along the shore, and on the horizon, and the careful gradation of color on the rainbow. *Tsushima* was one of the last pictures in the set of *Provinces.* After this, Hiroshige returned his attention to his own city and designed his last great set, the elaborately printed *100 Views of Edo.*

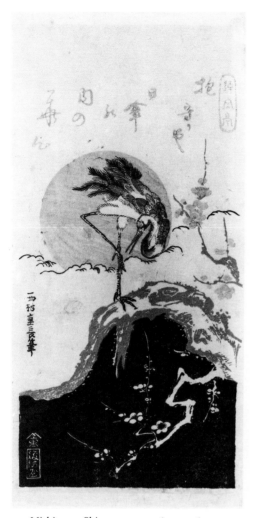

55. Nishimura Shigenaga, ca. 1697–1756
Crane on plum branch with rising sun, 1740s.
Catalogue 41.

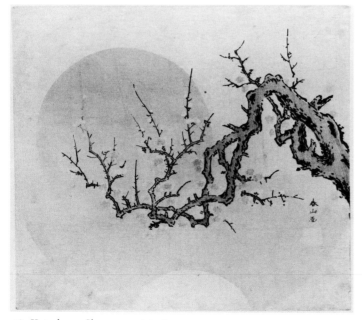

56. Katsukawa Shunzan, act. 1780s–1790s
Plum branch and rising sun, late 1780s or 1790s. Catalogue 253.

PLATES 55–64

Birds and flowers

THE EARLIEST PRINTS of birds may be the large eagles and hawks designed by Torii Kiyomasu in the early 1700s after illustrations in a late seventeenth-century hawk manual. In the 1720s pictures of birds and other animals became an established genre (PLATE 5) in which artists could experiment with subjects and drawing styles which fell outside the then rather narrow confines of *ukiyo-e*.

Harunobu designed a few pictures of animals, birds and flowers, and in the 1770s his successor Koryūsai designed many more, most of them in the upright *chūban* format, but some as narrow upright pillar prints. In the 1770s and 1780s a number of wider upright prints called *ishizuri-e* were designed which were printed and hand-colored in imitation of Chinese stone rubbings. A few of these prints of landscape and bird-and-flower subjects were signed with the names of ancient Chinese painters like Su T'ung-po (PLATE 58) or minor Japanese painters who worked in the Chinese style; one was designed in the 1770s by Shiba Kōkan. Most were unsigned; however, signatures of *ukiyo-e* artists like Harunobu, Koryūsai, and Utamaro were often added later to the unsigned prints to make them more saleable to collectors.

The *kachō*, or bird-and-flower, prints came into their own during the nineteenth century. The artist most responsible for this popularity and success was Utagawa Hiroshige, who used the genre as a vehicle for the compositions and brush techniques of the current Shijō painting syle. Hiroshige's bird-and-flower prints were frequently reprinted; later impressions of the bird on the cherry branch, for example, lack the seal of Hiroshige's relative, the priest Ryōshin, after the Chinese inscription at the upper left.

Another possible reason for the economic success of the bird-and-flower prints was the discovery that two or even three prints in the narrow upright format of a hanging painting could be printed on one full-sized sheet of paper. The picture of bamboo and a sparrow, which was designed with a ten-year-old girl who was his neighbor, is printed on the vertical half of a sheet in the standard *ōban* format (PLATE 61). Most of Hiroshige's bird-and-flower prints have poetic inscriptions, some in Chinese, but most in Japanese in 17- or 31-syllable forms.

Hiroshige's contemporary, Eisen, designed a few bird-and-flower prints (PLATE 63), but the most important designer of this genre, after Hiroshige, was Katsushika Hokusai. Hokusai designed a few prints with the broad brush work of modern painting, but most of his bird-and-flower subjects are drawn and engraved in a meticulous detailed style based on earlier Chinese painting (PLATES 62, 64).

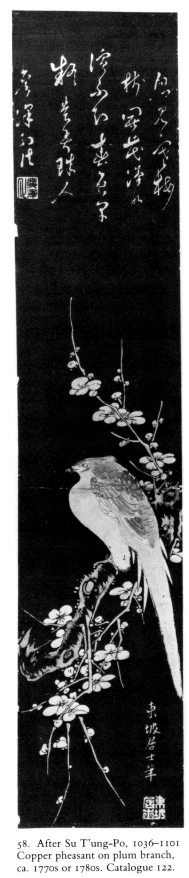

57. Suzuki Harunobu (?)
Copper pheasant on rock,
ca. 1770. Catalogue 112.

58. After Su T'ung-Po, 1036–1101
Copper pheasant on plum branch,
ca. 1770s or 1780s. Catalogue 122.

59. Unsigned
Hawk attacking weasel by stream, ca. 1770s. Catalogue 123.

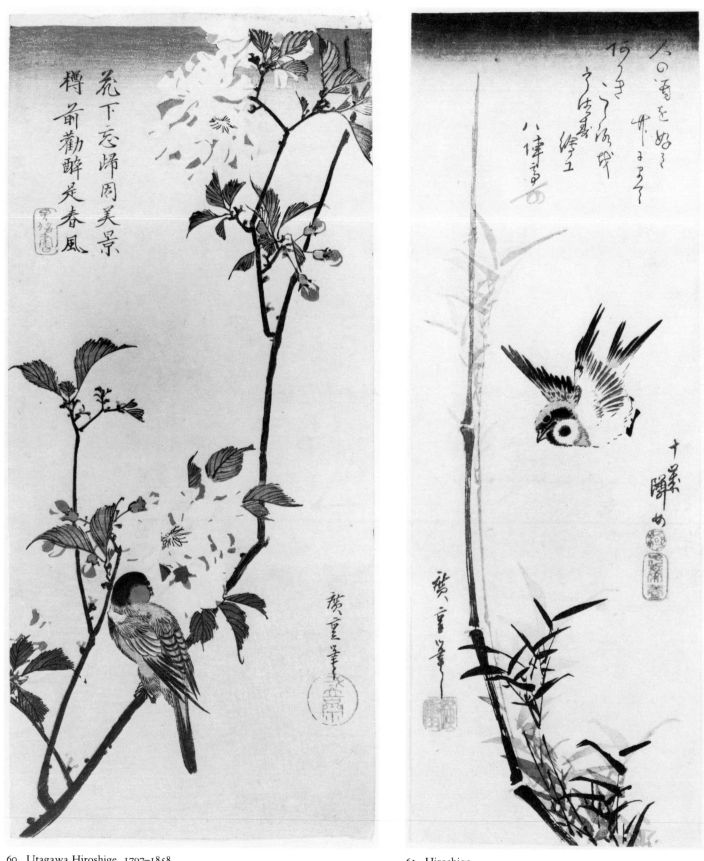

60. Utagawa Hiroshige, 1797–1858
Bunting on branch of cherry blossoms, 1830s. Catalogue 1292.

61. Hiroshige
Sparrow and bamboo, 1830s. Catalogue 1312.

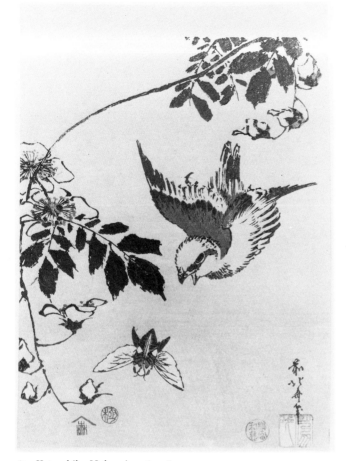

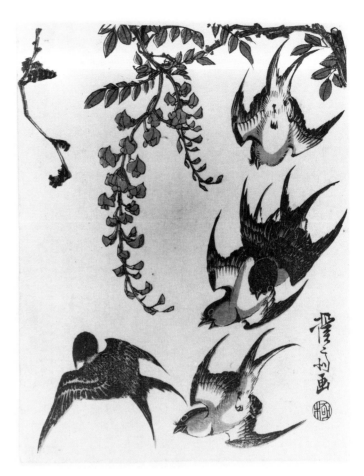

62. Katsushika Hokusai, 1760–1849
Sparrow, cicada and flowers, ca. 1830. Catalogue 349.

63. Keisai Eisen, 1790–1848
Swallows and wisteria, ca. 1820s. Catalogue 617.

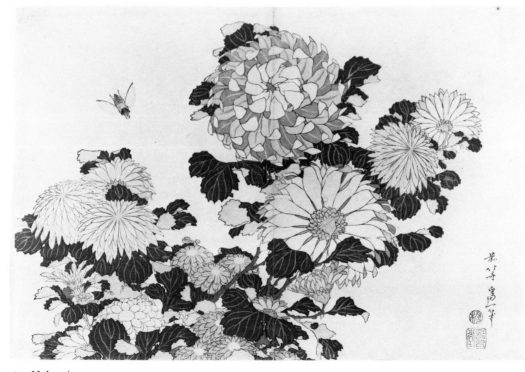

64. Hokusai
Chrysanthemums and bees, early 1830s. From untitled series of ten large
prints of flowers. Catalogue 352.

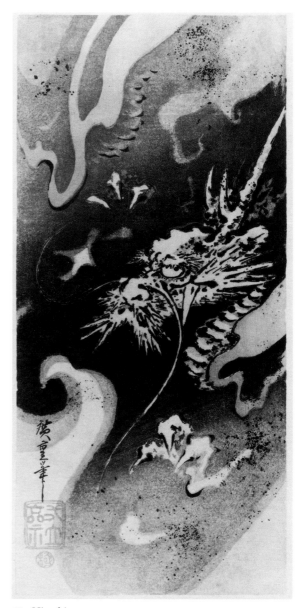

65. Utagawa Hiroshige, 1797–1858
Bats, full moon, and pilings, 1830. Catalogue 1349.

66. Hiroshige
Dragon in clouds, 1830s. Catalogue 1295.

PLATES 65–67

Dragons

HIROSHIGE also designed prints in the abbreviated style of drawing that often accompanies short 17-syllable haiku verse (PLATE 65), and occasionally designed prints like this dragon in the traditional Kanō painting style (PLATE 66).

Artists of the Ōsaka school in the 1830s enjoyed designing prints with contrasts of tone and style, placing small, exquisitely drawn, richly colored *ukiyo-e* style figures against broad wash or pastel-colored backgrounds. Most of the backgrounds are drawn in the Shijō style, but this print of the Chinese princess on the dragon combines elements of the *ukiyo-e* and Kanō styles (PLATE 67). Another picture in the collection, a long unsigned *surimono* published in Edo, shows a group of women watching a *geisha* with a *koto* stepping on board a dragon (CAT. NO. 241*). This picture is a *mitate,* that is to say, a re-creation of the legendary subject in a modern setting, with the Chinese princess and her mother's retinue all changed into modern women.

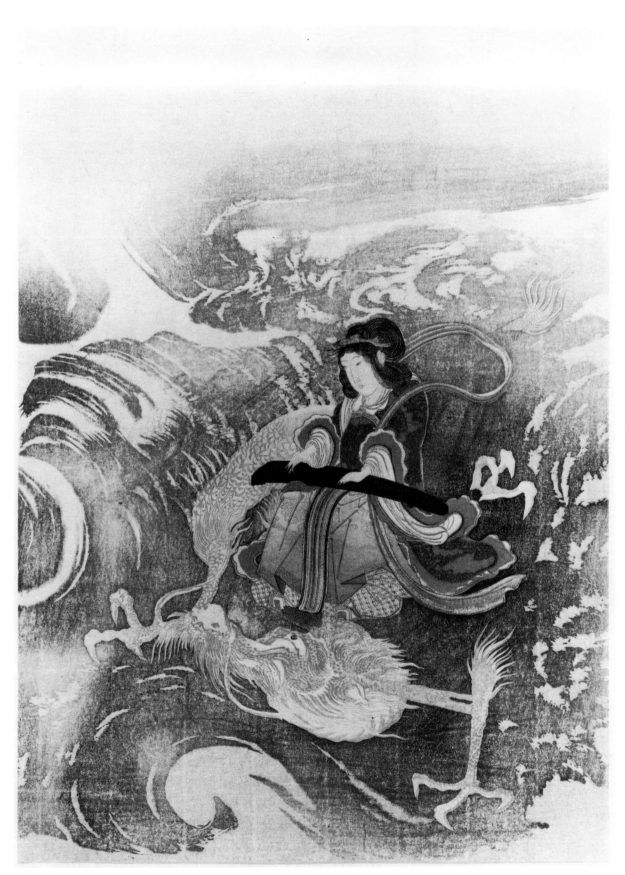

67. Attributed to Ryūsai Shigeharu, 1803–1853
Taishinō playing a zither as she rides a dragon through the clouds, early
or mid 1830s. Catalogue 436.

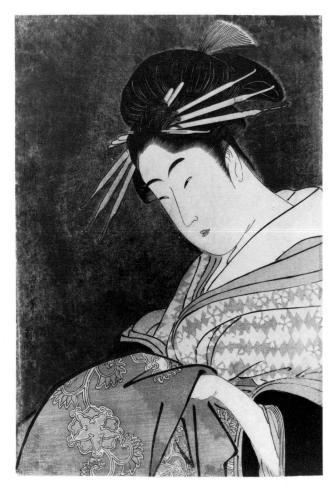

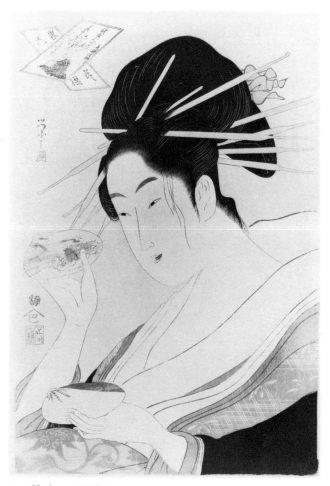

68. Kitagawa Utamaro, 1754–1806
The courtesan Hanaōgi of Gomeirō, the Ōgiya house, mid 1790s. From *A comparison between the features of beautiful women.* Catalogue 289.

69. Chōbunsai Eishi, 1756–1829
Priest Kisen: a courtesan holding a pair of painted shells, mid 1790s. From *Six immortal poets in modern dress.* Catalogue 262.

PLATES 68-72

Large heads

THE FIRST PRINTS that focused on people's faces or upper torsos were pictures of actors and male prostitutes designed in the 1720s. The form did not become popular, however, until Shunshō and Bunchō began drawing recognizable portraits of actors in the late 1760s and their book of half-length portraits of actors in fan format *Ehon butai ōgi* (CAT. NO. 174*) was published in 1770. In the 1770s and 1780s, Shunshō designed another series of half-length portraits in fan format; these were published as large single-sheet prints by Iwatoya Gempachi, but the form did not begin to appeal to other artists and collectors until Shunkō designed an extraordinarily powerful series of large heads of actors in 1788 and 1789 just before partial paralysis ended his career as a print artist. During the 1790s, Katsukawa Shunei, Shunen, Kiyomasa, Sharaku, Toyokuni and Kunimasa all designed large portrait heads of actors; and Utamaro, Eishi and his pupils, and Chōki designed numerous large portrait heads of courtesans and other women during the same period. The portraits of the men were distinctly recognizable, and the artists often exaggerated their features; the pictures of the women, on the other hand, often had very similar features, and most of them have printed inscriptions giving the women's names or naming their personality type.

A comparison of two portraits of courtesans by Utamaro and Eishi (PLATES 68–69) reveals the difference between the two artists, while two portraits from one set by Eishi of different courtesans (PLATES 69–70) show how a woman's personality could be conveyed with gesture, pose and costume irrespective of her face. The two women have the same features. A second picture by Utamaro (PLATE 72) shows how both the standard of female beauty and the style of engraving began to change around 1800. The woman in the picture by Sharaku (PLATE 71) has distinctly recognizable features. This is because the picture is an actor portrait and the woman's role is played by a man. For a more idealized portrait of a male actor in a female role see Shunei's portrait of Osome (PLATE 32).

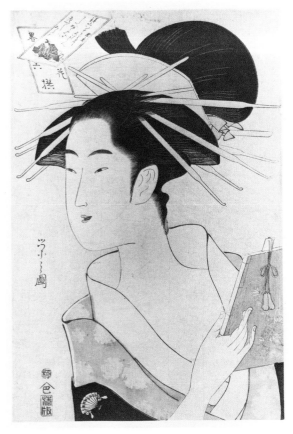

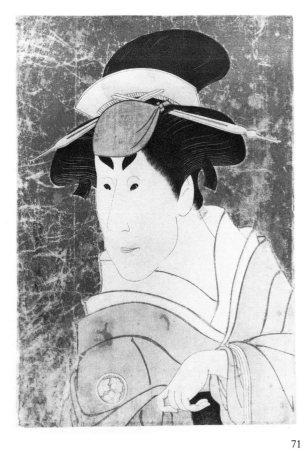

70

71

70. Chōbunsai Eishi, 1756–1829
Kuronushi, a courtesan of the Ōgiya house holding a book with a marker,
mid 1790s. From *Six immortal poets in modern dress*. Catalogue 261.

71. Tōshūsai Sharaku, act. 1794–1795
The actor Osagawa Tsuneyo possibly as Sakuragi, the wife of Sadanoshin
in *Koinyōbo somewake tazuna*, 5/1794. Catalogue 317.

72. Kitagawa Utamaro, 1754–1806
The courtesan Somenosuke of the Matsubaya house, ca. 1800. From
Courtesans of the green houses drawn from life. Catalogue 295.

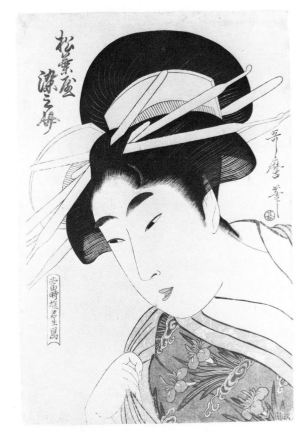

72

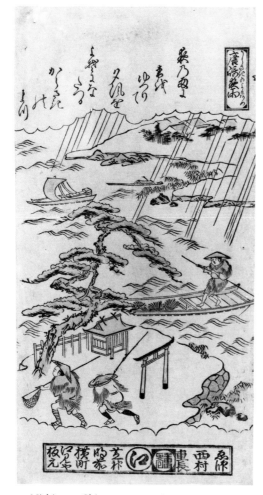

73. Nishimura Shigenaga, ca. 1697–1756
Evening rain at Karasaki, ca. late 1720s. From
an untitled series of eight views of Lake Biwa.
Catalogue 39.

74. Suzuki Harunobu, 1725–1770
Autumn moon at Ishiyama, ca. mid 1760s.
From *Eight views of Lake Biwa*. Catalogue 98.

PLATES 73-85

Eight views of Lake Biwa

THE EIGHT VIEWS of the Hsiao and Hsiang Rivers near Lake Tung-t'ing in Hunan province were a common classical theme of Chinese academic painting. They were transposed into the repertory of Japanese art as the Eight Views of Ōmi, the province in which much of the west shore of Lake Biwa, the location of the views, rests. The *Eight Views* were a subject of Japanese painting long before they began to appear in woodblock prints. The first prints of the *Eight Views* may be the set of landscapes in irregularly shaped oval borders which are drawn in a non-descript traditional painting style and have been provisionally dated to the late seventeenth century. Although dull as pictures, the prints are interesting because half of them represent the eight Chinese views, half of them the Japanese counterparts. A set of the prints, published in *Ukiyo-e* magazine, is in the Achenbach Foundation for Graphic Arts in San Francisco.

The *Eight Views* did not become a common subject for prints, however, until the late 1710s or early 1720s when Masanobu, Shigenaga, and Kiyomasu II all designed sets in the *hosoban* or narrow upright format. The sets are strikingly similar in their iconography, and all bear the same canonical 31-syllable verses, which are repeated on most prints of the eight views of Lake Biwa that were published through the middle of the nineteenth century. The source of these poems and the iconography of the prints have been discussed in an unpublished article by Bruce Coates, Harvard University.

Harunobu's prints of the *Eight Views* repeat the stiff conventions of the earlier prints; they were sometimes printed with conventional black outlines, as here (PLATE 74), sometimes with pale colored outlines. These impressions were called *mizu-e* or "blue prints." *Mizu* means "water," but also indicates the fugitive blue color derived

from the dayflower which was used to print the keyblock on many of these prints. Landscape did not particularly appeal to Harunobu or his literary patrons, but in the mid-1760s they produced a set of *Eight Parlor Views* with pictures of women in everyday occupations and attire. The titles of the pictures, like *Returning Sail of the Towel Rack* and *Descending Geese on the Koto,* were based on the traditional eight views.

The prints were popular and other artists swiftly followed Harunobu's lead; by the end of the eighteenth century nearly every designer of figure prints had designed sets of eight views (see CAT. NOS. 135*, 306*, 443*), many of them with titles like *Night Rain* and *Evening Bell,* which were taken from the conventional views of Lake Biwa.

75. Kitao Masayoshi, 1764–1824
Lingering snow on Mt. Hira, ca. 1810s. From *Eight views of Lake Biwa.*
Catalogue 427.

76. Utagawa Hiroshige, 1797–1858
Autumn moon at Ishiyama, early 1830s. From *Eight views of Lake Biwa.*
Catalogue 1209.

75

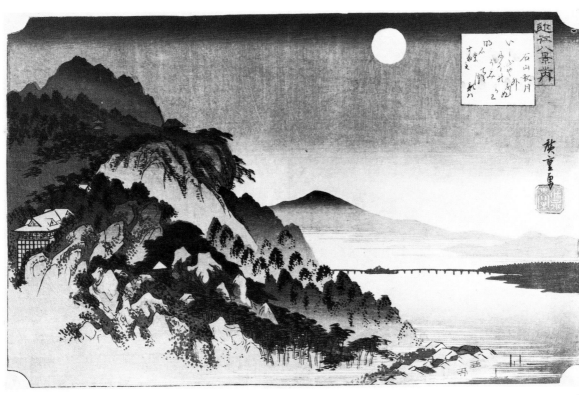

76

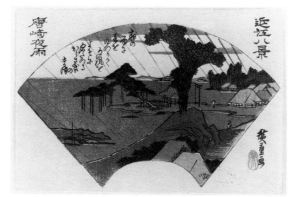

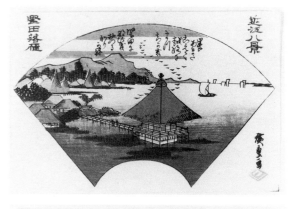

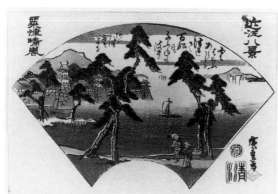

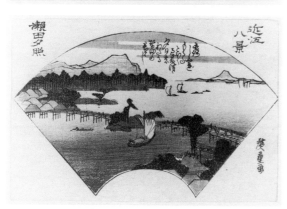

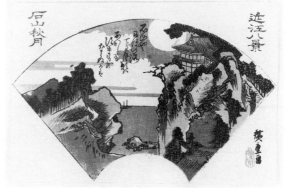

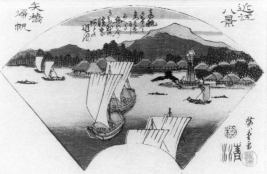

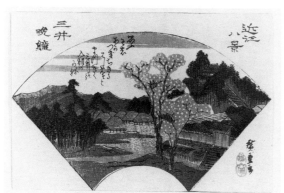

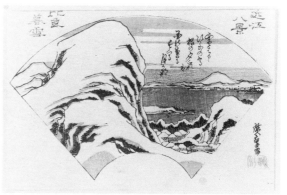

77–84. Utagawa Hiroshige, 1797–1858
77. Night rain at the Karasaki Pine
78. Descending geese at Katata
79. Evening glow at Seta
80. Returning sails at Yabase
81. Haze on a clear day at Awazu

82. Autumn moon at Ishiyama
83. Evening bell at Mii Temple
84. Evening snow on Mt. Hira
ca. early 1830s. From *Eight views of Lake Biwa*.
Catalogue nos. 1214–1221.

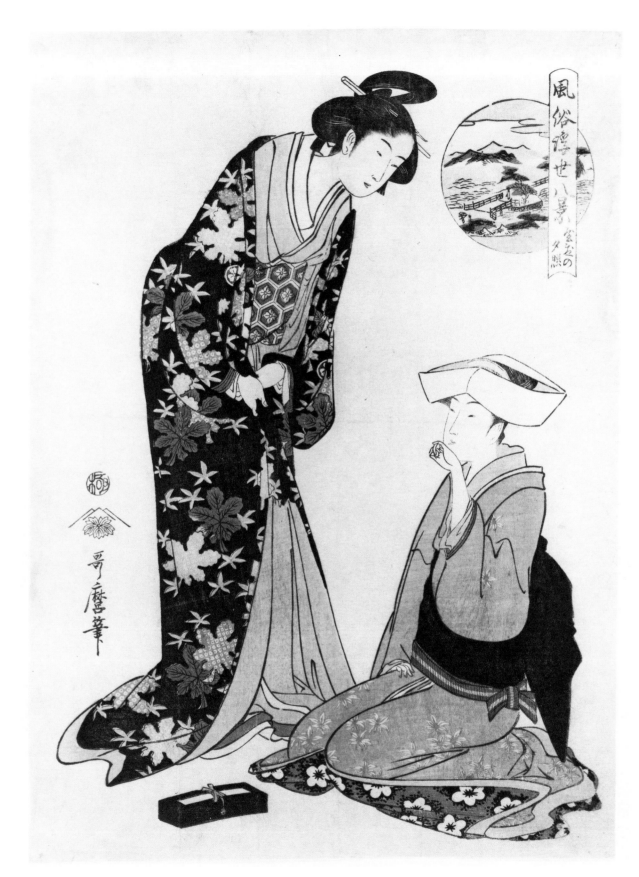

風俗浮世八景
宝亭の
夕照

85. Kitagawa Utamaro, 1754–1806
Evening glow in the mansion, ca. 1795. From *Eight modern views of the floating world*.
Catalogue 287.

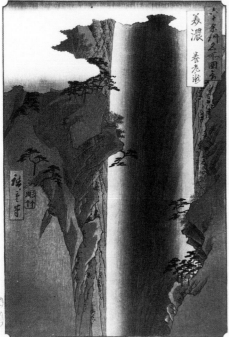

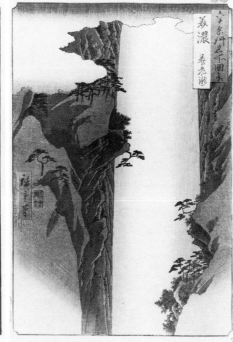

86. Utagawa Hiroshige, 1797–1858
Yōrō waterfall in Mino Province, 1853, Pl. 23
from *Famous places in the sixty-odd provinces*. Early
impression. Collection Prof. Dr. Gerhard Pulverer,
Köln.

87. Hiroshige
Yōrō waterfall in Mino Province. Later impression.
Catalogue 1111.

88. Hiroshige
Yōrō waterfall in Mino Province. Late impression.
Catalogue 1111A.

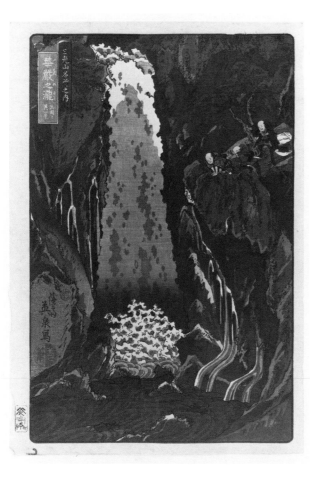

PLATES 86–90

Waterfalls

HOKUSAI designed *A Tour of Waterfalls in the Provinces*
(*Shokoku taki meguri*) in the early 1830s (PLATE 92), and
shortly afterwards designed the picture of the Chinese poet
Li Po contemplating the waterfall for the series of *Imagery
of the Poets* (*Shika shashinkyō*) (PLATE 90). Keisai Eisen
designed a series of five waterfalls in the mountains near
Nikkō (PLATE 89); two of his pictures were based on
Hokusai's prints, but whereas Hokusai's drawing is precise
and detailed, Eisen's is deliberately ragged. This and the
somber colors of Eisen's prints give them a much different
effect. Kuniyoshi also designed a few landscape prints with
waterfalls in the 1830s (PLATE 91; also CAT. NO. 614*).

The earliest impressions of Hiroshige's Yōrō waterfall
from the *60-odd Provinces* series published in the 1850s have
much overprinting on the cliffs and a strong pattern of
wood grain on the waterfall (PLATE 86), which is soon
replaced by embossing on the white water at the center of
the cascade (PLATE 87). In later impressions the waterfall is
entirely blue, and there is little or no overprinting on the
cliffs (PLATE 88).

89. Keisai Eisen, 1790–1848
View of the three cascades of Kegon waterfall, mid 1840s. From *Famous
places in the mountains of Nikkō*. Catalogue 620.

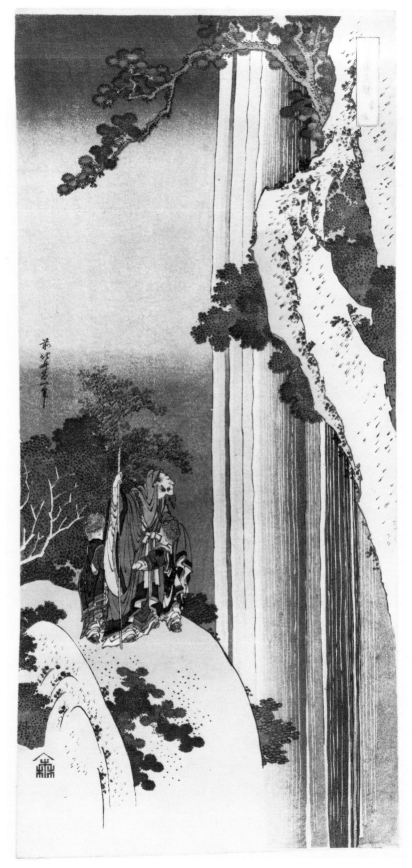

90. Katsushika Hokusai, 1760–1849
The poet Li Po viewing a waterfall, ca. 1834. From *A Mirror of the imagery
of Chinese and Japanese poets*. Catalogue 398.

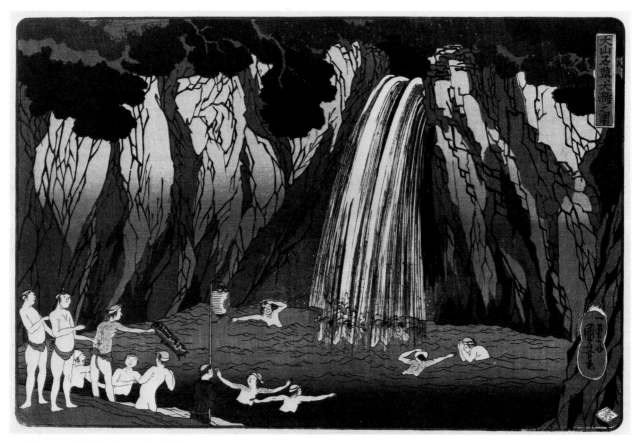

91. Utagawa Kuniyoshi, 1798–1861
The waterfall of the stone deity at Ōyama Mountain, ca. mid or late 1830s.
Catalogue 486.

PLATES 91–99

Ōyama

ŌYAMA IS A SACRED MOUNTAIN near the Izu peninsula inland from Kamakura and the island of Enoshima. During the Edo period it was a popular site of pilgrimage, especially during the summer months since it was a mountain where pilgrims often prayed for rain.

Women were forbidden to climb the mountain during the Edo period. The men who had walked there bathed and purified themselves in the Rōben Waterfall at the bottom of the mountain (PLATE 92), and then, carrying large wooden planks shaped like sword blades, they began their ascent. Before they reached the top of the mountain, they stopped at the temple of the Stone Fudō where they bathed again in a larger waterfall and pool (PLATE 91). Afterwards they continued their ascent, leaving their wooden sword blades as a sign of their devotion at the shrine on top of the mountain.

Kuniyoshi was particularly interested in Ōyama and probably visited there himself since, in addition to three horizontal landscapes, he designed two triptychs of pil-grims in the Rōben Waterfall. One of these is among his earliest prints.

Hiroshige designed a group of five prints of the road from Edo to Ōyama in the 1830s. The prints were not published during his lifetime, but his drawings survived and were published as woodblock prints in 1919 by the publisher Sakai Kokōdō together with fifteen other designs (PLATES 95-99; CAT. NOS. 989.1-20).

The only picture of rain at Ōyama was designed by Toyokuni II in the 1830s (PLATE 94). It is the masterpiece of a set of eight views of famous places, the artist's only set of landscape prints. There are two main states of each print, which may be distinguished by the style of calligraphy in which the series title is written. The titles of the earlier impressions are written in a square, formal script; on later impressions they are written in an abbreviated cursive script. In most cases there are also changes in the color blocks.

92. Katsushika Hokusai, 1760–1849
Rōben waterfall at Ōyama Mountain in Sagami Province, early 1830s.
From *A tour of waterfalls in the provinces*. Catalogue 389.

93. Utagawa Kuniyoshi, 1798–1861
The ferry at Tamura near Ōyama Mountain, ca. mid or late 1830s. Catalogue 487.

94. Gosotei Toyokuni II, 1802–ca. 1835
Night rain at Ōyama, 1830s. From *Eight views of famous places*. Catalogue 454.

74

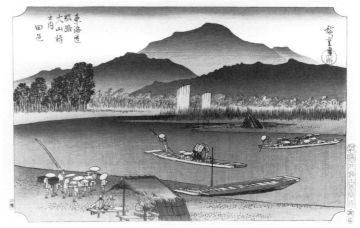

95. Utagawa Hiroshige, 1797–1858
The junction of the pilgrim road at Yotsuya, 1919. From *Intermediate Tōkaidō stations and views on the Narita Highway* (as Plates 96–99).
Catalogue 989.12.

96. Hiroshige
Ferry at Tamura, 1919.
Catalogue 989.13.

97. Hiroshige
Hills at Koyasu, 1919.
Catalogue 989.14.

98. Hiroshige
The great waterfall at Ōyama, 1919.
Catalogue 989.15

99. Hiroshige
Pilgrims at the temple on top of Mt. Ōyama, 1919.
Catalogue 989.16.

PLATES 100-104

Rain

IT IS PERHAPS SURPRISING that landscapes with falling rain are so uncommon in western prints. There is a suggestion of rain in one corner of Rembrandt's *Three Trees,* but Félix Buhot was perhaps the first artist to use rain as a common subject in his prints, and Buhot was certainly influenced by Hiroshige and other Japanese artists.

Rain first appears in a cursory form in prints of the Karasaki Pine at the end of the seventeenth century, and in the 1720s (PLATE 73). A few black lines suggest rain in prints of the poetess Ono no Komachi by Harunobu, and in the 1780s a broad grey block is used in Shunchō's picture of a woman at Mimeguri, the shrine where the Edo poet Kikaku successfully prayed for rain (CAT. NO. 249*). But it is in the nineteenth century that rain becomes a subject in its own right, and prints were designed showing every kind of rain from a drizzle to a downpour. (See also PLATES 94, 127, 179, 180, 191, 193, CAT. NO. 1207*.)

100. Totoya Hokkei, 1780–1850
Ferryboat at Rokugō, early 1830s. From *Chronicle of a journey to Enoshima.* Catalogue 418.

101. Yashima Gakutei, act. 1815–1852
Evening Rain at Mt. Tempō in Osaka, 1834
From *Views of Mt. Tempō.* Catalogue 422.

102. Utagawa Hiroshige, 1797–1858
Light rain on Nihon Bridge, 1830s. From *Famous views of the eastern capital*. Catalogue 628.

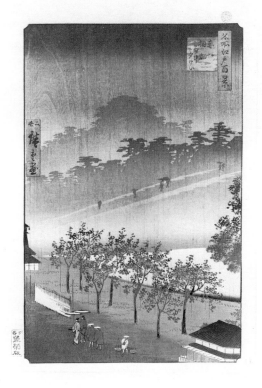

103. Hiroshige
Rain at the Seidō Hall and Shōhei Bridge over the Kanda River, 9/1857. From *One hundred views of famous places in Edo*. Catalogue 689.

104. Utagawa Hiroshige II, 1826–1869
Evening view of rain at the grove of paulownia trees at Akasaka, 4/1859. From *One hundred views of famous places in Edo*. Catalogue 695.

PLATES 105–108

Wind

MID-EIGHTEENTH CENTURY PRINT DESIGNERS like Toyonobu and Masanobu were delighted with the swirl of women's robes when they were caught in a gust of wind, and Harunobu, Koryūsai, Shunchō, and Kiyonaga all designed prints of women enjoying a breeze or struggling against a wind. Kuniyoshi, however, may have been the first print artist who tried to draw currents of breeze and water (PLATES 105, 106, 107); his technique of using graded bands of color was used by Hiroshige in the 1850s (PLATE 108) and by his pupil Yoshitoshi later in the century.

105. Utagawa Kuniyoshi, 1798–1861
Tiger in a storm, 1830s. Catalogue 601.

106. Kuniyoshi
Yang Hsiang (Yōkō) protecting his father from the tiger, ca. 1840. From *A mirror for children of the 24 paragons of filial piety*. Catalogue 559.

107. Kuniyoshi
The poet Bunya no Yasuhide watching a sudden wind blow umbrellas, ca. early 1840s. From *The 100 Poems*. Catalogue 588.

108. Utagawa Hiroshige, 1797–1858
Rain in the Yamabushi Gorge in Mimasaka Province, 12/1853. From *Famous places in the sixty-odd provinces*. Catalogue 1134.

105

106

107

108

PLATES 109–113

Chinese subjects

THE SHADOW OF CHINA darkens *ukiyo-e* far less than most other forms of Japanese painting and pictorial art, but certain Chinese influences must be recognized. The earliest secular Japanese woodblock prints are said to have been copies of a Chinese erotic album, and some of the earliest landscapes in Japanese prints are views of the Hsiao and Hsiang Rivers near Lake Tung-t'ing drawn in a style derived from Chinese painting.

Many Chinese subjects appear in Japanese prints, some of them in modern dress, but others in a more or less Chinese style. There are many representations, for example, of Shōki, or Chung K'uei, who offered to protect the T'ang emperor Ming Huang from demons (PLATES 114–117), and others of Kuan Yu (PLATE 110), Chang Liang, Han Shan and Shih Te (PLATES 109, 111), and other historical and legendary figures.

In the nineteenth century artists took an even more active interest in Chinese subjects, and Hokusai devised a new figure style to illustrate Bakin's translation of the Chinese novel *All Men Are Brothers* (*Suikoden*); this was imitated by his pupils and was probably an influence in the formation of Kuniyoshi's early style. (Kuniyoshi's first major success was a set of pictures of the Chinese heroes of the *Suikoden*.)

A few artists, including Hokusai (CAT. NOS. 390–91*, PLATE 36) designed landscapes which were deliberately Chinese in style, often with Chinese poems and inscriptions. Hokusai's bird-and-flower prints, particularly the small set (CAT. NOS. 350*–51*), were inspired by Chinese models, and Hiroshige's bird-and-flower prints often bear Chinese inscriptions.

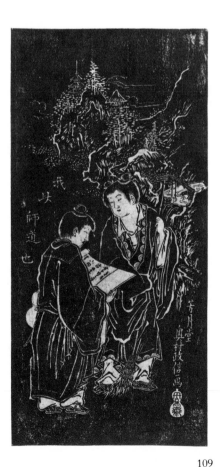

109

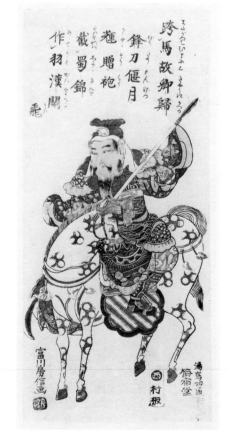

110

111

109. Okumura Masanobu, ca. 1686–1764
The Ch'an eccentrics Han Shan and Shih Te, 1740s or 1750s.
Catalogue 24.

110. Tomikawa Fusanobu, act. ca. 1750–1760s
The Chinese warrior Kuan Yu seated on horseback, 1750s.
Catalogue 70.

111. Kitagawa Utamaro II, act. late 1800s- early 1810s
The figures Han Shan and Shih Te, ca. 1810s. Catalogue 304.

112. Totoya Hokkei, 1780–1850
Crossing the Yellow River, early 1830s. From *An Album of pictures of Chinese poems*. Catalogue 413.

113. Bunsei, 1812–1830/31
Chinese landscape, ca. 1830s. Catalogue 437.

112

113

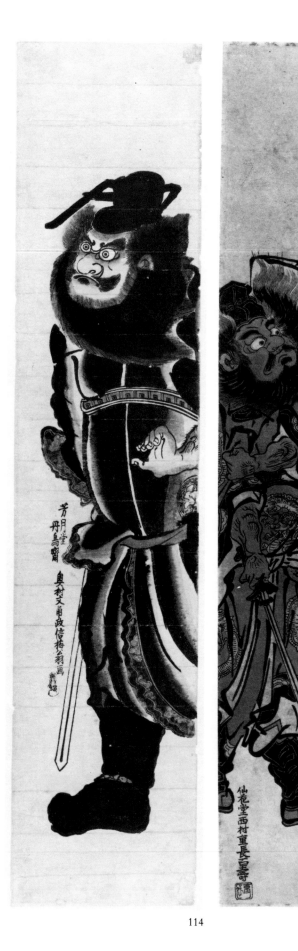

114 115

PLATES 114–117

Shōki

CHUNG K'UEI, or Shōki as he is known in Japan, was a
mythical figure whose spirit was said to have come to the
court of Ming Huang, an emperor of the T'ang dynasty,
during an illness, to protect him from the fever demons.
When the emperor recovered, the spirit explained that he
had killed himself in shame after failing the state exami-
nations. Nonetheless the emperor Kao Tsu had honored
him with a respectful burial, and so he determined to repay
this kindness by expelling all devils from the empire.

Shōki is seldom shown in Chinese art, but he was a
perennial favorite in Japan, particularly during the late Edo
period, when he appears in prints, paintings, and the
decorative arts, often in droll and incongruous situations
with the demons. Paintings of Shōki were hung on Boy's
Day, and during certain periods prints of him were thought
to protect households from disease (see CAT. NO. 1401).

114. Okumura Masanobu, ca. 1686–1764
Shōki, the demon queller, ca. early 1750s. Catalogue 23.

115. Nishimura Shigenaga, ca. 1697–1756
Shōki, the demon queller, 1750s. Catalogue 43.

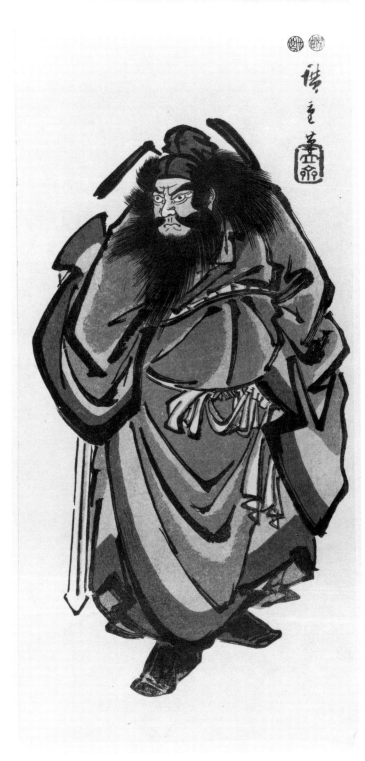

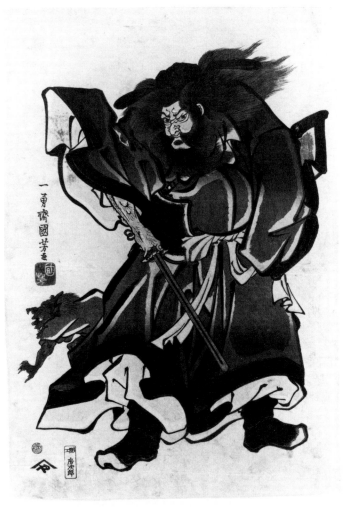

116. Utagawa Hiroshige, 1797–1858
Shōki, the demon queller, ca. 1850. Catalogue 1283.

117. Utagawa Kuniyoshi, 1798–1861
Shōki and a cowering demon, mid 1840s. Catalogue 605.

118. Suzuki Harunobu, 1725–1770
Sugawara Michizane seated in state with two court attendants, early 1760s. Catalogue 94.

84

PLATES 118–121

Sugawara Michizane

SUGAWARA NO MICHIZANE (845–903) was a scholar, poet, calligrapher and statesman, who, as the result of a court intrigue, was exiled to the island of Kyūshū for the last two years of his life. His titles were restored posthumously, largely in fear of his vengeful spirit, and eventually he was deified. Important temples were dedicated to him in Kyoto, Edo and elsewhere, and he is still worshipped as a patron and protector of calligraphers and students.

Between the 1720s and early 1760s a large number of prints depicting Michizane were published. Most of them show him standing in the black robe of a scholar holding a blossoming branch of his favorite tree, the plum. These pictures all derive from a hand-colored print by Kondō Kiyoharu (PLATE 119) which was itself based on an earlier book illustration. Other formal pictures by Masanobu and others show the deified courtier dressed in court robes seated on a dias beneath a plum tree (PLATE 118). Kiyomitsu designed a picture of Michizane riding an ox along the beach as he arrives at his place of exile in Kyūshū (CAT. NO. 85*), and an unknown artist designed a series of prints illustrating several episodes in his life, one of which is in the collection (CAT. NO. 310*). In the nineteenth century, Sadahide designed a dramatic series of large horizontal color prints illustrating acts in *Sugawara denju tenarai kagami*, a play based on the life of the courtier.

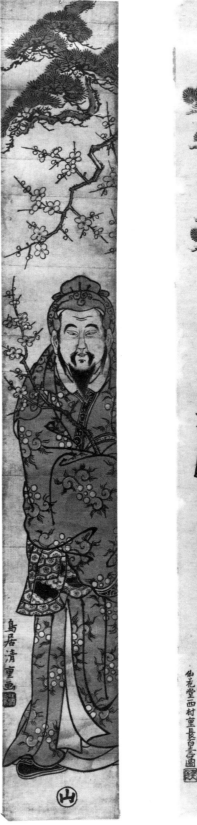

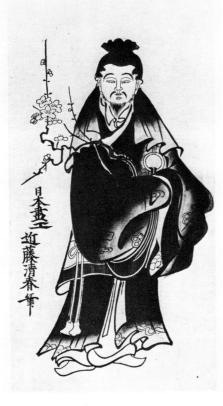

119. Kondō Kiyoharu, act. 1705–1730s
Sugawara Michizane. The Art Institute of Chicago, Clarence Buckingham Collection.

120. Torii Kiyoshige, act. late 1720s–early 1760s
Sugawara Michizane holding a plum branch, ca. late 1750s. Catalogue 76.

121. Nishimura Shigenaga, ca. 1697–1756
Sugawara Michizane holding a plum branch, ca. late 1750s. Catalogue 42.

PLATES 122-132

Nichiren

LIKE MANY ARTISTS of the *ukiyo-e* and more traditional schools, Kuniyoshi was an adherent of the Nichiren sect of Buddhism. Japanese writers believe that he designed this set of ten episodes in the life of the founding saint in 1832 to commemorate the 500th anniversary of the saint's death, but the English scholar B. W. Robinson feels that a date of 1835–1836 is more likely. The series title is printed in the right margin on each print, usually in black, but sometimes in red, violet, or blue; as the states and editions of the set have not been established, it is unclear whether the different title colors have any significance. The pictures are drawn in different styles, and at least two subjects—the prayer for the spirit of the cormorant fisher (in Shijō style) and Nichiren in the snow—are based on compositions in an illustrated book by the painter Kawamura Bumpō published in the 1820s. The pictures are arranged in the order of the events in Nichiren's career. The last picture by Hokui, a pupil of Hokusai, is one of at least two or three prints by that artist based on Kuniyoshi's set.

122

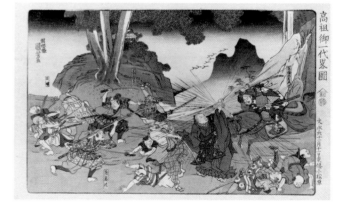

123

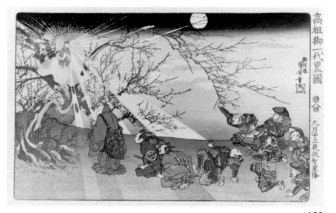
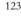

124

122. Utagawa Kuniyoshi, 1798–1861
Nichiren praying for the repose of the soul of the cormorant fisher at the Isawa River in Kai Province, mid 1830s. From *A short pictorial biography of the founder of the Nichiren sect.* (as Plates 123–131).
Catalogue 482.

123. Kuniyoshi
The descent of the star Ichi on the thirteenth night of the ninth month, mid 1830s. Catalogue 479.

124. Kuniyoshi
Tōjō no Saemon attacks Nichiren at Komatsubara in 1264, mid 1830s. Catalogue 476.

125. Kuniyoshi
Nichiren saved from execution at Takinoguchi in Sagami Province, mid 1830s. Catalogue 478.

126. Kuniyoshi
The mantram Namumyōhōrengekyō appears to Nichiren in the waves near Sumida, mid 1830s. Catalogue 480.

127. Kuniyoshi
Nichiren prays for rain at the promontory of Ryōzangasaki in Kamakura in 1271, mid 1830s. Catalogue 477.

128. Kuniyoshi
The rock settling a religious dispute at Ōmuro Mountain on the 28th day of the 5th month of 1274, mid 1830s. Catalogue 483.

129. Kuniyoshi
The appearance of the seven-headed god at Minobu Mountain in the 9th month of 1277, mid 1830s. Catalogue 484.

130. Kuniyoshi
The saint's efforts defeat the Mongolian invasion in 1281, mid 1830s. Catalogue 485.

131. Kuniyoshi
Nichiren walking through the snow at Tsukahara during his exile on Sado Island, mid 1830s. Catalogue 481.

132. Katsushika Hokui, act. ca. 1830s; died after 1893
Nichiren and the seven-headed god of Minobu, ca. 1850. From *Biography of St. Nichiren.* Catalogue 434.

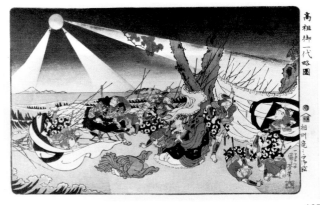

125

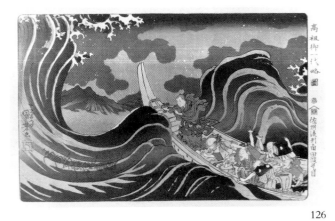

126

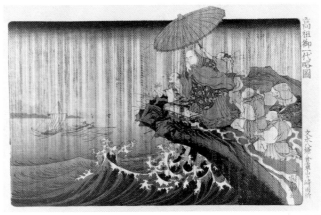

127

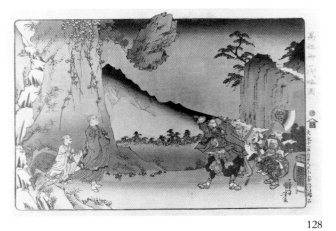

128

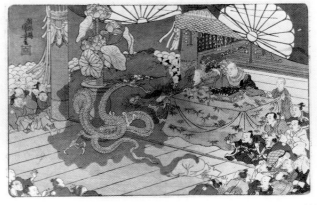

129

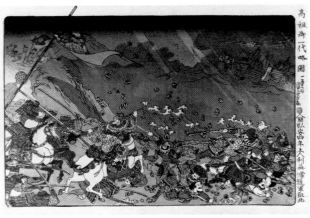

130

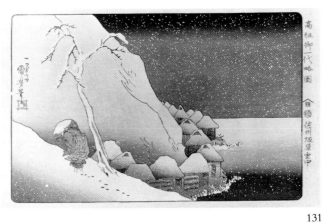

131

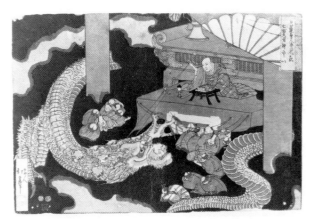

132

133. Torii Kiyomitsu, 1735–1785
The poet Kakinomoto no Hitomaro at Akashi Bay,
early 1760s. Catalogue 83.

134. Suzuki Harunobu, 1725–1770
The poet Kakinomoto no Hitomaro at Akashi Bay, ca.
mid 1760s. Catalogue 97.

135. Utagawa Kunisada, 1786–1865
The poet Kakinomoto no Hitomaro at Akashi Bay, ca. early 1830s. Catalogue 450.

PLATES 133–137

Classical verse

ONE OF THE MOST FAMOUS POEMS by Kakinomoto no Hitomaro, a courtier in the late seventh and early eighth centuries, describes ships hidden among the islands in the dim morning mist at Akashi Bay. This poem is the subject of two *mizu-e,* (see PLATES 73–85) which were published in the 1760s, one by Kiyomitsu, the other by Harunobu (PLATES 133, 134). A third version of the subject is a landscape by Kunisada in which the figure of the poet is printed in color and the distant landscape is printed in shades of blue (PLATE 135).

In the 49th poem in the anthology of *100 Poems,* Ōnakatomi no Yoshinobu, a poet of the late tenth century, compares his love to watchfires at the gate of the Imperial Palace which burn at night but fade by day. Kuniyoshi illustrates the poem quite literally (PLATE 136). Hokusai illustrates another love poem, number 50 in the anthology, more metaphorically, using the steam and the poses of the men and women relaxing after the bath to convey the languor of the verse (PLATE 137).

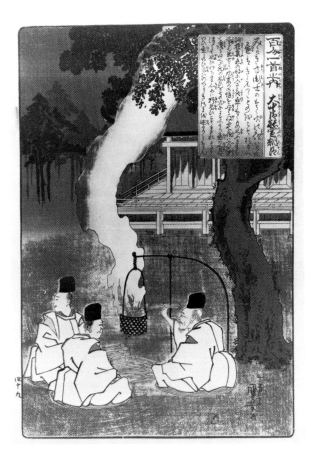

136. Utagawa Kuniyoshi, 1798–1861
Palace workmen burning twigs; illustration of a poem by Ōnakatomi no Yoshinobu, early 1840s. From *The 100 Poems.* Catalogue 593.

137. Katsushika Hokusai, 1760–1849
Resting after a bath; illustration of a poem by Fujiwara no Yoshitaka, mid 1830s.
From *The 100 Poems as explained by the old nurse.* Catalogue 405.

PLATES 138-141

Surimono

138. Kitagawa Utamaro, 1754–1806
Six women by a screen decorated with a painting of the poet Narihira passing Mt. Fuji on his jouney eastward, ca. early 1790s. Catalogue 284.

THE WORD *surimono* means "a printed object," but it was used to describe certain kinds of private publications rather than commercially published woodblock prints. Originally the word was applied to prints published by members of poetry groups for private distribution; gradually it was also used to describe prints which were issued to announce or commemorate certain events, like musical performances. What these prints shared, besides their circumstances of private publication, was an important printed text. Indeed, throughout their long history, many *surimono* were solely printed texts, a fact which is little appreciated since only *surimono* with pictures have been collected in the west.

Many of the announcements for musical performances were printed on large oblong sheets of thick *hōsho* paper which were folded in half lengthwise to make a long, narrow double surface; this format was commonly used for formal letters. The text of the announcement with the program, the name of the performers, sponsors and other information was printed on one long horizontal surface; the other was left for a picture which might allude to the subject or season, or include emblems of the sponsor or performers. Since the long *surimono* were designed in this way, the text and picture face opposite directions when the sheet on which they are printed is opened flat. This disturbed many early western collectors, and the text of most announcement *surimono* was trimmed off, leaving only the long narrow picture. Picture and text were

(continued p. 126)

139. Katsushika Hokusai, 1760–1849
Peasants harvesting rice in the countryside, 1799. Catalogue 339.

140. Nagayama Kōin, 1765–1849
An immortal flying to heaven on the back of a crane, followed by six
other cranes, 1825. Catalogue 439.

141. Kōin
An immortal flying to heaven, 1825. Pair with Plate 140. Catalogue 440.

142. Torii Kiyomasu II, act. mid 1720s-early 1760s
The warrior Kanemichi confronting the usurper Ōtomo
Matori, 1727. Catalogue 50.

143. Kondō Kiyoharu, act. 1705–1730s
Tawara Tōda and the giant millipede at Lake Biwa, 1731.
Catalogue 54.

PLATES 142-145

Picture calendars and calligraphic pictures

TIME IN JAPAN was calculated in sixty-year cycles, each composed of five shorter cycles of years which were named in sequence after the twelve animals of the Japanese zodiac. The goat was the eighth animal of the zodiac, and 1727, the date of this picture calendar (PLATE 142), was, appropriately, a goat year. Each year was divided into twelve or thirteen months which, like our own, were long or short; but unlike our calendar, the order of long and short months was not fixed, but changed from year to year. The sequence of the long and short months was announced in official almanacs at the beginning of every year, but pictures were often published with the numerals for the long and short months. Sometimes the numerals were quite conspicuous; at other times they were cleverly concealed.

The figure of Matori in this print (PLATE 142) is composed of cursive forms of the numerals for the long months of 1727, and the figure of his opponent is composed of the numbers for the short months. Although it is very unusual for actors to appear in picture calendars, Danjūrō and

Koshiro had acted these roles in a play given in the winter of the previous year.

The second picture calendar shows the warrior Tawara Tōda standing on the bridge at Seta preparing to shoot an arrow at the giant millipede who was poisoning Lake Biwa and threatening the Dragon King (PLATE 143). The numbers for the long months of 1731 are written in the upper right corner of the print, while the numbers for the short months, 1, 3, 5, 7, 10, and 12, are concealed in the figure of the warrior.

Pictures of people were often drawn with the characters or syllables of the person's name, as in Hokusai's set of the *Six Immortal Poets* (PLATE 145); see also CAT. NOS. 342, 343*, 344, 346–47. They could also be composed of some other sequence of words or letters, as in this fragment of a print by Masanobu (lacking a poem and the artist's signature at the left) which is made up of words which can be read as a brief love letter addressed to the courtesan whose face is drawn at the beginning: "Dearest (madam), someone wishes you repeated joy, yours sincerely" (PLATE 144).

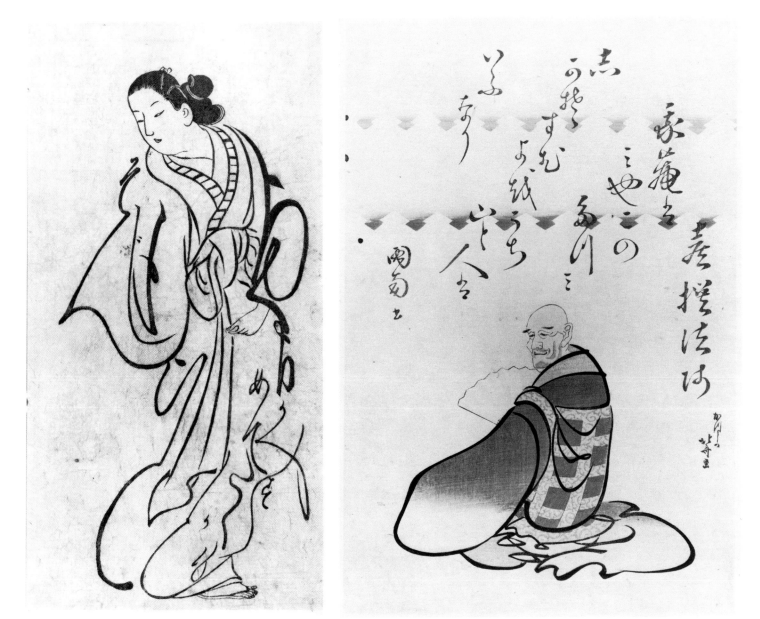

144. Okumura Masanobu, ca. 1686–1764
Portrait of a courtesan as a love letter, 1710s. Catalogue 19.

145. Katsushika Hokusai, 1760–1849
The poet Kisen Hōshi, mid 1810s. Catalogue 345.

146. Utagawa Kuninaga, d. 1829
The pyramids in Egypt, ca. 1800s or 1810s. Catalogue 448.

PLATES 146-148

Western perspective

THE STUDIES OF JULIAN LEE have shown that Japanese artists did not learn the methods of western perspective from studying western prints, but via an illustrated Chinese translation of a European treatise on perspective which was published in Canton in the early 1730s and found its way to Edo by 1739, the date of the first large perspective print, an interior of a *kabuki* theater designed by the artist Torii Kiyotada. Lee has also shown that in the 1760s Chinese copies of European *vues d'optique* found their way to Kyoto and were copied there for use in Japanese-made viewing instruments. These Kyoto prints (which are often attributed to the painter Maruyama Ōkyo since he is said to have painted a number of perspective views for a man who sold viewing apparatus) were brought to Edo, and around 1770 Utagawa Toyoharu, a young Edo artist, began designing a series of block-printed miniature views for use in hand-held optical viewing devices. Finding these

successful, Toyoharu redesigned many of the miniature pictures as full-size horizontal prints. (This may be why many of Toyoharu's prints have the words *saihan,* "re-printed," after the publisher's name.) The vogue for these *uki-e,* or perspective prints, lasted well into the nineteenth century, and many of Toyoharu's prints were reissued, often with new color blocks, until the keyblocks virtually wore out.

Gakutei's view of a teahouse at Mt. Tempō in Ōsaka (PLATE 148) is one of many prints that continued Toyoharu's legacy. The format of Kuninaga's view of the pyramids in Egypt (PLATE 146), with a printed borderline and a printed picture title at the right, was introduced by Toyoharu, but the other "European" elements, which begin to appear in prints by Hokusai and others in the 1800s, derived from sources which have not yet been identified.

94

147. Utagawa Toyoharu, 1735–1814
A perspective picture of a snow-viewing party, 1770s. Catalogue 320.

148. Yashima Gakutei, act. 1815–1852
Sheltering from rain at the new mountain by the Aji River in Ōsaka, 1834.
From *Views of Mt. Tempō*. Catalogue 423.

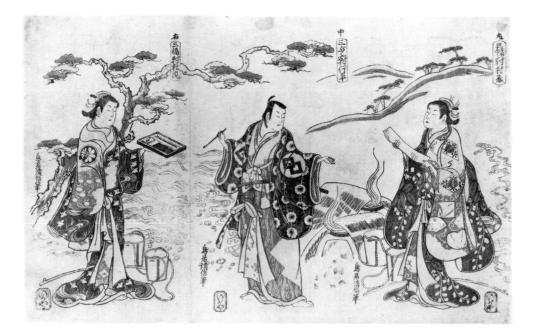

PLATES 149-157

Triptychs

ALTHOUGH IT WAS TRADITIONAL to group paintings in sets of twos and threes, and pairs of prints were published in the seventeenth century, triptychs did not seem to appear in Japanese prints until the 1720s when it was found that three panel prints could be designed at once, printed on a single sheet, and sold either together or individually (CAT. NO. 55*). This tradition continued after color printing was introduced and many two- and three-color prints were

149. Torii Kiyonobu III, act. 1750s–1760s
The actors Onoe Kikugorō I, Nakamura Shichisaburō and Segawa Kikunojō I as Murasame, Yukihira and Matsukaze on the beach at Suma, probably 1748. Catalogue 49abc.

designed in the triptych format, like this print of three actors in the role of the courtier Yukihira and the two sisters who fell in love with him when he was living in exile at the beach of Suma where they earned their livelihood by carrying water from the ocean to the salt kilns (PLATE 149). (See PLATES 204–205 for similar subject.) The background of the print is continuous, and the sheet of paper is uncut. The words "right" and "left" are reversed

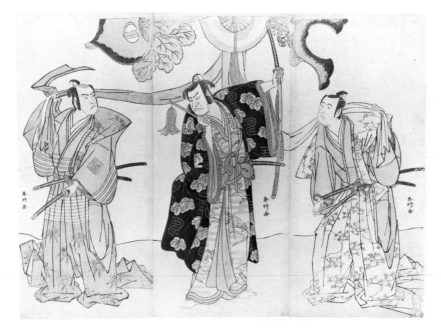

150. Katsukawa Shunkō, 1743–1812
The actors Sawamura Sōjūrō III, Nakayama Kojūrō, and Ichikawa Yaozō II in *Saruwaka banzei butai*, 1/1786. Catalogue 182abc.

151. Torii Kiyonaga, 1752–1815
Women washing and drying lengths of cloth in a garden beside the Sumida River, 1788.
Catalogue 231abc.

152. Utagawa Toyokuni, 1769–1825
Women washing and stretching lengths of cloth beside a well, late 1790s.
Catalogue 329abc.

on the outer panels and correspond to "stage right" and "stage left" or right and left from the picture subject's point of view. This reversal of right and left is normal on early triptychs, although the reason for the reversal is not clear. Perhaps it was customary for a collector displaying painted triptychs to kneel before the alcove facing his visitor and describe the position of the pictures from his point of view.

After the introduction of full-color printing, triptychs remained a popular format, but the separate panels were usually printed from separate blocks. The actor portraitists of the Katsukawa school particularly favored the three-panel format, although the panels were usually dispersed and complete Katsukawa triptychs are uncommon.

In the 1770s the large *ōban* format became more common, and by the 1780s artists like Kiyonaga, Shunchō and Eishi were regularly designing complex, grandly conceived *ōban* triptychs. Print styles changed rapidly in Edo, and only a decade separates the triptychs by Kiyonaga from those of Toyokuni and Eishi (PLATES 151, 152, 153), and another decade separates their work from Kiyomine's sharp, maudlin portraits of three *geisha* (PLATE 154).

Most nineteenth-century commercial artists designed triptychs, Kunisada and his pupils specializing in actor prints, Hiroshige in landscapes, Kuniyoshi in legendary and less orthodox subjects. The Ainsworth impression of his triptych of the ghosts of the Taira warriors attacking Yoshitsune's boat is particularly fine (PLATE 156), and the picture of the festival procession (PLATE 155) is especially interesting because it includes named portraits of many of Kuniyoshi's pupils and household servants.

153. Chōbunsai Eishi, 1756–1829
Young men entertained by several *geisha* and a jester behind a transparent screen, ca. 1795. Catalogue 259abc.

154. Torii Kiyomine, 1788–1869
Companions forcing a *geisha* to drink a cup of wine, ca. late 1810s. Catalogue 445abc.

155. Utagawa Kuniyoshi, 1798–1861
The paulownia pattern of bold Kuniyoshi, ca. 1850. Catalogue 610abc.

156. Kuniyoshi
The ghosts of the slain Taira warriors attacking Yoshitsune and his men, ca. 1850. Catalogue 608abc.

157. Kuniyoshi
The pilot Yoshibei leaps into the Chopping Block Shoals, ca. 1850. Catalogue 609abc.

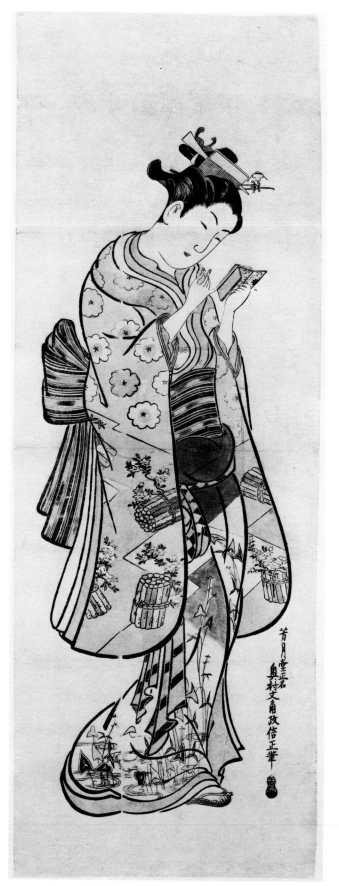

158

PLATES 158–161

Pillar prints

THE LARGE HAND-COLORED *kakemono-e* of the 1740s were printed on single sheets of paper, but many were engraved on blocks that were fitted together from two pieces of wood. In the course of time, the two pieces tended to warp and separate, and later impressions of many of these prints show a noticeable split along one side of the block. Perhaps to avoid the unsightly break, some impressions were printed on narrower sheets of paper from the larger portion of the wood. These prints led to a genre of even narrower prints called *hashira-e*, or pillar pictures. They were sold in paper mounts as hand-scrolls and were hung on the narrow support posts on the walls of rooms in houses. Harunobu and a follower both designed prints of women holding mounted pillar prints in their hands, and Harunobu designed one picture of a pillar print in place on a wall post.

Jacob Pins has pointed out that the early pillar prints were printed on a single sheet of paper, but that from the 1790s on they were printed on two sheets joined around the middle. The vogue for pillar prints diminished in the early nineteenth century. Large vertical prints were still published, but they were formed by joining two or sometimes three full-sized *ōban* sheets vertically (PLATE 47).

158. Okumura Masanobu, ca. 1686–1764
Woman with a hand mirror, 1740s. Catalogue 22.

159. Nishimura Shigenaga, ca. 1697–1756
The actor Sanogawa Ichimatsu as Hisamatsu holding a letter addressed to his lover Osome in *Higashiyamadono takara no ishizue*, 9/1745. Catalogue 40.

160. Torii Kiyonaga, 1752–1815
Woman smoothing her eyebrow, 1781. Catalogue 200.

161. Kitagawa Utamaro, 1754–1806
Young man kicking football, ca. 1805. Catalogue 302.

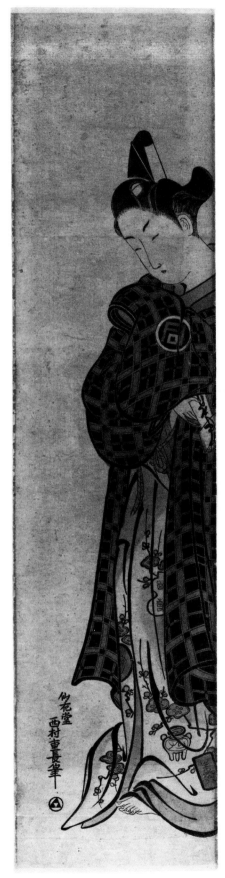

159

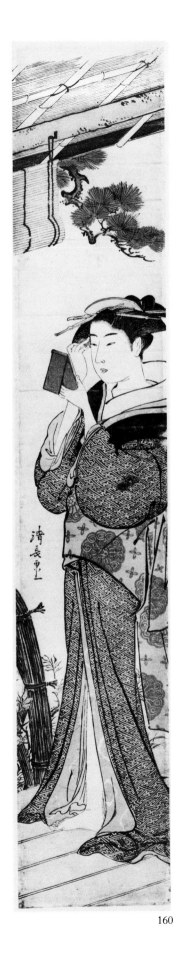

160

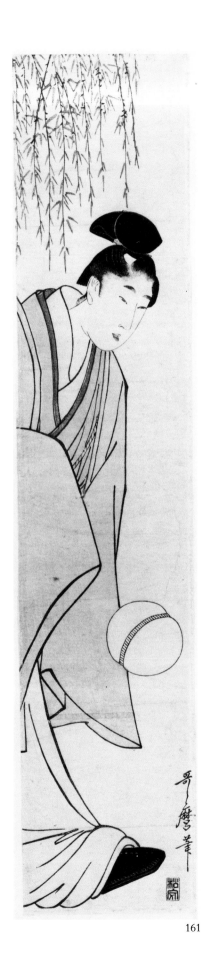

161

PLATES 162-166

Audiences

UNTIL THE 1760S most Japanese prints were pictures of women or actors and most of them were produced by commercial publishers for sale to the general public; the publisher's name regularly appeared on prints in this period alongside the designer's name. In 1765, calendar prints were designed by Harunobu and others which were printed in full color with unusual pigments on fine, heavy paper. These prints were commissioned and produced privately and do not have the marks of commercial publishers; the subjects of most of them were beautiful women. In 1768, an artist named Katsukawa Shunshō, unknown until then as a print artist, designed a series of recognizable portraits of *kabuki* actors. These portraits were printed, like the picture calendars, in full color on fine paper, and lacked the marks of commercial publishers. At the same time, conventional actor portraits were being designed by artists like Kiyotsune and Shigemasa, which were printed in three or four colors on thin sheets of rather poor paper. These prints always bore the marks of commercial publishers and were nearly always designed as individual prints, while Shunshō's prints were often designed in compositions of several panels.

There is a good possibility that the early full-color prints of the Katsukawa school were privately commissioned and distributed without charge to patrons, either by the actors themselves (the actor Nakamura Nakazō I had prints sent to him to distribute to patrons while he was on tour in Ōsaka in the 1780s), or by the owners of the theater-related teahouses who arranged for seats and refreshments for wealthy theatergoers. The tradition of the inexpensive, carelessly engraved portrait, printed in three or four colors on thin, inexpensive paper was established by the Torii artists in the 1750s and 1760s. It continued in the 1770s in the work of Kiyonaga.

In 1779, Kiyonaga seems to have left this part of his work to a young artist named Katsukawa Shunrō, to leave himself more time to design full-color prints of women. Shunrō supported himself by designing these commercial portraits and book illustrations for nearly ten years before he received any commissions to design full-color prints. He stopped designing commercial color prints altogether in 1792, and a few years later adopted the name Hokusai, by which he is best known to us.

The first full-color actor portraits designed by Katsukawa Shunshō were probably private publications. In the course of the next two decades, the technology of full-color printing was used to produce commercially saleable actor prints, most of them designed by artists of the Katsukawa School. By the 1790s, when major color print publishers were required to print their emblems on their woodblock prints, it would seem that most Katsukawa actor prints were produced for public sale. The simpler three- and four-color prints, however, continued to be produced until the beginning of the nineteenth century, indicating that there were at least two different audiences for commercial prints: one for the more expensive full-color publications, another for the cheaper three- and four-color prints. The difference between the prints designed for these audiences may be appreciated by comparing prints of actors in the role of Sukeroku by Kiyonaga and Shunei (PLATES 162-63; the Shunei print has a false signature of Sharaku), and portraits of women by Kiyonaga, Shunshō and Hokusai (PLATES 164-66).

162. Torii Kiyonaga, 1752–1815
The actor Ichikawa Monnosuke II as Hanakawado Sukeroku in *Sukeroku kuruwa no yozakura*, 3/1779. Catalogue 192.

163. Katsukawa Shunei, ca. 1762–1819
The actor Ichikawa Monnosuke II as Sukeroku in *Sukeroku kuruwa no futabagusa*, 4/1791. Catalogue 311.

164. Torii Kiyonaga, 1752–1815
The actor Ichimura Uzaemon IX as a young woman with a branch of cherry blossoms, ca. 1774. Catalogue 186.

165. Katsukawa Shunshō, 1726–1793
The actor Iwai Hanshirō IV as a young princess, ca. late 1770s. Catalogue 165.

166. Katsushika Hokusai, 1760–1849
The actor Iwai Hanshirō IV as the courtesan Agemaki in *Sukeroku yukari no botan*, 3/1791. Catalogue 338.

162

163

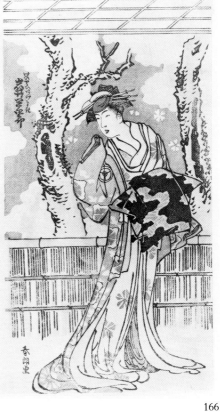

164

165

166

PLATES 167-178

Engravers

VERY FEW *ukiyo-e* artists engraved their own designs on woodblocks. Normally, they produced a more or less finished drawing on thin paper, which was pasted face down on the woodblock to preserve the direction of the design. Less finished sketches were redrawn by *hanshita eshi,* draughtsmen who specialized in preparing final drawings for the engravers during certain periods. Thus, when the block was engraved, the original drawing was destroyed. Many designers in the history of *ukiyo-e* were amateur artists, but the engravers were skilled professional craftsmen who underwent a long period of apprenticeship and training before they became masters and were allowed to engrave the heads, faces, and major outlines of the figures in the prints. During their training, the engravers learned many conventions; they also developed individual styles and personal mannerisms. As a result, works drawn by a single artist but carved by different engravers, often seem to have been designed by different men. Some print designers were aware of this issue, although they rarely seem to have had much choice of their engravers. A letter by the artist Hokusai to one of his publishers urges him

to employ an engraver named Egawa Tomekichi whom Hokusai could trust to engrave the faces in his pictures the way they were drawn; other engravers, he wrote, carved every face in the conventional Utagawa style.

The names of engravers and printers rarely appear on prints published between the seventeenth and early nineteenth centuries. In the middle of the nineteenth century, however, it became more common for engravers to put their names on figure prints. Kuniyoshi's set of pictures for stations of the Kisokaidō Road, for example, is the work of at least five different engravers. Some important mid-nineteenth century engravers seem to have been independent, and worked for several publishers, but in the *Kisokaidō* set each of the five named engravers is linked with a single publisher. The details of the prints illustrated here (PLATES 167-174) show how differently each of the engravers interpreted the artist's lines. Although these details are of different facial types, one will notice when comparing the lines carefully that certain engravers favored different qualities of line, and used different techniques of

(continued p. 126)

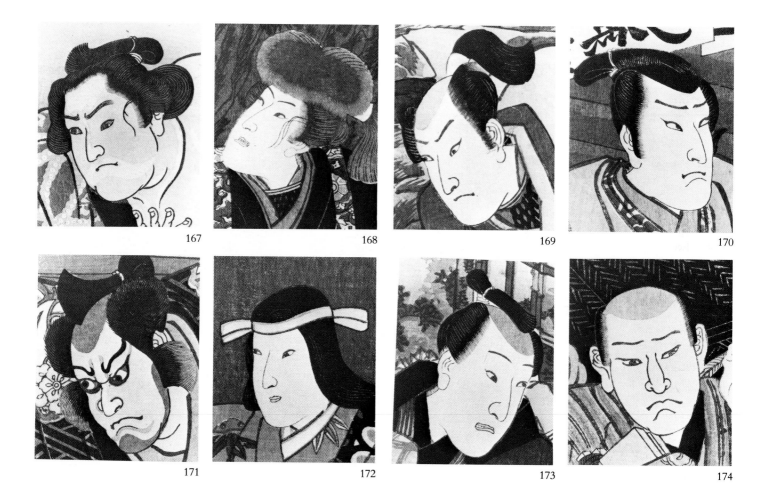

167

168

169

170

171

172

173

174

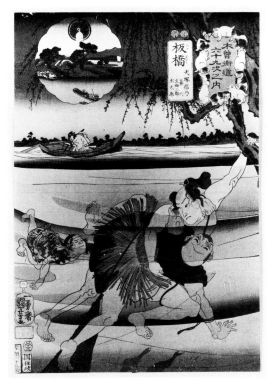

175. Utagawa Kuniyoshi, 1798–1861
Itabashi. Inuzuka Shinō rescuing the fisherman, 5/1852. Pl. 2 from *The sixty-nine stations of the Kisokaidō Road* Engraver: Sugawa Sennosuke. Publisher: Sumimasa. Catalogue 489.

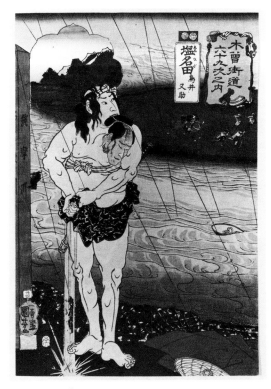

176. Kuniyoshi
Shionada. Torii Matasuke standing beside the Chikuma River with the head of an enemy in his teeth, 6/1852. Pl. 24 from *The sixty-nine stations* . . . Engraver: Asa Sen. Publisher: Minatoya. Catalogue 511.

167. Utagawa Kuniyoshi, 1798–1861
Detail of catalogue 488.
Engraver: Unidentified.
Publisher: Tsujiokaya.

168. Kuniyoshi
Detail of catalogue 500.
Engraver: Sugawa Sennosuke.
Publisher: Sumimasa.

169. Kuniyoshi
Detail of catalogue 504.
Engraver: Unidentified.
Publisher: Tsujiokaya.

170. Kuniyoshi
Detail of catalogue 509.
Engraver: Unidentified.
Publisher: Isekane.

171. Kuniyoshi
Detail of catalogue 516.
Engraver: Unidentified.
Publisher: Sumimasa.

172. Kuniyoshi
Detail of catalogue 520.
Engraver: Takichi.
Publisher: Kagayasu.

173. Kuniyoshi
Detail of catalogue 522.
Engraver: Unidentified.
Publisher: Minotoya.

174. Kuniyoshi
Detail of catalogue 548.
Engraver: Shōji.
Publisher: Kagayasu.

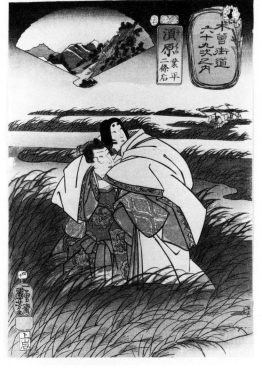

177. Kuniyoshi
Suhara. Prince Narihira and Princess Nijō hiding from pursuers on a moor, 7/1852. Pl. 40 from *The sixty-nine stations* . . . Engraver: Unidentified. Publisher: Unidentified. Catalogue 527.

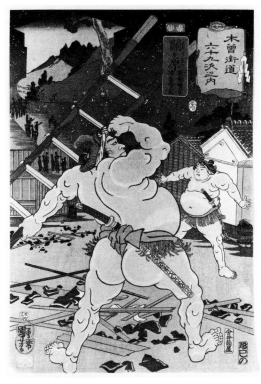

178. Kuniyoshi
Sekigahara. Outdoor battle between the wrestlers Hanaregoma Chōkichi and Nuregami Chōgorō, 9/1852. Pl. 59 from *The sixty-nine stations* . . . Engraver: Mino. Publisher: Izutsuya. Catalogue 546.

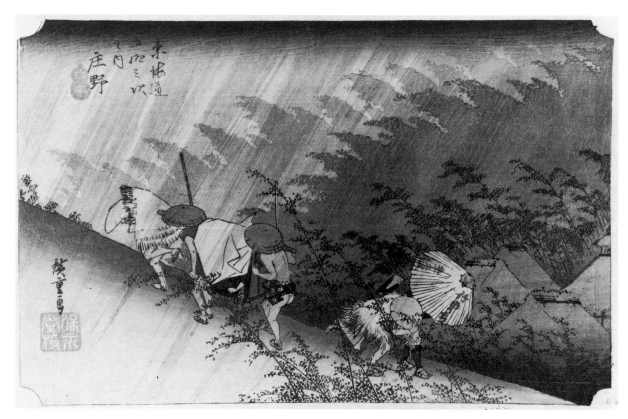

179. Utagawa Hiroshige, 1797–1858
Light rain at Shōno, ca. 1833, early impression. Pl. 46 from
Fifty-nine stations of the Tōkaidō Road. Catalogue 803.

180. Hiroshige
Light rain at Shōno, ca. 1833, later impression. Catalogue 804.

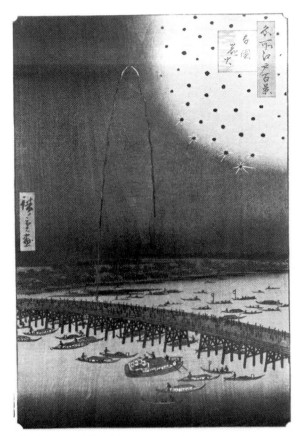

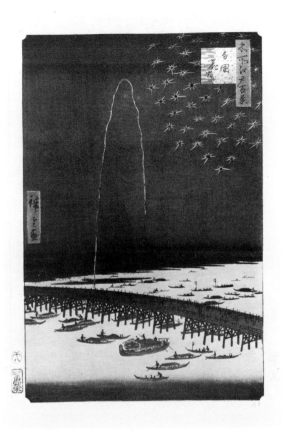

181. Utagawa Hiroshige, 1797–1858
Fireworks at Ryōgoku Bridge, 8/1858, early impression.
Pl. 98 from *One hundred views of famous places in Edo.*
Catalogue 723.

182. Hiroshige
Fireworks at Ryōgoku Bridge, 8/1858, later impression.
Catalogue 724.

PLATES 179–182

Printing variations

UNTIL THE COMMERCIAL DISCOVERY OF COLOR PRINTING in the early 1740s, most single-sheet Japanese prints were colored by hand. It is unclear precisely who applied the colors, but there was certainly great variety in the choice and placement of colors and the care with which they were applied. The visual effect of a picture can vary greatly from impression to impression, as, for example, in the two known impressions of Toshinobu's owl (PLATES 4–5).

Most color variation among figure prints in the late eighteenth and early nineteenth centuries is due to fading of the fugitive printed organic pigments (PLATES 19–22), but late commercial impressions of calendar prints by Harunobu were often printed with different colors than the original private publication. There also seem to have been deluxe and ordinary impressions of many designs by Kiyonaga and Utamaro, printed with different colors on different grades of paper.

The time of day, mood, and effectiveness of nineteenth-century landscapes depended on the printer's choice of colors and their arrangement. The different impressions of Hiroshige's *Evening snow on Mt. Hira* are described in the commentary with PLATE 48. Early impressions are often

marked by the care taken in their printing. The earliest impressions of Hiroshige's *Shōno* (PLATE 179), for example, have very light grey rain, and the distant row of bamboo is much lighter than the nearer row. In later impressions, this distinction is lost. The tips of both rows are printed with dark grey and the effect is more violent and stormy (PLATE 180). Early impressions of *Shōno* have the name of the publisher and the name of the series on the umbrella at the right. Many late impressions lack this writing, although in some impressions it is clear that the letters were not removed, they were simply not inked; the second late impression of the print in the Ainsworth collection (PLATE 180) shows faint traces of the letters accidently embossed on the umbrella.

Some effects in landscape prints were achieved mainly by the application and wiping of colors on the blocks. The earliest impressions of Hiroshige's *Fireworks at Ryōgoku Bridge* have light around the bursting fireworks (PLATE 181), while later impressions are printed with a uniformly dark sky as though the fireworks had just burst and gone out (PLATE 182).

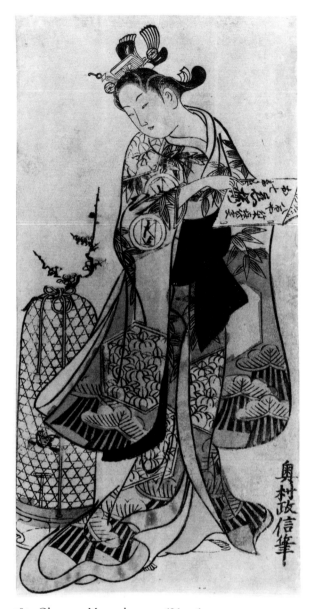

183. Okumura Masanobu, ca. 1686–1764
Osome, the greengrocer's daughter, standing beside a bird cage holding a libretto of the play *Yaoya oshichi koi no hizakura*, ca. 1722. Catalogue 20.

184. After Masanobu
Osome, the greengrocer's daughter, standing beside a bird cage, ca. 1722. Portland Art Museum, Mary Andrews Ladd Collection.

PLATES 183-195

Changes

ANY IMPRESSION PRINTED from an original block is an original print, although each impression differs from all the others depending on how the ink was applied, what paper was used, and how the image was printed. Impressions may also differ because of deliberate or accidental changes on the blocks themselves, and studying these changes makes it possible to decide which were the earlier and which were the later impressions of a given print. Accidental changes are usually caused by wear or damage to the block as, for example, the large crack on the left

side of the figure in Masanobu's print of a woman with a hand-mirror (PLATE 158), and usually indicate later impressions, although even the earliest impressions of certain prints, like *Nichiren in the Snow* (PLATE 131) and *Itabana* by Eisen (CAT. NO. 1022) have breaks in their surrounding borders, although these breaks are often penned in by restorers.

Wood also lent itself easily to deliberate alterations and changes. In the eighteenth century, the faces were the most important part of the picture, and when the thin lines of

the faces began to show wear, when hair styles changed, or when new actors performed a familiar theatrical role, the head on a woodblock would often be removed, and a new piece of wood set in and reengraved.

Oshichi was the heroine of a play which was first performed in Edo in 1718, with great success to judge from contemporary records and the number of woodblock prints of Oshichi which either commemorated or were inspired by the performance. Masanobu's picture of Oshichi was probably first published around 1718, and it was reprinted until the block had nearly worn out. In the 1730s, perhaps in 1738 when another *kabuki* play with Oshichi was performed, the worn block was pulled out, a crisp new head was engraved with the more elaborate hair style typical of the period, and the print was reissued (PLATE 183). The loss of eighteenth-century Japanese woodblock prints has been enormous. Of the hundreds, or perhaps even thousands of impressions of Masanobu's print which were originally printed, only this one with the new head is known to have survived. Prints by Masanobu were frequently copied during his lifetime, and an unsigned contemporary copy probably published around 1718 (PLATE 184) shows what the original head looked like. A Toshinobu with a reengraved head is in the collection (CAT. NO. 29*), as well as a Harunobu print in which an entire figure has been reengraved (PLATE 16). A *surimono* after a painting by Katsukawa Shunshō was originally published in a horizontal format with a frame like a votive painting (PLATE 185). The image was reduced, a new border was engraved, and it was republished in the square format of a hanging scroll (PLATE 186).

Early impressions of Hiroshige's *Hamamatsu* (PLATE 187) have a pattern of roof tops and trees printed in dark grey at the right on the horizon which is removed in late impressions (PLATE 188). Early impressions of *Evening Bell at Ikegami* (PLATE 189) have a pattern of dark trees silhouetted on the horizon which is removed, along with two poems in the sky, from later impressions (PLATE 190). These changes were made for aesthetic reasons. Others were made to correct mistakes. On the earliest impressions of Hiroshige's *Evening Snow at Kambara* from the *Hōeidō Tōkaidō* a few small areas on the legs and cloak of the man at the right were not cleared on the keyblock (PLATE 49). As soon as these areas were noticed, they were removed, but the engraver's hand slipped, and cut the outline of the man's leg above his knee, a break which is noticeable on all later impressions (PLATE 41). Establishing this sequence proves that the earliest impressions of *Kambara* were printed in light grey, with the sky darker at the top, and that the idea of printing darker impressions, with the sky black at the horizon, occurred to someone at a later date.

The discovery of a deliberate change on a color block of Hiroshige's *Rain on Ōhashi Bridge* has made it possible to solve the long-standing controversy over versions with and without two boats by the distant shore (PLATES 191-193). Minoru Uchida first observed that the boats were

185. After Katsukawa Shunshō, 1726–1793
Raikō and his retainers disguise themselves as priests and set off for Ōe Mountain, ca. 1810s. From an untitled series of four surimono after paintings by Shunshō. Catalogue 171.

186. After Shunshō
Raikō and his retainers disguise themselves as priests and set off for Ōe Mountain, ca. 1810s. From *Four paintings of the journey to Mt. Ōe by the late Shunshō*. Catalogue 172.

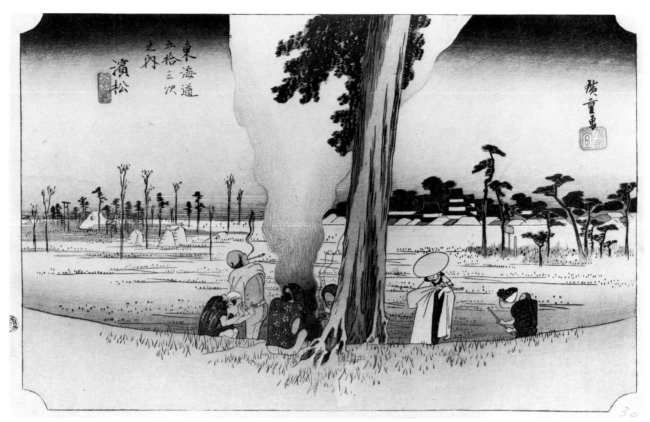

187. Utagawa Hiroshige, 1797–1858
Winter desolation at Hamamatsu, ca. 1833, first state, Pl. 30 from
Fifty-three stations of the Tōkaidō Road. Catalogue 786.

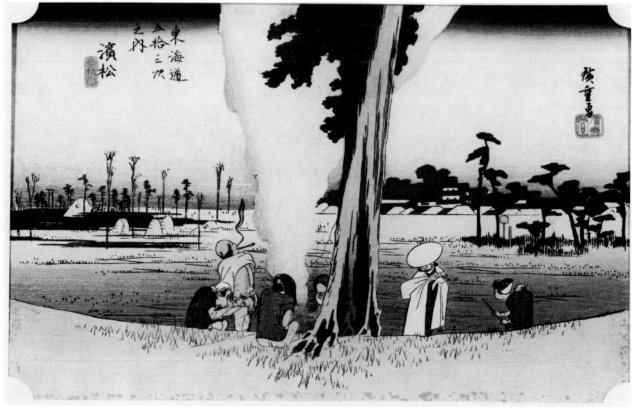

188. Hiroshige
Winter desolation at Hamamatsu, ca. 1833, second state. Pl. 30 from *Fifty-three stations of the Tōkaidō Road*.
The James A. Michener Collection, Honolulu Academy of Arts.

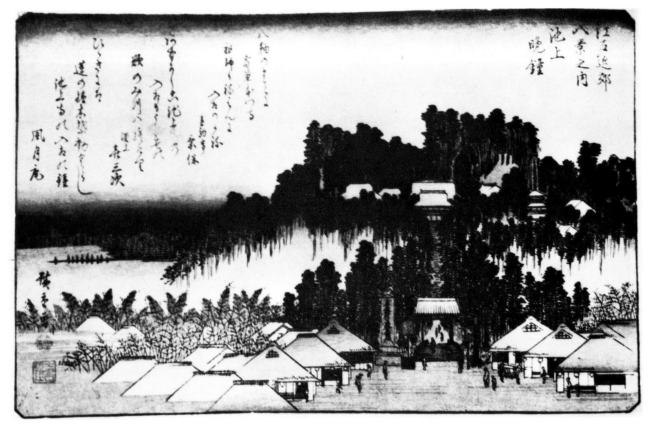

189. Utagawa Hiroshige, 1797–1858
Evening bell at Ikegami, ca. 1836, first state. From *Eight views of the environs of Edo*.
Photo: Suzuki, *Hiroshige*, pl. 120.

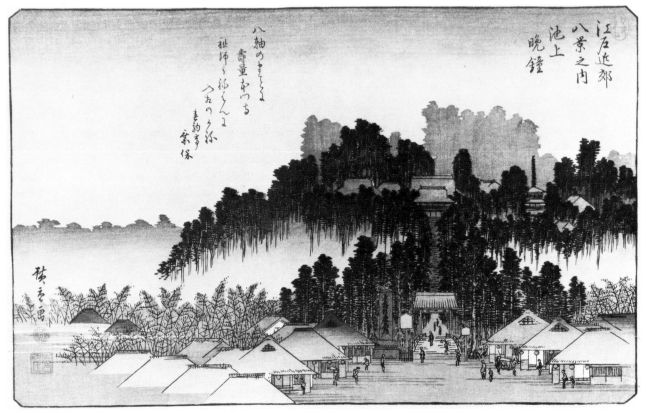

190. Hiroshige
Evening bell at Ikegami, ca. 1836, second state. From *Eight views of the environs of Edo*.
Catalogue 653.

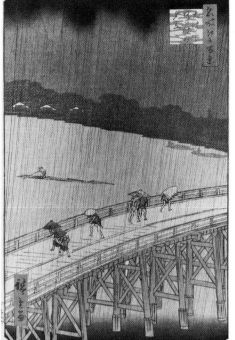 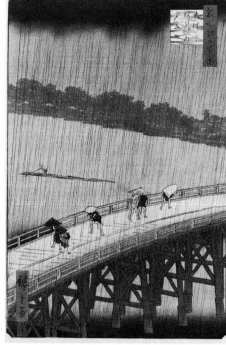 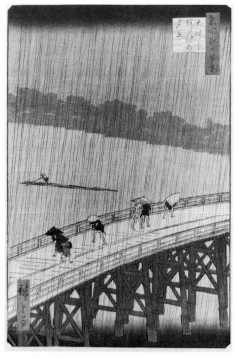

191. Utagawa Hiroshige, 1797–1858
Evening rain at Atake and Ōhashi Bridge, 9/1857, first state. Pl. 52 from *One hundred views of famous places in Edo*. Catalogue 699.

192. Hiroshige
Evening rain at Atake and Ōhashi Bridge, 9/1857, second state. Photograph courtesy Sotheby's, New York (Gerli impression, sold 26 June 1981).

193. Hiroshige
Evening rain at Atake and Ōhashi Bridge, 9/1857, third state. Catalogue 700.

not simply added or removed, but were part of the grey block with the houses and trees on the horizon. Since the block with the two boats was rather roughly engraved, and since impressions with the two boats lacked the shading on the bridge and the three-colored cartouche which marks certain fine impressions, Uchida suggested that the block with the two boats was designed by Hiroshige II and was used only on rather late impressions. Jūzō Suzuki has recently pointed out, however, that the impressions with two boats have a blank area between the pilings of the bridge which was unintentionaly left off the blue water block. When this was discovered, the holes were filled by inserting a plug among the pilings of one of the grey color blocks, which is visible on all later impressions. The pattern of wear on the lines of rain also shows that the impressions with the blank space beneath the bridge are early, and that the plug did not simply fall out. When the hole was plugged, the grey block for the houses and trees on the horizon was reengraved without the two boats. It is usually assumed that the earliest impressions of a print must be

the finest, but the earliest impressions of *Ōhashi* are not as rich as some of those which appeared later.

Color areas were occasionally enlarged or extended, as in the sky of Kuniyoshi's *Rendezvous Pine* (PLATE 38), and new blocks were sometimes added, as in Eisen's picture of Narai on the Kisokaidō Road (PLATES 194-95). The earliest impressions of this print with Eisen's signature have a white mountain printed in silhouette at the left of the print. In ordinary impressions (PLATE 194), the mountain was not completely outlined with blue and the space it should occupy looks disconcertingly empty; so when Eisen's signature was removed and the picture was reissued (PLATE 195), a new grey block was engraved for the two mountains, and the dotted pattern of trees on a darker grey block was extended across both to the left of the print. The blue block was not reengraved, but in late impressions it was more carefully printed to show the silhouette of another white mountain behind the wood-cutter on the path at the upper center of the print.

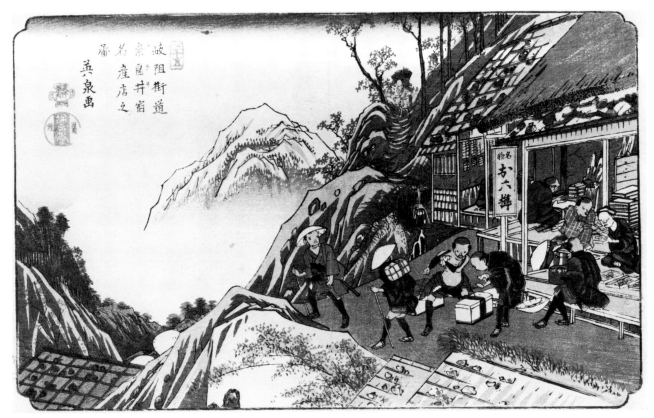

194. Keisai Eisen, 1790–1848
The Oroku comb shop at Narai Station, 1835, first state. Pl. 35 from
A set of pictures of the Kisokaidō Road. Catalogue 1043.

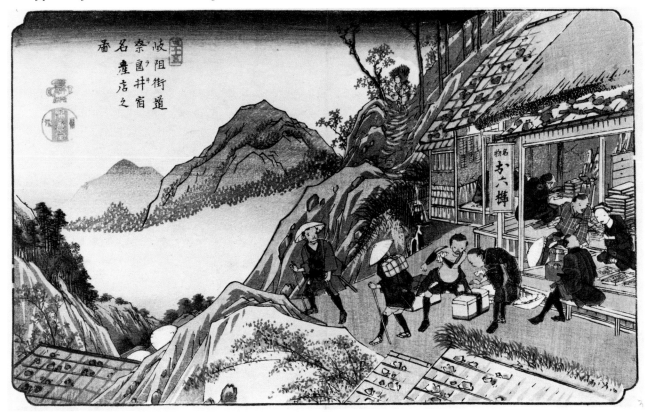

195. Eisen
The Oroku comb shop at Narai Station, 1835, second state. Catalogue 1044.

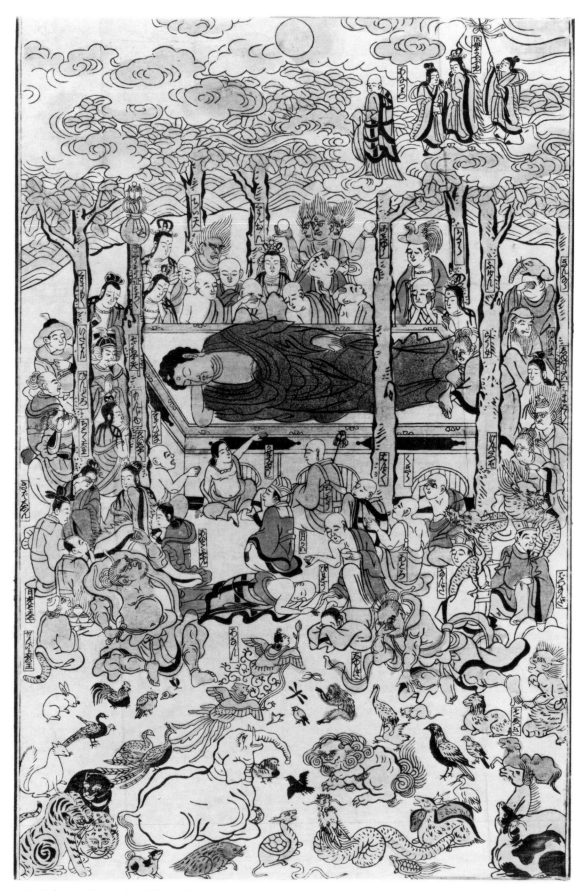

196. Nishimura Magosaburō Shigenobu, act. ca. 1730s–early 1740s
The death of the Buddha, ca. 1730s. Catalogue 57.

197. Unsigned
The death of the Buddha, ca. 1710s. The Cleveland Museum of Art, Gift of Mr. and Mrs. J. H. Wade.

198. Nishimura Shigenaga, ca. 1697–1756
The death of the Buddha, ca. 1720s. Honolulu Academy of Arts
(Photo: H. Link, *Primitive Ukiyo-e*, p. 154.)

PLATES 196–216

Copies

WE TEND TO CONFUSE copies with forgeries and overlook the many kinds of copies that appear in the history of Japanese prints. These fall into two distinct groups: contemporary copies, usually published within a few years of the original, and later copies published long afterwards.

Many early woodblock prints are known in two or more unsigned versions, and it is often impossible to decide whether one was the earlier, or whether all were based on some unrecognized or lost original. The three examples illustrated here of the *Death of Buddha* (PLATES 196–98), for example, are all probably based on an earlier painting.

Some early copies were free adaptations by one artist of another artist's work, as Masanobu's variations published in 1701 (CAT. NO. 12*) on Kiyonobu's album of 1700, *Keisei Ehon*.

Hand-colored prints of the 1720s-1740s were usually signed, and unsigned prints of this period usually seem to be copies of signed originals. Okumura Masanobu denounced these copies vigorously and often, and they seem to have been unauthorized "pirates" (CAT. NOS. 32*, 33*, 34*). The unsigned copies of prints of the 1720s are often crudely engraved compared to signed originals, and are usually less carefully colored. Nevertheless, they were published during the same period, share similar qualities, and often preserve designs that are otherwise unknown.

During the 1720s and 1730s similar designs often ap-

115

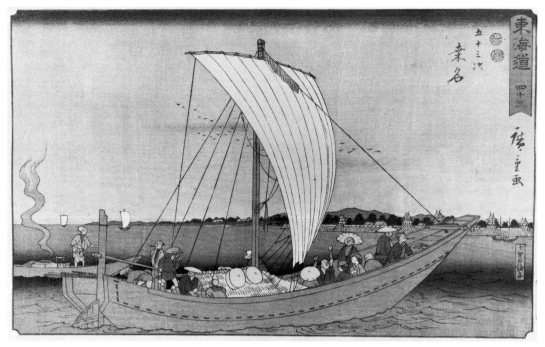

199. Utagawa Hiroshige, 1797–1858
The Seven-*ri* ferry boat approaching Kuwana, ca. 1850. Pl. 43 from
The Fifty-three stations of the Tōkaidō Road. Catalogue 857.

200. Hiroshige
The Seven-*ri* ferry boat approaching Kuwana, 7/1855.
Pl. 43 from *Pictures of famous places of the fifty-three stations*
(Vertical Tōkaidō). Catalogue 915.

201. Utagawa Hiroshige, 1797–1858
The Inari Shrine at Ōji, 1830s. From *Famous views of Edo*. Catalogue 649.

202. Hiroshige
The ceremonial gathering of foxes on New Year's Eve at the nettle tree near the Inari Shrine at Ōji, 9/1857. Pl. 118 from *One hundred views of famous places in Edo*. Catalogue 739.

203. Utagawa Hirokage, act. late 1850s–late 1860s
Fox fires at Ōji, ca. 1860. Pl. 16 from *Comic events at famous places in Edo*. Catalogue 1374.

よ゛えとふ侍きりの広次あふ人ふらと

204. Suzuki Harunobu, 1725–1770
The salt gatherers Matsukaze and Murasame on the beach at Suma, ca. 1770. Catalogue 110.

yohiro, and Kiyonaga's print was later copied by his son and pupil Kiyomasa. None of these artists formally acknowledged his source.

Copies in the late eighteenth century were not always direct. Kiyonaga used the idea of Harunobu's print of a woman and child watching floating fireworks (PLATE 206) for a three-panel print, placing the figures of the standing woman and kneeling girl in separate panels (PLATE 207).

Occasionally artists copied their own works, with variations. The second version of Utamaro's woman looking in a mirror (PLATE 24) is so coarse, however, that some scholars have suggested that it may be the work of the pupil who later became Utamaro II.

Hiroshige designed new versions for several of the first subjects in the *Hōeidō Tōkaidō,* perhaps because the prints were so popular and the earliest blocks showed so much wear by the time the set was finished. The first version of Nihonbashi has few people (CAT. NO. 751*); the second

205. Torii Kiyonaga, 1752–1815
The salt gatherers Matsukaze and Murasame on the beach at Suma, 1778 or earlier. Catalogue 191.

peared with different artists' signatures and different publishers' marks. These contemporary versions were obviously considered quite legitimate, and it is usually difficult to determine which design was the earliest.

There are fewer contemporary copies of color prints in the later eighteenth century. A few two-color triptychs by Masanobu were copied with curious pseudonymous signatures like Mangetsudō; and a few of Harunobu's prints like the *Five Virtues* were copied in square and panel format in the early 1770s. But many artists of this period, particularly Harunobu, often incorporated designs by earlier artists into their own work, and for a while this form of copying was a common practice. The print by Kiyonaga, for example, of the salt water carriers Matsukaze and Murasame, which was published in the mid 1770s (PLATE 205), was based directly on a print by Harunobu designed ca. 1770 (PLATE 204). Harunobu's print was based, in turn, on an earlier composition, perhaps a panel print by Ki-

has a crowd in the foreground (CAT. NO. 753*). In the two versions of Totsuka the traveller is shown mounting and dismounting his steed (CAT. NOS. 759*–60*).

In two pictures of the station Kuwana, from different *Tōkaidō* sets, Hiroshige repeated elements of the compositions (PLATES 199, 200). Hirokage, the designer of a number of comic prints, often combined elements from different Hiroshige prints with his own extra comic touches, as, for example, in his picture of the foxes at Ōji (PLATE 203) who have tricked a farmer into thinking he is a nobleman being carried in a procession. The trees and temple are taken from an early landscape of Ōji (PLATE 201); the vertical format and the foxes themselves are taken from Hiroshige's famous *Fox Fires* (PLATE 202).

More questionable are the many contemporary copies of Hiroshige's bird-and-flower prints, some of which are known in as many as three different versions. The prints were very popular; but it is unclear whether the many versions, which are usually quite close in design but often lack publishers' marks and are engraved in slightly different styles, were redesigned by Hiroshige, or simply reengraved from impressions of the original print design. Sadanobu, an Ōsaka artist, copied a few of Hiroshige's bird-and-flower prints and also made miniature copies of sets by Hiroshige, just as Hokumyō, an earlier Ōsaka artist, had made of Hokusai's *Thirty-six Views of Mt. Fuji*.

206. Suzuki Harunobu, 1725–1770
Courtesan and attendant at the riverside teahouse Iseya watching floating fireworks, late 1760s. Catalogue 105.

207. Torii Kiyonaga, 1752–1815
Cooling off in the evening at Shijōgawara. Minneapolis Institute of Arts, Bequest of Richard P. Gale.

208. Hishikawa Moronobu, d. 1694
Samurai and *wakashū* walking toward cherry and pine trees, ca. 1680s.
From *Flower viewing at Ueno*. Catalogue 2.

209. Utagawa Toyokuni, 1769–1825
Six men walking, ca. 1810. Print room, Rijksmuseum, Amsterdam.

120

210. Torii Kiyomasu I, act. ca. 1697–1720
The actors Ichikawa Danjūrō I and Yamanaka Heikurō as Yamagami
Saemon and Suzuki no Ōji in *Keisei ōshōkun*, 1/1701. William Rockhill
Nelson Gallery of Art, Atkins Museum of Fine Arts, Kansas City, Mo.

211. Torii Kiyomine, 1788–1869, after Kiyomasu
The actors Ichikawa Danjūrō I and Yamanaka Heikurō as Yamagami
Saemon and Suzuki no Ōji in *Keisei ōshōkun*, 1812. Catalogue 446.

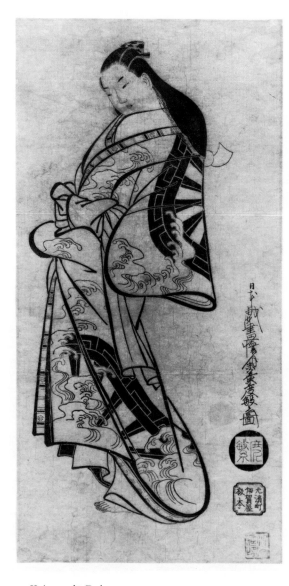

212. Kaigetsudō Dohan, act. ca. 1710s
Standing courtesan with pattern of water wheels and waves on her robe, ca. 1710s. Catalogue 8.

213. Nishimura Shigenaga, ca. 1697–1756
Young man holding a fan, 1720s. The Art Institute of Chicago, Clarence Buckingham Collection.

In the late eighteenth century, many artists and their public began to regard *ukiyo-e* in an historical light, and took a special interest in prints published in the late seventeenth and early eighteenth century. These prints seem to have been very uncommon; thus many were copied for both private and commercial publishers. Kiyonaga designed a few copies of earlier prints (CAT. NOS. 234*–235*), and Toyokuni designed a *surimono* which was based on a print by Moronobu (PLATES 208–209). The most interesting of these early nineteenth-century copies were the prints by Kiyomine (PLATE 211) after prints designed by Torii Kiyomasu around 1700. The blocks of these prints were found in the possession of the original publisher, and an impression of each was printed and hand-colored in a style completely unsuited to the original (PLATE 210). The hand-colored impressions were then copied by Kiyomine

and published as color prints. The inscription on this print by the *kabuki* historian Tatekawa Emba identifies the actors, roles, the title and date of the original theater production. The inscription at the left, with hand-stamped seals, is by Ichikawa Danjūrō VII, a direct descendant of one of the actors in the print. Curiously enough, although Kiyomine's print says it is after an original design by Torii Kiyonobu, both of the original pictures were actually designed by Torii Kiyomasu.

Facsimile copies of older Japanese prints, which were published from the 1890s on, often lack any mark to distinguish them as copies, and many collectors have bought copies thinking they were originals. The print signed Shigenaga (PLATE 187) for which Miss Ainsworth paid $300 in 1920 at the sale of the collection of her friend A. D. Ficke, a well-known connoisseur and author on

214

215

214. After Shigenaga
Young man holding a fan, late 19th-early 20th century facsimile.
Catalogue 44.

215. After Shigenaga
Young man holding a fan. Printed in 1979 from a facsimile block cut in late 19th-early 20th century. Catalogue 1402.

216. After Kaigetsudō Doshin
Standing courtesan, late 19th century facsimile. Catalogue 9.

216

Japanese prints, is a copy. Miss Ainsworth later bought the modern woodblock from which her impression was printed (PLATE 214), and subsequently an impression of the original print came to light (PLATE 213). The Shigenaga print was designed as one panel of a triptych. A copy of another panel from the same triptych in the collection bears a false Toshinobu signature (CAT. NO. 45*).

Copies can be deceptive; however, they are valuable when they are recognized, since they allow us to make comparisons and appreciate more finely the qualities of the original. Miss Ainsworth bought the late nineteenth-century copy of a Kaigetsudō print published by Kobayashi Bunshichi (PLATE 216) to compare with her two originals (PLATES 3, 212). For other examples of originals and modern copies by Kiyonaga, Hokusai, and Hiroshige, see CAT. NOS. 210*–211*, 373*, 379*, 1202*–3*.

Repairs and restoration

PAPER IS A FRAGILE MATERIAL, easily torn, soiled, and otherwise damaged. Prints which are damaged are often repaired, and there are two basic approaches to the restoration of works of art on paper. One is primarily structural, and endeavors to make the paper sheet as sturdy and durable as possible. The other is primarily cosmetic, and attempts to make the picture look as fresh and undamaged as possible. These two approaches are not necessarily incompatible, but restorers who are interested in strengthening the paper structure are often content to make their repairs inobtrusive but visible. Cosmetic restorers prefer repairs which are as invisible as possible, but are sometimes tempted to go further and alter the surface of the print, removing stained paper fibers, reinforcing worn lines with ink and brush, and even reprinting faded colors and adding false signatures.

The *Crow and Heron,* a man in black standing in the snow with a woman in white beneath an umbrella, was a common subject of color prints in the late 1760s and early 1770s. This version of the subject (PLATE 217), with the youth offering to remove the snow from the woman's sandal, was probably designed as a frontispiece for an erotic album. The print was originally unsigned, but was probably designed by Koryūsai. The print however has been extensively repaired and a false Harunobu signature has been added. The repairs were originally the same color as the adjacent areas, but they were colored with mineral-based pigments; when the picture was later exposed to light the original organic pigments faded, but not the colored repairs, so the repaired areas stand out distinctly. The man's hand and foot were also repaired and carefully redrawn with ink; the repairs may be identified by examining the black outline since it is thinner than lines elsewhere, and less even. A companion to the Ainsworth print, from the same erotic album, is also illustrated here for comparison (PLATE 218).

False signatures have been added to several prints in the collection: a Sharaku signature was added to a Shunei actor portrait (PLATE 163), a Moroshige signature to an unsigned print attributed to Kiyonobu (PLATE 1), a Masanobu seal on an unsigned print which was, in fact, designed by Masanobu (CAT. NO. 17*). The signature, series title, publisher's mark and censorship seal on Toyokuni's portrait of the actor Sawamura Yodogorō (PLATE 33) have been added on a repaired area of the print and the grey background has been covered with mica to make the repair less noticeable.

There are large and skillful repairs on the large heads by Eishō (PLATE 29) and Chōki (PLATE 27) and the entire top section of a print by Harunobu (CAT. NO. 106*) is drawn in pen. The blue, purple, red and pink areas of the Sharaku portrait of Morita Kanya (PLATE 30) have been reengraved and printed over a faded impression of the print; this is an example of deceptive facsimile restoration. Harunobu's print of a woman beside the window (CAT. NO. 99*) has also been skillfully repaired at the left, and most of its colors are new.

217. Artist unknown (signed "Harunobu")
Young man offering to help clear a woman's shoe of snow, ca. 1770.
Catalogue 114.

218. Artist unknown
A couple in snow beside a willow and fence, ca. 1770. Pendant to Plate 217.
Private collection. Photo courtesy of Sotheby's, New York.

(continued from p. 32, plates 17–18)

(compare the portraits by Kiyonaga, PLATES 162, 164), but it is far less brilliant than the Shunkō portrait (PLATE 17). (The three-color prints usually have descriptive backgrounds, and never form multi-panel compositions. The full-color prints, on the other hand, usually have simple backgrounds and frequently seem to have been designed and issued as sets or multi-paneled compositions.)

(continued from p. 32, plates 19–22)

illustrates these changes, and also shows how our impression of an artist's style may be conditioned by the technique, mannerisms, and differing personal styles of the engravers. The fugitive colors on the print of dancers (PLATE 19) are absolutely unfaded as are the colors of the actor portraits by Shigemasa and Shunkō (PLATES 18, 17). The purple and blue of the second print (PLATE 20) have just begun to fade and are noticeably different where the picture was exposed to air or moisture along the edges. The robe of the woman at the right in the flower-viewing print (PLATE 21) was printed with the same purple as the woman at the right above, but it has almost completely faded. The colors on the Kiyonaga (PLATE 22) are so completely faded that it is difficult to imagine that the sash of the woman at the left was deep red, the robe of the woman at the right purple, and the umbrella probably blue. The rate of fading of fugitive pigments is discussed in more detail in the Appendix at the end of this volume.

(continued from p. 34)

Thus one assumes that they are fairly close in date.

The circumstances of the publication of this set are unclear. Five designs are presently known, and another was recorded in a 1915 catalogue of the Japanese dealer Yamanaka, but one of these, the woman with a glass pipe, also appears with the title *Fujo ninsō juppin*, "Ten types of women," the title under which the other four prints in this group of half-length portraits with mica backgrounds is known. There is no agreement over which of these groups was published first, or whether the groups were intended as one or two sets. All of the prints, however, have a cartouche comprised of three tile-shaped strips in the upper right hand corner. The right strip gives the series title, the left Utamaro's signature. The center strip is blank on all but the earliest impressions of two plates from the *Fujin sōgaku juttai* group, which have the name of the woman's type printed there (PLATE 25). It is unclear why the publisher removed the names of the types, but since the cartouche was designed in three strips to accommodate the printed name, it would certainly seem, therefore, that the *Fujin sōgaku juttai* group is the earlier. The only other difference between the groups is Utamaro's signature. On the *Fujin sōgaku juttai* prints he signs himself as *sōmi Utamaro kōga*, "drawn with thought by the physiognomist Utamaro"; the *Fujo ninsō juppon* prints say *kansō Utamaro ga*, "drawn by the physiognomist Utamaro."

The woman looking in the mirror is described as the "Interested" type. She is a married woman, and is mainly interested in how her cosmetic blacking looks on her teeth as she begins to dress herself after a bath. Jack Hillier has noticed that most early impressions with the name in the center cartouche are smudged around the woman's mouth. Blacking, or *ohaguro*, was difficult to apply neatly, and the smudge was intentional. It was carefully done on the Ainsworth impression however; the black spreads only to the woman's lips. The blue on the robe in the Ainsworth impression has faded, but the mica is quite fresh and intact, and the lacquer applied to the mirror is still black and glossy for the most part, while on many impressions it has become cloudy and degraded.

(continued from p. 90)

occasionally combined on one large sheet, but this was much more common in the nineteenth-century prints of the Ōsaka Shijō school (PLATE 140). For distribution, the large sheet, which had already been folded lengthwise, was folded again into thirds (these creases are visible on the print by Kōin, PLATE 140), and slipped into a nearly square envelope. Some large *surimono* had small pictures which filled only one of the six squares of the folded print. This may have been the inspiration for the popular square format which was adopted around 1809 by the Edo poetry groups who commissioned *surimono*.

(continued from p. 104)

carving to end lines, to indicate corners, and so forth. By making these distinctions, we reach a better position to discuss Kuniyoshi's personal style: those elements of drawing and design which are either not affected by, or underlie the work of, the engravers. For other striking differences in an artist's work which are largely the result of the engravers' styles, compare the early prints by Shigemasa (CAT. NOS. 126*, 130*, 131*) and Kiyonaga (PLATES 19, 20).

Hiroshige may have welcomed the variety that engravers added to his landscape sets, and designed certain sets with the skills of particular engravers and printers in mind, as a composer might write a concerto for a particular violinist. In any case, each of Hiroshige's important sets has a distinct quality for which an engraver is largely responsible.

Occasionally, the engraved style of a set changes in midcourse. The early prints Hiroshige designed for the *69 Stations of the Kisokaidō Road* are very broad and solid compared to some of the perfunctorily engraved and carelessly printed designs from the end of the set. PLATES 44-46 are typical of the early pictures, and Tarui (CAT. NO. 1070*) is typical of the later ones. It has been chosen as an example because it also shows how inexpensive landscape and figure prints published in Edo were used as wall decoration even in remote provincial villages. Other Hiroshige prints, like Chiryū from the half-block *Sanoki Tōkaidō* (CAT. NO. 970) show prints decorating resthouses in other villages.

II. *Catalogue*

The Mary A. Ainsworth Collection

The catalogue is arranged in chronological order. All sheets are full-color woodblock prints unless indicated otherwise. Additional elements such as metallic pigments and embossing are cited. Dimensions are given in millimeters, height preceding width. Catalogue entries preceded by an asterisk are illustrated within this section. Prints illustrated in the essays section are indicated by a plate number following the catalogue entry. The majority of prints in the catalogue were bequeathed to the Museum by Mary A. Ainsworth in 1950. Prints in the Museum collection from other sources are catalogued separately, following the Ainsworth collection.

Key to the abbreviations used under "Reference" and "Publication" appears in the Bibliography. References listed under "Publication" refer to the Ainsworth impression, those under "Reference" to other impressions.

References to Metzgar in the catalogue remarks refer to Judson D. Metzgar's original (unpublished) catalogue of the Ainsworth collection, written at Oberlin between October 1950 and February 1951, soon after the receipt of the bequest. Mr. Metzgar's original numbering is preserved and recorded at the end of each entry after the initial A (for Ainsworth), along with the Museum accession number. The notes that appear after the initials "MA" in some entries are Miss Ainsworth's marginal notes in sales catalogues.

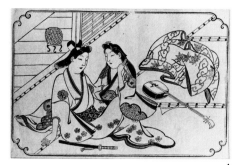

1

Hishikawa MORONOBU

*1. Couple seated in a room
Untitled series of twelve erotic prints
1680s
album sheet, 280 × 348
hand-colored
Reference: Shibui 1933, Moronobu Series E; UTK 1, 17 (color).

A2, 50.135

This set has characteristic indented borders. The color may be modern.

2. Samurai and *wakashū* walking toward cherry and pine trees
Series: *Ueno hanami no tei,* Flower viewing at Ueno
ca. 1680s
album sheet, 278 × 423
Provenance: Field
Publication: Field 10.

A3, 50.136

This print is from a series of thirteen unsigned prints attributed to Moronobu because of the similarity of the figures to those in signed paintings and illustrated books. The prints form a continuous panorama of townsmen and samurai viewing cherry blossoms near Kanei Temple in the Ueno district of Edo. The set was also published with the title *Edo monomairi no tei,* A visit to a temple in Edo.

PLATE 208.

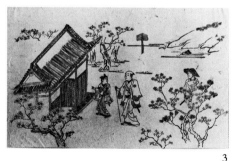

3

*3. *Samurai* and attendant approaching the Niō Gate at Kanei Temple
Series: *Ueno hanami no tei,* Flower viewing at Ueno
ca. 1680s
album sheet, 268 × 412
hand-colored

A59, 50.192

A somewhat later impression with modern coloring with the name 'Niō Gate' removed and the lower part of the samurai's right foot missing. An early impression with the name of the gate printed above is reproduced in Higuchi, *Shōki ukiyo-e,* Moronobu 21. On the impression the gate name has been removed and the lower part of the samurai's right foot is missing; the coloring is modern.

Attributed to Torii KIYONOBU I

4. The actor Matsumoto Hyōzō as a *samurai* beneath a plum tree
ca. 1697
Signature: Hishikawa Moroshige zu
Artist's seal: Moroshige
kakemono-e, 562 × 283

A12, 50.145

PLATE 1.

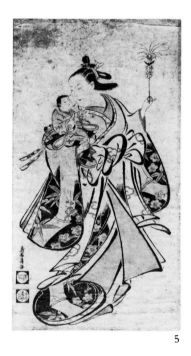

5

Torii KIYOMASU I

*5. Courtesan holding a festival ornament up for a small child
ca. 1700s
Signature: Torii Kiyomasu
Artist's seal: Kiyomasu
Publisher: Nakajimaya, hammoto, sakaicho
kakemono-e, 558 × 302
hand-colored
Reference: AIC I, 51, 8; Link 1977, 18; UTK 1, 112; TNM 65; Higuchi 23.
Provenance: Ficke

A19, 50.152

Impressions of this print in Chicago and Tokyo are uncolored.

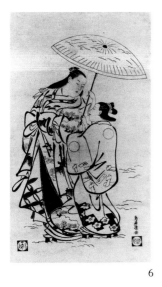

6

*6. Courtesan and attendant with umbrella in the snow
ca. 1710s
Signature: Torii Kiyomasu
Artist's seal: Kiyomasu
Publisher: Nakajimaya, hammoto, sakaichō
kakemono-e, 563 × 321
hand-colored
Provenance: Field
Publication: Field 27, repr.

A15, 50.148

Another impression, considerably toned, with orange and yellow coloring, was in the Yamamoto collection, Tokyo. The coloring on this impression is probably modern.

7

*7. *Gembuku gorō,* The coming of age of Soga no Gorō. The actors Ichikawa Danjūrō II and Nakamura Takesaburō as Soga no Gorō and his lover, the courtesan Kewaizaka no Shōshō in *Bandōichi kotobuki soga* at the Nakamura theater
1/1715
Signature: Torii Kiyomasu
Artist's seal: Kiyomasu
Publisher: Igaya Kanemon (Igaya hammoto, motohamachō)
album sheet, 299 × 440

A14, 50.147

Takesaburō's robe is decorated with the deep hat and bamboo flute of a *komusō,* or itinerant priest, a disguise adopted by Gorō in this play. This print is from an untitled series of pictures by Kiyomasu of theatrical performances in 1715 and 1716 with a characteristic double-bordered title cartouche. Other pictures from the series are reproduced in Link 1977, 23 and 24; UT 3, 220; and AIC I, Kiyomasu I, 11–12.

Kaigetsudō DOHAN

8. Standing courtesan with pattern of water wheels and waves on her robe
ca. 1710s
Signature: Nihon giga Kaigetsu matsuyō Dohan zu
Artist's seal: Dohan
Publisher: Igaya hammoto, motohamachō
kakemono-e, 609 × 296
Reference: TNM 23; Vever 20; Higuchi, pl. 12, 10.
Provenance: Takeuchi, Koechlin
Publication: Ficke 1923.

A49, 50.182

From a group, five of which were found in the stall of a bookseller on the banks of the Seine by the French collector, Raymond Koechlin. The other prints, with the same Japanese collector's seal, passed to Louis Ledoux and are now in the Metropolitan Museum, NY. Those prints, however, all seem to have center folds, and it is possible that this print was not part of the Koechlin album.
PLATE 212.

after Kaigetsudō DOSHIN

9. Standing courtesan
late 19th century
Signature: Nihon giga Kaigetsu matsuyō Doshin zu
Artist's seal: Doshin
Publisher: Nakaya, hammoto, tōriaburachō
kakemono-e, 593 × 321
Reference: TNM 24 (original); UTK 1, 152 (original).

A51, 50.184

This is a facsimile published by Bunshichi Kobayashi in the late 19th century, with his mark of an ivy leaf and plover, numbered 198, at lower left.
PLATE 216.

Kaigetsudō ANCHI

10. Courtesan in a robe decorated with ginko leaves
ca. 1710s
Signature: Nihon giga Kaigetsu matsuyo Anchi zu
Artist's seal: Anchi
Publisher: Maruya
kakemono-e, 560 × 292
hand-colored

Publication: Ficke 1923; Keyes 1976; UT 2, 40; Higuchi, pl. 13, 3; *Ukiyoe shūka* IX, 1.

A50, 50.183

No other impressions are presently known.
PLATE 3.

Okumura MASANOBU

11. Courtesan striking shuttlecock with battledore
1710s
Signature: Tōbu Yamato eshi Okumura Masanobu zu
Artist's seal: Masanobu
Publisher: Nishimura, komagome
kakemono-e, 652 × 322

A69, 50.202

A masterpiece and possibly unique.
Two more pictures of women in the same large format with the same long signature and unusual pulisher's mark are reproduced in V and I, I, 110 and 117, pl. 26.
PLATE 2.

12

*12. Monkey leader approaching a courtesan and companion
1700s
album sheet, 270 × 359

A55, 50.188

The monkey leader wears an emblem which is the same as that of the actor Nakamura Kichibei (1684–1765).
Perhaps from Masanobu's expanded version of Kiyonobu's album, *Keisei Ehon* which was published in 1700.

*13. Actor and courtesan ferrying the Buddhist patriarch Bodhidharma on a boat made from the leaf of a reed
Untitled series of historical parodies
early 1710s
album sheet, 305 × 418
Reference: AIC I, 123, 20.

A6, 50.139

The young man seems to be Arashi Kiyosaburō, an actor who died in the spring of 1713. Masanobu designed another version of this subject in album format which was signed Okumura Masanobu zu and published by Igaya later in the 1710s. In the second version, Daruma is seated upright

plucking his beard with tweezers, and the picture is titled "Two Elegant Reed Leaves" (*Fūryū ashinoha nichō*). An example in the Worcester Art Museum is illustrated in *Nihon bijutsu zenshū* 22, fig. 67.

13

14

*14. The god Hotei chanting from a libretto as an actor accompanies him with a *samisen*
Plate 10 or 11 from an untitled series
1710s
album sheet, 258 × 360
hand-colored

A56, 50.189

The color is probably modern.

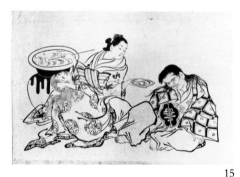

15

*15. The courtesan Takao and two drunken *shōjō*, or wine imps
Untitled series of parodies of classical or traditional themes
ca. late 19th century or early 20th century
album sheet, 277 × 401
Reference: TNM 234 (original).

A58, 50.191

A modern facsimile of a print originally published in the 1710s.
Manuscript number five in lower right corner.

16

*16. Genji and Yūgao; *kamuro* presenting a fan from a courtesan to a client
Plate 4 from an untitled series
1710s
album sheet, 259 × 362

A54, 50.187

A parody of the meeting of Prince Genji and Yūgao in the *Tale of Genji*.

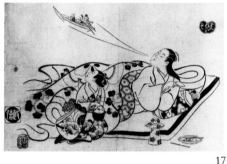

17

*17. *Rinreisō,* courtesan creating an image of her approaching lover in a cloud of winedrops, a parody of the Taoist immortal Lin Ling-su
Untitled series of parodies of classical or traditional themes.
1710s
Artist's seal: Masanobu
Publisher: Igaya Kanemon (hammoto, motohamachō)
album sheet, 300 × 440

A57, 50.190

Lin Ling-su was a Taoist immortal with magical powers in the service of the Sung emperor Hui Tsung from 1116–1120. To display his ability he blew water from his mouth which formed five colored clouds bearing a lion, a golden dragon, and three cranes.

*18. *Tanabata ni yoru imose,* My love, who comes at the Tanabata Festival
From an untitled series
1710s
Signature: Okumura Masanobu zu

Artist's seal: Masanobu
Publisher: Igaya
album sheet, 301 × 438

A53, 50.186

The goddess of Vega, the Weaver Star, approaching a youth composing a poem for the star festival. The star festival took place on the seventh day of the seventh month.

18

19. Portrait of a courtesan as a love letter
1710s
Signature: fūryū yamato eshi Okumura Masanobu kore o zusu (trimmed)
Artist's seal: Masanobu (trimmed)
right portion of an album sheet, 256 × 129
Provenance: Vignier, Metzgar

A36, 50.169

The woman's robe is composed of phrases from the letter and her face is placed where one would expect her name. The letter might be read in this order: . . . *dono e kaesugaesu mo medetaku zonji hito kashiku shime,* Dearest (madam), someone wishes you repeated joy, sincerely yours.

An impression of the entire sheet is in the Art Institute of Chicago with the signature and an enigmatic text speaking of a woman made of letters in the morning; it is reproduced in Link, 31.

Another impression is reproduced in Rouart, 26, and Ficke 1925, 4.

A note by Mary Ainsworth on the mat reads: Paris 1909 Vignier, but this print does not seem to appear in the V and I catalogue.

PLATE 144.

20. Osome, the greengrocer's daughter, standing beside a bird cage holding a libretto of the play *Yaoya oshichi koi no hizakura,* of which she is the heroine
ca. 1722
Signature: Okumura Masanobu hitsu hosoban, 289 × 144
hand-colored, with gloss
Reference: Jenkins 156; UT 2, 59 (unsigned copy); Higuchi, pl. 38, 32 (unsigned copy) and pl. 51, 7; Stern 8 (unsigned copy).

A62, 50.195

The play *Koi no hizakura* was first performed in Osaka in 1719. The first related play performed in Edo seems to have been *Yaoya shinjū* at the Ichimura theater in the spring of 1722. The print was popular and when the block began to show wear, the head was reengraved, as here.

An unsigned contemporary copy, showing the shape of the simpler original head, is in the Portland Art Museum.

PLATE 183.

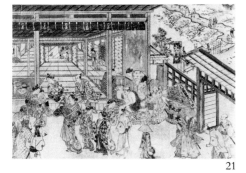

21

*21. View of the Tomoeya house at the entrance to the Yoshiwara
1740s
Signature: trimmed
Publisher: trimmed
large, 289 × 411
hand-colored
Reference: TNM 282; Vever 31; Waterhouse 25; Higuchi, pl. 45, 61.
Provenance: Hayashi

A64, 50.197

Untrimmed impressions have the printed title *Shinyoshiwara ōmonguchi nakanochō ukie kongen,* signature, and address of the publisher Okumuraya.

22. Woman with a hand mirror
1740s
Signature: Hōgetsudō shōmei Okumura Bunkaku Masanobu shōhitsu
Artist's seal: Tanchōsai
kakemono-e, 709 × 252
hand-colored, with gloss
Reference: AIC I, 98; Higuchi, pl. 49, 107.
Publication: *Ukiyoe shūka* IX, 119 (color).

A67, 50.200

The Chicago impression is very fine and early. Both the Ainsworth and the differently colored Hirose impression reproduced in Higuchi show a noticeable crack in the block at the left.

PLATE 158.

23. Shōki, the demon queller
ca. early 1750s
Signature: Hōgetsudō Tanchōsai Okumura Bunkaku Masanobu Baiō ga
Artist's seal: Okumura

pillar print, 569 × 123
hand-colored, with gloss

A66, 50.199

PLATE 114.

24. The Zen or Taoist sages Han Shan and Shih Te (Kanzan and Jittoku)
1740s or 1750s
Signature: Hōgetsudō Okumura Masanobu ga
Artist's seal: Tanchōsai
hosoban, 310 × 147
engraved in reserve

A61, 50.194

The five-character Chinese inscription reads "we are the path of mastery."

The picture is drawn like an academic painting and engraved in imitation of a Chinese stone rubbing. A similar print by Masanobu of Hsü Yu and Ch'ao Fu by the waterfall is reproduced in Michener 50. Another, of a Japanese subject, is reproduced in UT 3, 110.

PLATE 109.

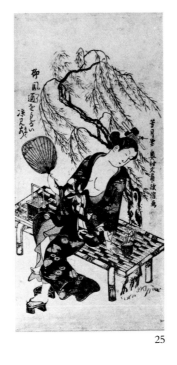

25

*25. Courtesan watching sparklers
1750s
Signature: Hōgetsudō Okumura Bunkaku Masanobu ga
Artist's seal: Tanchōsai
hosoban, 305 × 143
Provenance: Rouart
Publication: Rouart 21.

A65, 50.198

The poem refers to the legend of Kume, an immortal who lost his supernatural powers when he saw a young woman's bare limbs: "A breeze in the willow; a client loses his powers in the summer cool" (*Yanagikaze tsū o ushinai suzumi kyaku*).

A similar design by Kiyohiro is reproduced in V and I, 304, pl. 60; UTK 1, 237; and UT 3, 7.

A similar subject by Masanobu was published around the same time and was probably a panel from the same hosoban triptych since it has a nearly identical pattern of wormage. It is reproduced in Hillier, *Vever* 43.

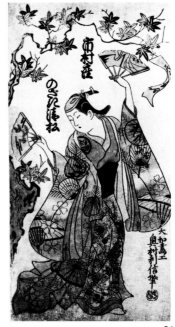

26

Okumura TOSHINOBU

*26. The actor Nozaki Kiyomatsu dancing beneath a maple tree in a performance at the Ichimura theater
1720s
Signature: Yamato gakō Okumura Toshinobu hitsu
Artist's seal: Mitsuoki
hosoban, 307 × 153
hand-colored

A25, 50.158

The area around the actor's half-concealed crest, the emblem of the Ichimura theater, has been reengraved. Kiyomatsu appears in the theatrical records between 1725 and 1735 as an *iroko*, or young male prostitute, employed by the Ichimura Theater.

27. Sparrows worrying an owl perched on a mattock, holding a pipe and tobacco pouch
1720s
Signature: Yamato gakō Okumura Toshinobu hitsu
hosoban, 297 × 156
hand-colored, with gloss
Reference: UTK I, 47.
Provenance: Rouart, Ficke

Publication: V and I 247, pl. 53; *Ukioye taisei* 2, 310; Rouart 29; Higuchi, pl. 55, 50; Ficke 1920, 29.

A26, 50.159
The seal of the Rouart collection was added after the print was illustrated in Vignier and Inada.

Gookin calls the print "A Picture Puzzle" and says, "The picture is a rebus as yet unsolved." Recent Japanese writers express the same thought and the same bewilderment.

PLATE 5 (COLOR).

28. The actor Ichikawa Danjūrō II as Soga no Gorō disguised as a street vendor of knives and chopsticks
1720s
Signature: Yamato gakō Okumura Toshinobu ga
Publisher: Masuya
hosoban, 291 × 154
hand-colored, with metallic dust and gloss

A27, 50.160

The writing around the figure is the actor's soliloquy.

Danjūrō acted the role of Gorō nearly every year in the 1720s. He wears the costume he first wore in *Bandōichi kotobuki soga* in 1/1715. The design on his robe is the crests of other actors.

PLATE 6 (color).

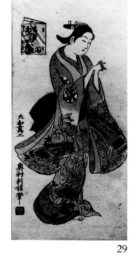

29

*29. The daughter of the oil merchant, Osome
ca. 1720s
Signature: Yamato gakō Toshinobu hitsu
Publisher: Igaya (the publisher of the book used for the cartouche)
hosoban, 320 × 148
hand-colored, with metallic dust and gloss
Reference: TNM 294.
Provenance: unidentified Japanese collection

A29, 50.162

This is the left panel of a triptych with a cartouche in the shape of a libretto. The print is sub-titled *Naniwa shōsashi*. Osome and her young lover Hisamatsu were from Naniwa, or Osaka.

The woman's head has been reengraved. An early state of the print with the same break in the lower hem, but with the original head and the mark of the publisher Izumiya Gonshirō, is in Tokyo National Museum.

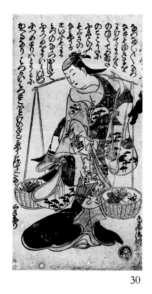

30

Torii KIYOTOMO

*30. An actor of the Arashi clan as a vendor of *nazuna,* a spring herb
ca. early 1720s
Signature: Torii Kiyotomo hitsu
Publisher: Iseya
hosoban, 295 × 152
hand-colored, with metallic dust and gloss

A41, 50.174

The actor may be Arashi Koroku, although Koroku does not seem to have assumed that name until 11/1727.

The inscription is the actor's soliloquy. The title is partially trimmed but the last five syllables are . . . *uri serifu,* "soliloquy of the . . . seller."

Torii KIYOTADA

*31. The actor Sanjō Kantarō as a young princess playing a *koto*
1720s
Signature: Torii Kiyotada hitsu
hosoban, 321 × 152
hand-colored, with gloss and metallic dust
Provenance: Rouart
Publication: Rouart 21, repr.

A21, 50.154

31

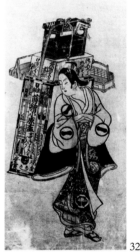

32

UNSIGNED

*32. The actor Ichikawa Monnosuke I as a street seller of cups, letter-boxes and other small lacquer objects
1720s
hosoban, 311 × 150
hand-colored, with gloss

A20, 50.153

A contemporary copy of a signed print, perhaps by Masanobu. The box is inscribed with the names of various objects offered for sale, and phrases like "cash sales," "orders taken." The youth's robe shows the facades of the three Edo kabuki theaters with their emblems and placards giving the names of leading actors.

UNSIGNED

*33. Fisherman and boy startled by angel picking a lotus
From an untitled series
ca. 1710s or 1720s
album sheet, 273 × 379

A52, 50.185

Perhaps a parody of the Nō play *Hagoromo*. The print was probably not designed by Masanobu.

33

UNSIGNED

*34. The actors Ichikawa Danjūrō II as Watanabe no Tsuna and Matsumoto Kōshirō I as Sakata Kintoki balancing a *go* board on his shoulder in a scene from *Kadomatsu shitennō* at the Nakamura theater
1/1726
hosoban, 291 × 153
hand-colored, with gloss and metallic powder
A4, 50.137

This print may have been designed by Okumura Masanobu.

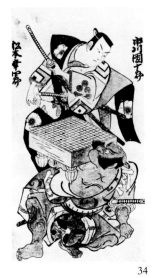

34

UNSIGNED

*35. The gods Ebisu and Daikoku grappling over a *semmai dōgu,* an object worth 1000 pieces of gold
1720s
hosoban, 308 × 159
hand-colored, with gloss
A5, 50.138

The objects above the figures: a key, a hat and straw cloak, and a mallet, are lucky objects associated with the gods.

35

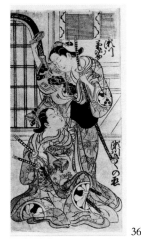

36

attributed to Torii KIYOMASU II

*36. The actors Segawa Kikujirō and Segawa Kikunojō I as Fuwa Banzaemon and Nagoya Sanza in a female version of *Sayate,* The clash of scabbards
mid 1730s
Signature: trimmed
hosoban, 291 × 145
hand-colored, with gloss and traces of metallic powder
A18, 50.151

The actors appeared together at the Ichimura theater and the Nakamura theaters from 11/1734-9/1737 and from 11/1741-9/1742. This scene may have occurred in the play *Higashiyamadono azuma nikki* at the Ichimura theater in autumn 1735.

UNSIGNED

*37. The Taoist immortal Tie Guai, or Tekkai, sending his etheric double out on his breath
ca. mid 18th century
408 × 294
A60, 50.193

From a group of rather large, Kanō-style pictures of figures and birds attributed by Tadamasa Hayashi, without explanation, to the virtually unknown painter, Nakaji Sadatoshi.

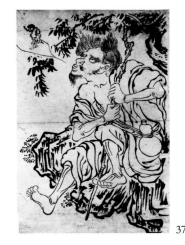

37

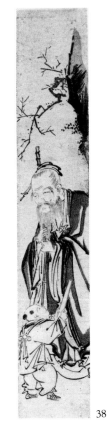

38

UNSIGNED

*38. Child offering scepter to Chinese sage
ca. 1770s
Publishers' seals: Okumura hammoto, Tōrishiochō
pillar print, 698 × 125
A68, 50.201

Drawn in Kanō style.

Nishimura SHIGENAGA

39. *Karasaki yau,* Evening rain at Karasaki
 Series: plate 4 from an untitled series of 8 views of Lake Biwa
 ca. late 1720s
 Signature: eshi Nishimura Shigenaga
 Artist's seal: Shigenaga
 Publisher: Emiya Kichemon (emblem, Emiya hammoto, shiba shimmeimae yokochō)
 hosoban, 312 × 156
 hand-colored, with gloss

 A30, 50.163

One of the earliest sets of views of Lake Biwa, a subject which became very popular in the 19th century. The poem about the pine in the night rain was repeated on most later pictures.
Five other subjects from the set, all lacking the upper outer border of the publisher's cartouche, are reproduced in Higuchi, pl. 57, 16-20.

PLATE 73.

40. The actor Sanogawa Ichimatsu as Hisamatsu holding a letter addressed to his lover Osome in *Higashiyamadono takara no ishizue,* Nakamura theater
 9/1745
 Signature: Senkadō Nishimura Shigenaga hitsu
 Publisher: Urokogataya
 wide pillar print, 698 × 165
 hand-colored, with gloss
 Reference: Link 118; Higuchi, pl. 60, 45.

 A34, 50.167

Another impression is in the Honolulu Academy of Arts.

PLATE 159.

41. Crane on plum branch with rising sun
 1740s
 Signature: Nishimura Shigenaga hitsu
 Publisher: Surugaya (emblem, surugaya)
 hosoban, 316 × 148

 A35, 50.168

The poem by Renkōtei reads: *Dakimori ya higasa no uchi no hanagokoro,* The baby-sitter: a fickle heart beneath the umbrella of the sun.

PLATE 55.

42. Sugawara Michizane, the god of calligraphy, holding a plum branch
 ca. late 1750s
 Signature: Senkadō Nishimura Shigenaga Hyakuju zu
 Artist's seal: Shigenaga
 Publisher: Urokogataya
 pillar print, 705 × 104
 Provenance: Ficke
 Publication: Ficke 1920, 44, $35.

 A32, 50.165

Many artists designed similar pictures of Sugawara Michizane, based on a common source (e.g. Kiyoshige 76).

PLATE 121.

43. Shōki, the demon queller
 1750s
 Signature: Senkadō Nishimura Shigenaga Hyakuju
 Artist's seal: Shigenaga
 Publisher: Urokogataya
 pillar print, 720 × 99
 three-color

 A33, 50.166

PLATE 115.

after Nishimura SHIGENAGA

44. Young man
 late 19th or early 20th century
 Signature: Nihon gakō Nishimura Shigenaga hitsu
 Artist's seal: Shigenaga
 hosoban, 332 × 158
 hand-colored, with gloss
 Reference: Harmsworth, Sotheby, 1913, pl. 6; Danckwerts, pl. 1.
 Provenance: Ficke
 Publication: Ficke 1920, 45, $300 (MA: "g. imp., uncut"); *Scribner's Magazine,* March 1916.

 A31, 50.164

Modern Facsimile

PLATE 214.

45

*45. *Yarō fū,* an effeminate young man
 late 19th or early 20th century
 Signature: Yamato gakō Okumura Toshinobu hitsu
 Publisher: Nakajimaya, sakaichō
 hosoban, 357 × 153
 hand-colored
 Reference: UTK I, 186.

 A28, 50.161

This is a modern copy of the right panel of a triptych by Shigenaga, published by Igaya Kanemon in the 1720's. Another panel of the Shigenaga triptych showing a *wakashū,* or handsome youth walking to the left, is reproduced in Higuchi, 56, 2.

46

Torii KIYONOBU II or III

*46. *Yūsuzumi odoriko fū,* A dancer cooling herself on a summer evening at the Niken teahouse in the Ryōgoku district of Edo
 1730s
 Signature: Torii Kiyonobu hitsu
 Publisher: Murataya Jirōbei (emblem, Murataya hammoto)
 hosoban, 313 × 147
 hand-colored, with gloss and metallic powder

 A11, 50.144

A related print designed by Nishimura Shigenaga around 1834 shows Okiku, the young daughter of the proprietor of a wine shop wearing a transparent robe and seated on a bamboo bench beneath a willow tree. It is reproduced in Waterhouse, 48.

Torii KIYONOBU III

*47. The actors Segawa Kikunojō I and Ichimura Uzaemon VIII as a woman traveller and a lord in a dance interlude perhaps in the play *Tamagushi yosooi soga* at the Ichimura theater, 1/1747.
 Signature: Torii Kiyonobu hitsu
 Publisher: Nakajimaya (hammoto, sakaichō)
 hosoban, 319 × 145
 two-color

 A9, 50.142

Kikunojō and Uzaemon acted together with these names only between 11/1746 and autumn 1747. The blossoming plum trees suggest a spring play; the costumes and poses of the actors, a dance interlude based on a *Nō* play.

47

48. The actors Sanogawa Ichimatsu I and Segawa Kikujirō as Ike no Shōji and Kan no Tsubone in *Mangetsu oguri yakata* at the Ichimura theater, 8/1747
Signature: Torii Kiyonobu hitsu
Publisher: Urokogataya Magohei (hammoto, emblem)
hosoban, 311 × 148
two-color

A8, 50.141

PLATE 9 (color).

49abc. The actors Onoe Kikugorō I, Nakamura Shichisaburō and Segawa Kikunojō I as Murasame, Yukihira and Matsukaze on the beach at Suma
Series: *Sambukutsui,* Triptych
probably 1748
Signature: Torii Kiyonobu hitsu
Publisher: Igaya Kanemon (Igaya)
hosoban triptych, 289 × 416
two-color
Provenance: Kobayashi, Appleton
Publication: Appleton, pl. 5; Ficke 1920, 35, $800. (MA: "xxx uncut, g. impression").

A10, 50.143

Each panel has a poem printed in pink which has faded. The actors appeared together between 11/1747 and autumn 1748. Kikugorō performed with great success in a dance interlude *Koiji no tomodori,* "Friendly birds on the path of love" at the Nakamura theater, 7/1748.

PLATE 149.

Torii KIYOMASU II

50. The warrior Kanemichi confronting the usurper Ōtomo Matori who is riding a goat
1725
Signature: Torii Kiyomasu kore o kaku
Publisher: Sagamiya hammoto
hosoban, 319 × 157
Provenance: Vignier
Publication: V and I, I, 92, pl. 24; UT 2, 316; NBZ 22, 200.

A13, 50.146

This is a calendar print. The two figures are composed of the numerals for the long and short months of the year 1725, a goat year, and have faces which are portraits of the actors Ichikawa Danjūrō II and Matsumoto Kōshirō I who appeared in these roles in the finale to the play *Kadomatsu shitennō* at the Nakamura theater in the spring of 1725.

PLATE 142.

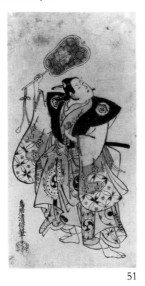

51

*51. A young man, probably an actor, in the role of Soga no Jūrō, holding a *gumbai,* or large fan
ca. mid 1720s
Signature: Torii Kiyomasu hitsu
Publisher: Igaya Kanemon (Igaya hammoto, motohamachō)
hosoban, 305 × 152
hand-colored, with metallic dust and gloss

A16, 50.153

The youth wears the Soga crest, but has no other identifying marks. Another Kiyomasu hand-colored panel print of this period published by Izutsuya (UT 2, 101) shows the actor Arashi Wakano in a similar formal costume decorated with blossom and drums, with an identical hair style, holding a similar fan and standing above Ichikawa Danjūrō II who wears a dark cloak over his armor and carries a travelling hat, the usual costume of Akushichibyōe Kagekiyo.

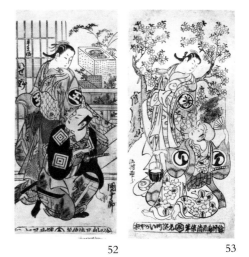

52 53

*52. The actors Sodezaki Iseno as Princess Giō (?) and Ichikawa Danjūrō II as a samurai
ca. late 1720s or early 1730s
Signature: eshi Torii Kiyomasu hitsu
Publisher: Urokogataya Magohei (emblem, Urokogataya hammoto) (partly trimmed)
hosoban, 305 × 141
hand-colored, with gloss and metallic dust
Provenance: Metzgar, Sotheby

A17, 50.150

The actors appeared together at the Nakamura theater from 11/1728-9/1730 and at the Ichimura theater from 11/1732-9/1733.

*53. Sawamura Sōjūrō I and another actor with a wine kettle beneath a cherry tree in an unidentified dance interlude
1730s
Signature: eshi Torii Kiyomasu hitsu
Publisher: Igaya Kanemon (emblem, Igaya han, motohamachō)
hosoban, 322 × 151
hand-colored, with metallic powder and gloss

A63, 50.196

Kondō KIYOHARU

54. Tawara Tōda and the giant millipede at Lake Biwa
1731
Signature: Kondō Sukegorō Kiyoharu hitsu
Publisher: Sagamiya
hosoban, 328 × 154

A42, 50.175

A calendar print. The numerals for the long months are written at the upper left with a syllabic gloss mentioning the millipede. The numerals for the short months are concealed in the figure of the warrior.

PLATE 143.

Nishimura Magosaburō
SHIGENOBU

*55. Koito, daughter of the thread mer-
chant in the second block of the
Honchō district
Series: left panel of a triptych, *Mu-
sumefū sampukutsui,* Three young
women
ca. early 1730s
Signature: eshi Nishimura Shige-
nobu hitsu
Publisher: Urokugataya Magohei
(emblem, urokogataya hammoto)
hosoban, 299 × 150
hand-colored, with metallic powder
and gloss
Provenance: Metzgar
Publication: Metzgar 1916, 263,
$22.50.

A71, 50.204

The woman wears the combined crests of
actors of the Segawa and Arashi clans.
An unsigned version from a different block,
perhaps a contemporary copy, is repro-
duced in Higuchi, pl. 36, 11 and identified
as the actor Segawa Kikujirō.

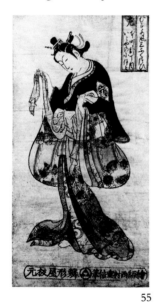

55

*56. The actors Sanjō Kantarō and Ogino
Isaburō as Nagoya Sanza and Fuwa
Banzaemon
ca. late 1730s
Signature: eshi Nishimura Mago-
saburō hitsu
Publisher: Maruya Kohei (emblem,
maruya, ōdemmachō sanchōme)
hosoban, 311 × 152
hand-colored, with metallic dust and
gloss

A70, 50.203

The actors appeared together at the Naka-
mura theater between 11/1733-9/1734 and
11/1737-9/1738. The later date is more
consistent with the style.

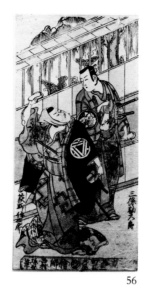

56

57. The death of the Buddha
ca. 1730s
Signature: trimmed
Publisher: trimmed
432 × 280
hand-colored, with lacquer and me-
tallic dust
Reference: Schmidt 75.
Provenance: Lathrop (?), Hirai (?)
(Nagoya)

A7, 50.140

An untrimmed impression of this print with
similar coloring in the Staatliche Museum
für Ostasiatische Kunst in Berlin is signed
gakō Nishimura Magosaburō Shigenobu in
the lower margin and bears the address of
the publisher Murataya, Toriaburachō. An
earlier version of the same subject designed
by Shigenaga around the 1720s is illustrated
in Link, *Primitive Ukiyo-e,* 154 (PL. 171
in this catalogue). An unsigned, larger ver-
sion, which may have been designed as
early as the 1700s or 1710s, is illustrated in
Hillier, *Vever,* pl. 62.

PLATE 196.

Ishikawa TOYONOBU

58. The actor Sanogawa Ichimatsu
holding a lantern and an umbrella
1740s
Signature: Tanjōdō Ishikawa Shūen
Toyonobu zu
Artist's seals: Ishikawa uji, Toyon-
obu
kakemono-e, 735 × 255
hand-colored, with gloss on collar
Reference: AIC I, 205, 15; Higuchi,
pl. 64, 9.

A76, 50.209

A similar print of a young man with a sash
tied in front holding a lantern with the crest
of Ichimatsu and facing left is reproduced
in Vever 65. The two prints may represent
the actor and a homosexual lover and may

have been published together as a diptych.
The Vever print, and an earlier impression
in the Mann collection, both have the mark
of a publisher which reads Izumi.

PLATE 7.

*59. Young woman holding an umbrella
1740s
Signature: Tanjōdō Ishikawa Shūen
Toyonobu zu
Artist's seals: Ishikawa uji, Toyon-
obu
Publisher: Urokogataya (emblem)
pillar print, 699 × 158
hand-colored, with gloss
Reference: AIC I, 16; Higuchi, pl.
65, 10; Amsterdam 24; V and I 212;
UT3, 11; UTK 1, 215.
Provenance: Buckingham, Gookin
Publication: V and I, 1; Gookin 20;
Ficke *Chats,* 113.

A77, 50.210

This may be the Rouart impression, no.
211 in the 1909 Paris exhibition, although
measurements vary slightly (no. 211 listed
as 712 × 155). The Bullier impression, no.
212, reproduced, pl. 53 of the catalogue, is
now in Honolulu. There are two states of
the print, before and after the break at the
bottom of the publisher's mark. An earlier
impression, before the break on the bottom
of the publisher's emblem, is reproduced in
Ficke 1925, 20.

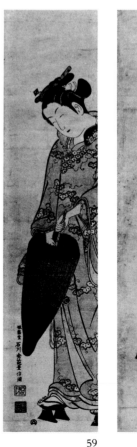

59 60

136

*60. Courtesan facing left with one arm
raised
1740s
Signature: Tanjōdō Ishikawa Shūen
Toyonobu zu
Artist's seals: Ishikawa uji, Toyon-
obu
Publisher: Murataya
pillar print, 615 × 161
hand-colored

A78, 50.211

A similar print by Toyonobu of a courtesan
with a pipe, published by Urokogataya with
no poem above, is reproduced in AIC I,
206, 17 and Higuchi, pl. 65, 11. The poem
reads: *Asanedori dare to makura o kawajima
no.*

61. The actor Bandō Hikosaburō II as
a pony dancer
early 1750s
Signature: Ishikawa Shūen Toyon-
obu zu
Artist's seals: Ishikawa uji, Toyon-
obu
Publisher: Maruya Kohei (hōsendō
maruya maruko han, tōriaburachō)
large ōban, 411 × 285
two-color
Reference: Von Seidlitz 1910, facing
p. 6 (color); Hillier 1966, 13.

A73, 50.206

The print may commemorate young Hi-
kosaburō's first spring performance with
his new name, possibly the spring of 1752.
A similar print of Segawa Kichiji as a child
performing a lion dance in front of a dec-
orative table with peonies and butterflies is
reproduced in Ōta 1980, 5. That print was
published in 1748 when Kichiji was eight
years old. The poem reads, *Harukoma ya
taiko ni hareshi asagasumi,* The spring pony
clears away the morning mist with a drum.
PLATE 10 (color).

*62. The actors Segawa Kikujiro and
Sanogawa Ichimatsu as lovers
mid 1750s
Signature: Tanjōdō Ishikawa Shūen
Toyonobu zu
Artist's seals: Ishikawa uji, Toyon-
obu
Publisher: Urokogataya Magohei
(emblem, hammoto)
large ōban, 428 × 268
two-color
Reference: V and I 219, pl. 51; UT
3, 133; AIC I, 211, 27; Higuchi, pl.
66, 25; Link 1980, 186, 13; Michener
74.
Provenance: Buckingham, Gookin,
Metzgar
Publication: Gookin 28.

A72, 50.205

Ichimatsu and Kikujiro appeared together
at the Nakamura theater through the au-
tumn of 1753 and at the Ichimura theater
from 11/1755 to the autumn of 1756 when

Kikujirō died. Segawa Kichiji changed his
name to Kikunojō II in 11/1756 but did not
act with Ichimatsu in the 1760's.
The dark colors of the print make a date of
1756 likely, although no suitable roles are
listed in the scant published theatrical rec-
ords.

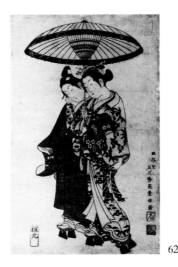

62

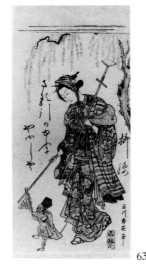

63

*63. Monkey leader and monkey under
a willow tree
ca. late 1750s or early 1760s
Signature: Ishikawa Shūen hitsu
Publisher: Urokogataya Magohei
(emblem, hammoto)
hosoban, 310 × 144
three-color
Provenance: Inada (?) (note on mount
by Ainsworth)

A74, 50.207

Poem: *Saruhiki no yū ni yasashi ya yanagi-
goshi,* The monkey leader is gentle in the
night: a willowy waist. This print is related
to an earlier hand-colored print by Masa-
nobu showing a monkey leader in a different
costume walking to the right, reproduced
in Higuchi, pl. 40, 14.

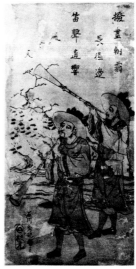

64

*64. Korean trumpeters
1764
Signature: Ishikawa Shūen hitsu
Publisher: Urokogataya Magohei
(emblem, hammoto)
hosoban, 285 × 142
three-color

A75, 50.208

A Korean embassy visited Edo in 1764 and
was the subject of prints by Harunobu and
other artists.
An incomplete Chinese couplet is partly
effaced in the sky.
Another impression in the Haviland collec-
tion seems to have been included in the
Paris exhibition in 1909 (V and I, 233).

*65. Woman on a beach wringing out
her skirt
ca. late 1750s
Signature: Tanjōdō Ishikawa To-
yonobu ga
Artist's seal: Toyonobu
Publisher:
Urokogataya
pillar print, 718 × 97
three-color

A79, 50.212

Another impression, with publisher's mark
and poem above, is reproduced in UT 3,
30; an impression with poem but without
publisher's mark is reproduced in Hayashi
340. Another state of the design (or a
different version) published by Tomita in
the early 1760s, is also reproduced in AIC
I, Toyonobu 53. Harunobu used the figure
in reverse in a pillar print of a diver and
octopus (V and I 2, 20, pl. 3 and UTK 2,
193) and once again, as a kneeling figure,
in a *chūban* illustrating "Abalone" in a shell
series (UTK 2, 160). A later copy by Kor-
yūsai in the early 1770s follows the pose of
the Toyonobu figure, but includes the rock
from the Harunobu print and introduces a
pine tree above.

65 66

*66. Woman tying sash of her undergarment
 ca. late 1750s
 Signature: Ishikawa Toyonobu hitsu
 Artist's seal: Toyonobu
 Publisher: Maruya Kohei (emblem)
 pillar print, 657 × 104
 three-color
 Reference: TNM 80; Van Caneghem 10.

 A80, 50.213

Toyonobu designed many pillar prints of partially naked women. The poem reads *Yuagari wa onna bakari ka ayamezake,* Is it only for woman after a bath: iris wine.
Another pillar print by Kiyomitsu based on this design, but with a different poem and other changes, published by Nishimiya around the early 1760s, is reproduced in Vever 86; AIC I,21; and Higuchi, pl. 99, 29.

Nishikawa SUKENOBU

*67. Young woman adjusting her kerchief with the help of a hand mirror
 ca. 1730s
 Signature: Yamato eshi Nishikawa Sukenobu hitsu
 book page, 257 × 168

 A46, 50.179

The signature on this and the following print may be a later addition.

67

68

*68. Woman reading a letter
 ca. 1730s
 Signature: Yamato eshi Nishikawa Sukenobu hitsu
 book page, 291 × 161
 hand-colored

 A48, 50.181

This print is from the same group as no. 67. The color is modern.

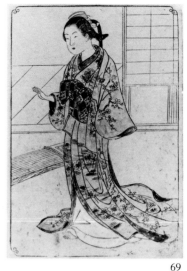

69

*69. Woman standing beside a *koto*
 ca. 1730s
 book page, 231 × 158
 hand-colored

 A47, 50.180

The color is probably modern.

Tomikawa FUSANOBU

70. The Chinese warrior Kuan Yu seated on horseback, holding a halberd
 1750s
 Signature: Tomikawa Fusanobu ga
 Artist's seal: Fusanobu
 Publisher: Nishimura han (Baishukudō, yushima kiridōshi)
 hosoban, 314 × 145
 two-color

 A44, 50.177

The inscription is a 20-character poem in Chinese with a Japanese syllabic gloss.
 PLATE 110.

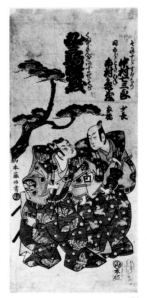

71

Yamamoto FUJINOBU

*71. The actors Nakamura Shichisaburō (Shōchō) and Ichimura Kamezō (Kakitsu) as Soga no Jūrō Sukenari and Soga no Gorō Tokimune in *Kujūsangi ōyose soga,* Ichimura theater
1/1758
Signature: Yamamoto Fujinobu hitsu
Artist's seal: Yamamoto
Publisher: Maruya Kohei (yamamoto han)
hosoban, 314 × 142
two-color
Provenance: Wakai, Hayashi
A45, 50.178
The writing above gives the actors' acting and poetry names, their roles and the title of the play.

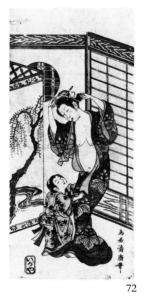

72

Torii KIYOHIRO

*72. Boy pulling open his mother's robe
late 1750s
Signature: Torii Kiyohiro hitsu
Publisher: Igaya Kanemon (Igaya)
hosoban, 309 × 144
two-color
A38, 50.171
Another slightly later impression in the Koechlin collection is reproduced in V and I, 314, pl. 62, and UTK 3, 66.

*73ab. Fisherman, girl fording stream, boy chasing sparrows
late 1750s or early 1760s
Signature: Torii Kiyohiro hitsu
Publisher: Maruya Kohei (yama, maruko fuji, tōriaburachō)
horizontal, 270 × 352
three- or four-color
A37, 50.170
The right two-thirds of a hosoban triptych; extensively damaged, with large areas of loss and restoration.

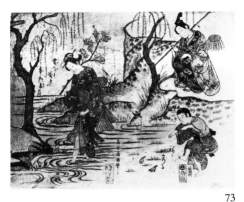

73

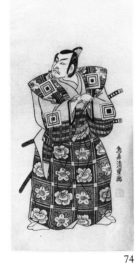

74

Torii KIYOSHIGE

*74. The actor Ichikawa Danjūrō IV as a lord
late 1750s or early 1760s
Signature: Torii Kiyoshige ga
Artist's seal: Kiyoshige
large hosoban, 362 × 177
four- or five-color
A22, 50.155
The picture has a colored background, unusual at this early date, although the color may have been added afterward.
An impression from different blocks, with the actor's name and a poem above, the mark of the publisher Maruya Kohei and with white tips on the ends of the scabbards is reproduced in *Ukiyoe taikei* 1, 48.

75. The actor Ōtani Hiroji (Jitchō) in a male role
late 1750s or early 1760s
Signature: Torii Kiyoshige ga
Artist's seal: Kiyoshige
Publisher: Maruya Kohei (Yamamoto)
large hosoban, 380 × 170
three-color
A23, 50.156
From a series of large hosoban portraits of actors designed by Kiyoshige and other

artists. The purple color is formed from overprinting pink with blue. The poem reads: *Kōryūno kainaki sora ya utsuridako.*
PLATE 12 (color).

76. Sugawara Michizane, the god of calligraphy, holding a plum branch
ca. late 1750s
Signature: Torii Kiyoshige ga
Artist's seal: Kiyoshige
Publisher: Maruya Kohei
pillar print, 682 × 99
three-color
A24, 50.157
For a similar subject see Shigenaga 42.
PLATE 120.

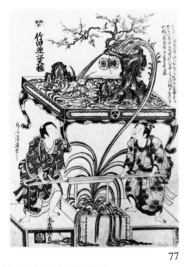

77

Torii KIYOMITSU

*77. A mechanical toy displayed in Edo by Takeda Ōmi
mid or late 1750s
Signature: Torii Kiyomitsu hitsu
Publisher: Sakaiya Kurōbei (Sakaiya hammoto, honkokuchō yonchōme)
large ōban, 409 × 289
two-color
A90, 50.223
The printed inscription explains that as the children pump the water it strikes the table in the background, causing the wheel to turn, the bird to sing, and the drum to sound.
Probably unique.

*78. The actor Nakamura Tomijūrō I as Kashimaya Onatsu dressed as a travelling nun in *Hanafubuki fuji no sugekasa,* Ichimura theater
3/1758
Signature: Torii Kiyomitsu ga
Artist's seal: Kiyomitsu
Publisher: Maruya Kohei, hōsendō, tōriaburachō. Publishers' seals: Fuji, Tsūsen han
pillar print, 644 × 99
three-color
Provenance: Appleton
Publication: Appleton 68, $26 (but not purchased during the sale).
A91, 50.224

The poem by Jōa reads:
Fuji shiroshi hana no yuki furu bikunigasa
The nun's hat: Fuji white with the snow of fallen blossom
A large hosoban of Tomijūrō in the same role, also designed by Kiyomitsu, published by Maruya Kohei, with the last 9 syllables of the poem by Jōa, formerly in the Yamamoto collection, is reproduced in UT 4, 336 and Higuchi, pl. 96, 4.

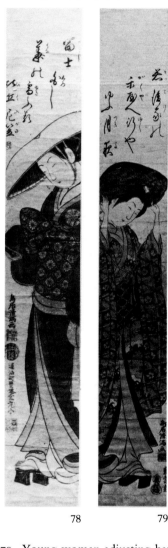

78 79

*79. Young woman adjusting hat
early 1760s
Signature: Torii Kiyomitsu ga
Artist's seal: Kiyomitsu
Publisher: Okumuraya Kakujudō
pillar print, 707 × 101
three-color
Provenance: Ficke
Publication: Ficke 1920, 56, $130. (MA: "used to want it"); Ficke, *Chats*, pl. 10.

A92, 50.225
Poem: *Waka goke no gakuya e yuku ya yū tsukiyo*
Is the young widow on her way to the theater in the moonlight?

*80. The actor Ichimura Uzaemon VIII as the *ashigaru* Teraoka Heiemon, perhaps in a performance of *Kanadehon Chūshingura* at the Ichimura theater in the autumn of 1762
Signature: Torii Kiyomitsu ga
Publisher: Maruya Jimpachi (maruya hammoto, Tōriaburachō)
hosoban, 300 × 137
three-color

A86, 50.219
A related print shows Uzaemon in a similar pose, still wearing a priest's disguise, holding a ladle in his mouth as the dragon on the bell spouts water. The print is illustrated in AIC I, Kiyomitsu 30 where the role is misidentified as Tadanobu.
PLATE 11 (color).

*81. The actor Onoe Matsusuke and Ōtani Hiroji III as Tamazukuri no Komachi and Hada no Daizen Taketora in *Kisoeuta sakae komachi* at the Ichimura theater
11/1762
Signature: Torii Kiyomitsu ga
Publisher: Iwatoya Gempachi (emblem, Iwatoya)
hosoban, 312 × 142
three-color

A87, 50.220
A portrait by Kiyomitsu of Hiroji as Taketora playing the *koto* is illustrated in AIC I, Kiyomitsu 1.

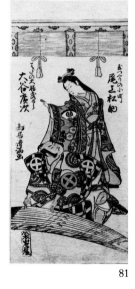

81

*82. The actors Nakamura Matsue and Ichimura Kichigorō as Murasame and an attending *yakko* in *Kisoeuta sakae komachi* at the Ichimura theater
11/1762
Signature: Torii Kiyomitsu ga
Publisher: Unidentified (emblem)
hosoban, 307 × 141
two-color

A88, 50.221

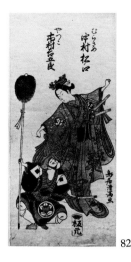

82

83. The poet Kakinomoto no Hitomaro watching sailboats at Akashi Bay
early 1760s
Signature: Torii Kiyomitsu ga
Publisher: Nishimuraya (emblem, eijudō han)
hosoban, 327 × 143
keyblock proof impression
Provenance: Wakai

A81, 50.214
This print was probably designed as a *mizue*. No other impressions seem to be known. The poem on boats rowing in the morning mist at Akashi Bay is included in the anthology *Hyakunin isshu*, 100 Poems.
PLATE 133.

*84. The poet Rokujō Udaijin at Nunobiki Waterfall
mid 1760s
Signature: Torii Kiyomitsu ga
Publisher: Nishimuraya Yohachi (eijudō)
hosoban, 277 × 123
five-color, with blue keyblock outline

A82, 50.215
The use of opaque white pigment is unusual.

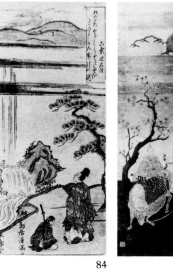

84 85

*85. The poet Sugawara Michizane in
exile
early 1760s
Signature: Torii Kiyomitsu ga
Publisher: Nishimura Yohachi (em-
blem, han)
hosoban, 312 × 133
three-color, with blue outline
Reference: AIC I, 44; Higuchi, pl.
103, 70.
Provenance: Rouart
Publication: Rouart 46.

A83, 50.216

Poem: *Kochifukaba nioi o koseyo ume no hana
aruji nashi tote haru o wasure zo.*

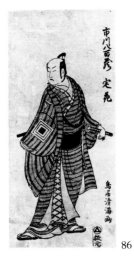

86

*86. The actor Ichikawa Yaozō II (Teika)
in a male role.
early 1760s
Signature: Torii Kiyomitsu ga
Publisher: Urokogataya Magohei
(emblem, hammoto)
hosoban, 313 × 148
two-color

A85, 50.218

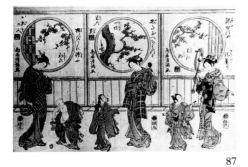

87

*87abc. Mother and children with toys
early 1760s
Signature: Torii Kiyomitsu ga
Publisher: Murataya Jirōbei (em-
blem, hammoto)
undivided hosoban triptych, 280 ×
432
three-color

A89, 50.222

The poems by Jōa read: *Kakedasu ya itazura
zakari haru no koma
Daitako e chotto hitoeda mado no ume
Kaji o toru mori ya sendō ochi no hito.*
No other impressions seem to be known.

*88. The actor Bandō Hikosaburō II as
Midajirō holding an arrangement of
flowers
mid 1760s
Signature: Torii Kiyomitsu ga
Publisher: Urokogataya Magohei
(emblem, Tomita han)
hosoban, 306 × 138
three-color

A84, 50.217

Poem: *Shūgetsu ya kazura onoko ga kono
waka ka.*
This publisher's marks appears on prints by
Harunobu in 1763–1764. Hikosoburō II died
in 5/1768.

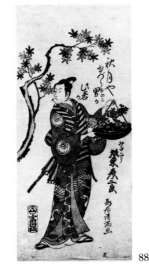

88

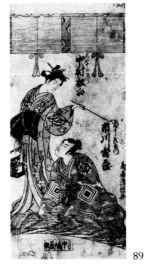

89

Torii KIYOTSUNE

*89. The actors Nakamura Matsue and
Ichikawa Raizō as Ōiso no Tora and

Kudō Saemon in *Hitokidori harutsuge
soga,* Nakamura theater
1/1764
Signature: Torii Kiyotsune ga
Publisher: Nakajimaya han, sakai-
chō
hosoban, 290 × 135
three-color

A39, 50.172

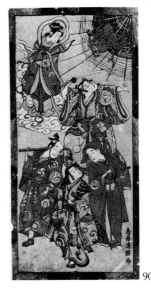

90

*90. The actor Ichimura Uzaemon VIII
and Onoe Tamizō in five roles from
a play
ca. 1770
Signature: Torii Kiyotsune ga
hosoban, 300 × 143

A40, 50.173

The printed border imitates the wood and
metal frame of a votive painting. The orange
blossom insignia is the emblem of the actor
Ichimura Uzaemon and of the Ichimura
theater.
A similar print, by Kiyotsune, showing the
actor Ichikawa Ebizō in five roles within a
printed frame, is reproduced in Higuchi,
pl. 108, 5.

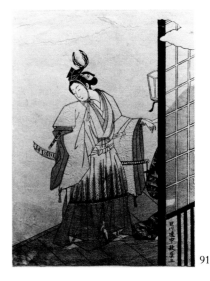

91

KOGAN (?)

*91. Princess Jōruri leading Ushiwaka-maru into her chambers
1765
Signature: Kyōsen renjū Kogan (?) kō
chūban, 255 × 185
with embossing
Reference: Yoshida 152; Keyes 1972, 171.
Provenance: Hayashi, Vignier, Ficke
Publication: Hayashi 411, 112 (ill.); V and I 2, 83; Ficke 1920, 79, $170, ill.

A101, 50.234

A calendar print for 1765; the words Meiwa 2 and the numerals for the long months of that year concealed in the pattern on the youth's sleeves. Although included in books on Harunobu, this picture was probably designed by the amateur artist whose signature appears on the print as the inventor of the design.
In the Ficke catalogue this print is titled "The Happy Prince."

UNSIGNED

92. Couple escaping through a hole in a wall
1765
chūban, 272 × 182
Provenance: Rouart
Publication: Rouart 251.

A104, 50.237

The composition and the faces of the figures suggest that the print was not designed by Harunobu. An earlier impression with calendar marks for 1765 and the seal of the conceiver or designer Gihō is in the Morse collection, Wadsworth Atheneum, Hartford.
A horizontal calendar print of this subject taken from the *Tales of Ise,* is reproduced in AIC II, 171.

PLATE 15 (color).

Suzuki HARUNOBU

*93. The actors Ichikawa Danjūrō IV and Sawamura Sōjūrō II as the priest Mongaku Shōnin and Taira no Kiyomori in *Naginoha izu no sugatami* at the Nakamura theater
11/1762
Signature: Suzuki Harunobu hitsu
Publisher: Iwatoya Gempachi (emblem, Iwatoya)
hosoban, 294 × 132
three-color
Reference: Not in Yoshida or Keyes 1972.
Provenance: Matsumoto

A93, 50.226

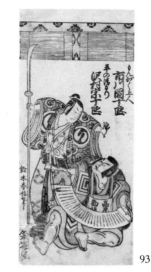

93

94. Sugawara Michizane seated in state with two court attendants
early 1760s
Signature: Suzuki Harunobu ga
Artist's seal: Harunobu
Publisher: Sakaiya Kurōbei han, honkokuchō yonchōme
large ōban, 410 × 275
three-color
Reference: Keyes 1972, 117.

A94, 50.227

Probably from the Samuel collection, Sotheby 24.I. 1911, lot 51. The poem, probably by Michizane reads:
Ware tanomu hito o munashiku nami naraba ame ga shita nite na o ya nagasan.

PLATE 118.

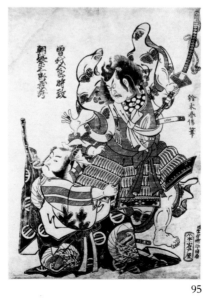

95

*95. Asaina Saburō Yoshihide pulling the armor of Soga no Gorō Tokimune
ca. 1763
Signature: Suzuki Harunobu hitsu

Publisher: Iwatoya Gempachi (emblem, Iwatoya, asakusa kayachō ni-chōme kado)
large ōban, 406 × 288
two-color
Reference: Not in Yoshida or Keyes 1972.
Publication: Keyes 1976; *Ukiyoe shūka* IX, 120 (color).

A95, 50.228

96

*96. Taira Tadamori and the oil thief
ca. mid 1760s
Signature: Harunobu ga
Publisher: Unidentified (emblem)
hosoban, 304 × 140
four-color, with blue outline
Reference: Yoshida 46; Keyes 1972, 26.

A96, 50.229

There seems to be a poem on the print reproduced by Yoshida, and there may be other differences.

97. The poet Kakinomoto no Hitomaro at Akashi Bay.
ca. mid 1760s
Signature: Harunobu ga
Publisher: Iwatoya Gempachi (emblem)
hosoban, 308 × 136
three-color
Reference: Not in Yoshida or Keyes 1972.

A97, 50.230

Four other related *mizue* of classical poets are reproduced in AIC II, Harunobu 7–10.

PLATE 134.

98. *Ishiyama shūgetsu,* Autumn moon at Ishiyama
Series: *Ōmi hakkei no uchi,* Eight views of Lake Biwa
ca. mid 1760s
Signature: Harunobu ga
hosoban, 309 × 140
three-color
Reference: Yoshida 36; Keyes 1972, 68.

A98, 50.231

Neither the impression in Yoshida nor in the MFA Boston have publisher's marks. Five other prints in the series have the mark of Iwatoya.

PLATE 74.

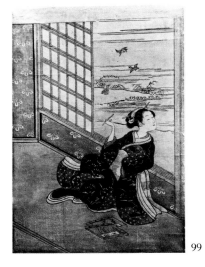

99

*99. Girl seated by an open window; illustration of a poem on evening by the priest Saigyō
1765
Unsigned
chūban, 279 × 196
Reference: Yoshida 228; Keyes 1972, 150; TNM 543; UTK 2, 97; Hillier 1970, 43.

A102, 50.235

The left panel of a triptych matching young women with three poems on the subject of evening, this print illustrates the poem by Saigyō mentioning snipe rising from a marsh on an autumn evening.

This is the second state of the print, with calendar marks on the girl's sash removed. The first, illustrated in Amsterdam 31, has calendar marks for 1765 and the signatures of the inventor, Sogiku, and the designer, Harunobu. The seals of Kyōsen on the impression in the British Museum seem to be added by hand and do not constitute a separate state.

Another impression of this state in the Springfield Museum is reproduced in Hillier, *Harunobu*, 43. The complete triptych is reproduced in UTK 2, 95–97.

The print is much restored and the blue on the walls and water are modern additions, as may be the pink on the girl's sash.

*100. Bowl of chrysanthemums
1766
Unsigned
chūban, 267 × 192
Reference: Yoshida 136; Keyes 1972, 235; V and I 2, 216; Seidlitz 60 (color).
Provenance: Vicomte de Sartiges
Publication: Rouart 250, ill.

A106, 50.239

The second state of three. The first, reproduced in Ledoux 1945, 30, is signed and has calendar marks for 1766. In the second, these are removed. In the third, the shape of the moon is more nearly round, and two bands of cloud are added in the sky.

The print has faded and has been extensively restored since it was reproduced in the Rouart catalogue.

100

101

*101. Woman washing cloth at the Chōfu Tama River in Musashi Province
Series: untitled series of six Tama Rivers
ca. 1766
Unsigned
chūban, 280 × 208
with embossing
Reference: Yoshida 120; Keyes 1972, 436; TNM 423; UTK 2, 36 (color).

A107, 50.240

Other prints of the series are signed. An unfaded impression is reproduced in *Ukiyoe taikei* 2, 36. The complete set is reproduced in NBZ, figs. 75–80. Harunobu designed at least four sets of pictures of the Tama

Rivers; all the pictures for the Chōfu Tama River have the same poem by Fujiwara Teika.

102

*102. Young couple seated by a heater for silk wadding.
late 1760s
Signature: Harunobu ga
chūban, 282 × 218
with embossing
Reference: Stern 51.

A99, 50.232

103

*103. Mother watching two boys pretending to be a lord on horseback and an attendant
late 1760s
Signature: Harunobu ga
chūban, 270 × 196
with embossing
Reference: Yoshida 396; Keyes 1972, 888.

A103, 50.236

104

*104. Courtesan standing on a veranda
late 1760s
Signature: Harunobu ga
chūban, 280 × 213
with embossing
Reference: Yoshida 295; Keyes 1972,
802; Fuller 57, ill.; UTK 2, 16; UTS
5, 14; UZ 2, 4 (color); Vever 121
(color).

A108, 50.241

105. Courtesan and attendant at the riverside teahouse Iseya watching floating fireworks
late 1760s
Signature: Suzuki Harunobu ga
chūban, 282 × 212
Reference: Yoshida 593; Keyes 1972,
762; Ficke 1925, 50, ill.
Provenance: trace of unidentified seal on verso
Publication: *Ukiyoe shūka* IX, 123
(color).

A109, 50.242

An unfaded impression was in the Gidwitz collection, Chicago. Another is in the Art Institute of Chicago II, 184.
(Metzgar cited another impression, more trimmed, Rouart 256.)
PLATE 206.

106

*106. Tea server watching a cuckoo fly above a temple
late 1760s
Signature: Suzuki Harunobu ga
chūban, 284 × 208
Reference: Not in Yoshida or Keyes
1972.

A110, 50.243

107

*107. Two women dressed as court workmen, heating wine on a fire of maple leaves
late 1760s
Signature: Harunobu ga
untrimmed chūban, 284 × 212
with embossing
Reference: Yoshida 314; Keyes 1972,
876; V and I 2, 130, pl. 12; Sato
1916, 247.
Publication: *Ukiyoe shūka* IX, 121
(color).

A111, 50.244

Another impression is in the Museum of Fine Arts, Boston.

108. Woman throwing a snowball at a girl reading a love letter in a *kotatsu*
late 1760s
chūban, 217 × 269
with embossing

A112, 50.245

In another state of the print, a man is making love to the girl inside the room.
PLATE 16 (color).

*109. Client at a teahouse standing by a cistern and looking down at a torn letter
late 1760s
Signature: Harunobu ga
pillar print, 690 × 114
with grey ground and areas printed without outline
Reference: Not in Yoshida or Keyes
1972.
Provenance: Blanchard
Publication: Blanchard 1916, 28, $35
(MA: "beautiful color").

A115, 50.248

The letter is from a courtesan saying that a patron is going to ransom her.

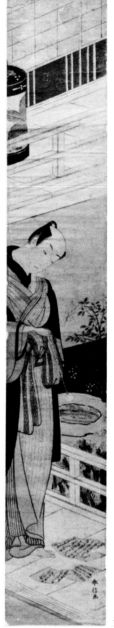

109

110. The salt gatherers Matsukaze and Murasame on the beach at Suma
ca. 1770
Signature: Harunobu ga
chūban, 274 × 184
Reference: Keyes 1972, 566.
Provenance: Rouart
Publication: Rouart 504.

A105, 50.238

Another impression is in the Museum of Fine Arts, Boston; a late 19th century reproduction is in the Bibliothèque Nationale, Paris; the print was copied by Kiyonaga. (See no. 206.) The poem mentions the beach at Suma.
PLATE 204.

Ippitsusai BUNCHŌ and Suzuki HARUNOBU

*111. Performer and courtesan parodying the armor-pulling scene from the story of the Soga brothers.
ca. 1770
Signature: Suzuki Harunobu giga; Ippitsusai Bunchō ga
chūban, 281 × 210
embossed outlines
Reference: Yoshida 291; Keyes 1972, 847.
Provenance: Rouart
Publication: Rouart 270, ill.; Keyes 1976, fig. 5; *Ukiyoe shūka* IX, 88 (color).
A184, 50.317
Only one other impression, now in the Waseda Theatrical Museum, seems to be known.

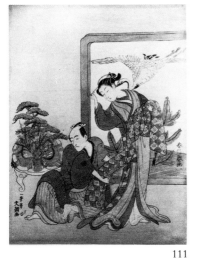

111

Suzuki HARUNOBU (?)

112. Copper pheasant on rock
ca. 1770
Signature: Suzuki Harunobu ga
pillar print, 699 × 106
with black ground
Provenance: Lathrop, Ficke.
Publication: Ficke 1920, 90, $160 (MA: "uncut").
A114, 50.247
The signature may be a later addition.
A note in the mat says that differently colored impressions are known signed Koryūsai. The style of the engraving and coloring is more like the 1770s.
PLATE 57.

School of Suzuki HARUNOBU

*113. The god Hotei watching a girl adjust a hairpin
late 1760s
Unsigned
chūban, 270 × 200
with embossing
A100, 50.233
Possibly by Komai Yoshinobu.

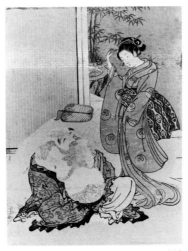

113

ARTIST UNKNOWN

114. Young man offering to help clear a woman's shoe of snow
ca. 1770
Signature: Harunobu ga
chūban, 230 × 310
with embossing
A113, 50.246
This print is from an erotic album. An unsigned pendant (PLATE 218) in the same format, shows the same couple making love beside the fence.
The theme of "crow and heron," a couple dressed in black and white standing beneath an umbrella in the snow, is common in prints of the late 1760's—early 1770's.
The signature is a modern addition; the print was probably designed by Koryūsai or Bunchō.
PLATE 217.

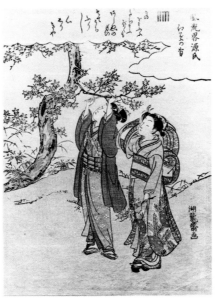

115

Isoda KORYŪSAI

*115. *Momiji no iwai,* The maple viewing party
Series: *Fūryū yatsushi genji,* The Tale of Genji in elegant modern dress
ca. early 1770s
Signature: Koryūsai ga
small chūban, 218 × 159
grey ground
Reference: TNM 667.
A162, 50.295
Each picture bears the title of a chapter from the *Tale of Genji,* the geometric emblem of the chapter, and a poem.
An earlier impression, before the break on the tip of the lower cloud and with a dark hillside, is reproduced in TNM.
Two other pictures from the series are illustrated in TNM 666, 668.

116

*116. *Gi,* Righteousness
Series: *Fūryū gojō kodomo asobi,* Five elegant acts of deference performed by children
ca. early 1770s
Signature: Koryūsai ga
chūban, 261 × 192
grey ground
A163, 50.296
Gojō, "five acts of deference," is homonymous with another word meaning "five virtues" of which righteousness is one. The picture may allude to the story of Konoshita Tōkichi, the youthful name of Hideyoshi, presenting sandals to Oda Nobunaga, or to the encounter between Benkei, Yoshitsune, and Togashi at Ataka Barrier.

*117. Young woman as a *manzai* dancer on a stage with a backdrop of a rising sun
early 1770s
Signature: Koryūsai ga
Artist's seal: Masakatsu
pillar print, 700 × 120
opaque white ground
Reference: V and I 2, 291, pl. 37; Ficke 1925, 84, ill.
A164, 50.297

145

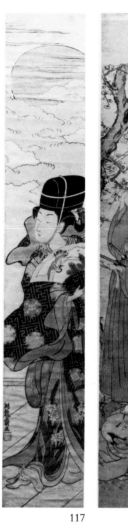
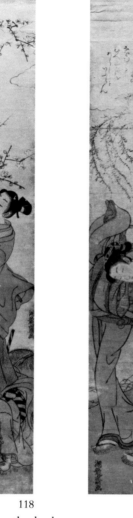
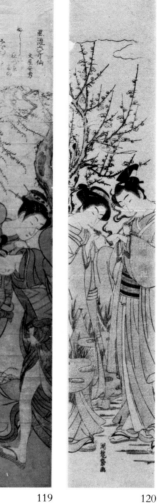
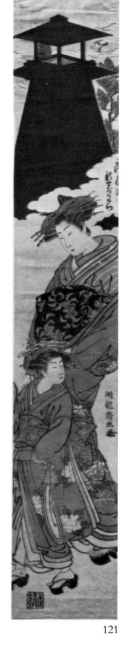

117 118 119 120

121

*118. Young man standing on the back
of a servant to tie a poem to the
branch of a plum tree
early 1770s
Signature: Koryūsai ga
pillar print, 681 × 122
grey ground
 A168, 50.301
The servants' hairy buttocks seem deliber-
ately rendered as part of the landscape. The
youth's crest is a small crab.

*119. Two women in a summer breeze.
Illustration of a poem by Bunya no
Yasuhide
Series: *Fūryū rokkasen,* The six ele-
gant immortal poets
ca. mid 1770s
Signature: Koryūsai ga
pillar print, 749 × 131
grey ground
Provenance: Vignier, Ficke
Publication: V and I 2, 360, pl. 32;
Ficke 1920, 129, $60 ill. (MA: "un-
cut, first color, streaked across de-
sign, finer than reproduction").
 A167, 50.300
Ficke 1920 lists the print as "Autumn winds
in the willow."

*120. Couple smoking by a plum tree
ca. late 1770s
Signature: Koryūsai ga
pillar print, 690 × 121
 A165, 50.298
Reminiscent of *chūban* by Harunobu of a
couple visiting the Garyū plum tree (UTK
2, 169). An *ōban* by Koryūsai of a similar
couple beneath a cherry tree is reproduced
in TNM 674.

*121. The courtesan Shinsugawara of the
Tsuruya house strolling past a bell
tower with a young attendant
ca. late 1770s
Signature: Koryūsai ga
Artist's seal: *kakihan*
Publisher: Eijudō
pillar print, 675 × 115
Provenance: Ficke
Publication: Ficke 1920, 119, $120
(reproduced) (MA: "uncut fine con.,
stunning design").
 A166, 50.299
A similar painting signed Koryūsai is in the
Harari collection.

after SU T'UNG-PO

122. Copper pheasant on plum branch
ca. 1770s or 1780s
Signature: Tōha Koji hitsu
Artist's seal: Tōha Koji
pillar print, 804 × 163
ishizuri-e, hand-colored, with black
ground
 A566, 50.699
The Chinese poem is sealed Hirosawa (or
Kōtaku). Prints imitating stone rubbings
are often attributed to Koryūsai because of
their frequent bird-and-flower subjects, and
often bear interpolated signatures of uki-
yo-e artists. They were designed, however,
by artists of other schools.
 PLATE 58.

146

UNSIGNED

123. Hawk attacking weasel by stream
ca. 1770s
kakemono-e, 712 × 298
ishizuri-e, hand-colored, with blue ground
A566A, 50.699A
PLATE 59.

Kitao SHIGEMASA

*124. The actor Bandō Hikosaburō II as the clerk Hisamatsu standing outside the oil merchant's shop to see his lover
ca. mid 1760s
Signature: Kitao Shigemasa ga
Publisher: Enami, mikawachō 1-chōme
hosoban, 291 × 136
three-color
A154, 50.287
Hikosaburō II died in 5/1768. The role is not listed in the published theatrical records for the decade before his death.

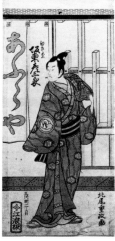

124

125. The actor Ichiyama Shichizō as Giō no Mae holding a flute
ca. late 1760s
Signature: Kitao Shigemasa ga
Publisher: Iseya (emblem)
hosoban, 301 × 135
three-color
A155, 50.288
Shichizō arrived in Edo in 11/1768 and performed at the Ichimura theater.
The blue color of the woman's costume appears to be printed over yellow.
PLATE 18 (color).

*126. Two young women by a fuller's block, representing the Tōi Tama River in Settsu province
Series: Plate 3 from Ukiyo mutama-gawa, A floating world version of the six Tama Rivers
late 1760s
Signature: Kitao Shigemasa

Publisher: Moriya Jihei (?) (Mori)
hosoban, 314 × 141
Reference: UTK 3, 262; Sato, 271.
Provenance: Field
A156, 50.289
An early series inspired by, and in the same format as, a set by Harunobu of seven episodes in the life of the poet Komachi. The poem by Sagami reads: *matsukaze no oto dani aki wa sabishiki ni koromo utsunari tamagawa no sato,* Autumn is sad with the sound of wind in the pine trees and the pounding of cloth in the villages by the Tama River.

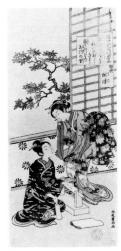

126

*127. *Kyōdai no aki no tsuki,* Autumn moon on the mirror stand
Untitled series of eight views
ca. late 1760s
Signature: Kitao Shigemasa ga
192 × 185
Provenance: Fenollosa, Gookin, Metzgar
A157, 50.290
The picture is trimmed at the left along a printed dividing line. Two subjects may have been printed on one sheet.
The poem is a repetitious verse about the rising of the autumn moon through clouds: *aki no yo no kumona no tsuki to miru made ni utena ni noboru aki no yo no tsuki.*

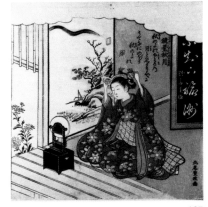

127

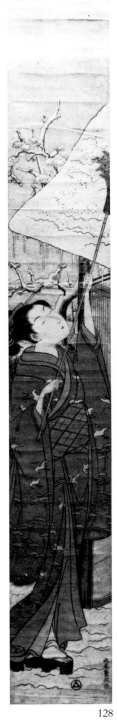

128

*128. Woman sweeping snow from a rooftop
ca. late 1760s
Signature: Kitao Shigemasa ga
Publisher: Urokogataya
pillar print, 715 × 104
four- or five-color
Provenance: Ficke
Publication: Ficke 1920, 193, $100 (reproduced) (MA: "xx uncut, first color") now faded.
A161, 50.294

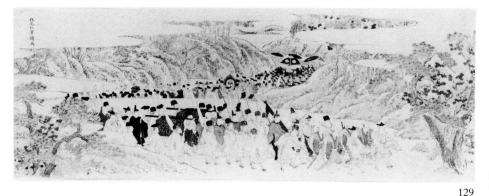

129

*129. Shrine festival procession in an autumn landscape
ca. 1800s
Signature: Kitao Kōsuisai ga
long surimono, 210 × 572
Provenance: Appleton, Blow

A329, 50.462

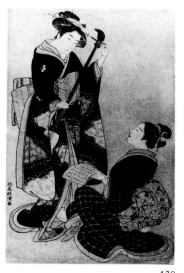

130

attributed to Kitao SHIGEMASA

*130. Two geisha with libretto and *samisen*
late 1770s
Signature: Kitao Masanobu ga
ōban, 378 × 253
grey ground
Reference: Hillier 1966, 21; Vever 217; V and I 3, 192, pl. 48.

A308, 50.441

Hillier argues plausibly in the Vever catalogue that the print is from a series of unsigned portraits of geisha designed by Kitao Shigemasa in the late 1770's. The Vever, the Javal impression reproduced in the V and I catalogue, and the British Museum impression reproduced by Hillier are all unsigned. The signature on the Ainsworth impression does not match the signatures on other Masanobu prints, and the hairstyle of the figure at the left is earlier than appears in genuine prints by Masanobu.

*131. *Takigawa no kihan*, Returning sails: the courtesan Takigawa of the ōgiya, 1-chōme, Edochō
Series: *Seirō bijin yosena hakkei*, Eight views with the names of beauties of the green houses
ca. late 1770s
Unsigned
aiban, 322 × 229

A158, 50.291

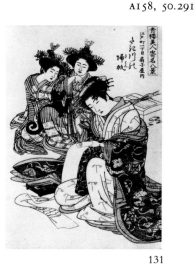

131

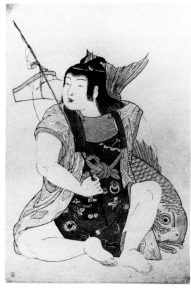

132

*132. Boy with sea bream, fishing pole and cap, attributes of the god Ebisu
Series: untitled series of children as the seven lucky gods
ca. late 1770s or early 1780s
Unsigned
ōban, 384 × 255
with embossed outlines and grey ground
Provenance: Hayashi

A159, 50.292

The set is traditionally attributed to Shigemasa, probably because the children are similar to figures in smaller signed prints, and because many of the artist's ōban pictures of women are unsigned.

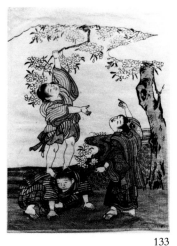

133

UNSIGNED

*133. Children breaking branches from a cherry tree
ca. early 1770s
small chūban, 226 × 164

A153, 50.286

Perhaps by Toyomasa or Shigemasa. Probably from an untitled series printed two to an *aiban* sheet.

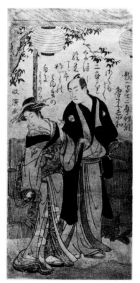

134

Kitao MASANOBU

*134. The poet Tōrai Sanwa with a geisha
1780s
Signature: Masanobu ga
hosoban, 311 × 143
A306, 50.439
Poem by the subject of the picture on the
theme of Fuji and the hawk, two of the
lucky dreams.

*135. *Shioiri no sekishō,* Evening glow of
the tide
Series: *Sumidagawa hakkei,* Eight
views of the Sumida River
late 1770s
Signature: Kitao Masanobu ga
chūban, 257 × 188
A307, 50.440
Another subject from the series, Evening
bell at Susaki, is reproduced in TNM 1383.

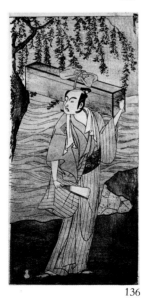

135

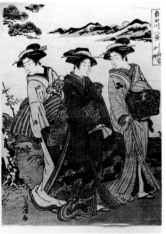

136

Katsukawa SHUNSHŌ

*136. The actor Ichikawa Yaozō II as a
young man carrying a *samisen* case
on his shoulder, perhaps as Makabe

no Hachirō in the scene beside the
willow on the riverbank in *Nenriki
yuzuriha kagami,* Nakamura theater,
autumn 1769
Signature: Shunshō ga
Artist's seal: Hayashi jar seal
Publisher: Okumuraya
hosoban, 316 × 150
with embossed outlines
Provenance: Metzgar, Ficke (?)
Publication: Ficke, cover illustra-
tion; Metzgar 1916, 41, $65 (pl. I).
A142, 50.275

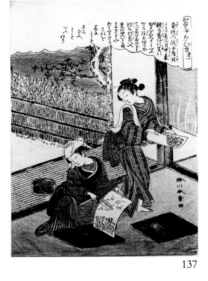

137

*137. Collecting the larvae of silkworms
Series: Pl. 1 from *Kaiko yashinaigusa,*
Raising silkworms
early 1770s
Signature: Katsukawa Shunshō ga
small chūban, 261 × 188
with embossed outlines
Reference: UTK 3, 147.
Publication: *Ukiyoe shūka* IX, 131
(color).
A143, 50.276
The set of 12 prints was designed jointly
by Shunshō and Shigemasa and was later
republished with different colors.
The text explains how and when the larvae
are to be gathered.

A group of prints from an untitled series
of approximately fifty illustrations from *Ise
Monogatari,* Tales of Ise
early 1770s
Signature: Shunshō ga and Katsukawa
Shunshō ga
chūban, each ca. 227 × 157
many with grey ground, some with em-
bossing
The pictures were printed two to an *aiban*
sheet.
Each print is numbered with a letter of
the Japanese syllabary and bears a poem
from the medieval romance.

138. 2 *Ro.* Attendant presenting letter to
court lady
A129, 50.262

139. 3 *Ha.* Courtier passing sleeping
guards
A118, 50.251

140. 4 *Ni.* Couple eloping at Akuta River
A135, 50.268

141. 5 *Ho.* Narihira viewing iris at Yat-
suhashi
A123, 50.256

142. 8 *Chi.* Couple hiding from pursuers
on Musashi Moor
A122, 50.255

143. 12 *Wo.* Woman seated beside a stream
A121, 50.254

144. 14 *Ka.* Woman standing by a stream
A117, 50.250

145. 17 *Re.* Lady entertaining courtier
A126, 50.259

146. 18 *So.* Lady standing by entrance
to shrine
A133, 50.266

*147. 21 *Na.* Courtiers beside waterfall
A128, 50.261

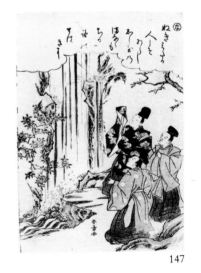

147

148. 23 *Mu.* Woman gathering maple
leaves
A119, 50.252

149. 24 *U.* Courtier presenting pheasant
to a lord
A136, 50.269

150. 25 *Wi.* Courtiers at Sumiyoshi Bay
A132, 50.265

151. 27 *O.* Courtier offering a gift to a
lord
A130, 50.263

152. 29 *Ya.* Lady offering "forgetful grass"
to a courtier
A134, 50.267

153. 31 *Ke.* Three peasant women out-
side palace
A125, 50.258

154. 34 *E.* Court lady viewing waves
A116, 50.249

155. 40 *Me.* Courtiers in snowy landscape

A120, 50.253

156. 41 *Mi.* Couple by writing desk

A131, 50.264

157. 42 *Shi.* Nobleman by carriage

A127, 50.260

158. 43 *Ye.* Narihira viewing maple leaves at the Tatsuta River

A124, 50.257

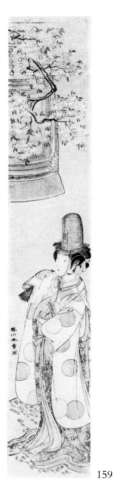

159

*159. The actor Segawa Kikunojō III as the *shirabyōshi* dancer in *Hanagatami kazeori eboshi,* a dance play on the *Dōjōji* theme performed at the Ichimura theater as a memorial to Segawa Kikunojō II who had died the previous year
3/1774
Signature: Katsukawa Shunshō ga
pillar print, 697 × 122
grey ground
Provenance: Ficke
Publication: Ficke 1920, 167, $210 (reproduced) (MA: "xxx uncut, first color") (cat: "superb impression in flawless condition") now somewhat faded.

A149, 50.282

*160. The actor Ichikawa Yaozō II as Sakuramaru in *Sugawara denju tenarai kagami,* Ichimura theater
7/1776
Signature: Shunshō ga
hosoban, 316 × 145
grey ground

A137, 50.270

Annotated *sammai,* "triptych," on verso.

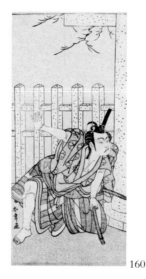

160

*161. The actor Nakajima Kanzaemon as an aged *samurai*
mid 1770s
Signature: Shunshō ga
hosoban, 310 × 151
grey ground
Provenance: unidentified Japanese collection

A138, 50.271

*162. The actor Yamashita Kinsaku II as a courtesan
mid 1770s
Signature: Shunshō ga
hosoban, 314 × 149
with embossed outlines
Provenance: Barbouteau

A139, 50.272

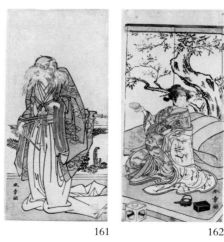

161 162

163. Young woman with sleeve raised
mid 1770s
Signature: Katsukawa Shunshō ga
wide pillar print, 696 × 166
grey ground
Provenance: Matsuki
Publication: Matsuki 387, ill.

A150, 50.283

An outstanding design. Two other designs by Shunshō in this large format are reproduced in UT 3, 43–44.
PLATE 8.

*164. The actors Ichikawa Danjūrō V and Yamashita Kinsaku holding a jar and a wine cup
ca. late 1770s
Signature: Shunshō ga
aiban, 319 × 225

A146, 50.279

Kinsaku, an Osaka actor, appeared in Edo between 1770 and 1780.

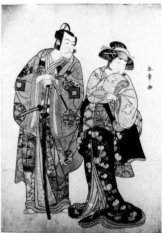

164

165. The actor Iwai Hanshirō IV as a young princess
ca. late 1770s
Signature: Shunshō ga
hosoban, 326 × 148
grey ground

A141, 50.274

PLATE 165.

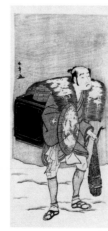

166

*166. The actor Ōtani Tomoemon I as a
street vendor standing in the snow
ca. 1780
Signature: Shunshō ga
hosoban, 322 × 149
grey ground
Provenance: Itō

A140, 50.273

Tomoemon died in 1781.

*167. The actors Nakamura Nakazō I and
Nakamura Rikō holding a sword
and mirror
ca. early 1780s
Signature: Shunshō ga
aiban, 320 × 220

A144, 50.277

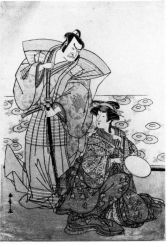

167

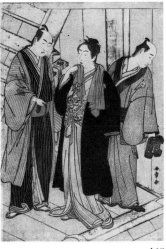

168

*168. The actors Ichikawa Monnosuke II,
Segawa Kikunojō III and Iwai Han-
shirō IV backstage
ca. 1784
Signature: Shunshō ga
ōban, 365 × 249
grey ground
Provenance: Gonse(?) (Metzgar re-
fers to no. 15 in the Gonse catalogue)

A145, 50.278

The first representations of actors out of
stage roles were published in Shunshō's
book *Natsu no fuji* in 1780 or 1781. Eight
subjects in this outstanding ōban series are
known, and judging from the actors de-
picted, the set was published around the
spring of 1784.

169

*169abc. Wrestlers of the east and west camps
watching Tanikaze and Izumikawa
take their places in the ring
ca. early or mid 1780s
Signature: Shunshō ga
Publisher: Kawazu
ōban triptych, 351 × 475

A147, 50.280

The printed names of the wrestlers were
removed and replaced when the picture was
trimmed.

*170. The wrestlers of the Eastern camp,
Nijigatake Somaemon of *sekiwake*
rank, from Awa province, and Fu-
denoumi Kinemon of *maegashira* rank
of Okura
Untitled series of portraits of wres-
tlers
ca. 1785
Signature: Shunshō ga
Publisher: Matsumura Yahei (Matsu)
ōban, 388 × 256
blue ground
Reference: UTK 3, 41 (color); Le-
doux 1945, 34; Stern 69.

A148, 50.281

There is a penciled date of 22/2/95 on the
verso.

170

after Katsukawa SHUNSHŌ

171. Raikō and his retainers disguise
themselves as priests and set off for
Ōe Mountain
Untitled series of four pictures after
paintings by Shunshō
ca. 1810s
Signature: Ko Katsukawa Shunshō
Artist's seal: Hayashi jar seal
surimono, 187 × 279
metallic pigments
Provenance: Appleton

A151, 50.284

The picture is framed like a votive painting
and has a centerfold as though it were
published in a poetry album. The picture
blocks were later reduced at the top, right,
and bottom and the print was reissued in
square surimono format with printed bor-
ders imitating the mounting of a hanging
scroll. (See no. 172)
The poems on this impression are by Tets-
noya Ōmon, Enritsuen Chirui and Kyō-
kadō Magao.

PLATE 185.

172. Raikō and his retainers disguise
themselves as priests and set off for
Ōe Mountain
Series: *Ko Shunshō hitsu ōeyama yon-
pukutsuzuki*, Four paintings of the
journey to Mt. Ōe by the late Shun-
shō
ca. 1810s
square surimono, 204 × 206

A152, 50.285

The set was designed for the Yomo Group
whose fan-shaped emblem appears on the
red edging around the painting. The set
was originally issued in horizontal format
with the pictures framed like votive paint-
ings, Shunshō's signature and jar seal at the
right and poems in the left margin. It was
later reissued in this square format. The
title slip is pasted on this impression and
may have been on a wrapper. The poem
by Tetsunoya Ōmon is not the same verse
he wrote for the first state of the print.
The paintings on which the prints are based
are not presently known.

PLATE 186.

Ippitsusai BUNCHŌ

*173. The actors Nakamura Utaemon I
and Arashi Hinaji as the priest Sei-
gen and the princess Sakurahime
3/1769
Signature: Ippitsusai Bunchō
Artist's seal: Mori uji
Publisher: Eijudō
hosoban, 398 × 142
blue ground
Reference: TNM 815; Amsterdam
102.

A183, 50.317

The name of the play is not given in the
theatrical records.

173

*174. The actor Ichikawa Datezō (Shi-
kaku) as Kajiwara Genta
Series: *Ehon butai ōgi,* "A picture
book of fans from the stage"
1770
Artist's seal: Mori uji
Publisher: Kariganeya Ihei
Engraver: Endō Matsugorō
book page, 283 × 185
blue ground
Reference: Binyon and Sexton 1.

A178, 50.311

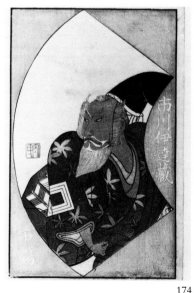

174

*175. The actor Iwai Hanshirō IV dancing
beside rice stooks and chrysanthe-
mums
Perhaps 9/1770
Signature: Ippitsusai Bunchō ga
Artist's seal: Mori uji
hosoban, 325 × 148
blue ground

A179, 50.312

The setting of the print and the actor's
costume and pose all suggest the role of the
fox Kuzunoha who took the form of a
woman to marry the man who saved her
from a hunter. This role was performed by
the actor Yamashita Kinsaku in *Ashiya dō-
man ōuchi kagami* at the Morita Theater in
9/1770. Hanshirō also appeared in this play,
and may have performed with Kinsaku in
a similar role.

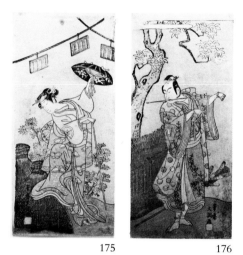

175 176

*176. The actor Ichikawa Yaozō II as
Sakon, a fox disguised as a teawhisk
seller in *Nue no mori ichiyō no mato,*
Nakamura theater
11/1770
Signature: Ippitsusai Bunchō ga
Artist's seal: Mori uji
hosoban, 313 × 142
blue ground

A180, 50.313

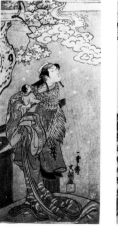 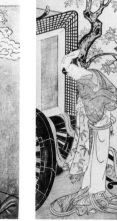

177 178

*177. The actor Nakamura Matsue as Sak-
uragi, the angel, in *Kuni no hana ono
no itsumoji,* Nakamura theater
11/1771
Signature: Ippitsusai Bunchō ga
Artist's seal: Mori uji
hosoban, 292 × 135
grey ground

A182, 50.315

Another impression with manuscript no-
tation identifying the actor, role, date and
play is in the Ashmolean Museum, Oxford.

*178. The actor Nakamura Tomijūrō I as
a teahouse waitress standing beside
a court carriage
ca. 1771
Signature: Ippitsusai Bunchō ga
Artist's seal: Mori uji
Publisher: Nishimura Eijudō
hosoban, 308 × 142
blue ground

A181, 50.314

Tomijūrō arrived in Edo in 11/1770 and
acted at the Nakamura theater. This print
may show him in the role of Giō.

Katsukawa SHUNKŌ

179. The actor Nakamura Tomijūrō I as
a pony dancer in *Kunikaeshi shichiyō
kagami,* a farewell performance with
seven quick changes, Ichimura thea-
ter
9/1778
Signature: Shunkō ga
hosoban, 314 × 151
grey ground

A174, 50.307

PLATE 17 (color).

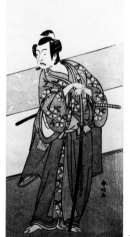

180

*180. The actor Ichikawa Yaozō II, per-
haps as Soga no Jūrō
ca. late 1770s
Signature: Shunkō ga
hosoban, 311 × 142

A173, 50.306

*181. The actor Iwai Hanshirō IV in a
female role
ca. late 1770s
Signature: Shunkō ga
hosoban, 303 × 154
grey ground
Provenance: unidentified collector's
seal

A175, 50.308

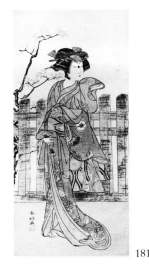

181

182abc. The actors Sawamura Sōjūrō III, Nakayama Kojūrō, and Ichikawa Yaozō II in *Saruwaka banzei butai,* Nakamura theater
1/1786
Signature: Shunkō ga
hosoban triptych, 325 × 435
A176, 50.309

Sōjūrō and Yaozō have identifying emblems which show that Sōjūrō's role is Sanaeno-suke. Nakamura Nakazō I acted with the name and crest of Kojūrō only between 11/1785 and 11/1786.
The purpose of the device in the background is unclear.
PLATE 150.

Katsukawa SHUNJŌ

*183. An actor, possibly Segawa Kichiji III, probably in the role of the merchant's daughter Shinanoya Ohan
ca. early 1780s
Signature: Shunjō ga
hosoban, 325 × 147
A177, 50.310

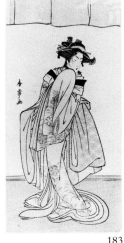

183

Ohan eloped with a middle-aged sash merchant at the age of twelve.
The actor is standing in front of a sash store.

UNSIGNED

*184. The actor Segawa Kikunojō II or III as Umegae
ca. 1770s
Unsigned
hosoban, 295 × 131
two or three-color
A43, 50.176

An inexpensive commercial print on thin paper.
Segawa Kikunojō II performed the role of Umegae in the play *Muken no kane* at the Ichimura theater in 1/1764, but the woman's hairstyle is later. Kikunojō II acted until early 1772; Kikunojō III assumed the name in late 1774.
There is no apparent justification for the old attribution to Kiyohisa.

184

185

Torii KIYONAGA

*185. Young woman helping youth dress in formal costume
early 1770s
Signature: Kiyonaga ga
chūban, 256 × 191
with embossed outlines
Reference: Hirano 50.
Publication: Hirano pl. 12.
A213, 50.346

No other impressions are presently known.

186. The actor Ichimura Uzaemon IX as a young woman with a branch of cherry blossoms
ca. 1774
Signature: Kiyonaga ga
Publisher: Eki
hosoban, 310 × 136
three-color
Reference: Hirano 30.
Publication: Hirano pl. 2.
A198, 50.331

The actor's role is trimmed at the right.
No other impressions are presently known.
PLATE 164.

*187. The actor Ōtani Hiroji III as Higuchi no Jirō in *Hiragana seisuiki,* Morita theater
3/1776
Signature: Kiyonaga ga
Publisher: Urokogataya
hosoban, 286 × 132
three-color
Reference: Hirano 60.
Publication: Hirano pl. 4.
A201, 50.334

No other impressions are presently known.

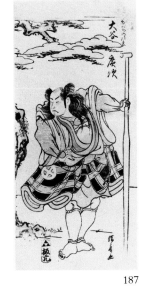

187

*188. The archer Sanada Yoichi preparing to hit the Taira fan at the battle of Dannoura
ca. 1776
Signature: Kiyonaga ga

Publisher: Ezakiya
hosoban, 265 × 128
three-color
Reference: Hirano 68.
Provenance: Appleton
Publication: Appleton 69, $5;
Hirano pl. 10.

A196, 50.229

Another impression from a different block without the name above, and with the shop name of the publisher Ezakiya is reproduced in V and I, 3, 1, pl. 1. Hirano finds the signature on that print awkward and unconvincing.

188

190

*190. The actor Ichikawa Monnosuke II as Soga no Gorō Tokimune in *Kaidō iro yawaragi soga,* Nakamura theater
1/1778
Signature: Kiyonaga ga
hosoban, 296 × 133
four-color
Reference: Hirano 86; Schraubstadter 292.

A199, 50.332

Hirano reproduces the impression in the Schraubstadter collection.

189

*189. Evening snow at Kinryūzan Temple; Autumn moon at Atago Hill
Series: *Edo hakkei,* Eight views of Edo
ca. 1776
Signature: Kiyonaga ga
hosoban, 137 × 316
with black ground
Reference: Hirano 277; UTK 4, 74.
Publication: Hirano pl. 132.

A193, 50.326

The inscription gives the series and picture titles and 31-syllable poems on the two places.
From a set of eight views on four horizontal sheets, five more of which are reproduced in UTK 4, 2, 73, and 77.

191. The salt gatherers Matsukaze and Murasame
1778 or earlier
Signature: Kiyonaga
chūban, 263 × 192
Reference: Hirano 126.
Provenance: unidentified Japanese collection

A214, 50.347

A copy of a print designed by Harunobu. See no. 103. Kiyonaga's print was copied by his son Kiyomasa around 1790 (UTK 4, 215). Hirano records two other impressions in Boston and Berlin.

PLATE 205.

192. The actor Ichikawa Monnosuke as Hanakawado Sukeroku in *Sukeroku kuruwa no yozakura,* Nakamura theater
3/1779
Signature: Kiyonaga ga
Publisher: unidentified (Dai)
hosoban, 308 × 140
Reference: Hirano 156.
Provenance: Lathrop, Ficke
Publication: Ficke 1920, 202, $120 (ill.) (MA: "xxx uncut fair imp. g. con. holes lovely color"); Hirano pl. 6.

A203, 50.336

PLATE 162.

193

*193. *Hatsuharu seiran,* Haze on a clear day at the beginning of spring
Series: *Shiki hakkei,* Eight views for the four seasons
1779
Signature: Kiyonaga ga
Publisher: Eijudō
chūban, 262 × 190
Reference: Hirano 182.
Publication: Hirano pl. 16; *Ukiyoe shūka* IX, 140 (color).

A211, 50.344

The *kamuro* are drawing lots for prizes from the young street vendor. The costumes of the courtesan and vendor are white in the Worcester impression.

194. *Boshun banshō,* Evening bell at the end of spring
Series: *Shiki hakkei,* Eight views for the four seasons
1779
Signature: Kiyonaga ga
Publisher: Eijudō
chūban, 255 × 188
grey ground
Reference: Hirano 183.
Publication: Hirano pl. 16; *Ukiyoe shūka* IX, 141 (color).

A212, 50.345

No other impressions are presently known.
PLATE 20 (color).

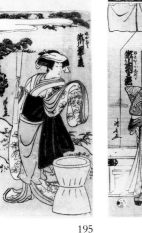
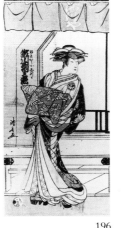

195 196

*195. The actor Segawa Kikunojō III as
Kajibei's daughter Onami in *Saki-masuya ume no kachidoki,* Ichimura
theater
11/1780
Signature: Kiyonaga ga
hosoban, 312 × 135
five-color
Reference: Hirano 112.
Publication: Hirano pl. 5.
 A197, 50.330
No other impressions are presently known.

*196. The actor Segawa Kikunojō III as
Nuregami Oshizuka dressed as a
courtesan of the Matsuya house in
Umegoyomi akebono soga, Ichimura
theater
1/1780
Signature: Kiyonaga ga
Publisher: Iseji Jisuke (Iseji)
hosoban, 285 × 134
four-color
Reference: Hirano 222.
Publication: Hirano pl. 6.
 A200, 50.333
No other impressions are presently known.

197. Dancers and accompanists on a pa-
rade float
Series: *Sannō osairei,* The Sannō Fes-
tival
1780
Signature: Kiyonaga ga
Publisher: Nishimura Yohachi (Eiju
han)
chūban, 260 × 194
Reference: Hirano 238.
Publication: Hirano pl. 19.
 A205, 50.338
The inscription gives the names of two
dances: Stone Bridge and Flower Hats; and
the name of three districts in Edo that may
have sponsored the float: Shinōsakachō,
Tōriaburachō and Tadokorochō. No other
impressions are presently known.
 PLATE 19 (color).

*198. Woman running in breeze beneath
wisteria
1780
Signature: Kiyonaga ga
pillar print, 623 × 110 on 2 sheets
of paper
Reference: Hirano 270.
 A238, 50.371
An earlier impression with different color-
ing in Boston is reproduced in Hirano. Also
see Hayashi 727.

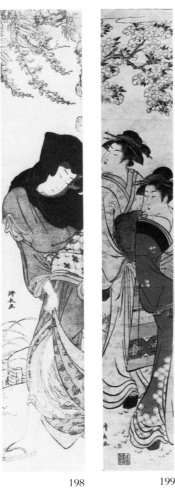

198 199

*199. Two women viewing cherry blos-
soms
1781
Signature: Kiyonaga ga
Publisher: Eijudō
pillar print, 701 × 124
Reference: Hirano 318.
 A240, 50.373
Another impression with the same coloring
is in the Library of Congress.
On the impression in Worcester the woman
at the right wears a blue robe, the woman
at the left a violet robe with a red sash.
These colors are probably later.
This print may have been published as a
diptych together with a similar print of two
women standing beneath a cherry tree,
Hirano 274.

200. Woman smoothing her eyebrow
1781
Signature: Kiyonaga ga
pillar print, 804 × 121
Reference: Hirano 322.
Provenance: Ficke
Publication: Hirano pl. 88; Ficke,
Chats, pl. 30; Ficke 1920, 223, $160
(MA: "x uncut first color") now
faded (Ficke catalogue: "superb
impression and flawless condi-
tion").
 A239, 50.372
No other impressions are presently known.
 PLATE 160.

*201. Woman fixing her hair
Series: *Irokurabe empusugata,* A com-
parison of lovely women
1781
Signature: Kiyonaga ga
chūban, 285 × 184
Reference: Hirano 370.
Provenance: Ficke
 A207, 50.340
The painting on the door panel in the upper
right is signed Hanabusa Itchō.
Hirano reads the third and fourth characters
of the title as *onna,* women, and reproduces
another impression formerly in the Havi-
land collection.
Eight subjects in the set are presently known.

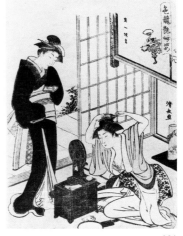

201

*202. Couple standing under umbrella
1782
Signature: Kiyonaga ga
Publisher: Eijudō
pillar print, 641 × 118
Reference: Hirano 1024.
 A237, 50.370
The woman wears a butterfly crest which
was used by Segawa Kikunojō III, an actor
of female roles.
Hirano identifies the couple as the lovers
Ochiyo and Hambei, reproduces another
impression formerly in the Vignier collec-
tion, and mentions another state of the print
with a flying cuckoo in the Tikotin collec-
tion.

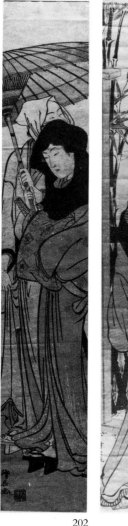

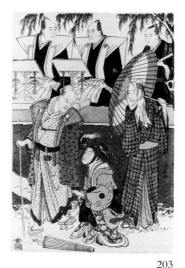

203

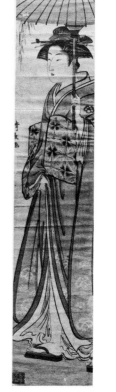

206

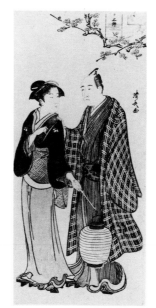

205

202 204

*203. The actors Morita Kanya VIII, Nak-
amura Katsugorō and Osegawa
Tsuneyo as Chūbei, Magoemon and
Umegawa in *Keisei koi no hikyoku*,
Morita theater
5/1783
Signature: Kiyonaga ga
Publisher: Eijudō
ōban, 385 × 262
Reference: Hirano 475.
 A222, 50.355
The picture may have been published later
in the year since Chūbei wears the crest of
Morita Kanya VIII, but was acting with the
name Bando Matakurō in 5/1783 and did
not change his name to Kanya until the 8th
month.
From a series of over 40 ōban pictures of
scenes from plays with chanters and accom-
panists seated on a raised platform in the
background.
Hirano identifies the chanters as Tomimoto
Buzendayū and Tomimoto Itsukidayū and
the accompanist as Namizaki Tokuji and
cites another impression in the Ledoux col-
lection.

*204. Woman standing by a doorway
1783
Signature: Kiyonaga ga
pillar print, 685 × 113
Reference: Hirano 519.
Publication: Hirano pl. 95.
 A235, 50.368
No other impressions are presently known.

*205. The actor Sawamura Sōjurō III and
a teahouse waitress with a lantern
From an untitled series of at least
12 portraits of actors off stage
1783
Signature: Kiyonaga ga
hosoban, 325 × 144
grey ground
Reference: Hirano 593; Fuller 76,
ill.
 A202, 50.335
The lantern above bears the poetry name
of Ichikawa Danjurō V, Sanshō. Hirano
cites three other impressions.

*206. Woman with umbrella beneath a
willow tree
1783
Signature: Kiyonaga ga
Publisher: Eijudō
pillar print, 700 × 118
Reference: Hirano 688; Wright 19,
ill. (another impression of this state).
 A236, 50.369
Hirano reproduces an earlier impression
with a different color block for the leaves
of the willow tree.
Kiyonaga designed another version of the
print with different clothing patterns, a
horizon line, and a sweeter face (Hirano
689).

*207. Young mother walking with chil-
dren and attendants
Series: *Fūzoku azuma no nishiki*,
Modern brocades of the east
1784
Signature: trimmed
ōban, 383 × 248
Reference: Hirano 580.
 A220, 50.353
An impression with the signature at the
right is reproduced in UTK 4, 13.

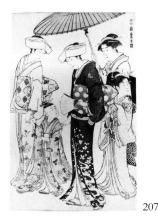

207

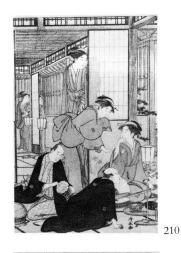

210

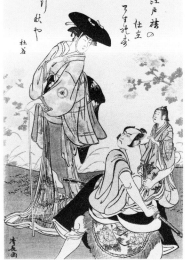

212

*208. Women beneath a cherry tree
Series: *Fūzoku azuma no nishiki*,
Modern brocades of the east
1784
Signature: Kiyonaga ga
ōban, 384 × 155
Reference: Hirano 582A.

A219, 50.352

Right panel of a diptych. An early impression of the complete diptych in the Riese collection, with overprinting on the robe of the woman with the pipe, is reproduced in UTK 4, 16.

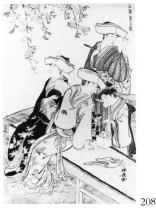

208

209. Mother, child and attendant with parasol
Series: *Fūzoku azuma no nishiki*,
Modern brocades of the east
1785
Signature: Kiyonaga ga
ōban, 390 × 263
Reference: Hirano 586.

A223, 50.356

Hirano reproduces another unfaded impression formerly in a French collection.
PLATE 22 (color).

*210. Entertainment at a teahouse
1784
Signature: Kiyonaga ga
ōban, 383 × 155
Reference: Hirano 630.

A225, 50.358

Left panel of a diptych from the series *Minami jūnikō*. Complete in Boston.

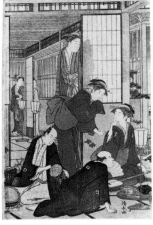

211

*211. Entertainment in a teahouse
early 20th century
Signature: Kiyonaga ga
ōban, 385 × 259

A226, 50.359

Modern facsimile of no. 210 above.

*212. The actors Ichikawa Yaozō II and Iwai Hanshirō IV as the *yakko* Yokampei and Kuzunoha in *Ashiya dōman ōuchi kagami,* Nakamura theater 9/1784
Signature: Kiyonaga ga
ōban, 356 × 242
areas printed without outline
Reference: Hirano 633.

A218, 50.351

The play was performed before Hanshirō's departure for the Osaka area; the poem signed Tojaku is by the actor and says that in the departing autumn he will not forget Edo, *Edozuma no shitate wasurezu yuku aki ya.*

Hirano identifies Yaozō's role as the servant Bekunai and cites impressions in Tokyo and Boston.

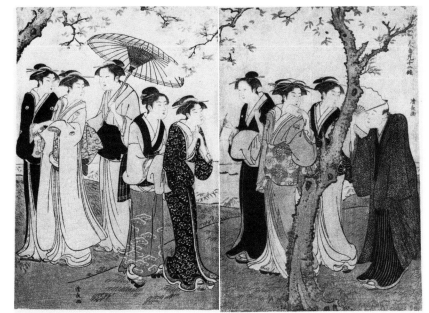

213

*213ab. Viewing cherry blossoms at Goten-
yama
Series: *Minami jūnikō,* Twelve
months to the south of Edo
1784
Signature: Kiyonaga ga
ōban diptych, 368 × 695
Reference: Hirano 625.
 A242a-b, 50.375
Also complete in Boston and Chicago.

*215. Geisha and attendants preparing an
entertainment
1784
Signature: Kiyonaga ga
ōban, 377 × 250
grey ground
Reference: Hirano 347.
Provenance: Hayashi
 A227, 50.360
The left panel of a diptych from the series
Tōsei yūri bijin awase. Complete in Boston.

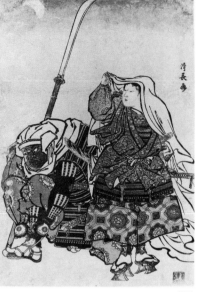

216

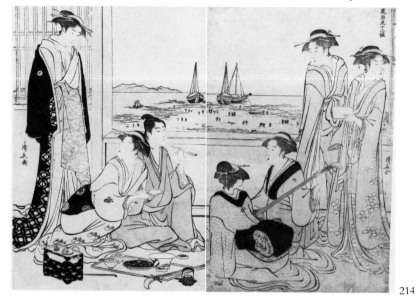

214

*214ab. Courtesans and geisha entertaining
a client in a house overlooking Ta-
kanawa Bay
Series: *Minami jūnikō,* Twelve
months to the south of Edo
1784
Signature: Kiyonaga ga
ōban diptych, 371 × 240 (right),
370 × 254 (left)
Reference: Hirano 626.
 A241, 50.374
Metzgar cites impressions in von Seidlitz,
and in the Rouart and Van Caneghem
catalogues, but none is probably the same
as this.
Hirano reproduces early impressions in the
Spaulding collection with the series title
printed on both panels.

*216. Ushiwakamaru and Benkei
1784
Signature: Kiyonaga ga
Publisher: Eijudō
ōban, 379 × 259
Reference: Hirano 639.
 A217, 50.250
Hirano cites impressions in Boston and
Tokyo.

217. *Hanamizuki,* The flower-viewing
month
Series: *Fūryū shiki no tsukimairi,* El-
egant monthly visits to sacred places
in the four seasons
1784
Signature: Kiyonaga ga
chūban, 256 × 187
Reference: Hirano 647.
Provenance: Appleton, Metzgar,
Ficke
Publication: Ficke 1920, 203, $90
(MA: "xx uncut g. imp. g. con.")
(cat: superb impression and condi-
tion) now quite faded.
 A216, 50.349
Hirano reproduces another impression in
Boston.
 PLATE 21 (color).

215

218-219

*218–*219.
Youth, attendant, and waitress at an outdoor tea shop at Hagidera
Series: *Fūzoku azuma no nishiki,* Modern brocades of the east
1785
Signature: Kiyonaga ga
ōban diptych, 365 × 248 (left), 381 × 252 (right)
Reference: Hirano 590; NBZ, fig. 84.
Provenance: Hayashi (left panel); Charles Morse (?) (right panel)
A230-31, 50.363-64
Also complete in Boston.

*220. Fuji in the summer from beneath New Ōhashi Bridge
Series: *Shiki no Fuji,* Fuji in the four seasons
1785
Signature: Kiyonaga ga
chūban, 264 × 199
Reference: Hirano 715.
A204, 50.337
Hirano reproduces ten prints from the series and cites two other impressions of this subject.

220

221

*221. A merchant's daughter from Suru-gachō being carried to a shrine
Series: *Shiki no Fuji,* Mt. Fuji in the four seasons
1785
Signature: Kiyonaga ga
chūban, 247 × 186
Reference: Hirano 720.
A206, 50.339
Hirano reproduces another impression in the Museum of Fine Arts, Boston.

222

*222. *Ishidō yakata no dangiri,* Datehei protecting Chizukahime from attackers outside Ishidō's mansion
From a series of illustrations for the play *Gotaiheiki shiraishibanashi*
1785
Signature: Kiyonaga ga
chūban, 256 × 195
Reference: Hirano 800.
A209, 50.342
Hirano reproduces a trimmed impression in Worcester.

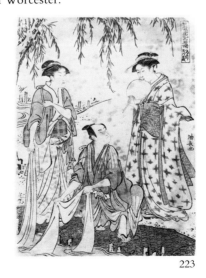

223

*223. *Michiyuki tamagawa no dan,* Couple washing cloth in the Tama River
Series: Act 8, from a series of at

least nine illustrations for the play *Gotaiheiki shiraishibanashi*
1785
Signature: Kiyonaga ga
chūban, 244 × 190
Reference: Hirano 802.
A208, 50.341
Hirano cites two other impressions in Boston.

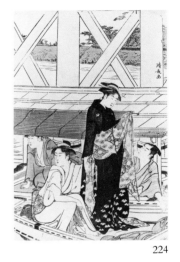

224

*224. Boating party beneath Azuma Bridge
1786
Signature: Kiyonaga ga
ōban, 371 × 249
embossing
Reference: Hirano 796.
Provenance: unidentified Japanese collection
A228, 50.361
Center panel of a triptych. The complete triptych in the Tokyo National Museum is reproduced full-size in UTK 4, 23-25.

*225. The actors Sawamura Sōjūrō III and Arashi Murajirō as Kusunoki Masatsura and the fox Chieda disguised as Koto no naishi, in the *jōruri* interlude *Furisode yuki yoshino shūi,* Nakamura theater
11/1786
Signature: Kiyonaga ga
Publisher: Eijudō
ōban, 382 × 259
grey ground
Reference: Hirano 807.
A221, 50.354
The print is restored at the upper right and lacks the first part of the poem by Eiju saying that the actor Murajirō cannot keep his eyes off Sōjūrō.
The names of three chanters of the Tomimoto clan, Toyokidayū, Itsukidayū, and Kagadayū and two samisen accompanists Namizaki Tokuji and Sasaki Ichishirō are printed above.
Hirano reproduces another impression in Boston, identifies the inscription on the tree as a motto used on banners by Masatsura's father, and transcribes the poem.

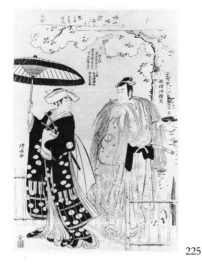

225

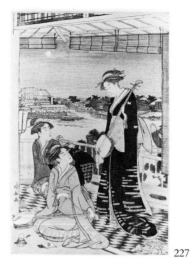

227

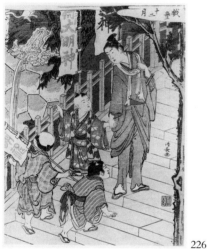

226

*232. Two women viewing cherry blossoms near the statue of Hotei at Nippori
Series: *Edo shichifukujin mairi,* Visiting the seven lucky Gods in Edo
1792
Signature: Kiyonaga ga
chūban, 247 × 188
Reference: Hirano 938A.

A210, 50.343

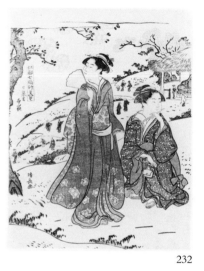

232

*228.–*230.

Flower viewing at Asukayama
1787
Signature: Kiyonaga ga
ōban triptych, 378 × 247 (right),
381 × 247 (center), 392 × 265 (left)
Reference: Hirano 850.

A232-34, 50.365-67

An unfaded impression of the complete triptych in a private collection is reproduced in UTK 4, 45-47.

*226. Boys on steps of the Inari Shrine at Ōji
Series: Second month from *Gidō jūnigatsu,* The 12 months with children's amusements
1787
Signature: Kiyonaga ga
Publisher: Eijudō
chūban, 254 × 193
Reference: Hirano 817.

A215, 50.348

Hirano reproduces another impression in Boston.

*227. Geisha with *samisen* in a teahouse overlooking the Sumida River
1787
Signature: Kiyonaga ga
ōban, 390 × 253
grey ground
Reference: Hirano 846.

A229, 50.362

Right panel of a triptych. A later impression of the complete triptych, in the Art Institute of Chicago, lacking the grey sky in the two right panels and the slight oxidation on the woodwork, is reproduced in UTK 4, 35-37.

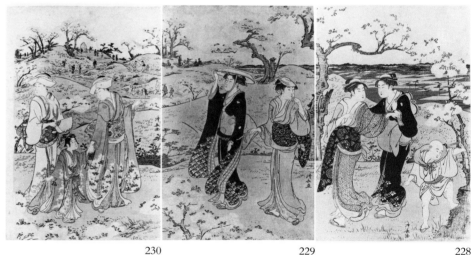

230 229 228

231abc. Women washing and drying lengths of cloth in a garden beside the Sumida River
1788
Signature: Kiyonaga ga
Publisher: Tsutaya Jūzaburō
ōban triptych, 383 × 260 (center),
384 × 248 (left), 385 × 253 (right)
Reference: Hirano 859; UTK 4, 182, 184.
Provenance: May
Publication: May 591, $830.

A243a-c, 50.376

Also complete in Boston.
PLATE 151.

Left sheet of a diptych. Hirano reproduces another more faded impression formerly in the Haviland collection.

*233. Blind man's bluff outside the Kankanrō teahouse
early 1790s
Signature: Kiyonaga
Publisher: Iseya Jisuke
Censorship seal: kiwame
ōban, 366 × 251
Reference: Hirano 958.
Provenance: Fenollosa, Gookin, Metzgar

A224, 50.357

First state of the left panel of a triptych. In later impressions the publisher's mark is changed to that of Wakasaya and the rooftops are printed in brown.

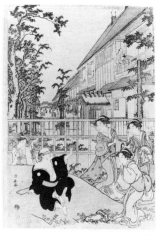

233

*234. The actor Ichikawa Danjūrō II as a vendor of moxa
1/1805
Signature: Torii nidai Kiyomasu zu Kiyonaga ga
surimono, 238 × 163
Reference: Hirano 1017.
Publication: Hirano pl. 104.

A195, 50.328

A color-printed copy of an early hand-colored woodcut by Torii Kiyomasu I. According to a note on the print in *Ukiyoe no Kenkyū*, nos. 7–8, the picture was privately published as a *surimono* with poems in the spring of 1805. The poems on the Ainsworth impression have been trimmed.

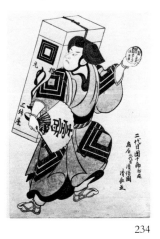

234

*235. The actor Tsuruya Namboku as Asaina in *Monzukushi nagoya no soga*, Ichimura theater, 1/1748
ca. early 1800s
Signature: Torii Kiyomasu hitsu Kiyonaga sha
book page, 260 × 173
Reference: Not in Hirano.

A194, 50.327

The print was designed after an earlier picture by Torii Kiyomasu II or III.
The inscriptions give the names of the actor, role, play, theater, the name and address of the publisher, Izumiya Gonshirō, who published the book from which the picture was copied.
The inscription dates the play to the Enkyō period (1744–1747) but the play was actually performed in the first year of the Kanen period, 1748. The theatrical records do not list Namboku in this role.

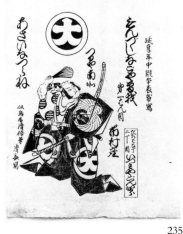

235

Kubo SHUMMAN

*236. Pounding cloth at the Tōi Tama River in Settsu Province
Untitled series of six Tama Rivers
late 1780s
Signature: Shumman ga
Artist's seal: Shumman
Publisher: Fushizen
ōban, 384 × 240
Reference: TNM 1642; UTK 4, 265.

A187, 50.320

The set of six pictures form a continuous composition and are reproduced complete, in color, in Stern, 98-102. Both Stern and the editor of volume 4 of UTK mistakenly call this the Mishima Tama River.

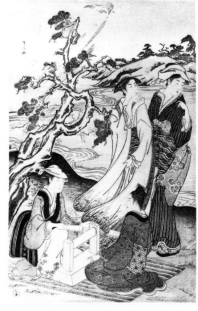

236

*237. Visitors and priest at a shrine on New Year's Day
ca. late 1790s
Artist's seal: Shumman
long surimono, 187 × 511
Provenance: Appleton

A191, 50.324

237

*238. Seven types of women
late 1790s or early 1800s
Signature: Shōsadō Kubo Shumman ga
Artist's seal: Shumman
surimono, 214 × 283
embossing

A188, 50.321

The seven women are court lady, shrine attendant, courtesan, geisha, housewife, peasant, and diver. There is a poem for each type of woman. The first five poems are by Seikandō Mikazuki Funenari of Yokkaichi in Ise. The last two are by Hajintei Hikaru and the artist, both from Edo.
The picture has a centerfold and may have been published in a poetry album.

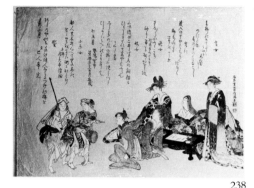

238

UNSIGNED

*241. Geisha presenting peaches to a companion who is about to mount a dragon with her zither and fly away
ca. early 1830s
long surimono, 194 × 515
with embossing, metallic pigments, and areas printed without outline
Provenance: Appleton

A192, 50.325

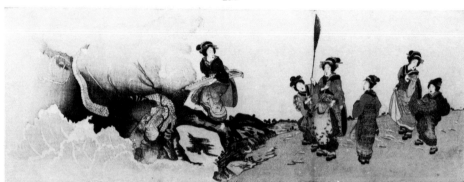

241

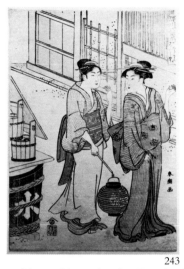

243

*243. *Yagurashita no banshō*, Evening bell at Yagurashita
Series: *Fukagawa hakkei*, Eight views of the Fukagawa district
late 1780s
Signature: Shunchō ga
small chūban, 222 × 156
Provenance: Ficke
Publication: Ficke 1920, 257, $50
(MA: "uncut, good con. good imp. charming").

A247, 50.380

239. Plum branch and peacock feathers
mid–late 1810s
Artist's seal: Shumman
square surimono, 212 × 183
embossing and metallic pigment

A189, 50.222

Another impression in the Hillier collection is reproduced in *Art of the Surimono,* pl. 27. The poem is by Hasunoya Noriyumi.

PLATE 39 (color).

*240. *Inetsumuharu* and *fukinodai*
Series: *Kasumiren sōmoku awase,* Plants for the Kasumi Circle
late 1810s
Signature: Shumman sei
square surimono, 202 × 175
metallic pigment

A190, 50.323

The poem is by Sukago Matsukage.

A modern parody of Hsi Wang Mu, the Taoist divinity who tended the peach tree of immortality and her daughter T'ai Chen who rode a white dragon playing a zither.

Yūshidō SHUNCHŌ

*242. Young couple with attendants
Series: *Imoseyama gomaitsuzuki,* Five illustrations for the play *Imoseyama*
1780s
Signature: Shunchō ga
chūban, 257 × 186

A246, 50.379

The couple are probably Kuganosuke and Hinadori, the ill-fated young lovers in the *Imoseyama* story.

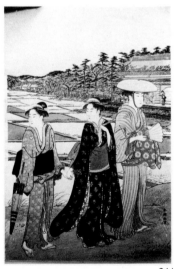

244

*244. Women strolling in the countryside
ca. late 1780s
Signature: Shunchō ga
Artist's seal: Nakabayashi
ōban, 389 × 264
Reference: Crighton III, 58 (color).

A248, 50.381

Panel of a polyptych, two panels of which are in the Victoria and Albert Museum. Related to the three-panel view of women on a bank before rice fields with the mark of the publisher Takatsu reproduced in Vever 511 and UTK 4, 235–237.

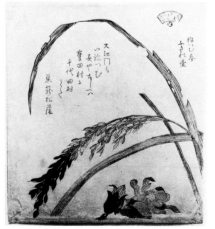

240

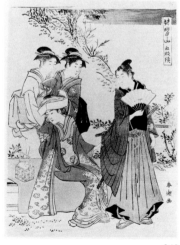

242

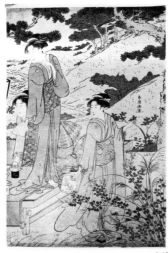

245

*245. Women enjoying an outing near a clump of bush clover
ca. late 1780s
Signature: Shunchō ga
Artist's seal: Nakabayashi
ōban, 371 × 250

A249, 50.382

The complete triptych is reproduced in Vever 510.

Two impressions are known with *kiwame* seals and the mark of the publisher Wakasaya. These may be reissues or reengraved versions.

The scene may be of the precincts of the rural Hagidera or Bush Clover Temple in the Fukagawa district of Edo.

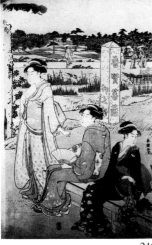

246

*246. Women near a marker for the Boddhisattva Fugen at Oshiage village
ca. early 1790s
Signature: Shunchō ga
Artist's seal: Nakabayashi
Publisher: Izumiya Ichibei (Senichi)
ōban, 392 × 259
one sash printed without outline
Provenance: Vignier, Ficke
Publication: Ficke 1920, 245, $200

(ill.) (MA: "uncut, 1st color") (catalogue: "superb impression in flawless condition") now faded.

A250, 50.383

Right panel of a triptych reproduced in Vever 514.

Oshiage was a village in the West Katsushika area east of the Sumida River. The Fugen Hall was at Shunkei Temple, belonging to the Nichiren sect.

*247. The actor Onoe Matsusuke probably as Ikyū, in an unrecorded play on the Sukeroku theme at the Kiri theater
1/1794
Signature: Shunchō ga
Publisher: Yamaguchiya Chūsuke
hosoban, 308 × 139

A245, 50.378

Panel of a polyptych.

From a group of hosoban actor portraits by Shunei, Sharaku and Shunchō published in 1793 and 1794 and dated with numerical and zodiacal seals on the verso.

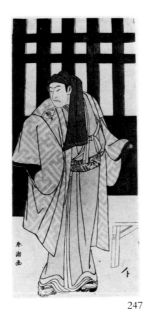

247

*248. Courtesan by window overlooking the Sumida River
ca. 1794
Signature: Shunchō ga
Artist's seal: Nakabayashi
Publisher: unidentified
pillar print, 692 × 116 on two sheets
Reference: NBZ 22, 201; Ficke 1925, 160 ill.
Provenance: Ficke
Publication: Ficke 1920, 255, $65 (MA: "uncut, Ficke's favorite") (catalogue: "a remarkably fine impression, superb condition") slightly faded.

A251, 50.384

The lantern and the woman's robe bear the fan-shaped crest of the Ōgiya house. The

print must have been designed after the fire of 1794 when the Yoshiwara burned and was temporarily relocated in premises along the Sumida River.

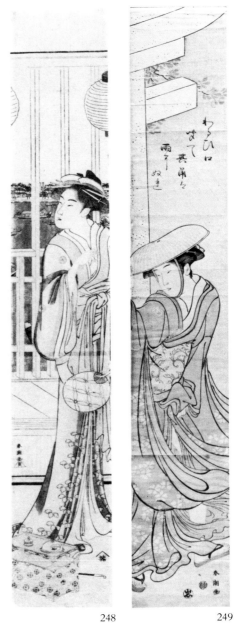

248 249

*249. Women in rain at entrance to Mimeguri shrine
1790s
Signature: Shunchō ga
Publisher: Iwatoya
pillar print, 702 × 122
grey ground
Reference: TNM 1750.

A252, 50.385

The poem refers to the haiku poet Kikaku who ended a long drought by composing a verse at Mimeguri Shrine.

The poem reads: *Waruiguchi kikite kikaku wa ame ni nure*, "The poet Kikaku hears something bad and gets caught in the rain."

*250. Two women viewing cherry blossoms at Gotenyama
mid 1790s
Signature: Shunchō
Artist's seal: Nakabayashi
Publisher: unidentified
pillar print, 685 × 120 on two sheets
Reference: TNM 1752.

A253, 50.386

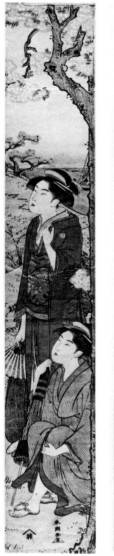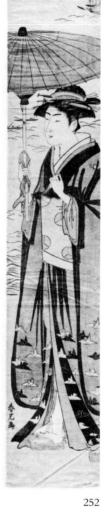

250 252

UNSIGNED

*251. Women visiting a temple
Series: *Edo jissho zekkei,* Views of 10 places in Edo
ca. late 1780s or early 1790s
Publisher: Enomoto Kichibei (emblem)
chūban, 248 × 182
Provenance: Jacquin 258, $90

A302, 50.435

Gookin attributed the print to Shunchō in the Jacquin catalogue.

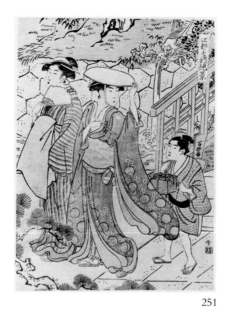

251

SHUNKŌ

*252. Woman walking beside Takanawa Bay
ca. mid 1780s
Signature: Shunkō ga
pillar print, 666 × 122 on two sheets
Reference: Stern 79.
Provenance: Metzgar, May
Publication: May 299, $12.50; Metzgar 1916, 244.

A244, 50.377

This Shunkō was a designer of a few pictures of women and children in the 1770s and 1780s; his name is occasionally transcribed as Harumitsu in western catalogues.

Katsukawa SHUNZAN

253. Plum branch and rising sun
late 1780s or 1790s
Signature: Shunzan ga
fan print, 230 × 257

A186, 50.319

PLATE 56.

*254. *Tagoto no uetsuke,* Rice planting in the paddy fields
Series: *Seirō niwaka zensei asobi,* Entertainment for the Niwaka festival at the green houses
mid 1790s
Signature: Katsu Shunzan ga
Publisher: Eijudō
Censorship seal: kiwame
aiban, 338 × 230
with yellow ground

A185, 50.318

The inscription at the left gives the names of the 8 geisha who performed this dance in the Niwaka festival in the Yoshiwara; in addition there were two chanters, two samisen players, and one bell accompanist.

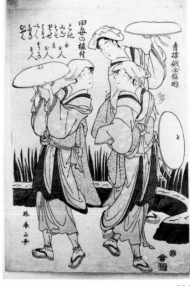

254

Chōbunsai EISHI

*255. Three women in an open room
Series: *Miyako yae no nishiki,* Eight layers of brocade from the capital
ca. 1787–88
Signature: Eishi ga
chūban, 263 × 194
Reference: Brandt 11(?).

A313, 50.446

Brandt lists a print with a similar description in the 2nd Haviland sale, 330. Only two pictures from the set are known.

This is probably the same impression that MA bought at Ficke, 1920 (lot 294) for $150, which is described as "Three ladies on a veranda." MA wrote of it "uncut, fair impression, fine color, lovely color and design."

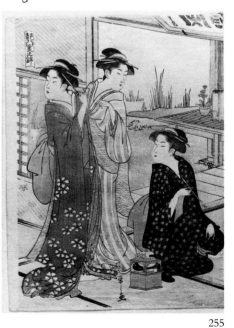

255

*256ab. Viewing cherry blossoms at Goten-
yama
late 1780s
Signature: Eishi ga
two ōban, 387 × 524
Reference: Brandt 90.
A318a-b, 50.452
Two right panels of a triptych.

An example of *benigirai*, a technique of
grisaille coloration avoiding pink that Eishi
and other designers used in the late 1780s.
Brandt lists nine triptychs in this series based
on chapters of Lady Murasaki's novel, *Genji
Monogatari*. This may be the only complete
set of this design.

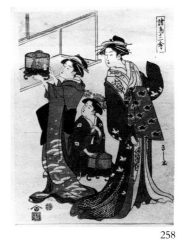

258

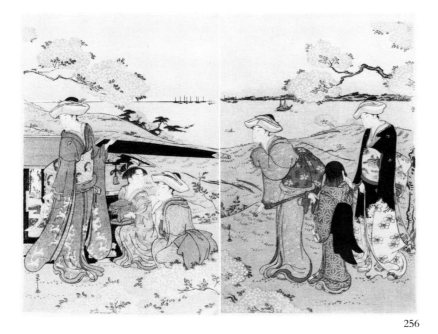

256

*257abc.
Asagao, Morning glory
Series: *Fūryū yatsushi genji*, Scenes
from the *Tale of Genji* in elegant
modern dress
ca. late 1780s
Signature: Eishi ga
Publisher: Izumiya Ichibei (Senichi)
ōban triptych, 388 × 268 (center),
392 × 264 (left), 386 × 252 (right)
Reference: Brandt 54.
A320a-c, 50.453

*258. Courtesan and attendants with two
caged quail
Series: *Shochō jūnikin*, Twelve birds
ca. 1791
Signature: Eishi ga
Publisher: Eijudō
Censorship seal: kiwame
chūban, 255 × 193
Reference: Not in Brandt.
A312, 50.445
Brandt lists three other pictures in the series.

259abc. Young man entertained by several
geisha and a jester behind a trans-
parent screen
ca. 1795
Signature: Eishi zu
Publisher: Iwatoya
Censorship seal: kiwame
ōban triptych, 390 × 779
yellow ground
Reference: Brandt 205.
A319a-c, 50.452
PLATE 153.

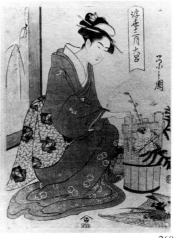

260

*260. *Tairo*, the 12th month. Woman pre-
paring new year decorations
Series: *Ukiyo jūnigatsu*, Twelve
months in the floating world
ca. mid 1790s
Signature: Eishi zu
Publisher: Eijudō
Censorship seal: kiwame
chūban, 234 × 175
yellow ground
Reference: Not in Brandt.
Provenance: Ficke
Publication: Ficke 1920, 289, $22.50.
(MA: "uncut, small, faded to 1.
color, have nothing like it").
A314, 50.447

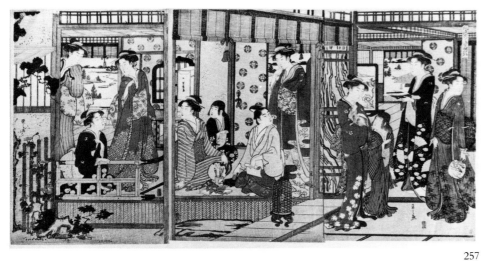

257

Brandt lists three plates in the series from descriptions in the 2nd Haviland sale catalogue.

261. Kuronushi, a courtesan of the Ōgiya house holding a book with a marker
Series: *Yatsushi rokkasen*, Six immortal poets in modern dress
mid 1790s
Signature: Eishi zu
Publisher: Nishimura (?) (emblem, Sei han)
Censorship seal: kiwame
ōban, 371 × 245
grey ground
Reference: Brandt 250.
Provenance: Jacquin (?)
Publication: Jacquin 1921, 322, $40.
A315, 50.448

Brandt knew this subject only from a description in the Jacquin sale catalogue, very likely the source of the Ainsworth print. The cartouche is in the shape of two poem cards, one with the series title, the other with a picture of the poet Kuronushi and his poem on Mirror Mountain, or Kagamiyama.

PLATE 70.

262. Priest Kisen; a courtesan holding a pair of painted shells
Series: *Yatsushi rokkasen*, Six immortal poets in modern dress
mid 1790s
Signature: Eishi zu
Publisher: Nishimura (?) (emblem, Chō han)
Censorship seal: kiwame
ōban, 387 × 258
yellow ground
Reference: Brandt 249.
Provenance: Jacquin (?)
Publication: Jacquin 323, $130.
A316, 50.449

Brandt cites an impression in the Jacquin sale 1921, 323. Many Jacquin prints were mounted on Japan vellum, as here, and both this and the preceding print were probably purchased there.

The cartouche gives the title, a picture of the poet, and the well-known poem on the poet's hut at Ujiyama which is included in the *100 Poems*.

This impression was bought by the dealer Oshima at the sale.

PLATE 69.

*263abc.
Lady in carriage presenting a poem slip to be hung in a cherry tree
mid 1790s
Signature: Eishi zu
Publisher: Izumiya Ichibei
Censorship seal: kiwame
ōban triptych, 383 × 739
yellow ground
Reference: Not illustrated in Brandt.
Provenance: Vignier, Ficke
Publication: Ficke 1920, 291, $210 (ill.) (MA: "very fine copy, uncut") (catalogue: "flawless and luminous state,") now faded.
A321a-c, 50.454

*264. The waitress Okita of the Naniwaya teahouse holding a small dog
mid 1790s
Signature: Eishi ga
Publisher: Eijudō
pillar print, 645 × 118 on two sheets
A322, 50.455

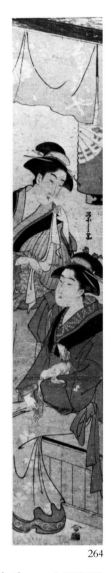

264

After Chōbunsai EISHI

*265. *Ōgiya takigawa hatsukai zashiki no zu*, The courtesan Takigawa of the Ōgiya house offering herself publically for the first time in the year
Series: *Seirō bijin awase*, Beauties of the green houses
probably late 19th century
Signature: Eishi giga
Publisher: Iwatoya Kisaburō (emblem)
ōban, 376 × 247
white mica printed over a yellow ground
Reference: Brandt 185; Stern 128, ill.; Binyon and Sexton, pl. XII (unsigned); Rouart 546, ill.; Van Caneghem 247 (unsigned).
Provenance: Rouart
Publication: Keyes 1976, fig. 7.
A317, 50.450

This is a modern copy. Early impressions are printed with different outline and color blocks and have a yellow floor and dark mica background. An unsigned impression

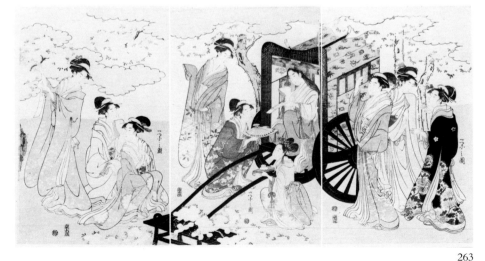

263

of this version in the British Museum was illustrated as pl. XII in Binyon and Sexton and in color on the dust wrapper of the republication of that book and it has not been questioned until now. Contemporary copies were made of some prints in the 1790s, but the colors on this impression are late and harsh.

265

Chōkōsai EISHŌ

266. The courtesan Somenosuke of the Matsubaya house holding a fan
mid 1790s
Signature: Chōkōsai Eishō ga
Publisher: Yamaguchiya Chūsuke (emblem)
ōban, 382 × 253
dark silver mica ground
Reference: Brandt A9; TNM 2276 (dark mica); TNM 2277 (white mica).
A325, 50.458
This impression is untrimmed at the right, but lacks the left edge of Somenosuke's fan and the tips of her hairpins.
PLATE 29 (color).

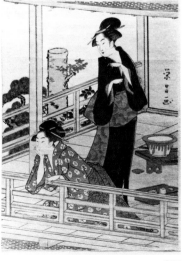

267

*267. Two women on an open balcony
late 1790s
Signature: Eishō ga
small chūban, 249 × 182
Reference: Apparently not in Brandt.
A323, 50.456
Possibly a panel of a polyptych.

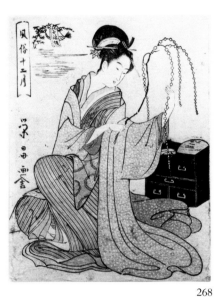

268

*268. Twelfth month: Woman making *mochibana*, or new year decorations with rice balls
Series: *Fūzoku jūnikagatsu,* Twelve modern months
late 1790s
Signature: Eishō ga
Publisher: Enomoto
chūban, 233 × 175
yellow ground
Reference: Not in Brandt.
A324, 50.457
Brandt lists three other pictures in the series.

Ichirakutei EISUI

*269. The courtesan Somenosuke of the Matsubaya house
Series: *Bijin gosekku,* Beauties for the five yearly festivals
late 1790s
Signature: Ichirakutei Eisui ga
Publisher: Maruya Bunemon
Censorship seal: kiwame
ōban, 391 × 256
grey ground
Reference: Brandt C 3; TNM 2312; Stern 132 (color).
Provenance: Fenollosa, Buckingham
A335, 50.468
The courtesan's *kamuro* are named as Wakaki and Wakaba.

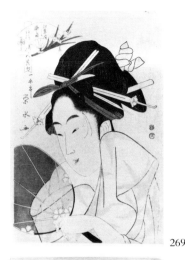

269

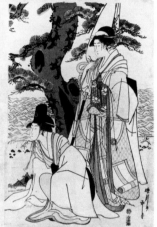

270

Rekisentei EIRI

*270. Women dressed as courtiers beside the sea
late 1790s
Signature: Rekisentei Eiri hitsu
Publisher: Izumiya Ichibei (Senichi han)
Censorship seal: kiwame
ōban, 392 × 262
A254, 50.387
Right panel of a triptych.

Eishōsai CHŌKI

*271. The waitress Ohisa of the Takashimaya teahouse holding a fan with a portrait of the actor Matsumoto Kōshirō IV as the fisherman Gorōbei by Sharaku
ca. 1794
Signature: Chōki ga
Publisher: Murata ya
Censorship seal: kiwame
pillar print, 612 × 111 on two sheets
A300, 50.433
The fan is probably a painting by Sharaku. A reversed version of the same design was published as a mica ground ōban by Tsutaya Jūzaburō in 1794.

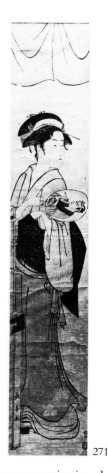

271

*272. Three women viewing cherry blossoms
Series: *Asakusa senbonzakura,* The
1000 cherry trees at Asakusa
mid 1790s
Signature: Chōki ga
Publisher: Tsuraya Kiemon
Censorship seal: kiwame
aiban, 315 × 209
yellow ground

A296, 50.429

Right panel of a triptych.

272

*273. The courtesans Nishio and Suma-
goromo of the Nakamanjiya house
strolling in the snow
mid 1790s
Signature: Chōki ga
Publisher: Tsutaya Jūzaburō
ōban, 378 × 246

A297, 50.430

Panel of a triptych. The names of Nishio's
kamuro, Sono and Chidori, and Sumago-
romo's *kamuro,* Koume, Niwano and Ni-
noto are given above.

273

274. Courtesan and companion enjoying
the summer moon
mid 1790s
Signature: Chōki ga
Publisher: Tsutaya Jūzaburō (em-
blem)
Censorship seal: kiwame
ōban, 377 × 248
silver, blown color, and white mica
ground
Reference: Berlin 305 (ill. cover).

A298, 50.431

Chōki designed four prints of women for
Tsutaya with mica grounds, and some writ-
ers have suggested they were published
together as a set of four seasons, although
this print and the picture of fireflies both
represent summer.

PLATE 27.

*275. The chanter Tomimoto Buzendayū
and the geisha Tetsu and Sanosuke
as street vendors of clay cooking
pots and hand drums in the dance,
Kotobuki miyako no nishiki
Series: *Seirō niwaka zensei asobi,* En-
tertainments for the Niwaka festival
in the green houses
mid. 1790s
Signature: Chōki ga
Publisher: Tsuruya Kiemon (em-
blem)
ōban, 381 × 250
yellow ground
Reference: Stern 136 (color).

A299, 50.432

Another triple portrait from the same series
was in the Ledoux collection.

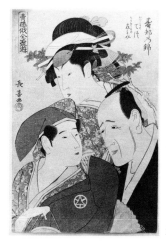

275

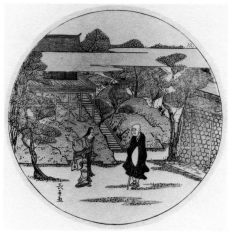

276

*276. Priest asking directions at Kiyomizu
Temple
ca. early 1800s
Signature: Chōki ga
chūban, diameter 165
shades of grey with embossing in
borders.

A295, 50.428

Kitagawa UTAMARO

*277. Classical landscape with peasant sil-
houetted against a full moon
Series: *Kyōgetsubō,* The moon-mad
monk
8/1789
Publisher: Tsutaya Jūzaburō
album sheet, 256 × 386
printed entirely in grey with em-
bossing for moon
Provenance: Ficke
Publication: Ficke 1920, 336, $130
(MA: "xx unusual").

A266, 50.399

From Utamaro's second dated poetry al-
bum.

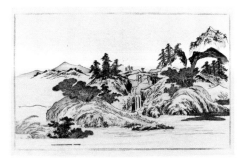

277

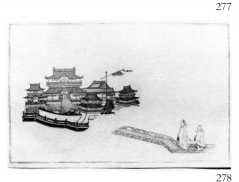

278

*278. A Chinese emperor and a Taoist immortal approaching the palace of the moon
Series: *Kyōgetsubō,* The moon-mad monk
8/1789
Publisher: Tsūtaya Jūzaburō
album sheet, 353 × 381
with embossing, gold and silver
Provenance: Walpole Galleries, NY, 1920, 328

A266A, 50.399A

*279–283.
Poems and shells
Series: *Shiohi no tsuto,* Gifts of the ebb tide
ca. 1790
Publisher: Tsutaya Jūzaburō
album sheets each: 270 × 385
embossing, mica, and metallic powder

A267–71, 50.400–404

From a relatively late edition of the poetry album, lacking the printed waves between shells and poems; the album originally contained two additional pictures by Utamaro and a few pages of printed text.

284. Six women by a screen decorated with a painting of the poet Narihira passing Mt. Fuji on his journey eastward
ca. early 1790s
Signature: Utamaro ga
long surimono, 192 × 247
embossing
Unrecorded
Provenance: Appleton

A292, 50.425

PLATE 138.

281

279

282

280

283

285. *Omoshirokisō,* Interested
Series: *Fujin sōgaku juttai,* Ten aspects of the physiognomy of women
ca. 1793–1794
Signature: Sōken Utamaro ga
Publisher: Tsutaya Jūzaburō (emblem)
Censorship seal: kiwame
ōban, 363 × 244
white mica ground, lacquer on mirror, and embossing of robe
Reference: Shibui 49.2.1; Shōgakukan 18.5.1; TNM 1805.

A281, 50.414

First state with the words *omoshirokisō.* Eight prints in the set are known.

PLATE 25.

286. Osen, the former waitress at the Kagiya teahouse at Kasamori, presenting a scroll with her secrets to Ohisa of the Takashimaya teahouse
ca. 1794
Signature: Utamaro hitsu
Publisher: Tsuruya Kiemon
Censorship seal: kiwame
ōban, 381 × 250

yellow ground
Reference: Not in Shibui; Shōga-
kukan 81.2.
Provenance: Hirakawa, Hayashi
Publication: Keyes 1976, fig. 6; Hir-
akawa 237.

A284, 50.417

A companion print showing another beauty
of the 1760's, Ofuji, presenting a scroll to
Ohisa's rival Okita is in the Nelson Gallery
in Kansas City.
Another impression of this print is in the
Museum of Fine Arts in Boston, reproduced
in *Ukiyoe shūka*.

PLATE 26.

287. *Yashiki no sekishō*, Evening glow in
the mansion
Series: *Fūzoku ukiyo hakkei*, Eight
modern views of the floating world
ca. 1795
Signature: Utamaro hitsu
Publisher: Tsutaya Jūzaburō (em-
blem)
Censorship seal: kiwame
aiban, 330 × 233
yellow ground
Reference: Not in Shibui; Shōga-
kukan 61.6.

A277, 50.410

Another impression is in Brussels.
PLATE 85.

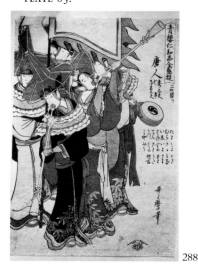

288

*288. *Tōjin*, Five geishas as Chinese mu-
sicians
Series: *Seirō niwaka zensei asobi ni no
kawari*, The second group of enter-
tainments for the *niwaka* festival at
the green houses
ca. mid 1790s
Signature: Utamaro hitsu
Publisher: Tsutaya Jūzaburō (em-
blem)
aiban, 329 × 228
grey ground
Reference: Not in Shibui; Shōga-
kukan 67.1.

A274, 50.407

Suzuki dates the print to 1799, but the style
of the print seems closer to the mica ground
triple portrait with a geisha as a foreigner
published in the mid 1790's. The names of
three musicians, Shūdayu, Shichihei, Shi-
nadayū, and 20 geishas are given at the
right.

289. The courtesan Hanaōgi of Gomeirō,
the Ōgiya house
Series: *Bijin kiryō kurabe*, A com-
parison between the features of
beautiful women
mid 1790s
Signature: Utamaro hitsu
Publisher: Takasu Sōshichi (Takasu
han)
Censorship seal: kiwame
ōban, 371 × 250
dark mica ground
Reference: Shibui 61.1.4; Shōga-
kukan 531.4.

A285, 50.418

The print has been washed and some of the
mica has been lost. Other impressions are
in the Metropolitan Museum, NY, and
the Tokyo National Museum.

PLATE 68.

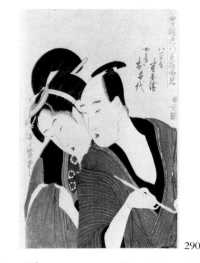

290

*290. The greengrocer Hambei and his
wife Ochiyo
Series: *Jitsukurabe iro no minagami*,
The source of love
ca. early 1798
Signature: Utamaro hitsu
Publisher: Nishimura Chō
Censorship seal: kiwame

ōban, 373 × 247
Reference: Not in Shibui; Shōga-
kukan 367.19.
Publication: *Ukiyoe shūka* IX, 45.

A286, 50.419

Twenty-one prints in this series are pres-
ently known. Three other impressions of
the print are recorded.

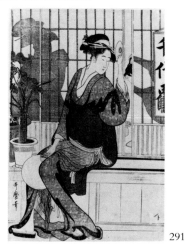

291

*291. Waitress at the Chiyozuru restau-
rant holding her cup out for wine
Series: From an untitled series of
three portraits of waitresses with
shadows on door panels behind
late 1790s
Signature: Utamaro hitsu
Publisher: Yamaguchiya Chūsuke
ōban, 372 × 251
Reference: Shibui 194.1.2; Shōga-
kukan 402.2.

A276, 50.409

Price marked on verso—$75.
This print was the source for an *inrō* signed
Yoyusai.

*292. Children playing with battledores
as their mother prepares a plum
branch for a flower arrangement
spring 1799
Signature: Utamaro ga
long surimono, 173 × 662
on crepe paper
Provenance: Appleton

A293, 50.426

Poems by Asakusaan and eight others in-
cluding Gofukudō Orisuke, a man who
may have been a cloth merchant and may
also have commissioned the print, since his
poem appears set slightly apart at the right.

292

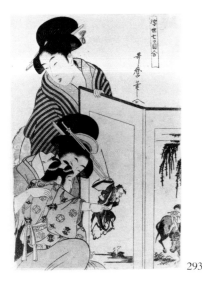

293

*293. Two women and a child by a painted screen
Series: *Ukiyo nanatsume awase,* Pairs of sevenths in the floating world
ca. 1799
Signature: Utamaro hitsu
Publisher: Moriya Jihei (emblem)
ōban, 363 × 239
white mica ground
Reference: Shibui 98.1.2; Shōgakukan 464.2; TNM 1952; Kawaura 1925, 274.
Publication: Appleton 156, $70.

A280, 50.413

The mica is original, since the publisher's mark and title are hand-stamped over it. There are six prints in the series, each representing a pair of signs from the zodiac, sheep and ox in this case. If they are counted in order, the second animal in the pair is always the seventh (*nanatsume*) in succession.

*294abcdefg.
Women imitating the procession of a Korean embassy
ca. 1799
Signature: Utamaro hitsu
Publisher: Yamaguchiya Chūsuke
Censorship seal: kiwame
seven-panel ōban, 370 × 1752

A289, 50.422

At least two panels, the leftmost and the second from the right, were also published as single-sheet prints with the series title *Seirō niwaka zensei asobi,* Entertainments for the Niwaka festival in the green houses. The prints, and the entertainment, were prompted by the arrival of a Korean legation in Edo in 1799.

295. The courtesan Somenosuke of the Matsubaya house
Series: *Seirō yūkun ikiutsushi,* Courtesans of the green houses drawn from life
ca. 1800
Signature: Utamaro hitsu
Publisher: Maruya Jimpachi (emblem)
ōban, 388 × 260
grey ground and mica on pink collar
Reference: Not in Shibui; Shōgakukan 179.2.
Provenance: Two unidentified collectors' marks on verso
Publication: *Ukiyoe shūka* IX, 97 (color).

A282, 50.415

A portrait of a merchant's concubine published by Murataya Jirōbei with a nearly identical pose is illustrated in TNM 1972.
PLATE 72.

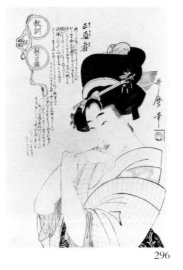

296

*296. *Shōjikimono,* An honest woman
Series: *Kyōkun oya no megane,* Instructions from a parent's spectacles
ca. 1803

Signature: Utamaro hitsu
Publisher: Tsuruya Kinzō (emblem)
ōban, 379 × 252
Reference: Shibui 55.3.2; Shōgakukan 155.10; TNM 2019.
Provenance: Hayashi

A278, 50.411

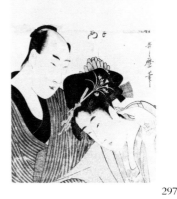

297

*297. The lovers Ohan and Chōemon
Series title: trimmed
early 1800s
Signature: Utamaro hitsu
aiban, 234 × 214

A275, 50.408

Fragment of an apparently unrecorded print.

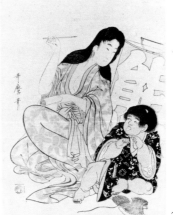

298

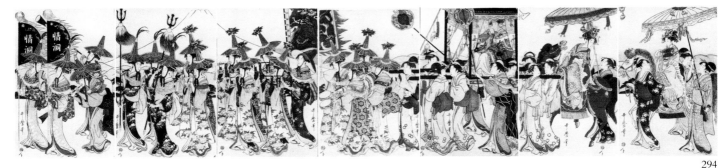

294

*298. Yamauba and Kintoki seated by a
kite
early 1800s
Signature: Utamaro hitsu
Publisher: Tsuruya Kinzō (emblem)
ōban, 375 × 258
Reference: Shibui 210.2.4; Shōga-
kukan 737; TNM 1947.

A279, 50.412

Reference: Not in Shibui; Shōga-
kukan 284.2.

A283, 50.416

The picture bears Komachi's poem on fad-
ing beauty and probably represents Ko-
machi in the graveyard, the last of the set.
Another impression is in the Museum of
Fine Arts, Boston.

*301abc.
Gathering persimmons
ca. 1805
Signature: Utamaro hitsu
Publisher: Wakasaya Yoichi
ōban triptych, 394 × 258 (right),
389 × 262 (center), 393 × 257 (left)
Reference: Shibui 31.1; Shōgakukan
242, 1–3.

A287, 50.420

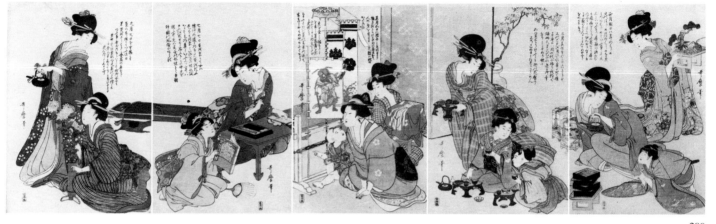

299

*299abcde.
Women and children in pastimes
linked with the five annual festivals
early 1800s
Signature: Utamaro hitsu
Publisher: Izumiya Ichibei (Senichi
han)
ōban pentaptych, each panel ca. 390
× 255
three right panels with grey ground
Reference: Shibui 29; Shōgakukan
264.
Provenance: Blanchard
Publication: Blanchard 38, $162.50
(catalogue: "faultless impression,
beautiful condition"); *Ukiyoe shūka*
IX, 152–56 (color).

A288, 50.421

The inscriptions describe the festivals in the
first, third, fifth, seventh, and ninth months
of the lunar year. One other complete set
of the prints is in the Tokyo National
Museum.

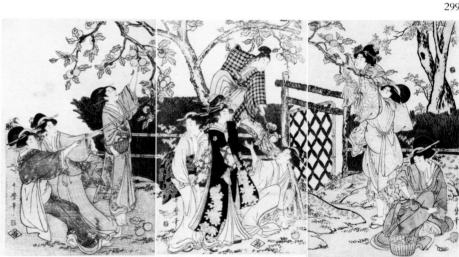

301

*300. The courtesan Karagoto of the Chō-
jiya House leaning on an instrument
case
Series: *Yūkun nanakomachi,* Cour-
tesans representing the seven aspects
of the life of the poetess Ono no
Komachi
ca. 1805
Signature: Utamaro hitsu
Publisher: Izumiya Ichibei (Senichi
han)
ōban, 390 × 265

300

Metzgar wrote in his typed catalogue that
this triptych was "in remarkable condition
of color." The print was exhibited, how-
ever, and the color has completely faded
except where it was covered by the mat.

302. Young man kicking football
ca. 1805
Signature: Utamaro hitsu
Publisher: Matsuan
pillar print, 596 × 120 on two sheets
Publication: Ficke 341, $80 ill. (MA:
"uncut, slightly spoiled, very nice")
(catalogue: "superb impression,
flawless condition") now faded.

A290, 50.423

PLATE 161.

Kitagawa UTAMARO II

*303. Butterfly and peonies
ca. 1810s
Signature: Utamaro hitsu
small panel, 353 × 84
in pink and grey

A272, 50.405

Pictures of this subject, format, and color scheme are usually attributed to Utamaro II.

305

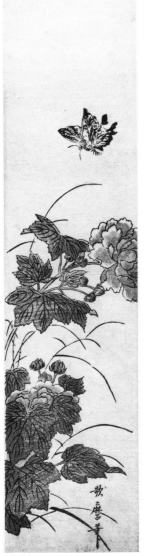

303

304. The Taoist immortals Han Shan and Shih Te (Kanzan and Jittoku)
ca. 1810s
Signature: Utamaro hitsu
hosoban, 339 × 150
printed in black and grey

A273, 50.406

The picture is drawn in a traditional painting style. Fourteen-syllable Chinese couplet above.

PLATE III.

Kitagawa UTAMARO II and Ōumiya KAZUSADA

*305. Woman arranging bush clover in a vase
ca. 1805–1810
Signature: Utamaro hitsu
Artist's seal: Ōumiya Kazusada
long surimono, 195 × 534
embossing and areas printed without outline
Provenance: Appleton

A294, 50.427

Utamaro designed the figures on the right and Kazusada the landscape and flowers on the left.

306

Tamagawa SHŪCHŌ

*306. The lovers Umegawa and Chūbei
Series: *Eawase hakkei*, Eight views with matching pictures
late 1790s
Signature: Shūchō ga
Publisher: Ezakiya Kichibei (emblem, hammoto)
ōban, 362 × 238, on smaller sheet than usual
grey ground
Publication: *Ukiyoe shūka* IX, 101 (color).

A301, 50.434

Yoshida only knew one picture from this series, Evening bell at Kichijō Temple.

BANKI

*307. *Shinguchimura no bōsetsu,* Evening snow at Shinguchi Village, the lovers Umegawa and Chūbei
ca. 1800
Signature: Banki hitsu
Publisher: Ihiko
pillar print, 633 × 117 on two sheets
Publication: Ficke 1920, 386, $105 (ill.) (MA: "uncut") (catalogue: "superb impression in wholly flawless untouched condition,") now slightly faded.

A339, 50.482

From a series of pictures of couples from famous *kabuki* plays.

307

BUNRŌ

308. The god Daikoku and Fukusuke as
manzai dancers
early 1800s
Signature: Bunrō ga
Publisher: Ezakiya
ōban, 368 × 245

A338, 50.471

The poem speaks of happiness and great
amounts of money.
Another similar print by Bunrō of Fukusuke
wrestling with the god Daikoku is repro-
duced in TNM 2107.

Kikukawa EIZAN

309. Geisha kneeling by *samisen* case
Series: *Fūryū sakashiki sanbijin,* Three
elegant beauties at a drinking party
8/1814
Signature: Kikugawa Eizan hitsu
Publisher: Yamashō (?)
Censorship seal: kiwame
ōban, 391 × 266
Provenance: Genthe
Publication: Genthe 403, ill.

A327, 50.460

Probably the left panel of the triptych.

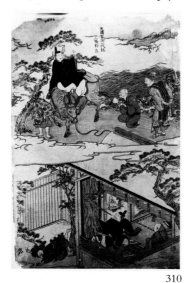

310

UNSIGNED

*310. Sugawara Michizane in exile breath-
ing fire and riding an ox
Series: *Temmangū goichidaiki sam-
pukutsui,* Biography of the founder
of the Temman Shrine: a triptych
ca. 1790s
Publisher: Eijudō
ōban, 393 × 267

A160, 50.293

The picture is the left panel of the triptych,
and has been variously attributed to Shun-
shō and Shigemasa.

Katsukawa SHUNEI

311. The actor Ichikawa Monnosuke II
as Sukeroku in *Sukeroku kuruwa no
futabagusa,* Ichimura theater
4/1791
Signature: Tōshūsai Sharaku ga
Censorship seal: kiwame
hosoban, 337 × 145
grey ground

A305, 50.438

The signature and mica are recent additions.
A related print of the same actor in the
same role signed Shunei is reproduced in
the catalogue of the Ficke sale, 174.

PLATE 163.

312. The actor Ichikawa Monnosuke II
as a rough townsman
Untitled series of half-length por-
traits with the actor's house and
poetry names
1791
Signature: Shunei ga
Publisher: Iseya Jihei
Censorship seal: kiwame
hosoban, 311 × 145
blue ground

A170, 50.303

Monnosuke's house name is Takinoya; his
poetry name is Shinsha.

313. The actor Ichikawa Monnosuke II
as a lord standing beneath a maple
tree, possibly as Takatsuna in *Ōmi
genji senjin yakata,* Ichimura theater,
autumn 1793
Signature: Shunei ga
Publisher: Tsutaya Jūzaburō
Censorship seal: kiwame
hosoban, 305 × 136
Reference: Stern 82 (color).
Provenance: Hayashi

A171, 50.304

From a five-panel series.
Another version of the scene by Shunei was
published by Emiya Kichiemon.
A Japanese dealer's number code is stamped
in red on verso.

314. The actor Kataoka Nizaemon as Kō
no Moronao in *Kanadehon chūshin-
gura,* Miyako theater
4/1795
Signature: Shunei ga
Publisher: Enomoto Kichibei
aiban, 324 × 211
Provenance: Metzgar
Publication: Metzgar 1916, 504,
$32.50 (pl. 4).

A169, 50.302

Shunei designed a full-length portrait of the
actor in the same pose in his series of grey
ground ōban for *Chūshingura* performances
in 1795 published by Iwatoya.

315. The actor Segawa Kikunojō III as
Osome, the oil merchant's daugh-
ter, in *Hayariuta hiyoku sammon,* Kiri
theater
7/1796
Signature: Shunei ga
Publisher: Uemura Yohei (Uemura)
Censorship seal: kiwame
ōban, 380 × 258
colored outline and grey ground
Reference: UTK 3, 50 (color); Rouart
795, ill.
Publication: *Ukiyoe shūka* IX, 92
(color).

A172, 50.305

The right panel of a diptych. The left panel
shows Matsumoto Yonesaburo as Hisa-
matsu holding an iris; the impression in the
Russell collection is illustrated in the Javal
catalogue.

PLATE 32 (color).

Taga RYŪKŌSAI

316. The actors Kanō Hinasuke and Ichi-
kawa Danzō as Ōmori Hikoshichi
and Kuryū Saemon disguised as a
demon in *Hitogokokoro kanō kaomise,*
Kado theater
11/1792
Signature: Ryūkōsai
Artist's seal: kakihan
Publisher: unidentified (emblem,
daisa han)
hosoban, 313 × 141
colored ground
Provenance: Hayashi
Publication: Keyes 1976, fig. 8.

A265, 50.398

Tōshūsai SHARAKU

317. The actor Osagawa Tsuneyo pos-
sibly as Sakuragi, the wife of Sa-
danoshin in *Koinyōbo somewake ta-
zuna* at the Kawarazaki theater
5/1794
Signature: Tōshūsai Sharaku ga
Publisher: Tsutaya Jūzaburō (em-
blem)
Censorship seal: kiwame
ōban, 365 × 251
dark mica ground
Reference: Henderson and Ledoux
21; UTK 7, 26; TNM 2366; Yoshida
1957, 28; Stern 126.

A303, 50.436

PLATE 71.

318. The actor Morita Kanya VIII in the
role of the palanquin bearer Uguisu
no Jirōsaku in *Hanashōbu omoi no
kanzashi,* an interlude at the Kiri
theater
5/1794
Signature: Tōshūsai Sharaku ga

Publisher: Tsutaya Jūzaburō (emblem)
Censorship seal: kiwame
ōban, 366 × 251
dark mica ground
Reference: Henderson and Ledoux 28; UTK 7, 18; TNM 2360; Yoshida 1957, 5 (color).
Publication: Keyes 1976, fig. 9.

A304, 50.437

The blue-green, red, pink, and purple color blocks have been reengraved and reprinted over the faded original colors to make the print seem unfaded. This was intentionally deceptive and this is probably one of the "revamped" prints Metzgar speaks of in his book on Japanese prints.
PLATE 30 (color).

Utagawa TOYOHARU

319. *Ichinotani hiodorigoe sakaotoshi no zu,* Picture of Ichinotani and the rear attack from Hiodori Pass
Series: *Shimpan ukie,* New perspective pictures
ca. 1770s
Signature: Utagawa Toyoharu ga (trimmed)
Publisher: Iwatoya Gempachi (trimmed)
ōban, 231 × 332
black sky
Reference: TNM 2426.

A309, 50.442

320. *Ukie yukimi shūen no zu,* A perspective picture of a snow-viewing party
1770s
Signature: Utagawa Toyoharu ga
Publisher: Eijudō Nishimura (seal unread)
ōban, 244 × 375
Provenance: unidentified collector's mark

A310, 50.443
PLATE 147.

321. *Ukie yoshinaka awazu gassen no zu,* A perspective picture of Yoshinaka's defeat at Awazu
ca. 1770s
Signature: Utagawa Toyoharu ga
Publisher: Eijudō Nishimuraya (seal unread)
ōban, 264 × 388

A311, 50.444

Utagawa TOYOKUNI

322. The actor Sawamura Sōjūrō III (Kinokuniya) as Nagoya Sanza in *Keisei sambongasa,* Miyako theater
Series: *Yakusha butai sugatae,* Actors on stage
7/1794
Signature: Toyokuni ga
Publisher: Izumiya Ichibei (Senichi)

Censorship seal: kiwame
ōban, 382 × 256
grey ground
Reference: Yoshida 9.
Provenance: Kobayashi
Publication: Shōgakukan IX, 8.

A261, 50.394

The second panel from the right in a pentaptych.
Numbered two below the publisher's mark.

323. The actor Sawamura Yodogorō (Kinokuniya) as the lord Ōe no Onitsura in *Zensei azuma garan,* Kawarazaki theater
Series: *Yakusha butai sugatae,* Actors on stage
8/1795
Signature: Toyokuni ga
Publisher: Izumiya Ichibei (Senichi)
Censorship seal: kiwame
ōban, 366 × 245
mica over grey ground
Reference: Yoshida 39.
Publication: Keyes 1976, fig. 10; *Ukiyoe shūka* IX, 68.

A260, 50.393

The series included more than 50 designs and was published from the spring of 1794 to 1796. The mica ground is a modern addition, although some pictures from the series published in 1794 do have mica grounds.
The actor's personal name may also be pronounced Dengorō, but it is given as Yodogorō in *Kabuki nempyō.*
PLATE 33 (color).

324. Two courtesans in a teahouse overlooking the Sumida River
ca. 1794
Signature: Toyokuni ga
Publisher: Wakasaya
ōban, 385 × 258

A262, 50.395

Probably published after the fire of 1794 when the Yoshiwara was temporarily relocated along the Sumida River.

325

*325. Woman in a summer kimono resting after a bath
mid 1790s
Signature: Toyokuni ga
Publisher: Wakasaya Yoichi
chūban, 244 × 175

A256, 50.389

Perhaps from an untitled set of seasons or months including the following (no. 324).

326. Geisha seated on a bench
mid 1790s
Signature: Toyokuni ga
Publisher: Wakasaya
chūban, 245 × 174

A257, 50.390

Possibly from an untitled series with no. 323.

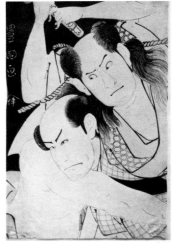
327

*327. The actors Sawamura Sōjūrō III and Arashi Ryūzō in a night battle from an unidentified play performed at the Kiri theater
mid 1796
Signature: Toyokuni ga
Publisher: Yamaden
ōban, 322 × 221
colored outline and black ground

A258, 50.391

From a series of half-length double portraits of actors published in 1796 by Yamaden, an otherwise virtually unknown publisher.

328. The actors Segawa Kikunojō III and Arashi Sampachi as Mikuni Kojorō and her older brother Kyūjūrō in *Tomioka koi no yamabiraki,* Kiri theater
2/1798
Signature: Toyokuni ga
Publisher: Nishimura (?) (emblem, Chō han)
Censorship seal: kiwame
ōban, 388 × 263
mica over a grey ground

A259, 50.392

From an untitled series of double half-length portraits of actors published in the spring of 1798.

The mica may be a later addition, although it does appear on a few large heads by Toyokuni in this period.

PLATE 28 (color).

329abc. Women washing and stretching lengths of cloth beside a well
late 1790s
Signature: Toyokuni ga
Publisher: Tsutaya Jūzaburō (emblem)
Censorship seal: kiwame
ōban triptych, 362 × 749

A263a–c, 50.396

PLATE 152.

330. The actor Ichikawa Ebizō IV as Toraya Tōkichi disguised as an *uirō* seller in a memorial performance for the actor Ichikawa Danjūrō VI at the Nakamura theater
5/1800
Signature: Toyokuni ga
Publisher: Tsuruya Kinsuke (emblem)
hosoban, 321 × 147

A255, 50.388

In 11/1800 Ebizō changed his name to Ichikawa Danjūrō VII.

The packet contains *uirō,* a medicinal powder manufactured in the town of Odawara on the Tōkaidō Road.

*331abc.
Women washing, rinsing, and fulling cloth by a stream
ca. 1800
Signature: Toyokuni ga
Publisher: Izumiya Ichibei (Senichi)
ōban triptych, 371 × 766
Reference: Blanchard 55, ill.
Provenance: Hayashi

A264a–c, 50.397

332

Utagawa TOYOKUNI and Utagawa KUNINAGA

*332. Dancer adjusting her hair with a hand mirror before asking two priests of Dōjō Temple to allow her to dance beside the temple bell
ca. early 1810s
Signature: Toyokuni ga, monjin Kuninaga kore o utsusu
long surimono, 191 × 528
embossing

A375, 50.508

Utagawa KUNIMASA

333. The actor Iwai Kumetarō as the *kamuro* Tayori from the Shimabara district in Kyōto in *Modorikago nori no shigayama,* a dance play performed as a memorial to Nakamura Nakazō I at the Kiri theater
4/1796
Signature: Kunimasa ga
Publisher: Uemura Yohei (Uemura)
Censorship seal: kiwame
ōban, 352 × 244
colored outline, painted eyes, and grey ground

A340, 50.473

From the second group of bust portraits of actors published by Uemura, including designs by Shunei, Toyokuni and Kunimasa.

The inscription seems to be added later. An additional note in the same hand adds that the actor later used the name Iwai Hanshirō. The actor assumed that name at the end of 1804.

PLATE 31 (color).

Katsukawa SHUNTEI

334. The actors Ichikawa Danzō and Osagawa Tsuneyo as Daihanji Kiyozumi and the widow Sadaka in *Imoseyama onna teikin,* Morita theater
9/1798
Signature: Shuntei ga
Publisher: Tsuruya Kiemon (emblem)
ōban, 374 × 247
grey ground

A326, 50.459

From a set of fifteen or more grey ground double portraits of actors, most of them designed by Kunimasa, published by Tsuruya between 8/1798 and 1/1799. The early prints in the group have the actors' crests above their names, as here.

335

Katsushika HOKUSAI

*335. Summer. Two women by a stream
Series: *Fūryū shiki no tsuki,* The elegant moon in the four seasons

331

176

ca. late 1780s
Signature: Shunrō ga
small chūban, 217 × 155
Provenance: Authentication seal of
J.S. Happer on verso

A572, 50.705

Portion of contiguous panel showing in margin at right.
One other picture from the set, Spring, is known (Morse 64).

336

*336. *Sambonbashira*, Three poles
Series: *Fūryū mitate kyōgen,* Elegant parodies of comic plays
ca. 1790
Signature: Shunrō ga
Publisher: Tsutaya Jūzaburō
small chūban, 213 × 150
Unrecorded

A573, 50.706

One other print from the set is known.

337

*337. Chinese children playing by a pine tree
ca. 1790
Signature: Shunrō ga
Publisher: Eijudō
ōban, 380 × 250
Reference: Morse 73.

A574, 50.707

The right panel of one of two diptychs of children designed for the publisher Eijudō whose name appears on the banner in this print. The complete diptych is reproduced in Hillier, *Hokusai.*

338. The actor Iwai Hanshirō IV as the courtesan Agemaki in *Sukeroku yukari no botan,* Nakamura theater
3/1791
Signature: Shunrō ga
hosoban, 254 × 139
the actor's lips hand-colored

A571, 50.704

PLATE 166.

339. Peasants harvesting rice in the countryside
1799
Signature: Sōri aratame Hokusai ga
long surimono, 192 × 502
embossing
Provenance: Appleton

A633, 50.766

PLATE 139.

340

*340. Women comforting child as servant retrieves his kite on the way to a festival at an Inari Shrine in Edo
early 1800s
Signature: Gakyōjin Hokusai ga
long surimono, 198 × 540
Provenance: Appleton

A634, 50.767

Nos. 341–347 are from the same series and have the same signature, publisher, and format.
The poets are drawn with the syllables for their names, and each has his/her name and a poem above in calligraphy by Kokunan (?).
The publisher's mark appears on the portraits of Sōjō Henjō and Ariwara Narihira.
ca. mid 1810s
Signature: Katsushika Hokusai ga
Publisher: Ezakiya
ōban, 379 × 252, with variation up to 4 mm. within set

341. The poetess Ono no Komachi
Untitled series of the Six Immortal Poets
Reference: Morse 127.3.

A635, 50.768

342. The poetess Ono no Komachi
Different color block for the first horizontal geometric pattern above.

A636, 50.769

343

*343. The poet Sōjō Henjō
Reference: Morse 127.2.

A637, 50.769

344. The poet Ōtomo no Kuronushi
Reference: Morse 127.5.

A638, 50.771

345. The poet Kisen Hōshi
Reference: Morse 127.4.

A639, 50.772

PLATE 145.

346. The poet Bunya no Yasuhide
Reference: Morse 127.6.

A640, 50.773

347. The poet Ariwara no Narihira
Reference: Morse 127.1.

A641, 50.774

*348. *Hannya,* Demon with a child's head
Series: *Hyaku monogatari,* Ghost tales
1830
Signature: Zen Hokusai hitsu
Publisher: Tsuruya Kiemon
chūban, 252 × 185
Reference: Morse 131.3.
Provenance: May
Publication: May 888, $10.

A630, 50.762

From a series of five ghost prints. A drawing related to this print, often described as a preparatory sketch, is probably a later copy of the print.

348

349. Sparrow, cicada and flowers
Untitled series of pictures printed in blue
ca. 1830
Signature: Zen Hokusai hitsu
Artist's seals: unread
Publisher: Moriya Jisuke
Censorship seal: kiwame
chūban, 241 × 170
Reference: not in Morse.
Provenance: Lafarge, May
Publication: May 642, $7.50.
A626, 50.759

Yasuda points out that Hokusai used a different seal on each print in the series.
PLATE 62.

350

*350. Paddy bird and magnolia
Untitled series of ten chūban prints of birds and flowers
early 1830s
Signature: Zen Hokusai Iitsu hitsu
Publisher: Nishimuraya Yohachi (Eijudō)

Censorship seal: kiwame
chūban, 254 × 179
Reference: Morse 130.7; TNM 3846.
Provenance: May
Publication: May 666, $12.50.
A627, 50.760

A Chinese poem is printed at the right.

351

*351. Canary and rose
Untitled series of ten chūban prints of birds and flowers
Signature: Zen Hokusai Iitsu hitsu
Artist's seal: Manji
Censorship seal: kiwame
chūban, 250 × 173
Reference: Morse 130.6; TNM 3849 (2 seals).
A628, 50.761

Impressions with the single square, diagonally divided seal are from different blocks than the original edition of the prints which have a square and round seal for the publisher's and censor's mark. There is no general agreement whether the impressions with the single seal are contemporary or later copies, but some of the single-seal impressions are on thin Chinese-style paper. An impression of the other version of the print is reproduced in Blanchard, 231.
The poem by Otsuji is about roses.

352. Chrysanthemums and bees
Untitled series of ten large prints of flowers
early 1830s
Signature: Zen Hokusai Iitsu hitsu
Publisher: Eijudō
Censorship seal: kiwame
ōban, 256 × 372
yellow ground
Reference: Morse 129.4; TNM 3812.
A631, 50.763

PLATE 64.

*353. Two cranes on a pine tree in the snow
ca. 1834
Signature: Zen Hokusai Iitsu hitsu

Publisher: Moriya Jihei
Censorship seal: kiwame
nagaban, 507 × 230
Reference: Morse 161.
A632, 50.805

From an untitled group of five prints of bird and animal subjects in this format published by Moriya Jihei probably during the same period as the *Imagery of the Poets* series.

353

Nos. 354–379 are from the same series and have the same series title, signature and format, except when noted.
The last ten prints in the set (nos. 369–78) have black keyblocks and seem to have been published at a slightly later date.

354. *Gaifū kaisei*, Fuji in clear weather (Red Fuji)
Series: *Fugaku sanjūrokkei*, Thirty-six views of Mt. Fuji
ca. early 1830s
Signature: Hokusai aratame Iitsu hitsu (nos. 354–360); Zen Hokusai Iitsu hitsu (nos. 361–379)
ōban, 244 × 372, with variation up to 18 mm.
Reference: Goncourt 8; Morse 33; UTK 13,2.
Provenance: Jacquin
Publication: Jacquin 514, ill., $300.
A578, 50.711

On clear summer mornings the rays of the rising sun make Fuji look pink on its northern slopes, and inhabitants of this area call this phenomenon "Pink Fuji." The earliest impressions of the print capture this effect and are very light and delicate. Later impressions are printed with a harsher contrast between the blue, red-brown, and green, and as they are more common, the print has been given the popular name "Red Fuji."
Gaifū kaisei literally means clear weather with a south breeze.

355

*355. *Sanka hakuu*, Rain beneath the peak (Fuji over lightning)
Reference: Goncourt 9; Morse 32; UTK 13, 3.
Provenance: Jacquin
Publication: Jacquin 512, ill., $425.
A579, 50.712

356. *Fukagawa mannenbashi no shita*, Fuji from beneath Mannen Bridge in the Fukagawa district of Edo
Reference: Goncourt 31; Morse 6; UTK 13, 4.
Provenance: May
Publication: May 399, $22.50.
A592, 50.725

357. *Tōto surugadai*, Fuji from Surugadai in the eastern capital
Reference: Goncourt 43; Morse 3; UTK 13, 5.
Provenance: Blanchard
Publication: Blanchard 203, $35.
A588, 50.721

358. *Bushū senju*, Fuji from the weir at Senju in Musashi Province
Reference: Goncourt 36; Morse 14; UTK 13, 7.
A584, 50.717

359. *Kōshū inumetōge*, Fuji from the Dog's-eye Pass in Kai Province
Reference: Goncourt 16; Morse 121.41; UTK 13, 9.
Provenance: Bunshichi Kobayashi
A576, 50.709

360. *Bishū fujimigahara*, Fuji seen through a barrel on the plain of Fujimihara in Owari Province
Reference: Goncourt 4; Morse 40; UTK 13, 10.
A595, 50.728

361. *Tōto asakusa honganji*, Fuji from the roof of Hongan Temple, Asakusa, in the eastern capital
Reference: Goncourt 44; Morse 4; UTK 13,11.
Provenance: May
Publication: May 393, $5.
A590, 50.723

362. *Sōshū umezawa hidari*, Fuji from Umezawa Marsh in Sagami Province

Reference: Goncourt 29; Morse 27; UTK 13, 14.
A593, 50.726

Japanese writers agree that the character *hidari*, or "left," at the end of the picture title is an uncorrected engraver's error, but it could mean Mt. Fuji with Umezawa Marsh at the left.
PLATE 34.

363. *Kōshū mishimagoe*, Fuji from Mishima Pass in Kai Province
Reference: Goncourt 18; Morse 29; UTK 13, 16.
Provenance: May
Publication: May 410, $22.50.
A594, 50.727

364. *Shinshū suwako*, Fuji from Lake Suwa in Shinano Province
Publisher: Eijudō
Censorship seal: kiwame
Reference: Goncourt 13; Morse 44; UTK 13, 17.
A599, 50.732

365. *Jōshū ushibori*, Fuji from Ushibori in Hitachi Province
Reference: Goncourt 12; Morse 19; UTK 13, 20.
A587, 50.720

366. *Edo surugachō mitsui mise ryakuzu*, A simple sketch of the Mitsui cloth shop at Surugachō in Edo
Reference: Goncourt 42; Morse 2; UTK 13, 21.
Provenance: May or Blanchard
Publication: May 391, $5 or Blanchard 202, $25.
A585, 50.718

367. *Ommayagashi yori ryōgokubashi sekiyō o miru*, Twilight at Ryōgoku Bridge from the Ommaya Bank of the Sumida River
Publisher: Eijudō
Censorship seal: kiwame
Reference: Goncourt 45; Morse 12; UTK 13, 22.
A583, 50.716

368. *Shimomeguro*, Fuji from lower Meguro
Publisher: Eijudō
Censorship seal: ame
Reference: Goncourt 35; Morse 10; UTK 13, 25.
Provenance: Hayashi, Blanchard, and stamped Japanese dealer's code number on verso
Publication: Blanchard 198, $25.
A586, 50.719

369. *Sōshū enoshima*, Fuji from Enoshima Island in Sagami Province
Reference: Goncourt 25; Morse 25; UTK 13, 27.
A598, 50.731

370. *Kazusa no kairo*, Fuji with ships under sail in Kazusa Province
Reference: Goncourt 11; Morse 17; UTK 13, 30.
Provenance: May
Publication: May 474, $3.75.
A591, 50.724

371. *Sumidagawa sekiya no sato*, Horsemen galloping at Sekiya village near the Sumida River
Reference: Goncourt 46; Morse 13; UTK 13, 30.
Provenance: May
Publication: May 402, $25.
A596, 50.729

The galloping horsemen figure in one of the highly finished watercolor paintings Hokusai produced for Philipp Frank von Siebold in the 1820s.

372. *Kōshū misaka suimen*, Fuji reflected in the lake at Misaka in Kai Province
Reference: Goncourt 17; Morse 42; UTK 13, 35.
A582, 50.715

373

*373. *Tōkaidō hodogaya*, Fuji from Hodogaya on the Tōkaidō Road
Reference: Goncourt 21; Morse 23; UTK 13, 36.
A580, 50.713

374. *Sōshū nakahara*, Fuji from Nakahara in Sagami Province
Publisher: Eijudō (emblem on man's pack)
Reference: Goncourt 26; Morse 26; UTK 13, 40.
A589, 50.722

375. *Kōshū izawa akatsuki*, Dawn at Izawa in Kai Province
Publisher: Eijudō
Censorship seal: kiwame
Reference: Goncourt 13; Morse 121.43; UTK 13, 41.
A575, 50.708

*376. *Sunshū ōno shinden*, Reclaimed land at Ōno in Suruga Province
Publisher: Eijudō
Censorship seal: kiwame
Reference: Goncourt 2; Morse 31; UTK 13, 43.
A577, 50.710

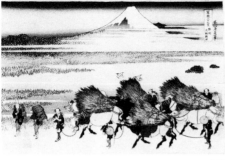

376

377. *Tōkaidō kanaya no fuji*, Fuji from the ford on the Ōi River at Kanaya on the Tōkaidō Road
Publisher: Eijudō
Censorship seal: kiwame
Reference: Goncourt 23; Morse 37; UTK 13, 45.
Provenance: May
Publication: May 411, $30.
A597, 50.730

378. Same as 377
Publisher: Eijudō
Censorship seal: kiwame
A597A, 50.730A
A later, darker, but some ways more effective impression with break in the publisher's mark.

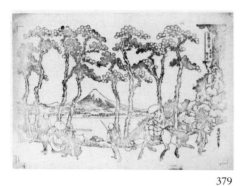

379

*379. Fuji from Hodogaya on the Tōkaidō Road
A581, 50.714
Keyblock proof impression, printed in brown, of a modern facsimile of Hokusai's print (no. 373).

Nos. 380–382 are from the same series and have the same series title, signature, format, approximate size and date.
The complete set of three prints is in the collection.
The three subjects are matched with the three largest cities in Japan.

380. *Sumida*, Snow on the Sumida River in Edo
Series: *Setsugekka*, Snow, moon and flowers
early 1830s
Signature: Zen Hokusai Iitsu hitsu

ōban, 255 × 381
Reference: Morse 119, 1.
A600, 50.733

381. *Yodogawa*, Moon over the Yodo River in Osaka
Reference: Morse 119, 2.
A601, 50.734

*382. *Yoshino*, Cherry blossoms at Yoshino near Kyōto
Publisher: Eijudō (on cloth coverings)
Reference: Morse 119, 3.
A602, 50.735

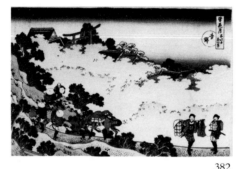

382

Nos. 383–388 are from the same series and have the same series title, date, signature, publisher, censorship seal and format. Eleven pictures in the series are known. Ten were probably published together ca. 1832–33.

383. *Settsu ajikawaguchi tempōzan*, Mt. Tempō at the mouth of the Aji River in Settsu Province
Series: *Shokoku meikyō kiran*, Famous bridges of the provinces
early 1830s
Signature: ōju naniwa no zu o manete Zen Hokusai Iitsu hitsu (drawn by Hokusai by special request after a picture from Ōsaka)
Publisher: Eijudō
Censorship seal: kiwame
ōban, 254 × 375, with variation up to 13 mm. within set
Reference: Morse 120, 8.
Provenance: May
Publication: May 651, $22.50.
A613, 50.746
This print may have been added when Mt. Tempō, a man-made hill, was completed in the spring of 1834 from silt raised in the dredging of the Aji River near Ōsaka.
PLATE 35 (color).

384. *Mikawa no yatsuhashi no kozu*, An ancient picture of the eight-section bridge of Yatsuhashi in Mikawa Province
Reference: Morse 120, 11.
Provenance: Blanchard
Publication: Blanchard 229, $35 (catalogue: "fine impression, superb condition") now slightly faded.
A614, 50.747

385. *Kameido tenjin taikobashi*, The drum bridge at the Tenjin Shrine at Kameido in Edo
Reference: Morse 120, 7.
Provenance: May
Publication: May 650, $22.50.
A615, 50.748

386. *Ashikaga gyōdōzan kumo no kakehashi*, The bridge of hanging clouds at Mt. Gyōdō near Ashikaga in Tochigi Prefecture
Reference: Morse 120, 3.
Provenance: May
Publication: May 646, $22.50.
A616, 50.749

*387. *Hietsu no sakai tsuribashi*, The suspension bridge on the boundary of Hida and Etchū Provinces
Reference: Morse 120, 4.
A617, 50.750
The first state of the print, before the right edge of the mountain below the bridge was removed.

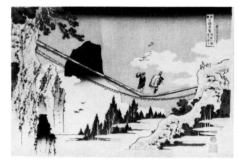

387

388. *Kōzuke sano funabashi no kozu*, An ancient picture of the Bridge of Boats at Sano in Kōzuke Province
Reference: Morse 120, 2.
A612, 50.745
A modern facsimile with the maker's mark in a circle in the lower right hand corner.

389. *Sōshū ōyama rōben no taki*, Rōben Waterfall at Ōyama Mountain in Sagami Province
Series: *Shokoku taki meguri*, A tour of waterfalls in the provinces
early 1830s
Signature: Zen Hokusai Iitsu hitsu
Publisher: Eijudō
Censorship seal: kiwame
ōban, 377 × 259
Reference: Morse 123, 7.
Provenance: Blanchard
Publication: Blanchard 209, $27.50.
A620, 50.753
PLATE 92.

Nos. 390–391 are from the same series and have the same series title, signature, format and approximate size.

390. *Chōkō shūsei*, The voice of autumn at Chōkō
Series: *Ryūkyū hakkei*, Eight views

180

of the Ryūkyū Islands
mid 1830s
Signature: Zen Hokusai Iitsu hitsu
Publisher: Moriya Jisuke
ōban, 257 × 382
Reference: Morse 118, 6.

A618, 50.751

From a set of eight color prints after simple black and white illustrations in a guidebook to the Ryūkyū (or Loochoo) Islands published ca. 1830. (The Ryūkyū Islands include Okinawa.)

PLATE 36 (color).

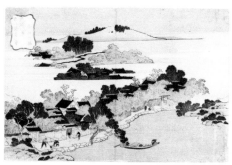

391

*391. *Kumemura chikuri,* Bamboo groves at Kume Village
Reference: Morse 118, 3.
Provenance: May
Publication: May 655, $12.50.

A619, 50.752

Nos. 392–400 are from the same series and have the same series title, date, signature, publisher, censorship seal and format.

392. The poet Harumichi no Tsuraki viewing a mountain stream
Series: *Shika shashinkyō,* A mirror of the imagery of Chinese and Japanese poets
ca. 1834
Signature: Zen Hokusai Iitsu hitsu
Publisher: Moriya Jihei
Censorship seal: kiwame
nagaban, 512 × 227, with variation up to 10 mm. within set
Reference: Morse 159, 1.

A603, 50.736

Nine of the ten plates in the series (lacking the reed cutter) are in the Ainsworth collection. This set has been greatly admired by collectors, and forms a transition in both subject matter and technique between the pure landscapes of the early 1830's and the intensely colored landscapes with figures of the *100 Poems,* which began appearing around the spring of 1835.

393. The poet Abe no Nakamaro viewing the moon on the night before his departure from China
Reference: Morse 159, 2.

A604, 50.737

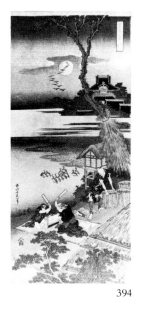

394

*394. Fullers pounding cloth by moonlight; illustration of a poem by Ariwara no Narihira
Reference: Morse 159, 3.

A605, 50.738

395. The poet Tōru Daijin contemplating a landscape with a crescent moon
Reference: Morse 159, 4.

A606, 50.739

Hillier has suggested that the poet may be in his own garden, which contained a miniature landscape of the area around Shiogama in northern Japan.

396. Horsemen in a summer landscape; illustration of a Chinese poem on the pleasures of traveling, entitled *Shōnenkō*
Reference: Morse 159, 6.

A607, 50.740

397. The Chinese poet Po Chu-i (Hakurakuten) visits Japan, meets Sumiyoshi, the Japanese god of poetry disguised as a fisherman, and submits a couplet in competition with him
Reference: Morse 159, 7.

A608, 50.741

398. The poet Li Po viewing a waterfall
Reference: Morse 159, 8.

A609, 50.742

PLATE 90.

399. A soldier in the army of Meng Chang-jun tricks the guards at Kankokukan into opening their gates by imitating a cock crow; illustration to a remark by the Japanese poetess Sei Shōnagon
Reference: Morse 159, 9.

A610, 50.743

400. A Chinese poet on horseback stopping his horse to contemplate a flock of gulls in the snow
Reference: Morse 159, 10.

A611, 50.744

The picture is never titled, but the subject is usually identified as the Chinese poet Su Tung-po.

Nos. 401–405 are from the same series and have the same series title, signature, publisher and censorship seals, and format.

401. 1. Peasants walking through autumnal rice fields; illustration of a poem by the emperor Tenchi
Series: *Hyakunin isshu uba ga etoki,* The 100 Poems as explained by the old nurse
1835–36
Signature: Zen Hokusai Manji
Publisher: Eijudō
Censorship seal: kiwame
ōban, 237 × 371
Reference: Morse 122, 1.

A622, 50.755

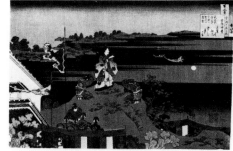

402

*402. 7. The poet Abe no Nakamaro viewing the moon on the night before his departure from China
247 × 371
Reference: Morse 122, 7.
Publication: perhaps Blanchard 212, $27.50 (catalogue: "fine impression, perfect condition").

A623, 50.756

403. 24. Carriage and attendants waiting for the poet Sugawara Michizane as he worships on Mt. Tamuke
252 × 373
Reference: Morse 122, 15.

A625, 50.758

Mary Ainsworth bought an impression of this print at the Blanchard sale, lot 214, for $17.50. The catalogue describes it as a "splendid impression, beautiful condition" so it is probably not this print, which is a late impression, with double printing at lower left.

404. 36. Pleasure boats on the Sumida River on a summer night; illustration of a poem by Kiyowara no Fukayabu
260 × 374
Reference: Morse 122, 20.

A624, 50.757

405. 49. Resting after a bath; illustration of a poem by Fujiwara no Yoshitaka
250 × 365
Reference: Morse 122, 24.

A621, 50.754

First state of the print with the red seals printed over the yellow band at the left.

PLATE 137.

Ryūryūkyo SHINSAI

406. Women preparing "dragon water" on the first dragon day of the new year
1808
Signature: Shinsai ga
surimono, 134 × 186
with gold

A358, 50.491

Poems by Hassōsha Kanekazu, Sasaura Suzunari and Shūchōdō Monoyana. 1808 was a dragon year.

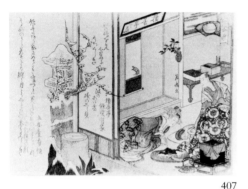

407

*407. *Shiragai*, White shell: The poet Sekizentei Ariie watching a woman prepare a tray landscape
Series: *Kasen awase*, Matching poets
1809
Signature: Shinsai ga
surimono, 234 × 185
with gold

A359, 50.492

Poems by Sekizentei Yokei no Ariie, Goandai Aritsune and Yomo Utagaki Magao, who also inscribed the placard with the characters Sekizentei above the alcove.
From a series of 36 prints based on shells for the snake year, 1809.

408. Woman fixing her hair before a mirror
ca. early 1810s
Signature: Shinsai
square surimono, 215 × 188
embossing and metallic pigments
Provenance: Jacquin
Publication: Jacquin 1921, 323.

A361, 50.494

Poems by Fumizukue Masame and Hikyūen Komatsu.

409. Peasants in snow startled by woman with bucket on head
ca. 1810s
Signature: Shinsai
chūban, 227 × 168
Provenance: Hayashi

A629, 50.762

410. *Yabase kihan*, Returning sails at Yabase
Series: *Ōmi hakkei*, Eight views of Lake Biwa
ca. 1810s
Signature: Ryūryūkyo Shinsai sha
ōban, 243 × 363

A356, 50.489

Shinsai's rare western-style landscapes have the same colors, drawing, and printed borders as Hokusai's similar landscapes of this period.
A slightly later impression than no. 411, with slightly different coloring.

411

*411. *Yabase kihan*, Returning sails at Yabase
ca. 1810s
Signature: Ryūryūkyo Shinsai sha
ōban, 262 × 385

A357, 50.490

See remark on no. 410.

412

Shōtei HOKUJU

*412. *Tōto asakusagawa sanyabori iriguchi muki ushijima no kei*, View of Ushijima from the mouth of the Sanya Canal and the Asakusa River in the Eastern Capital
Untitled series of western style views of Edo
early 1820s
Signature: Shōtei Hokuju ga
Publisher: Eijudō
Censorship seal: kiwame
ōban, 262 × 372

A362, 50.495

Totoya HOKKEI

413. Crossing the Yellow River
Series: *Kanshi gafu no uchi*, An album of pictures for Chinese poems
early 1830s
Signature: Hokkei
chūban, 255 × 179

A343, 50.476

The series has printed blue borders and may have been published as an album.

PLATE 112.

414. *Takinogawa momiji*, Autumn leaves by the Takino River
early or mid 1830s
Signature: Hokkei
album sheet, 251 × 347
with silver and gold

A344, 50.477

From a poetry album.

415. The spirit of Yang Kuei-fei offering the Emperor Ming Huang the elixir of immortality by the palace of the moon
1831
Signature: Hokkei
surimono, 427 × 183
metallic pigments
Provenance: Appleton

A345, 50.478

Poems by Kagendō Tsugio and Seiyōkan Umeyo.
The woman on the steps of the palace holds a rabbit, indicating the rabbit year 1831.

416. Prince Kaoru and Ukifune in a snowy landscape
Untitled series for the Akabane group
late 1820s
Signature: Hokkei
square surimono, 210 × 483
silver pigment
Provenance: Appleton

A346, 50.479

Poems by Fukkitei Kanezane, Akebono no Haruko and Hananoto Masao.

417. *Ryūtō*, the Cave of the Dragon on the island of Enoshima
Series: *Enoshima kikō jūrokuban tsuzuki*, Record of a journey to Enoshima: a set of 16 pictures
early 1830s
Signature: Hokkei
square surimono, 210 × 179

metallic pigments and embossing
Provenance: Appleton

A347, 50.480

Fourteen of the 16 prints are presently known.
Poems by Shinrintei Kimori and Shinsuitei Umaki.

418. Ferryboat at Rokugō
Series: *Enoshima kikō,* Record of a journey to Enoshima
early 1830s
Signature: Hokkei
square surimono, 209 × 170
with silver
Provenance: Appleton

A348, 50.481

Poems by Morinoya Okage and Moriashi Asobito.
PLATE 100.

419

*419. Travellers at Ushigafuchi
Untitled series of views of places including the word *ushi,* or ox
1829
Signature: Hokkei
square surimono, 195 × 172
with gold and silver
Provenance: Appleton (?), Rouart

A349, 50.482

Poems by Manmansai Managa, Shinsuitei Ōeda and Shinratei. The last poem has corrections in red added by hand.

UNIDENTIFIED

*420. *Nangaku kōzan,* Kōzan, the Southern Mountain. Courtesan holding a tray with an incense burner
Series: *Gogaku no uchi,* Five sacred Mountains of China
1806 or 1818
Unsigned
surimono, 136 × 193
gold, silver, and embossing

A291, 50.424

Poems by Issosha Hayanori, Katatasha Katagoto and Jōtōsha Senzuke. The picture has been attributed to Gakutei in the past because he used the word Gogaku, part of the series title, as a signature. The style of the picture, however, is closer to Hokusai, and this may explain the large character for *sai* in seal script. The picture is dated Spring, year of the tiger, and was therefore published in 1806 or 1818.

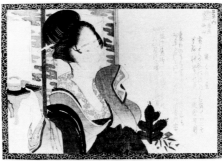

420

Yashima GAKUTEI

421. The stone bridge at the new mountain by the Aji River in Ōsaka
Series: *Tempōzan shōkei ichiran,* Views of Mt. Tempō
1834
Signature: Gogaku
Artist's seals: geometric seal
Publisher: Shiyoya Kisuke
ōban, 253 × 378

A350, 50.483

Originally published as an album of six pictures with printed covers, and preface. An example of the complete album is in the Pulverer collection. The meaning of the seal reading *kō* is unclear. Perhaps this was the publisher of a commercial edition of the individual prints.

422. Evening rain at Mt. Tempō in Ōsaka
Series: *Tempōzan shōkei ichiran,* Views of Mt. Tempō
1834
Signature: Gogaku
Artist's seals: geometric seal
ōban, 261 × 381

A352, 50.485

See remarks on no. 421.
PLATE 101.

423. Sheltering from rain at the new mountain by the Aji River in Ōsaka
Series: *Tempōzan shōkei ichiran,* Views of Mt. Tempō
1834
Signature: Gogaku
Artist's seals: geometric seal
ōban, 256 × 380

A351, 50.484

See remarks on no. 421.
PLATE 148.

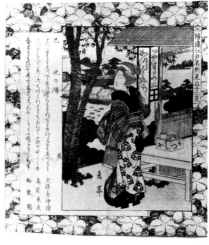

424

*424. Snake: The Katsushika teahouse at Ikenohata
Series: *Ichiyōren edo meisho mitate jūnishi,* Famous places in Edo matched with animals of the zodiac for the Ichiyō Circle
early 1820s
Signature: Gakutei
square surimono, 212 × 187
embossing

A353, 50.486

Poems by Bunseisha Okizumi, Torioi Itohiko and Bairyūen.
The snake was sacred to the goddess Benten who was worshipped at the shrine in the middle of Shinobazu Pond in the background.

425. The courtesan Hyōgo
Series: *Katsushikaren gakumen fujin awase,* Votive paintings of women for the Katsushika Circle
early 1820s
Signature: Gakutei
square surimono, 209 × 183

A354, 50.487

Poems by Bumpōsha Tamamaru and Shōbaisha Shimaru.

426. The Immortal Rinnasei with wine cup and crane, plum blossoms and rising sun
mid 1820s
Signature: Gakutei
Artist's seal: Yashima Sadaoka
square surimono, 211 × 189
embossing and metallic pigment
Provenance: Appleton

A355, 50.488

Poem by Kōjuken Shikyō.
The poet Rinnasei (or Lin Ho-tsing), usually shown with a crane beneath a plum tree, had no wish to leave his poems to posterity, and never wrote them down.
PLATE 40 (color).

Kitao MASAYOSHI

427. *Hira bōsetsu*, Lingering snow on Mt. Hira
Series: *Ōmi hakkei*, Eight views of Lake Biwa
ca. 1810s
Signature: Kitao Masayoshi ga
chūban, 258 × 189
A328, 50.461
PLATE 75.

428. Bush warbler and peonies
Series: *Ehon kachō kagami*, A mirror of flowers and birds
1789
Signature: Keisai sha
Artist's seal: Kitao Masayoshi
Publisher: Matsumoto Zembei
Engraver: Shumpūdō Ryūko
album sheet, 252 × 373
the flowers printed without outline
Reference: Binyon and Sexton 15.
A330, 50.463

The bird is given the Chinese name *kōri*, or *kōchō*, which is the same as the Japanese *uguisu*.

The illustrations are said to be copies of pictures by the painter Ishōsai Shūsen.

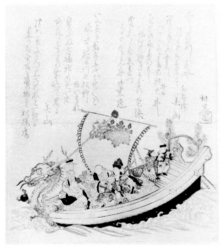

429

SŌRAN

*429. Treasure ship with the seven lucky gods
1817
Signature: Sōran
Artist's seal: unread
Printer: Shūgyokudō (seal on verso)
square surimono, 214 × 188
gold and silver pigments added
Provenance: Appleton
A342, 50.475

Poems by the courtesan Miyama of the house Kōtokurō and her attendants Aizome and Ainare.

The first line of the poem seems to mention an ox, indicating the ox year, 1817.

A seal on the back gives the name Ebiya Kichisuke, probably the proprietor of Kōtokurō, a brothel or house of entertainment in the Yoshiwara district.

The first character in the name also appears on the sail of the ship and Kichisuke may also have been the designer of the print.

Katsushika TAITO II

430. Full moon beneath the Monkey Bridge
From an untitled series of assemblage pictures
ca. mid or late 1830s
Signature: Katsushika Taito
Artist's seals: illegible
Publisher: Echigoya Chōhachi
Censorship seal: kiwame
ōban, 384 × 257
A642, 50.775

The second state of the print with the larger moon.

The Chinese poem above printed in imitation of a stone-rubbing is signed Senseki. *Harimaze*, or assemblage pictures, were composed of pictures and verse in various formats, often by different artists, arranged to fill a standard ōban sheet.

*431. Carp and water weeds
Untitled *harimaze* series
ca. mid or late 1830s
Signature: Katsushika Taito
Artist's seals: Ko . . . no in, Bunyū (2nd character in first seal unread)
Publisher: Echigoya Chōhachi
Censorship seal: kiwame
ōban, 373 × 256
Reference: Crighton IV, 13.
Provenance: May
Publication: May 643, $10.
A643, 50.776

The Chinese poem at the left is printed in reserve in imitation of a stone-rubbing. It seems to be signed Tenō ryōshi, and is sealed Shinsei no in.

431

432. Paddy birds on cherry branch
ca. mid-late 1830s
Signature: Katsushika Taito
Artist's seals: unread
350 × 86, section of an assemblage print
Provenance: May
Publication: May 643, $5.
A644, 50.777

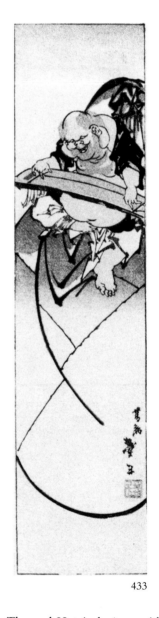

433

*433. The god Hotei playing a zither on a huge sack
ca. mid or late 1820s
Signature: Katsushika Taito
Artist's seals: unread
Censorship seal: kiwame
364 × 87, section of an assemblage print
Provenance: May
Publication: May 643, $2.50.
A645, 50.778

Katsushika HOKUI

434. Nichiren and the seven-headed god
of Minobu
Series: *Nichiren shōnin goichidaiki,*
Biography of St. Nichiren
ca. 1850
Signature: Hakusanjin Hokui hitsu
Artist's seal: Fuji
Publisher: unidentified
Censorship seals: Watanabe, Kinu-
gasa
ōban, 245 × 354
A564, 50.697
PLATE 132.

Shunkōsai HOKUSHŪ

435. The actors Nakamura Utaemon III
and Arashi Koroku as Fukashichi
and Omiwa in *Imoseyama onna tei-
kin,* Kado theater
3/1821
Signature: Shunkōsai Hokushū ga
Artist's seal: Yoshinoyama
ōban, 388 × 255
embossing, metallic pigments, and
gold ground
A363, 50.496
Another impression in the Philadelphia Mu-
seum is reproduced in Keyes and Mizushima
1973.
Later impressions have different colors, lack
the artist's seal and gold ground.

attributed to Ryūsai SHIGEHARU

436. Taishinō playing a zither as she rides
a dragon through the clouds
early or mid 1830s
unsigned
ōban surimono, 354 × 251
metallic pigment and areas printed
without outline
Provenance: Appleton
A360, 50.493
Perhaps a proof, without poems, of an
Osaka surimono. No other impressions are
presently known.
PLATE 67.

BUNSEI

437. Chinese landscape
ca. 1830s
Signature: Bunsei
Artist's seals: unread
ōban, 255 × 377
A563, 50.696
Chinese poem by Nanzan (Nan Shan).
Possibly from a set of Chinese-style land-
scapes issued in album format.
PLATE 113.

Nakamura HŌCHŪ

438. Pine tree and plum blossom
ca. 1810s or 1820s
Signature: Hōchū kore o utsusu
Artist's seal: Hōsei (?)
long surimono, 216 × 457
embossing and metallic pigments
A567, 50.700
Poem by Reinichian Baisoku at the age of
60.
PLATE 41 (color).

KŌIN

439. Immortal flying to heaven on the
back of a crane, followed by six
other cranes
1825
Signature: Kōin
Artist's seals: unread
Publisher: Bokusendō Kataoka kō
two uncut long surimono with text,
each ca. 445 × 571
embossed outlines, gold pigment,
and gold flakes
A568, 50.701
This picture and the following form a pair
published in honor of the Osaka actor
Nakamura Utaemon III and bear poems
by many Osaka actors. The tone of the text
and poems is felicitous, and the print was
probably issued to commemorate Utae-
mon's announcement of his retirement in
1825. If so, the print is of special historical
interest since Prussian blue seems to be used
on the immortal's cap and this color, which
is used in so many landscape prints, is said
not to have been introduced in Edo until
1828.
PLATE 140.

440. Immortal flying to heaven on the
back of a crane, followed by six
other cranes
Date, signature, seals, publisher,
format and size same as preceding
entry.
A569, 50.702
PLATE 141.

Utagawa TOYOHIRO

*441. Shrike and autumn grass
ca. 1810s
Signature: Toyohiro ga
narrow panel, 334 × 72
grey and black
A331, 50.464

442. Geese in flight
ca. late 1820s (?)
Signature: Toyohiro ga
chūban, 228 × 172
two shades of Prussian blue
Provenance: Blanchard
Publication: Blanchard 60, $15.
A332, 50.465
Prussian blue does not seem to have been
used in Edo before 1829, the year before
Toyohiro's death. The print may be a late
impression of a picture designed earlier.

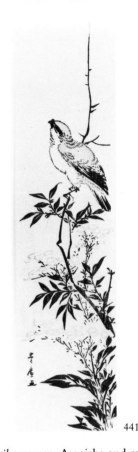

441

*443. *Geiko no yau,* A geisha and evening
rain
Untitled series of eight views
1800s
Signature: Toyohiro ga
surimono, 190 × 128
A333, 50.466

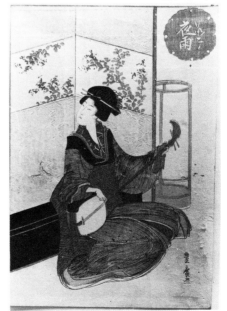

443

444. Act XI of the play *Chūshingura*
Series: *Ozashiki ningyō,* A private puppet performance
ca. 1800
Signature: Toyohiro ga
Publisher: Yamaden
small chūban, 218 × 160

A334, 50.467

From a series of 12 pictures of couples manipulating puppets in different scenes of the *Chūshingura*.

Torii KIYOMINE

445abc. Companions forcing a *geisha* to drink a cup of wine, perhaps as a forfeit for losing a round of a hand game
ca. late 1810s
Signature: Kiyomitsu ga
Publisher: Eijudō
Censorship seal: kiwame
ōban triptych, 343 × 722
embossing

A336, 50.469

Kiyomine changed his name to Kiyomitsu II on the death of Kiyonaga in 1815.

PLATE 154.

Torii KIYOMINE after Torii KIYOMASU I

446. The actors Ichikawa Danjūrō I and Yamanaka Heikurō as Yamagami Saemon and Suzuki no Ōji grappling with an elephant in *Keisei ōshōkun,* Nakamura theater, 1/1701
1812
Signature: ganso Torii Kiyonobu zu motome ni ōjite godaime Kiyomine zu
Artist's seal: Kiyomine
Publisher: Emiya V, 1-chōme Bakurochō Edo; Murataya
Censorship seals: kiwame and two *gyōji* seals
497 × 231
Reference: Link 1977, 91; TNM 1629.

A337, 50.470

Copy of a print by Kiyomasu I now in the Nelson Atkins Gallery, Kansas City, reproduced in color in Link 1977, 13. Another impression of Kiyomine's print is reproduced in Link, 91. The age of the author Tatekawa Emba, 70, dates the print, and the inscription describes the circumstances under which the wood block for the original print was discovered and the present print published. The poem at the left is by a

descendant of one of the actors, Ichikawa Danjūrō VII. The publisher is a descendant of the original publisher, and the artist is a descendant of Kiyonobu, the founder of the Torii School, although the picture was, in fact, designed by Torii Kiyomasu.

PLATE 211.

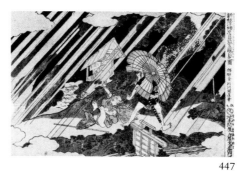

447

Utagawa KUNINAO

*447. The murder of Yoichibei, act five
Series: *Shimpan ukie chūshingura*
Newly published perspective pictures of the play *Chūshingura*
ca. 1810s
Signature: Dokusuisha Utagawa Kuninao hitsu
Artist's seals: Maruya Bunemon kō jihontonya, Kanda Benkeibashi Sugiedachō
ōban, 251 × 375
printed black border

A538, 50.671

The border shows emblems of characters in the play engraved in reserve.

Utagawa KUNINAGA

448. *Shimpan oranda ukie ejifute koku senkei kōdai,* The pyramids in Egypt, a newly published Dutch perspective picture
ca. 1800s or 1810s
Signature: Kuninaga ga
Publisher: Izumiya Ichibei hammoto, Shiba shimmeimae
ōban, 257 × 378

A539, 50.672

PLATE 146.

Utagawa KUNISADA

*449. Geisha reaching out of a boat to wash her hands
ca. 1820s
Artist's seal: Kunisada
surimono, 187 × 190
Provenance: Appleton

A341, 50.474

Probably a section of a larger print or album page.

449

450. *Akashi no ura no zu,* The poet Kakinomoto no Hitomaro at Akashi Bay
Untitled series of ten landscapes
ca. early 1830s
Signature: Kōchōrō Kunisada ga
Artist's seal: unread
Publisher: Yamaguchiya Tōbei
Censorship seal: kiwame
ōban, 255 × 363
embossing, the distant landscape in blue
Reference: UTK 10, 159.

A536, 50.669

PLATE 135.

451. Act 5: Sadakurō approaches Yoichibei as Kampei meets Yagorō
Series: *Chūyūgiroku,* A record of loyalty and courage
mid 1840s
Signature: Kokuteisha (Kunisadasha) Toyokuni hitsu
Publisher: Eikyūdō shinkō
ōban, 251 × 366
Reference: TNM 2724.

A373, 50.506

From a series of landscapes illustrating the tale of the 47 *rōnin*.

452. Memorial portrait of Utagawa Hiroshige
9/1858
Signature: Omoikiya rakurui nagara Toyokuni ga
Artist's seals: Kien ikkū (smoke rising in the sky)
Publisher: Uoei
Engraver: Yokogawa Hori Take
ōban, 353 × 242
Reference: Suzuki 86A.

A646, 50.779

The inscription is a biography and eulogy of the artist (translated in Strange and elsewhere) by his friend Temmeirōjin, including the artist's well-known farewell verse:

*Azumaji e fude o nokoshite tabi no sora
nishi no mikuni no nadokoro o min,*

186

I leave my brush on the pathways of the east and journey to see the famous places in the Western Land.

The western land was a euphemism for the Buddhist paradise.

The artist's signature is a seventeen-syllable poem, saying "drawn by Toyokuni with tears in his eyes, thinking about him."

Utagawa KUNISADA II

453. *Maboroshi,* The Phantom, Chapter 41
Series: *Murasaki shikibu genjikaruta,* Game cards for the chapters of Lady Murasaki's *Tale of Genji*
11/1857
Signature: Baichōrō Kunisada ga
Publisher: Tsutaya Kichizō
Censorship seal: aratame
ōban, 355 × 249
with embossing and printed borders
A537, 50.670

Gosotei TOYOKUNI II

454. *Ōyama yau,* Night rain at Ōyama
Series: *Meisho hakkei,* Eight views of famous places
1830s
Signature: Toyokuni hitsu
Artist's seal: Utagawa
Publisher: Iseri han, Nakachō
Censorship seal: kiwame
ōban, 249 × 363
Reference: UTK 9, 62 (color) (cursive script).
A374, 50.507

There are two states of the print, one with square and one with cursive script in the purple cartouche. Impressions with cursive script have four streaks of grey and blue rain by the signature in the upper right, while those with the square script have only blue. It is unclear which is earlier.
PLATE 94.

Ichiyūsai KUNIYOSHI

Nos. 455–459 are from the same series and have the same date, signature, and format.

455. *Chūshingura jūichidamme youchi no zu,* The night attack in act XI of the play *Chūshingura*
Untitled series of at least eight landscapes
ca. 1833
Signature: Ichiyūsai Kuniyoshi ga
Publisher: Yamaguchiya Tōbei
ōban, 264 × 382, with variation up to 8 mm. within set
Reference: Robinson 1961, 7; TNM 3035; Riccar 86; Springfield 25; UTK 10, 32 (color).
Publication: Van Caneghem 114, $75
A412, 50.545

Fine, fresh impression, lacking the pink block with the artist's seal, the censor's and publisher's marks and the light cast by the lantern at the right.

The five views of the eastern capital were always recognized as part of a set, but the group also includes this print, the view of Usui Pass, and the western-style picture of Okane and the horse which is not in the collection.
PLATE 37 (color).

456. *Tōto shubi no matsu no zu,* The pine tree of rendezvous in the eastern capital
Artist's seal: toshidama
Censorship seal: kiwame
Reference: Robinson 1961, 7; Riccar 3; Springfield 22; UTK 10, 30 (color).
A413, 50.546

The Ainsworth impression seems to be an unrecorded first state of the print with the green overprinting on the right side of the rock and with a different pattern of clouds in the upper part of the sky.
PLATE 38 (color).

*457. *Tōto ommayagashi no zu,* Ommayagashi in the eastern capital
Artist's seal: toshidama
Publisher: Yamaguchi han
embossing
Reference: Robinson 1961, 7; Riccar 1; TNM 3048; Springfield 24; UTK 10, 191.
A414, 50.547

The umbrella at the left bears the name of Yamatoya, a shop or restaurant in Yanagishima.

The umbrella at the right has the mark of the publisher and the number 1861. Some writers have fancifully interpreted this as the artist's premonition of his death that year (in the western calendar).

457

*458. *Usuitōge yori asamayama o miru zu,* View of Mt. Asama from Usui Pass
Artist's seal: toshidama
Publisher: Yamaguchiya han
Reference: Robinson 1961, 7; Riccar 35; Springfield 33.
A415, 50.548

Another state or version of the print with smoke rising from the peak of the mountain is reproduced in Borie 108.

458

*459. *Tōto hashiba no zu,* The statue of Jizō near the ferry at Hashiba in the eastern capital
Artist's seal: toshidama
Publisher: Yamaguchiya han
Reference: Robinson 1961, 7; Springfield 21.
A416, 50.549

459

Nos. 460–465 are from the same series and have the same date, signature, publisher, censorship mark, format and technique.

*460. *Yanagibashi ryōgoku,* Geisha, attendant, and three dogs near Yanagi Bridge at Ryōgoku
Series: *Tōto meisho,* Famous views of the eastern capital
ca. 1834
Signature: Ichiyūsai Kuniyoshi
Publisher: Kagaya Kichibei (emblem, Kagaya, Ryōgoku)
Censorship seal: kiwame
ōban, 251 × 357
Reference: Robinson 1961, 8; TNM 3038; Riccar 9.
Publication: Jacquin 175, $26.
A396, 50.529

Six plates from a series of ten landscapes with green printed borders simulating frames of bamboo.

460

461. *Susaki hatsuhinode no zu,* Geisha and worshipers greeting the sunrise at Susaki on New Year's Day
232 × 330
Reference: Robinson 1961, 8; Riccar 11.
Provenance: Rouart

A397, 50.530

462. *Tsukudajima,* Pilgrim's markers fluttering into the sea below the bridge near Tsukuda Island
247 × 374
Reference: Robinson 1961, 8; Riccar 12; Springfield 32.

A398, 50.531

*463. *Surugadai,* Travellers viewing a rainbow at Surugadai
258 × 379
Reference: Robinson 1961, 8; Suntory 110; Riccar 13; UTK 10, 189.

A399, 50.532

There is an unidentified Japanese collector's mark on the verso.

463

*464. *Ōmori,* Kelp gatherers at Ōmori
240 × 340
Reference: TNM 3039; Springfield 31.

A400, 50.533

The trimmed impression of this print in the Borie sale 1919, lot 107, sold for $510.

464

465. *Kasumigaseki,* Passers-by at the top of the slope at Kasumigaseki
240 × 362
Reference: TNM 3038.

A401, 50.534

Nos. 466–475 are from the same series and have the same date, signature, publisher, censorship seal, and format.

466. 2. Hodogaya to Hiratsuka
Series: *Tōkaidō gojūsaneki meisho jūni mai no uchi,* Famous places on the Tōkaidō Road: a set of 12 pictures
The complete set is reproduced in color in a booklet by Amy Poster. *Shukuzu* means drawn together or combined, since each landscape shows a large area of the region traversed by the Tōkaidō road and the names of several stations are indicated on each picture.
The Ainsworth group lacks nos. 1 and 8. Some pictures have yellow, others have orange borders.
ca. 1835
Signature: Ichiyūsai Kuniyoshi shukuzu
Publisher: Tsutaya Kichizō and Tsuruya Kiemon
Censorship seal: kiwame
ōban, 262 × 378, with variation up to 10 mm. within set except where noted
printed yellow borders
Reference: Robinson 1961, 10; Riccar 22–30; Springfield 38; UTK 10, 190.

A417, 50.550

467. 3. Ōiso to Mishima with a view of Tora's rock and the Hakone mountains
yellow border
Provenance: Jacquin
Publication: Jacquin 183, $34.

A425, 50.558

468. 4. Hara to Kambara with a view of Mt. Fuji
Artist's seal: Yoshi in gourd-shaped *toshidama*
248 × 371
orange border and printed plate number

Provenance: Jacquin
Publication: Jacquin 184, $31.

A424, 50.557

469. 5. Yui to Mariko
250 × 378
yellow border

A420, 50.553

470. 6. Okabe to Kanaya with a view of the Ōi River
251 × 278
orange border

A423, 50.556

Manuscript inscription in right margin *roku no kan,* 'volume six.'

471. 7. Nissaka to Hamamatsu, with a view of the mountains along the Tenryū River
orange border

A426, 50.559

472

*472. 9. Akasaka to Narumi
orange border

A418, 50.551

473. 10. Miya to Ishiyakushi
249 × 367
yellow border

A419, 50.552

474. 11. Shōno and Tsuchiyama
222 × 345
trace of yellow border

A421, 50.554

475. 12. Minakuchi to Kyōto with a view of Lake Biwa
247 × 371
yellow border
Provenance: Jacquin
Publication: Jacquin 190, $12.

A422, 50.555

The number twelve in the lower left corner seems to be added by hand.

Nos. 476–485 are from the same series and have the same date, publisher, censorship seal, format and technique.

The complete set of ten scenes from the life of the Buddhist saint Nichiren, two (481, 482) based on designs by the painter Kawamura Bumpō. Robinson dates the set ca. 1835–36, but Yoshida suggests that Kuniyoshi, who was an adherent of the Nichiren sect, may have designed the set in 1831 as part of the activities commemorat-

ing the 550th anniversary of the founder's death, observing that on some of the prints Kuniyoshi uses the boxed orange blossom emblem of the Nichiren sect as a seal, and on others uses the *toshidama* emblem of the Utagawa clan in a similar box. The prints are listed in the sequence of Nichiren's life.

476. Tōjō no Saemon attacks Nichiren at Komatsubara in 1264
Series: *Kōso goichidai ryakuzu,* A short pictorial biography of the founder of the Nichiren sect. Series title printed in black.
mid 1830s
Signature: Chōōrō Kuniyoshi ga
Publisher: Iseya Rihei
Censorship seal: kiwame
ōban, 260 × 381, with variation up to 3 mm, within set except where noted
Reference: Robinson 1961, 11; Riccar 179–190; Springfield 18–20.
A404, 50.537
PLATE 124.

477. Nichiren prays for rain at the promontory of Ryōzangasaki in Kamakura in 1271
Signature: Ichiyūsai Kuniyoshi ga
Provenance: May (?)
Publication: May 783 (?), $15.
A407, 50.540
PLATE 127.

478. Nichiren saved from execution at Takinoguchi in Sagami Province
Series title printed in blue
Signature: Ichiyūsai Kuniyoshi hitsu
Artist's seal: *toshidama*
Provenance: Jacquin
Publication: Jacquin 500, $6.
A405, 50.538
PLATE 125.

479. The descent of the star Ichi on the 13th night of the ninth month
Series title printed in black
Signature: Chōōrō Kuniyoshi hitsu
Artist's seal: *toshidama*
A403, 50.536
PLATE 123.

480. The mantram Namumyōhōrengekyō appears to Nichiren in the waves near Sumida on the way to exile on Sado Island
Series title printed in purple
Signature: Ichiyūsai Kuniyoshi ga
Artist's seal: *toshidama*
with spots of white pigment
A406, 50.539
PLATE 126.

481. Nichiren walking through the snow at Tsukahara during his exile on Sado Island
Series title printed in red
Signature: Ichiyūsai Kuniyoshi hitsu

Artist's seal: *toshidama*
with spots of *gofun*
A411, 50.544
Early impression before the printed horizon line was removed. This picture was based on a design by Bumpō.
PLATE 131.

482. Nichiren praying for the repose of the soul of the cormorant fisher at the Isawa River in Kai Province
Series title printed in red
Signature: Ichiyūsai Kuniyoshi hitsu
Artist's seals: triple *toshidama*
A402, 50.535
This picture was also based on a design by Bumpō.
PLATE 122.

483. The rock settling a religious dispute at Ōmuro Mountain on the 28th day of the 5th month of 1274
Series title printed in red
Signature: Ichiyūsai Kuniyoshi ga
A408, 50.541
PLATE 128.

484. The appearance of the seven-headed god at Minobu Mountain in the 9th month of 1277
Series title printed in black
Signature: Chōōrō Kuniyoshi ga
Artist's seal: orange blossom
A409, 50.542
PLATE 129.

485. The saint's efforts defeat the Mongolian invasion in 1281
Series title printed in black
Signature: Ichiyūsai Kuniyoshi ga
A410, 50.543
PLATE 130.

486. *Ōyama sekison ōtaki no zu,* The waterfall of the stone deity at Ōyama mountain
ca. mid or late 1830s
Signature: Ichiyūsai Kuniyoshi ga
Artist's seal: *toshidama* signature cartouche
Publisher: Wakasaya Yoichi
ōban, 252 × 364
Reference: Riccar 37; Springfield 60.
A440, 50.573
This picture, the view of the Tamura Ferry near Ōyama (no. 487), and a view of Rōben Waterfall (TNM 3034), were published together.
Kuniyoshi may have visited Ōyama with the pilgrims since he designed at least two triptychs of them purifying themselves at Rōben Waterfall at the base of the mountain. The waterfall of the stone deity is higher on the mountain.
PLATE 91.

487. *Sōshū ōyama tamurawatashi no zu,* The ferry at Tamura near Ōyama Mountain in Sagami Province
ca. mid or late 1830s

Signature: Ichiyūsai Kuniyoshi ga
Publisher: Wakasaya Yoichi
ōban, 262 × 372
Reference: Riccar 36.
A441, 50.574
PLATE 93.

Nos. 488–557 are from the same set. The complete set of 70 prints of ōban format was issued jointly by several publishers between the 5th month of 1852 and the 2nd month of 1853. Each picture illustrates a historical or legendary scene associated in some way with a place or the name of a place on the post road. The place itself is shown in a variously-shaped cartouche in the upper left-hand corner of the print. The border of the title cartouche at the upper right also varies from print to print, and is composed of some element, attribute, or symbol of the story. Many of the associations between the picture and place are based on visual and verbal puns.

There are some date seals (nos. 5 and 36), which seem to read 4/1852, but these are probably engravers' errors for 6/1852.

Most of the prints have engraved numbers. Some of these, however, are incorrect, and the pictures have been placed in their proper geographical order.

Print sets often have larger numbers than the series titles prescribe. The publishers of Kuniyoshi's set apparently wanted 70 pictures, like the early Kisokaidō set by Eisen and Hiroshige, and omitted the station of Ōtsu from the series to keep the number of prints to 70.

488. 1. Nihonbashi. Ashikaga Yorikane, Narukami Katsunosuke and Ukiyo Watahei on Nihon Bridge
5/1852
Series: *Kisokaidō rokujukutsugi no uchi,* The sixty-nine stations of the Kisokaidō Road
Signature: Ichiyūsai Kuniyoshi ga
Artist's seal: paulownia
Publisher: Tsujiokaya Bunsuke
Censorship seals: Hama, Magomi
ōban, 358 × 242 (variation no more than 3 mm. within set)
Reference: Robinson 1961, 57.
A456, 50.589
PLATE 167 (detail).

489. 2. Itabashi. Inuzuka Shino rescuing the fisherman
5/1852
Publisher: Sumimasa
Engraver: Horikō Sugawa Sennosuke
Censorship seals: Hama, Magomi
A457, 50.590
PLATE 175.

*490. 3. Warabi. Inuyama Dōsetsu on a funeral pyre
5/1852
Publisher: Izutsuya
Censorship seals: Hama, Magomi
A458, 50.591

490

*491. 4. Urawa. Danshichi Kurōbei, the fish seller, washing himself after the murder in the muddy field
5/1852
Publisher: Sumimasa
Engraver: Horikō Sugawa Sennosuke
Censorship seals: Hama, Magomi
A459, 50.592

491

492. 5. Ōmiya. Abe no Muneto
6(?)/1852
Publisher: Kyū
Engraver: Horikō Asa Ryūta
Printer: Surikō Kozen Kame
Censorship seals: Fuku, Muramatsu
surface polishing
A460, 50.593

The date seal gives the 4th month of 1852, but this is probably an engraver's error for the sixth month, which is written with a nearly identical seal character. (No. 36 also reads 4th month, and has the name of the same printer).

493. 6. Ageo. The courtesan Takao of the Miuraya house being ransomed for her weight in gold
5(?)/1852
Publisher: Rinshō
Censorship seals: Muramatsu, Fuku
A461, 50.594

494. 7. Okegawa. The courtesan Kojorō hiding Tamaya Shimbei from pursuers
6/1852
Publisher: Sumimasa
Engraver: Horikō Sugawa Sennosuke
A462, 50.595

495. 8. Kōnosu. Kō no Moronao attempting to hide from the 47 rōnin
5/1852
Publisher: Kagayasu
Engraver: Hori Takichi
Censorship seals: Magomi, Hama
A524, 50.657

496. 9. Kumagaya. The warrior Kojirō Naoie on horseback
5/1852
Publisher: Kagayasu
Engraver: Hori Takichi
Censorship seals: Magomi, Hama
A463, 50.596

497. 10. Fukaya. The archer Yuriwaka Daijin
5/1852
Publisher: Kagayasu
A464, 50.597

498. 11. Honjō. The outlaw Shirai Gompachi standing in the rain
5/1852
Publisher: Minatoya Kohei
Engraver: Hori Takichi
Censorship seals: Magomi, Hama
A465, 50.598

499. 12. Shimmachi. Gokumon Shōbei and Kurobune Chūemon meeting on a bridge
6/1852
Publisher: Isekane
Censorship seals: Fuku, Muramatsu
A466, 50.599

500. 13. Kuragano. The outlaw and magician Jiraiya seated by a fire
5/1852
Publisher: Sumimasa
Engraver: Horikō Sugawa Sennosuke
Censorship seals: Hama, Magomi
A467, 50.600
PLATE 168 (detail).

501. 14. Takasaki. Konomura Ōinosuke watching the hawk fly away from a painted scroll
5/1852
Publisher: Kagayasu
Engraver: Hori Takichi
A468, 50.601

*502. 15. Itabana. Ushiwakamaru fencing with the goblins at Mt. Kurama
5/1852
Publisher: Rinshō
Censorship seals: Muramatsu, Fuku
A469, 50.602

Mt. Kurama is near Kyōto. The tengū, or goblins, had long noses or hana. When they were struck, their noses hurt, itai, and 'hurt nose,' itaibana, was the pun that gave Kuniyoshi the subject for the picture.

502

503. 16. Annaka. The renegade priest Seigen praying to the ghost of his lover Sakurahime
6/1852
Publisher: Kagayasu
A470, 50.603

504. 17. Matsuida. Yamauba and Matsui Tamijirō
6/1852
Publisher: Tsujiokaya
Censorship seals: Fuku, Muramatsu
A471, 50.604
PLATE 169 (detail).

505. 18. Sakamoto. Child leading a samurai at Gojōzaka
9/1852
Publisher: Minatoya Kohei
Censorship seals: Magomi, Hama
A472, 50.605

*506. 19. Karuizawa. Kamada Matahachi placing a sandal under a temple column
7/1852
Publisher: Kyū
Censorship seals: Watanabe, Mera
A480, 50.613

506

507. 20. Kutsukake. Ch'ang Liang returning the shoe to Huang Shih Kung
6/1852
Publisher: Isekane
Censorship seals: Fuku, Muramatsu
A522, 50.655

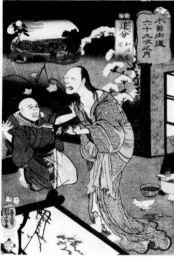

508

*508. 21. Oiwake. The ghost of Oiwa appearing to Takuetsu
6/1852
Publisher: Kyū
Engraver: trimmed
Censorship seals: Fuku, Muramatsu
A473, 50.606

509. 22. Odai. Teranishi Kanshin, a wealthy patron of the licensed quarters
7/1852
Publisher: Isekane
A474, 50.607
PLATE 170 (detail).

510. 23. Iwamurada. Ōiko removing the boulder to irrigate the ricefields
7/1852
Publisher: Kagayasu
Censorship seals: Watanabe, Mera
A475, 50.608

511. 24. Shionada. Torii Matasuke standing beside the Chikuma River with the head of an enemy in his teeth
6/1852
Publisher: Minatoya Kohei
Engraver: Hori Asa Sen
Censorship seals: Muramatsu, Fuku
A476, 50.609
PLATE 176.

512. 25. Yawata. The warriors Ōmi Kotōta and Yawata Saburō
6/1852
Publisher: Rinshō
Censorship seals: Fuku, Muramatsu
A477, 50.610

513

*513. 26. Mochizuki. Kaidōmaru with his animal companions catching a small *tengū* with a limed stick
6/1852
Publisher: Rinshō
Engraver: Hori Take
Censorship seals: Fuku, Muramatsu
A478, 50.611

514. 27. Ashida. Araimaru and Jogetsuni performing sorcery with an enemy's severed head
Publisher: Sumimasa
Censorship seals: Kinugasa, Murata
A479, 50.612

515. 28. Nagakubo. The lovers Oshichi and Kichiza
9/1852
Publisher: Tsujiyasu
Engraver: Hori Shōji
Censorship seals: Hama, Magomi
A523, 50.656

516. 29. Wada. The *samurai* Wadahei surrounded by musketeers
9/1852
Publisher: Sumimasa
Censorship seals: Hama, Magomi
A519, 50.652
PLATE 171 (detail).

*517. 30. Shimonosuwa. Princess Yaegaki and the fox spirits
8/1852
Publisher: Kagayasu
Censorship seals: Mera, Watanabe
A482, 50.615

517

518. 31. Shiojiri. Takagi Toranosuke watching a whaling fleet
8/1852
Publisher: Izutsuya
Engraver: Hori Mino
Censorship seals: Kinugasa, Murata
A483, 50.616

519. 32. Seba. The rival warrior priests Musashibō Benkei and Tosabō Shōshun riding one horse
8/1852
Publisher: Kagayasu
Engraver: Hori Shōji
A484, 50.617

520. 33. Motoyama. The spirit of Yamauba as a Nō dancer
7/1852
Publisher: Kagayasu
Engraver: Hori Takichi
Censorship seals: Watanabe, Mera
A485, 50.618
PLATE 172 (detail).

521. 34. Niegawa. Takeuchi no Sukune proving his innocence before his brother Umashi no Sukune by surviving the ordeal of boiling water
5/1852
Publisher: Kagayasu
Censorship seals: Fuku, Muranatsu
A486, 50.619

522. 35. Narai. Zenkichi and Oroku, the comb maker
5/1852
Publisher: Minatoya Kohei
Censorship seals: Magomi, Hama
A487, 50.620
PLATE 173 (detail).

523. 36. Yabuhara. The death of Sue Harukata
6(?)/1852
Publisher: Sumimasa
Engraver: Horikō Sugawa Sennosuke
Printer: Surikō Daikyū
Censorship seals: Muramatsu, Fuku
A488, 50.621

524. 37. Miyanokoshi. Prince Ōtonomiya reading sutras in his cave prison in Kamakura
5/1852
Publisher: Sumimasa
Engraver: Horikō Sennosuke
Printer: Surikō Daikyū
Censorship seals: Hama, Magomi
A499, 50.632

525. 38. Fukushima. The turtle showing Urashima Tarō the palace of the dragon king
5/1852
Publisher: Izutsuya
Censorship seals: Hama, Magomi
A481, 50.614
The picture is mistakenly numbered 37. This has been corrected to 38 by hand.

526. 39. Uematsu. Eda Genzō hiding in a pine tree from pursuers
7/1852
Publisher: Kagayasu
Censorship seals: Watanabe, Mera
A490, 50.623
The yellow figure above Genzō's head is the name of a star.

527. 40. Suhara. Prince Narihara and Princess Nijō hiding from pursuers on a moor
7/1852
Publisher: unidentified
Censorship seals: Watanabe, Mera
embossing
A491, 50.624
PLATE 177.

528. 41. Nojiri. Hakamadare Yasusuke preparing to kill Hirai Yasumasa playing his flute on a deserted moor
5/1852
Publisher: Izutsuya
Censorship seals: Hama, Magomi
A492, 50.625

529. 42. Midono. Mitono Kotarō defending himself from ruffians at a deserted temple
6/1852
Publisher: Minatoya Kohei
Engraver: Hori Asa Sen

Censorship seals: Muramatsu, Fuku
A493, 50.626
The number two has been added to the picture number by hand.

530

*530. 43. Tsumagome. Abe no Yasuna watching his wife change into a fox spirit and disappear
6/1852
Publisher: Minatoya Kohei
Engraver: Hori Takichi
Censorship seals: Muramatsu, Fuku
A494, 50.627

531. 44. Ochiai. The Taoist Immortal Kume plunging to the ground for lusting after a woman doing laundry
6/1852
Publisher: Shōrin
Engraver: Hori Take
Censorship seals: Fuku, Muramatsu
A495, 50.628

532. 45. Magome. A horse leader offering to carry Takebayashi Teishichi across a stream on his back
6/1852
Publisher: Sumimasa
Printer: Surikō Daikyū
Censorship seals: Muramatsu, Fuku
A496, 50.629

533. 46. Nakatsugawa. The wife and daughter of Horibe Yasubei in a grove of pine trees
8/1852
Publisher: Kagayasu
Engraver: Hori Takichi
Censorship seals: Watanabe, Mera
A497, 50.630

*534. 47. Ōi. The renegade Ono Sadakurō pursuing the farmer Yoichibei in the rain
5/1852
Publisher: Kagayasu
Censorship seals: Hama, Magomi
A498, 50.631

534

535. 48. Ōkute. The goddess Kannon prevents the hag of Adachi moor from killing a young girl
7/1852
Publisher: Kagayasu
Engraver: Hori Takichi
Censorship seals: Watanabe, Mera
A500, 50.633

*536. 49. Hosokute. Horikoshi Tairyō haunted by the ghosts of victims
7/1852
Publisher: Kagayasu
Engraver: Hori Takichi
Censorship seals: Watanabe, Mera
surface polishing
A501, 50.634

536

*537. 50. Mitake. Akushichibyōe Kagekiyo on the great statue of the Buddha at Nara
6/1852
Publisher: Sumimasa
Engraver: Horikō Sugawa Sennosuke

Censorship seals: Muramatsu, Fuku
surface polishing

A502, 50.635

537

538. 51. Fushimi. Tokiwa Gozen pro-
tecting her children from the snow
2/1853
Publisher: Hirabayashiya Shō-
gorō (?)
Censorship seals: Fuku, Muramatsu
embossing

A503, 50.636

539. 52. Ōta. Amakawaya Gihei dis-
missing the quack doctor Ryōchiku
8/1852
Publisher: Bunseidō
Engraver: Hori Sennosuke
Printer: Surikō Daikyū
Censorship seals: Kinugasa, Murata

A504, 50.637

540. 53. Unuma. Yoemon murdering his
wife Kasane
7/1852
Publisher: Jōshūya Iwakichi
Censorship seals: Mera, Watanabe

A505, 50.638

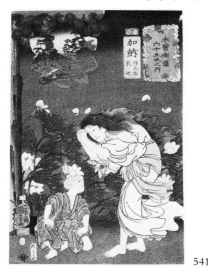

541

*541. 54. Kanō. Bōtarō and his wet nurse
by a lotus pond
7/1852
Publisher: Kagayasu
Engraver: Hori Sennosuke
Censorship seals: Mera, Watanabe

A506, 50. 639

542. 55. Gōdo. A procession of blind
masseurs fording a river
7/1852
Publisher: Jōshūya Iwakichi
Censorship seals: Mera, Watanabe

A507, 50.640

543. 56. Mieji. Women dressed as *eji* or
palace workmen, viewing maple
leaves
7/1852
Publisher: Kagayasu
Censorship seals: Watanabe, Mera

A508, 50.641

A pun on *mieji,* "beautiful *eji.*"

*544. 57. Akasaka. The empress Kōmei
massaging a leper
7/1852
Publisher: Isekane
Censorship seals: Mera, Watanabe

A525, 50.658

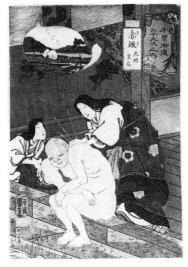

544

545. 58. Tarui. Sarunosuke untying a
child from a well
7/1852
Publisher: Kagayasu
Engraver: Hori Takichi
Censorship seals: Watanabe, Mera

A509, 50.642

546. 59. Sekigahara. Outdoor battle be-
tween the wrestlers Hanaregoma
Chōkichi and Nuregami Chōgorō
9/1852
Publisher: Izutsuya
Engraver: Hori Mino
Censorship seals: Hama, Magomi

A510, 50.643

PLATE 178.

547. 60. Imasu. The Soga brothers find
their enemy Kudō asleep
6/1852
Publisher: Tsujiokaya
Engraver: Horikō Mura Yasu
Censorship seals: Fuku, Muramatsu

A511, 50.644

548. 61. Kashiwabara. Sankatsu of the
Kasaya house with a porter carrying
her luggage
8/1852
Publisher: Kagayasu
Engraver: Hori Shōji
Censorship seals: Murata, Kinugasa

A512, 50.645

PLATE 174 (detail).

549. 62. Samegai. Kanai Tanigorō killing
the alligator in the snow
6/1852
Publisher: Tsujiokaya
Censorship seals: Fuku, Muramatsu

A513, 50.646

550. 63. Bamba. Utanosuke exacts
vengence while Domori no Ma-
tabei guards against intruders
9/1852
Publisher: Isekane
Censorship seals: Hama, Magomi

A514, 50.647

551. 64. Toriimoto. Taira no Tadamori
and the oil thief
6/1852
Publisher: trimmed
Engraver: trimmed
Censorship seals: Fuku, Muramatsu

A515, 50.648

552. 65. Takamiya. The young samurai
Kamiya Iemon fishing
8/1852
Publisher: Bunseidō
Engraver: Horikō Sugawa Senno-
suke
Printer: Surikō Daikyū
Censorship seals: Murata, Kinugasa

A516, 50.649

553. 66. Echikawa. The warrior Sagiji
Heikurō washing his ax in a river
7/1852
Publisher: Jōshūya Iwakichi
Censorship seals: Watanabe, Mera

A517, 50.650

554. 67. Musa. Miyamoto Musashi pro-
tecting himself from a huge bat as
he crosses a basket ferry (Misnum-
bered on print as 48)
6/1852
Publisher: Sumimasa
Engraver: Horikō Sugawa Senno-
suke
Censorship seals: Muramatsu, Fuku

A499, 50.632

555. 68. Moriyama. The Zen patriarch Bodhidharma eating noodles at a restaurant
7/1852
Publisher: Kyū
Censorship seals: Mera, Watanabe

A518, 50.651

556. 69. Kusatsu. Yoshitaka and the gold-laden pack horse (Misnumbered on the print as 67)
1/1853
Publisher: Minatoya Kohei

A520, 50.653

*557. 70. Kyōto. The *nue*, a monster, descending on the Imperial palace
7/1852
Publisher: Minatoya Kohei
Censorship seals: Fuku, Muramatsu

A521, 50.654

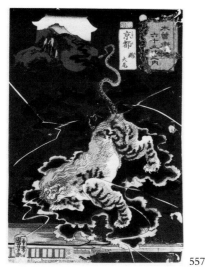

557

Nos. 558–568 are from the same series and have the same title, date, signature, publisher, and format.
Eleven of the 24 pictures in the series are in the Ainsworth collection.

558. Ōhō frightened by the thunder god
Series: *Nijūshikō dōji kagami,* A mirror for children of the 24 paragons of filial piety
ca. 1840
Signature: Ichiyūsai Kuniyoshi ga
Publisher: Wakasaya Yoichi, Shiba Shimmeimae
ōban, 252 × 366, with variation up to 7 mm. within set
Reference: Robinson 1961, 12.

A427, 50.56c

According to Edmunds, the mother of Wang Ngai (Ōsui) was afraid of thunder-storms. After she died Wang stood by her tomb during thunderstorms and reassured her that she had nothing to fear since he was there. The name Ōhō in the title may be a mistake.

PLATE 116.

559. Yang Hsiang (Yōkō) protecting his father from the tiger

A428, 50.561

PLATE 106.

560. The woodcutter Tseng Shen (Sōsan) hurrying home to his mother who had bitten her finger in irritation at his absence to call him home

A429, 50.562

561. Kuo Ku (Kakkyō) discovers a pot of gold as he digs a grave to bury his infant son so he may provide more for his aged mother

A430, 50.563

562. Wang Siang (Ōshō) catching carp for his step-mother from a frozen river
Reference: TNM 3094.

A431, 50.564

563. Lu Su (Rikuzoku) explaining to his host that he had taken two extra oranges for his parents

A432, 50.565

564. Wu Meng (Gomō) fetching braziers to keep mosquitoes from biting his father

A433A, 50.566A

Earlier impression, with lighter smoke, than no. 564A.

564A. Wu Meng (Gomō) . . . (same as preceding entry)
211 × 346

A433, 50.566

565. Meng Tsung (Mōsō) searching for bamboo shoots in the snow to satisfy a craving of his mother embossing

A434, 50.567

*566. Chiang Shih (Kyōshi) and his wife catching fish for his mother

A435, 50.568

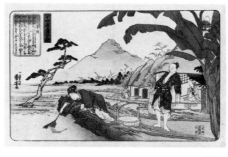

566

*567. Elephants and birds helping Ta Shun (Tai Shun) cultivate land in the Li mountains whence he was driven by his family's cruelty

A436, 50.569

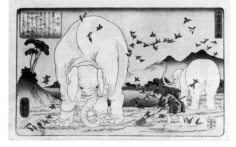

567

568. Min Son (Binshiken) sweeping snow while his step-mother spoils her two sons

A437, 50.570

Nos. 569–579 are from the same series and have the same format.
Eleven prints from the set of twelve (lacking the rabbit). *Buyū* usually means valor, courage, but in this case it seems to convey the sense of force, since many of the subjects are not virtuous.

569. 1. The priest Raigō Ajari destroying sutras which turn into rats
Series: *Buyū mitate jūnishi,* Bravery matched with the 12 animals of the zodiac
ca. 1840
Signature: Ichiyūsai Kuniyoshi ga
Artist's seal: *toshidama*
Publisher: Minatoko
medium panel, 365 × 117, with variation up to 8 mm. within set
grey ground
Reference: Robinson 1961, 22.

A452, 50.585

570. 2. Ox. The outlaw Kidōmaru, disguised with an oxhide, waiting to attack Raikō on his way to Mt. Kurama
Signature: Chōōrō Kuniyoshi ga
Artist's seal: Ichiyūsai
blue ground

A446, 50.579

571. 3. Kashiwade no Ōmi Hatebe and the tiger
Artist's seal: *toshidama*
grey ground

A453, 50.580

572. 5. Susanoo no Mikoto and the dragon
Artist's seal: *toshidama*
green ground

A454, 50.587

573. 6. Nitta Yoshisada and the apparition of the goddess Benten riding a serpent in the cave on Mt. Fuji
Artist's seal: *toshidama*
grey ground

A450, 50.583

*574. 7. Soga no Gorō setting out for Ōiso on horseback
Artist's seal: *toshidama*
green ground
Publication: Keyes 1976, fig. 12.

A448, 50.581

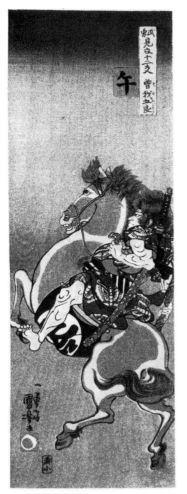

574

575. 8. Kuan Yu and his sheep in moonlight
Artist's seal: *toshidama*
blue ground

A447, 50.580

576. 9. The monkey Songokū creating an army from his fur
Artist's seal: *toshidama*
pinkish-grey ground

A451, 50.584

577. 10. Kaidōmaru, or Kintarō, refereeing a wrestling match between a *tengu* and a rooster
Artist's seal: *toshidama*
blue ground

A455, 50.588

578. 11. Hata Rokurōzaemon and his pet dog
Artist's seal: *toshidama*
grey ground

A445, 50.578

579. 12. The emperor Yūryaku killing the boar
Artist's seal: *toshidama*
grey ground

A449, 50.582

Nos. 580–599 are from the same series, and have the same date, format, technique, and series title.
From a series of illustrations for the *100 Poems* anthology of classical poetry. Each print has a printed text in the upper right hand corner with the name of the poet, the poem, and a commentary. The pictures were numbered in the lower left margin.

580. 1. The emperor Tenchi watching peasants harvesting rice
Series: *Hyakunin isshu no uchi,* The 100 Poems
ca. early 1840s
Signature: Ichiyūsai Kuniyoshi ga
Artist's seal: Ichiyū
Publisher: Ebisuya Shōshichi
Engraver: Hori Katsu
ōban, 365 × 244
Reference: Robinson 1961, 32.

A394, 50.527

581. 3. The poet Kakinomoto no Hitomaro comparing the long summer night to the tail of a copper pheasant
Artist's seal: Kuniyoshi
375 × 255
Reference: Robinson 1961, 32.

A391, 50.524

582. 4. The poet Yamabe no Akahito at Tago Bay
Artist's seal: Kuniyoshi
365 × 240

A376, 50.509

The number 123 on the lower right corner of this print is handstamped.

583. 7. The poet Abe no Nakamaro watching the moon rise before his departure from China
Artist's seal: *toshidama*
370 × 255

A384, 50.517

584. 11. Ship carrying the poet Sangi no Takamura into exile
Artist's seal: *toshidama*
341 × 228

A392, 50.525

The poet asks the fishing boats to tell his lover that he is sailing off to exile.

585. 13. Travellers watching the cascade of the Minano River on Mt. Tsukuba; illustration of the poem by Yōzeiin
378 × 255

A382, 50.515

586. 16. The poet Chūnagon Yukihira viewing the distant peak of Mt. Inaba

Artist's seal: *toshidama*
366 × 238
Reference: Robinson 1961, 32.

A387, 50.520

587. 17. The poet Ariwara no Narihira Ason watching maple leaves on the Tatsuta River
Artist's seals: triple *toshidama*
371 × 253

A386, 50.519

The robes of the two men in the impression reproduced as the color frontispiece in Robinson's *Kuniyoshi* are blue and blue green, but the printing is otherwise similar.

588. 22. The poet Bunya no Yasuhide watching a sudden wind blow umbrellas
370 × 248

A381, 50.514

PLATE 107.

589. 23. Palanquin bearers returning home by moonlight; illustration of a poem by Ōe no Chisato
Artist's seal: Kuniyoshi
355 × 233

A393, 50.526

590. 24. Sugawara no Michizane approaching a sacred mountain
371 × 254

A378, 50.511

591

*591. 34. The poet Fujiwara no Okikaze passing the old pine at Takasago in an evening rain
Artist's seal: Kinaki (?)
382 × 263
Publication: Van Caneghem 107, $35.

A383, 50.516

195

592. 42. Couple swearing fidelity at Suenomatsuyama in Mutsu province; illustration of a poem by Kiyohara no Motosuke
376 × 254

A380, 50.513

The poet says that his love will last until the waves cross Suenomatsu mountain.

593. 49. Palace workmen burning twigs; illustration of a poem by Ōnakatomi Yoshinobu no Ason
Signature: Ichiyūsai Kuniyoshi ga
375 × 264
Publication: Van Caneghem 105, $22.50.

A390, 50.523

PLATE 136.

594. 60. The demon of Ōeyama; illustration of a poem by Koshikibu no Naishi
375 × 255

A377, 50.510

595. 64. Morning mist at a weir on the Uji River; illustration of a poem by Gonchūnagon Sadayori
Artist's seal: toshidama
360 × 246

A385, 50.518

596. 78. The poet Minamoto no Kanemasa listening to plovers cry off the coast of Suma
Signature: Chōōrō Kuniyoshi ga
Artist's seal: toshidama
372 × 253

A395, 50.528

597. 83. The poet Kotaigū no Tayū Toshinari reflecting on the sorrows of court life
Signature: Chōōrō Kuniyoshi ga
358 × 245

A388, 50.521

598. 87. The priest Jakuren walking past a grove of yew trees in a shower on an autumn evening
Artist's seal: toshidama
355 × 232

A389, 50.522

599. 97. Gonchūnagon Sadaie holding a cat while an attendant prepares fish shavings
374 × 254

A379, 50.512

*600. The courtesan Motozue of the Daimonjiya house, 1-chōme Kyōmachi in the New Yoshiwara
1830s
Signature: Ichiyūsai Kuniyoshi ga
Publisher: Kawaguchiya Chōzō
Censorship seal: kiwame
ōban, 367 × 245
printed in red and blue

A529, 50.662

The inscription in the cartouche duplicates the words at the right. The circular cartouche has a view of Ryōgoku Bridge.

600

601. Tiger in storm
1830s
Signature: Ichiyūsai Kuniyoshi ga
Printer: Marusei (?)
vertical diptych, 726 × 257
Reference: NBZ 201 (color, with bamboo); Springfield 79 (with bamboo).

A535, 50.668

Another state of the print is known with a different contour of wind across the tiger's face and a large green bamboo in the upper right corner.

PLATE 105.

*602. Shinōhashi kyōka no chōbō, A distant view of Mt. Fuji from beneath New Ōhashi Bridge
Series: Tōto fujimi sanjūrokkei, Thirty-six views of Mt. Fuji from the eastern capital
early 1840s
Signature: Ichiyūsai Kuniyoshi ga
Artist's seal: geometric seal
ōban, 244 × 359
blue ground
Reference: Robinson 1961, 9; TNM 3042; Riccar 17; Robinson 1979, 21; Springfield 83.
Provenance: Van Caneghem
Publication: Van Caneghem 113, $110.

A438, 50.571

Robinson cites five pictures in the series, and dates it to ca. 1843.
The poem, by Banshōtei Gyokuga (or Tamaka) was translated as follows in the catalogue of the Van Caneghem collection: "With the lifting of the bamboo shade of the boat as it passes between the piers of the bridge, there comes into view the fair Fuji brow which I longed to see."
The poem was an afterthought. A keyblock

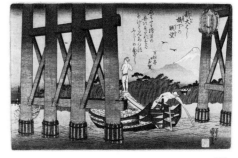

602

proof of the print lacks the poem and shows the two birds flying close to the center piling of the bridge.

603. Praying demon, in the style of a folk painting from Ōtsu
Series: Shingaku osana etoki, Moral philosophy illustrated for children
early 1840s
Signature: Ichiyūsai Kuniyoshi ga
medium panel, 376 × 131
Reference: Robinson 1961, 15; Riccar 242.
Provenance: Schraubstadter, Russell
Publication: Schraubstadter 924; Russell 174, $2.50.

A530, 50.663

From a series of eight or more pictures with homiletic verses.

604. Woman in a sudden rain on the Sumida River; illustration of a verse on evening rain by Kikaku
Series: Chūkō meiyō kijinden, Stories of people famous for loyalty and filial devotion
mid 1840s
Signature: Ichiyūsai Kuniyoshi ga
Artist's seal: paulownia
Publisher: Enshūya Matabei
Censorship seal: Muramatsu
ōban, 348 × 227
Reference: Robinson 1961, 35.

A528, 50.661

605. Shōki and a cowering demon
mid 1840s
Signature: Ichiyūsai Kuniyoshi ga
Artist's seal: Kuniyoshi
Publisher: Fujiokaya Hikotarō
Engraver: Horikō Fusajirō
Censorship seal: Muramatsu
ōban, 364 × 249
embossed ground
Provenance: Babuto (Pierre Barbouteau?), Jacquin
Publication: Jacquin 171, $22.50.

A531, 50.664

PLATE 117.

606. Ts'eng ts'an (Sōsan) climbing down from a tree
Series: Tōdo nijūshikō, The 24 Chinese paragons of filial piety

late 1840s
Signature: Ichiyūsai (Kuniyoshi)
chūban, 246 × 170
surface polishing
Reference: Robinson 1961, 14.

A526, 50.659

The set was designed in western style and the surfaces were polished in imitation of the varnish of oil paintings. Each of the 24 pictures is accompanied with a short biography of the subject by Tanekazu.

607. Chūyū carrying sacks
Series: *Tōdo nijūshikō,* The 24 Chinese paragons of filial piety
late 1840s
chūban, 251 × 168
surface polishing
Reference: Robinson 1961, 14.

A527, 50.660

Chūyū is not included on the usual lists of the 24 Paragons.

608abc. The ghosts of the slain Taira warriors attacking Yoshitsune and his men as they cross Daimotsu Bay
ca. 1850
Signature: Ichiyūsai Kuniyoshi ga
Artist's seal: paulownia
Publisher: Enhiko
Censorship seals: Fuku, Muramatsu
ōban triptych, 368 × 740
Reference: Suntory 9; Riccar 104;
Springfield 98 (color).

A532, 50.665

PLATE 156.

609abc. The pilot Yoshibei leaps into the Chopping Block Shoals and sacrifices himself to save his ship off the coast of Buzen Province
ca. 1850
Signature: Ichiyūsai Kuniyoshi ga
Artist's seal: paulownia
Publisher: Santetsu
Censorship seals: Muramatsu, Fuku
ōban triptych, 375 × 249 (center),
376 × 256 (left), 375 × 252 (right)
Reference: Riccar 111.

A533, 50.666

PLATE 157.

610abc. *Isamashiki kuniyoshi kiri no tsūi moyō,* The paulownia pattern of bold Kuniyoshi
ca. 1850
Signature: Ichiyūsai Kuniyoshi ga
Artist's seal: paulownia
Publisher: Ningyoya Takichi
Censorship seals: Kinugasa, Hama
ōban triptych, 376 × 251 (center),
379 × 256 (left), 375 × 259 (right)

A534, 50.667

A festival procession, perhaps for the Sannō Festival of Hie Shrine in which groups of musicians, artists, etc. marched in groups beneath parasols marked with their crest or emblem. This picture of Kuniyoshi's "Paulownia group" includes portraits of his

Students Yoshisada, Yoshikane, Yoshitsuna, Yoshiyuki, Yoshifuji, and Yoshitsuru, and two other men, Shige and Den, who may have been household servants. The leader, with his back to the viewer, may be Kuniyoshi himself, although Metzgar suggests it is his son.

PLATE 155.

611. *Asakusa kinryūzan bentenyama setchū no zu,* Snow at the Benten Shrine and Kinryūzan Temple at Asakusa
2/1853
Signature: Kuniyoshi ga
Publisher: Maruya Seibei
Censorship seals: Fuku, Muramatsu
ōban, 246 × 366
Reference: Riccar 39 (snow on pond);
Springfield 129 (snow on pond);
UTK 10, 196 (no snow on pond).

A442, 50.575

Published together with the view of the theater district, no. 612, and a view of cherry blossoms at Tsukiji, as a set of snow, moon, and flowers.
A late impression, with snowflakes on the water. Early impressions lack the snow on the water.

*612. *Shibaichō hanei no zu,* A picture of prosperity in the theater district
2/1853
Signature: Kuniyoshi ga
Publisher: Maruya Seibei
ōban, 250 × 365

A443, 50.576

612

613. Tonase and her mother rest in view of Mt. Fuji, Act 8
Series: *Kanadehon chūshingura*
11/1854
Signature: Ichiyūsai Kuniyoshi ga
Publisher: Sanoya Kihei han, Shiba Shimmeimae Mishimachō
Censorship seal: aratame
ōban, 248 × 367
Reference: Robinson 1961, 69.

A444, 50.577

From a series of 12 illustrating acts of the play *Chūshingura,* with printed borders.

*614. *Nikkō urami no taki,* the Back-view Waterfall at Nikkō
ca. late 19th century
Signature: Ichiyūsai Kuniyoshi ga
Artist's seal: *toshidama*
Publisher: unidentified
ōban, 240 × 360
Reference: Springfield 61.

A439, 50.571

The style and signature of this print and the view of lightning at Amanohashidata reproduced in Robinson, pl. 46, are characteristic of the late 1830s, but both prints were probably published for the first time during the Meiji period, based on surviving drawings or unpublished keyblock proofs for prints by Kuniyoshi. The red used in this and other impressions is synthetic and was not used in the 1830s or 1840s.

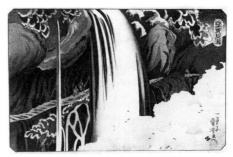

614

Keisai EISEN

615. *Nadeshiko ni chō,* Pinks and butterfly
ca. 1820s
Signature: Keisai
chūban, 224 × 169
printed in black and grey with colored border on three sides

A365, 50.498

616. Cranes and plums
1830s
Signature: Eisen ga
Publisher: Sōshūya, Jukō
ōban, 375 × 256
printed in red and blue

A366, 50.499

The second seal, *jukō,* means "felicitous publication."

617. Swallows and wisteria
ca. 1820s
Signature: Keisai ga
Censorship seal: kiwame
chūban, 222 × 167

A367, 50.500

PLATE 63.

618. *Atami onsen no zu,* Picture of the hot springs at Atami
early 1830s
Signature: Keisai ga
surimono, 210 × 184
Provenance: Appleton

A368, 50.501

Poems by Shiganoya Miyako, Hidaka Somako, Fude no Sayako, and Shibanoya Kamon.

The islands are identified as Helmet Rock, Hatsushima, and Ōshima. The hot spring is named Ippekirō. The hand-stamped seal in the upper right corner reads *takara*, or treasure. It is probably the mark of the group of female poets who commissioned the print and studied under Kamon.

619. *Ukie aki no miyajima benten yashiro no zu*, Perspective picture of the Benten Shrine at Miyajima in Aki Province
ca. 1830s
Signature: Eisen sha
Publisher: Sōshūya Yohei han, 2-chōme Nihonbashi
Censorship seal: kiwame
ōban, 256 × 371
A369, 50.502

620. *Kegon no taki san no taki no sono ikkei*, View of the three cascades of Kegon Waterfall
Series: *Nikkōzan meisho no uchi*, Famous places in the mountains of Nikkō
mid 1840s
Signature: Keisai Eisen sha
Artist's seal: Ippitsu
Publisher: Yamamoto, Yoshimachi kawagishi
Censorship seal: Watari
ōban, 365 × 249
Reference: TNM 2473.
A370, 50.503
Five prints were published in this set.
PLATE 89.

621ab. *Yaguchi watashi kassen*, The battle of Yaguchi Ferry
ca. 1810s
Signature: Eisen ga
Publisher: Ōtaya
Censorship seal: kiwame
two right panels of an ōban triptych, 368 × 502
A371, 50.504

*622. Carp ascending a waterfall
1830s
Signature: Keisai hitsu
Artist's seal: Eisen
Publisher: Kansendō
vertical diptych, 728 × 248
Reference: UTK 10, 228–229.
A372, 50.505
For other prints by Eisen see catalogue nos. 1004 seq.

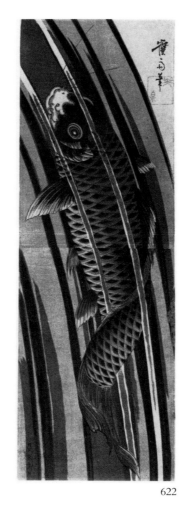

622

TANKA

*623. *Sumidagawa tōgan no zu*, Mt. Tsukuba from the east bank of the Sumida River
ca. 1850
Signature: Tanka sha
Artist's seal: Tanka
Publisher: Enshūya Matabei
Censorship seals: Mera, Murata
fan print, 219 × 292
Provenance: Jacquin
Publication: Jacquin 227, $11.
A565, 50.698
A design by an unrecorded artist, from a fan seller's sample book with binding holes at left edge.

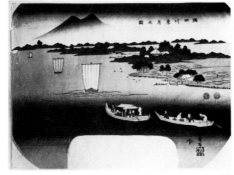

623

Utagawa HIROSHIGE

Nos. 624–627 are from the same series and have the same signature, publisher, and format.

624. *Ryōgoku no yoizuki*, Twilight moon at Ryōgoku Bridge
Series: *Tōto meisho*, Famous sites in the eastern capital
ca. 1831
Signature: Ichiyūsai Hiroshige ga
Publisher: (Kawaguchi Shōzō, 4-chōme Ginza, Edo)
ōban, with printed border, 222 × 357, with variation up to 7 mm. within set
Reference: Suzuki 243.
A648, 50.781
From Hiroshige's first set of ten landscapes. The impression, which is late, lacks the publisher's name in right margin.

625. *Sumidagawa hazakura no kei*, Cherry trees in leaf beside the Sumida River brown printed borders
Reference: Suzuki 245.
Provenance: Wakai, Jacquin
Publication: Jacquin 478, ill., $110.
A651, 50.784

626. *Susaki yuki no hatsuhi*, Snowy sunrise on New Year's Day at Susaki
Lacks printed borders.
Reference: Suzuki 246.
A650, 50.783

*627. *Tsukudajima hatsu hototogisu*, First cuckoo at Tsukuda Island
yellow borders
Reference: Suzuki 251.
A649, 50.782

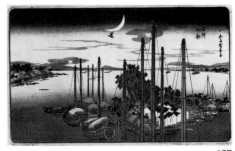

627

Nos. 628–635 are from the same series and have the same series title, signature, publisher, censorship seal, and format.

628. *Nihonbashi no hakuu*, Light rain on Nihon Bridge
Series: *Tōto meisho*, Famous places in the eastern capital
1830s
Signature: Hiroshige
Artist's seal: Ichiryūsai
Publisher: Kikakudō, Shiba Shimmeimae
Censorship seal: kiwame
ōban, 229 × 350, with variation up

to 11 mm. within set
blue cartouche
Reference: Matsuki 11; Suzuki 135,
12

A962, 50.1095

From the first set of 21 views of Edo
Hiroshige designed for Sanoya Kihei be-
tween ca. 1832 and 1839.
The title is in a cartouche above the pub-
lisher's mark and the censorship seal in the
right margin.
The publisher's name also appears on one
of the umbrellas.
PLATE 102.

629. *Kameido umeyashiki no zu,* The plum
garden at Kameido
Artist's seal: Utagawa
blue cartouche
Reference: Matsuki 15; Suzuki 135,
13.

A963, 50.1096

630. *Kameido temmangū keidai yuki,* Snow
on the precincts of the Temman
Shrine at Kameido
Artist's seal: Ichiryūsai
pink cartouche
Reference: Matsuki 16; Suzuki 135,
15.

A964, 50.1097

631. *Nagatababa sannōgū,* The entrance to
the Sannō Shrine at Nagatababa
Artist's seal: Ichiryūsai
pink cartouche
Reference: Matsuki 21; Suzuki 135,
10.

A965, 50.1098

632. *Ueno tōeizan no zu,* Cherry trees in
blossom at Tōeizan Temple in Ueno
Artist's seal: Ichiryūsai
yellow cartouche
Reference: Matsuki 22; Suzuki 135,
6.
Provenance: May
Publication: May 687, $5.

A966, 50.1099

633. *Massaki yukibare no zu,* Clear weather
after snow at Massaki
Artist's seal: Utagawa
lacking seals and title cartouche
Reference: Matsuki 24; Suzuki 135,
20.

A967, 50.1100

634. *Asakusa kinryūzan toshi no ichi gun-
shū,* Crowds at the year-end festival
at Kinryūzan Temple in Asakusa
Artist's seal: Ichiryūsai
yellow cartouche
Reference: Matsuki 26; Suzuki 135,
16.

A968, 50.1101

635. *Shiba atago sanjō no zu,* Rainbow
from the top of Atago Hill in Shiba
Artist's seal: Ichiryūsai
yellow cartouche
Reference: Matsuki 29; Suzuki 135,
5.

A969, 50.1102

636. *Asakusa kinryūzan toshi no ichi,* Snow
at the year-end festival at Kinryūzan
Temple in Asakusa
Series: *Tōto meisho,* Famous places
in the eastern capital
late 1830s
Signature: Hiroshige ga
Publisher: trimmed
Censorship seal: trimmed
ōban, 211 × 336
Reference: Matsuki 52; Suzuki 135,
11.
Publication: perhaps May 687, $5.

A971, 50.1104

From the second *Tōto meisho* series, pub-
lished by Sanoya Kihei between the late
1830s and 1858, including sixteen pictures
with a tile-shaped cartouche in the right
margin. An untrimmed impression is re-
produced in Suzuki 152.

637. *Asakusa kinryūzan toshi no ichi,* Snow
at the year-end festival at Kinryūzan
Temple in Asakusa
Series: *Tōto meisho,* Famous places
in the eastern capital
9/1856
Signature: Hiroshige ga
Publisher: Sanoki
Censorship seal: aratame
217 × 340
yellow cartouche
Reference: Matsuki 53; Suzuki 133,
12.

A972, 50.1105

A later version of the previous subject,
from the same series.

638. *Dōkanyama mushikiki no zu,* Listen-
ing to insects by moonlight on Mt.
Dōkan
Series: *Tōto meisho,* Famous places
in the eastern capital
ca. late 1840s
Signature: Hiroshige ga
Artist's seal: Ichiryūsai
Publisher: Sanoki
ōban, 215 × 336
Reference: Matsuki 34; Suzuki 135,
6.

A970, 50.1103

From the third set of nine or more views
of Edo, published by Sanoya Kihei, with
the cartouche cut diagonally on the four
corners. An early untrimmed impression is
reproduced in color in Suzuki, pl. 45.

639. *Sumidagawa hanazakari,* Cherry trees
in full bloom along the Sumida
River

Series: *Tōto meisho,* Famous places
in the eastern capital
ca. late 1830s
Signature: Hiroshige ga˙
Artist's seal: Utagawa
Publisher: Kawashō
Censorship seal: kiwame
ōban, 220 × 357
Reference: Matsuki 68; Suzuki 136,5.
Provenance: Matsuki

A973, 50.1106

From a series of 15 views of Edo published
by Kawaguchi Shōzō from ca. the late 1830s
to mid 1840s.

640. *Sumidagawa uchū no hana,* Cherry
trees in the rain beside the Sumida
River
Series: *Edo meisho no uchi,* Famous
places in Edo
mid 1840s
Signature: Hiroshige ga
Publisher: Marujin
Censorship seal: Tanaka
ōban, 222 × 344
Reference: Matsuki 165; Suzuki
137,4.

A984, 50.1117

From a series of at least 14 views of Edo
with adjacent vertical and square title car-
touches within the picture published by
Maruya Jimpachi between the mid 1840s
and 1854.
There are two contemporary versions of
this print, from different blocks.

641. *Ryōgoku ōhanabi,* Fireworks over
Ryōgoku
Series: *Edo meisho,* Famous places in
Edo
mid 1840s
Signature: Hiroshige ga
Artist's seal: Hiro
Publisher: Aritaya
Censorship seal: Tanaka (trimmed)
ōban, 216 × 337
embossing
Reference: Matsuki 189; Suzuki
138,3.

A982, 50.1115

From a series of 32 views of Edo with a
tile-shaped red title cartouche within the
picture published by Yamashiroya Jimbei
and Aritaya Seiemon between the mid 1840s
and mid 1850s. Poem on fireworks by
Shōeisai (?).

Nos. 642-643 are from the same series
and have the same signature, publisher,
format and approximate size.

642. *Kameido umeyashiki,* Visitors beside
the Reclining Dragon plum tree at
the plum garden at Kameido
Series: *Edo meisho,* Famous places in
Edo
11/1853
Signature: Hiroshige ga

Publisher: Yamadaya
Censorship seals: Mera, Watanabe
ōban, 218 × 342
Reference: Matsuki 240; Suzuki
139,20.

A983, 50.1116

From a set of 40 views of Edo with people, begun in 1853–54, completed in 1858, and known, because of the conspicuous human figures, as the Yamadaya figure set.

643. *Asukayama hanami no zu,* Viewing cherry blossoms at Asuka Hill
8/1853
Censorship seals: Murata, Kinugasa
Reference: Suzuki 138,8.

A987, 50.1120

Nos. 644-649 are from the same series and have the same series title, signature, publisher, censorship seal, and format except where noted otherwise.

644. *Meguro fudō mōde,* Visitors to the shrine of the Fudō at Meguro
Series: *Edo meisho,* Famous places in Edo
1830s
Signature: Hiroshige ga
Artist's seal: Yūsai
Publisher: Kikakudō
Censorship seal: kiwame
ōban, 221 × 344, with variation up to 5 mm. within set
Reference: Matsuki 132; Suzuki 139, 2.

A979, 50.1112

From the first series of 15 prints of this title with a tile-shaped cartouche published by Sanoya Kihei.

645. *Susaki shiohigari,* Gathering shells at low tide at Susaki
Artist's seal: Utagawa
Reference: Matsuki 133; Suzuki 139,4.

A980, 50.1113

646. *Ueno shinobazu no ike,* Trees coming into leaf at Shinobazu Pond in Ueno
Artist's seal: Ichiryūsai
Reference: Matsuki 127; Suzuki 139,6.
Provenance: May
Publication: May 977, $12.50.

A977, 50.1110

647

*647. *Yushima temmangū,* Steps to the Temman Shrine at Yushima
Artist's seal: Hiroshige
Publisher: trimmed
Censorship seal: trimmed
Reference: Matsuki 131; Suzuki 139,10.

A978, 50.1111

648. *Sumidagawa hanazakari,* Cherry trees in full bloom along the Sumida River
Artist's seal: Ichiryūsai
Reference: Matsuki 134; Suzuki 139,14.

A981, 50.1114

649. *Ōji inari no yashiro,* The Inari Shrine at Ōji
Artist's seal: Utagawa
Reference: Matsuki 125; Suzuki 139,15.

A976, 50.1109

PLATE 201.

650. *Ryōgokubashi nōryō,* Fireworks on a cool summer evening at Ryōgoku Bridge
Series: *Edo meisho,* Famous places in Edo
1830s
Signature: Hiroshige ga
Artist's seal: Ichiryūsai
Publisher: Kikakudō
Censorship seal: kiwame
ōban, 226 × 349
Provenance: Happer authentication seal on verso

A975, 50.1108

From the third group of views of Edo with this title and cartouche with indented corners published by Sanoya Kihei. The boat in the foreground has lanterns which read Utagawa. The boat in the background is the Kawaichimaru.

Nos. 651–655 are from the same series and have the same series title, publisher, censorship seal and format.
From a series of eight views originally commissioned by the *kyōka* poet Taihaidō Nomimasu and published by Sanoya Kihei for Nomimasu's poetry group. Early impressions of the prints have the name of the poet Taihaidō *kaihan* in the margin, and several poems. Later impressions have fewer poems and Taihaidō's mark is removed.

*651. *Shibaura seiran,* Haze on a clear day at Shiba Bay
Series: *Edo kinkō hakkei,* Eight views of the environs of Edo
ca. 1837–1838
Publisher: Kikaku
Censorship seal: kiwame
ōban, 225 × 350, with variation up to 7 mm. in set, except where noted
embossing
Reference: Suzuki 139, 1, pl. 20.

A905, 50.1036

Second state with the three original poems removed and a new poem added by Fūgetsuan on the subject of Shiba Bay.

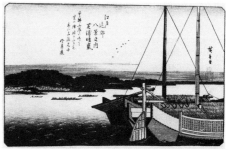
651

652. *Azuma no mori yoru no ame,* Night rain at the forest of Azuma
rain printed dark grey
Reference: Suzuki 139, 2, pl. 118.

A903, 50.1036

Second state with the original three poems removed, and the second poem by Suichōdō reengraved with some changes in substance and script and inserted beside the title upper right.

653. *Ikegami banshō,* Evening bell at Ikegami
Reference: Suzuki 119, 4, pl. 120.
Provenance: Wakai, Gookin
Publication: probably May 239, $45.

A904, 50.1037

Second state with two poems at the left removed and most of the background trees removed from the keyblock, leaving a greyblue silhouette. Poem by Shunkutei Norimasa.

PLATE 190.

654. *Koganeibashi sekishō,* Evening glow with cherry trees in blossom at Koganei Bridge
embossing
Reference: Suzuki 139, 5.

A906, 50.1039

Second state with poems by Umenoya and Nomimasu, but with a third poem at the center of the print removed.

655. *Asukayama bōsetsu,* Evening snow at Asuka hill
embossing
Reference: Suzuki 139, 8, pl. 18 (first state).

A902, 50.1035

Second state with two poems and the mark of Taihaidō removed and lacking the spattered snowflakes.
Poem by Nomimasu.

656. *Yoshiwara emonzaka no zu,* The Emon Slope at the Yoshiwara
Series: *Tōto meisho sakazukushi no uchi,* Slopes at famous places in Edo
ca. 1840
Signature: Hiroshige ga

Publisher: Yamadaya Shōjirō, Nakabashi
ōban, 232 × 352
Reference: Matsuki 114; Suzuki 140, 6.

A974, 50.1107

From a series of ten prints with decorative printed borders and the series title in a tile-shaped cartouche in the right margin.

657. *Gotenyama hanami,* Flower viewing at Goten Hill
Series: *Edo meisho mitsu no nagame,* Three views of famous places in Edo
late 1830s
Signature: Hiroshige
Publisher: Enjudō
ōban, 221 × 343
Reference: Matsuki 307; Suzuki 141, 3.

A985, 50.1118

From one of two sets of three with the same title on the theme of snow, moon and flowers, published by Maruya Jimpachi in the late 1830s.

658. *Yuki no asa susaki no hinode,* Snowy New Year's dawn at Susaki
Series: *Tōto meisho,* Famous places in the eastern capital
mid 1840s
Signature: Hiroshige ga
Publisher: trimmed
Censorship seal: Hama (trimmed)
aiban, 195 × 317
Reference: Matsuki 346; Suzuki 142, 7.

A986, 50.1119

From a series of ten views of Edo in medium format published by Ezakiya Tatsuzō in the mid 1840s.

Nos. 659-660 are from the same series and have the same approximate date, signature, format and size.

659. *Ryōgoku yoru no kei,* Night view with fireworks at Ryōgoku
Series: *Edo meisho,* Famous places in Edo
ca. late 1830s
Signature: Hiroshige ga
Artist's seal: Ichiryūsai
aiban, 190 × 322
Reference: Suzuki 142, 11.

A989, 50.1122

From a set of at least 11 prints in medium format with an irregularly shaped title cartouche within the picture, published by Izumiya Ichibei between the mid and late 1830s.

660. *Kameido no zu,* Wisteria arbor and drum bridge at the Temman Shrine at Kameido
Publisher: Senichi
Censorship seal: kiwame
Reference: Suzuki 142, 9.

A990, 50.1123

Nos. 661-739 are from the same series and have same series title, signature, publisher, censorship mark, format, and technique.

661. 1. *Nihonbashi yukibare,* Clear weather after snow at Nihon Bridge
Series: *Meisho edo hyakkei,* One hundred views of famous places in Edo

The *100 Views of Edo,* Hiroshige's last major set, was published by Uoya Eikichi at Shitaya in Edo between 1856 and 1858. When the 118 prints were completed, a decorative title-page with table of contents was added, dividing the prints by seasons, and the prints were published as a set. The numbering of the group follows the order of the printed table-of-contents as followed in the two volumes devoted to the series in *Ukiyoe taikei,* which reproduces the extremely fine set in the Hirose collection in original size and in color. There is much variation in the printing of the series and it is instructive to compare the Ainsworth prints with those in the Hirose album. Suzuki also reproduces a similarly fine album and references are given to the illustrations in his monograph.

5/1856
Signature: Hiroshige ga
Publisher: Uoei
Censorship seal: aratame
ōban, 340 × 223, with variation up to 6 mm. within set
Reference: Suzuki 462.
Publication: perhaps Metzgar 397, $7.50.

A1247, 50.1380

662. 4. *Eitaibashi tsukudajima,* Moon over ships moored at Tsukuda Island from Eitai Bridge
2/1857
Reference: Suzuki 463.

A1248, 50.1381

663. 6. *Bakurochō hatsune no baba,* Cloth stretched to dry at Hatsune Field in Bakurochō
9/1857
embossing, two-color cartouche
Reference: Suzuki 467.
Provenance: unidentified collector's mark.

A1249, 50.1382

664. 8. *Surugachō,* Fuji from Surugachō
9/1856
Reference: Suzuki 469.

A1250, 50.1383

665. 10. *Kanda myōjin akebono no kei,* The view at sunrise from the Myōjin Shrine in Kanda
9/1857
embossing, three-color cartouche
Reference: Suzuki 471.

A1251, 50.1384

666. 13. *Shitaya hirokōji,* The Matsuzakaya clothing store at Hirokōji Street in Shitaya
9/1856
Reference: Suzuki 474.

A1252, 50.1385

667. 14. *Nipporizato jiin no rinsen,* The temple garden in Nippori Village
2/1857
Reference: Suzuki 475.
Publication: perhaps Ficke 1920, 829, $10 (MA: "uncut").

A1253, 50.1386

668. 17. *Asukayama kita no chōbō,* View of Mt. Tsukuba north of Asuka Hill
5/1856
Reference: Suzuki 478.

A1254, 50.1387

669. 19. *Ōji otonashigawa entai sezoku ōtaki to tonau,* The Otonashi River Dam, popularly called Ōtaki Waterfall
Reference: Suzuki 480.

A1255, 50.1388

670. 21. *Shiba atagoyama,* Priest in ceremonial dress ascending the steps of the shrine on Atago Hill in Shiba
8/1857
Signature: Shōgatsu mikka bishamonzukai Hiroshige ga
Reference: Suzuki 482.

A1256, 50.1389

Hiroshige's signature is preceded by the words "Servant of the god Bishamon on the third day of the first month" and it has been suggested that this may be a self-portrait of the artist. The placard above the door is dated 1857.

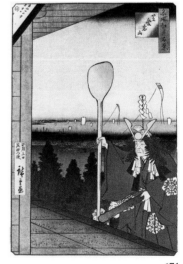

671

*671. 21. *Shiba atagoyama*
A fine, early impression with a three-color cartouche

A1256A, 50.1389

201

672. 22. *Hiroo furukawa*, The Furu River at Hiroo
7/1856
Reference: Suzuki 483.

A1257, 50.1390

673. 23. *Meguro chiyogaike*, The waterfall at Chiyo Pond in Meguro
7/1856
Reference: Suzuki 484.

A1258, 50.1391

674. 24. *Meguro shinfuji*, The new man-made Mt. Fuji at Meguro
4/1857
Reference: Suzuki 485.
Provenance: unidentified Japanese collector's seal
Publication: perhaps Ficke 1920, 836, $7.50 (MA: "uncut").

A1259, 50.1392

675. 25. *Meguro motofuji*, The original man-made Mt. Fuji at Meguro
4/1857
Reference: Suzuki 486.
Provenance: unidentified Japanese collector's mark
Publication: perhaps Ficke 1920, 838, $10 (MA: "uncut").

A1260, 50.1393

676. 27. *Kamata no baien*, Plum orchard at Kamata
2/1857
three-color cartouche
Reference: Suzuki 488.

A1261, 50.1394

677. 28. *Shinagawa gotenyama*, Cherry trees in blossom on Goten Hill at Shinagawa
4/1856
Reference: Suzuki 489.

A1262, 50.1395

678. 30. *Kameido umeyashiki*, The grove of plum trees at Kameido
11/1857
two-color cartouche
Reference: Suzuki 491.

A1263, 50.1396

679. 34. *Matsuchiyama sanyabori yakei*, Night views of Matsuchi Hill and the entrance of the Sanya Canal from the Sumida River
8/1857
Reference: Suzuki 495.

A1264, 50.1397

680. 35. *Sumidagawa suijin no mori massaki*, Massaki and the Forest of the Water God along the Sumida River
8/1856
Reference: Suzuki 496.

A1265, 50.1398

681. 36. *Massaki hen yori suijin no mori uchikawa sekiya no sato o miru zu*, View of the Forest of the Water God, and Sekiya Village and the Uchi River from a window in Massaki
8/1857
three-color cartouche
Reference: Suzuki 496.

A1266, 50.1399

682. 37. *Sumidagawa hashiba no watashi kawaragama*, Tile kilns by the Hashiba ferry on the Sumida River
4/1858
Reference: Suzuki 498.

A1267, 50.1400

683. 38. *Kakuchū shinonome*, Dawn in the licensed quarters
4/1857
Reference: Suzuki 499.

A1268, 50.1401

684. 39. *Azumabashi kinryūzan embō*, Distant view of Azuma Bridge and Kinryūzan Temple from a pleasure boat
8/1857
two-color cartouche
Reference: Suzuki 500.

A1269, 50.1402

A defect in the black block is visible on the middle of the boat.

685. 40. *Sekiguchi jōsuibata bashōan tsubakiyama*, Camellia Hill and the hut of the poet Bashō beside the water supply at Sekiguchi
4/1857
Reference: Suzuki 501.

A1270, 50.1403

686. 42. *Tamagawa tsutsumi no hana*, Cherry trees in blossom on the embankment of the Tama River
2/1856
Reference: Suzuki 503.
Publication: Ficke 1920, 851, $7.50.

A1271, 50.1404

687. 43. *Nihonbashi edobashi*, Edo Bridge from Nihon Bridge with the tub of a fishseller
12/1857
two-color cartouche
Reference: Suzuki 504.

A1272, 50.1405

688. 62. *Yatsumi no hashi*, Willow at Ichikoku Bridge from which there is a view of eight bridges
8/1856
with mica on the base of Mt. Fuji
Reference: Suzuki 506.

A1273, 50.1406

689. 46. *Shōheibashi seidō kandagawa*, Rain at the Seidō Hall and Shōhei Bridge over the Kanda River
9/1857
three-color cartouche
Reference: Suzuki 508.

A1274, 50.1407

PLATE 103.

690. 63. *Suidōbashi surugadai*, Carp banner by Suidō Bridge at Surugadai
Intercalary 5/1857
Reference: Suzuki 509.

A1275, 50.1408

691. 47. *Ōji fudō no taki*, The waterfall of the Fudō at Ōji
two-color cartouche
Reference: Suzuki 510.

A1276, 50.1409

692. 64. *Tsunohazu kumano jūnisha zokushō jūnisō*, The twelve shrines of Kumano at Tsunohazu, commonly called the Jūnisō
7/1856
embossed cartouche
Reference: Suzuki 511.

A1277, 50.1410

693. 65. *Kōjimachi itchōme sannō matsuri nerikomi*, The Sannō festival procession turning in at the first block of Kōjimachi
7/1856
Reference: Suzuki 512.

A1278, 50.1411

694. 48.1 *Akasaka kiribatake*, The grove of paulownia trees at Akasaka
4/1856
Reference: Suzuki 513.

A1279, 50.1412

(Utagawa Hiroshige II)

695. 48.2 *Akasaka kiribatake uchū yūkei*, Evening view of rain at the grove of paulownia trees at Akasaka
4/1859
Signature: nisei Hiroshige ga
three-color cartouche
Reference: Suzuki 514.

A1280, 50.1413

This picture was designed by Hiroshige II after his teacher's death as a replacement for the previous print.
PLATE 104.

696. 50. *Tsukudajima sumiyoshi no matsuri*, Banner for the festival of the god Daimyōjin at the Sumiyoshi Shrine on Tsukuda Island
7/1857
embossing
Reference: Suzuki 517.

A1281, 50.1414

The banner is dated 6/1857. The calligraphy is signed Seikengū Gengyo.

697. 51. *Fukagawa mannenbashi*, Turtle dangling from the pole of a vendor's tub on Mannen Bridge in Fukagawa
11/1857
Reference: Suzuki 518.

A1282, 50.1415

698. 67. *Mitsumata wakare no fuchi,* The parting depths near Mitsumata
2/1857
Reference: Suzuki 519.
Publication: perhaps May 474, $3.75.
A1283, 50.1416

699. 52. *Ōhashi atake no yūdachi,* Evening rain at Atake and Ōhashi Bridge
9/1857
Reference: Suzuki 521.
A1284, 50.1417
First state of the print with two boats and before the gap in the color blocks was plugged underneath the bridge.
PLATE 191.

700. 52. *Ōhashi atake no yūdachi,* Evening rain at Atake and Ōhashi Bridge
9/1857
Reference: Suzuki 520.
A1285, 50.1418
Later state with new color block for distant shore and the gap beneath the bridge filled.
PLATE 193.

701. 69. *Ayasegawa kanegafuchi,* Raft at Kanegafuchi on the Ayase River
7/1857
Reference: Suzuki 527.
A1286, 50.1419

702. 56. *Horikiri no hanashōbu,* Iris at Horikiri
Intercalary 5/1857
three-color cartouche
Reference: Suzuki 528.
A1287, 50.1420

703. 57. *Kameido tenjin kedai,* The Drum Bridge from the wisteria arbor on the precincts of the Tenjin Shrine at Kameido
7/1856
Referencce: Suzuki 529.
A1288, 50.1421

704. 58. *Sakai no watashi,* Herons by the Sakai Ferry
2/1857
embossing
Reference: Suzuki 531.
A1289, 50.1422

705. 71. *Fukagawa sanjūsangendō,* The Thirty-three *ken* Hall at Fukagawa
8/1857
Reference: Suzuki 533.
A1290, 50.1423

706. 61. *Tonegawa barabara matsu,* Cast net and scattered pine trees along the Tone River
8/1856
Reference: Suzuki 535.
Publication: certainly not Ficke 1920, 866, $40 (MA: "uncut, lovely, extremely exceptional quality").
A1291, 50.1424

707. 73. *Shichū hanei tanabata matsuri,* Decorations for the Tanabata Festival in the prosperous city of Edo
7/1857
Reference: Suzuki 537.
A1292, 50.1425

708. 74. *Ōtemmachō gofukuten,* Ceremonial procession of carpenters in front of the Daimaru clothing store at Ōtemmachō
7/1858
three-color cartouche
Reference: Suzuki 538.
A1293, 50.1426

709. 75. *Kanda konyachō,* Cloth drying in the dyer's district in Kanda
11/1858
embossing
Reference: Suzuki 539.
A1294, 50.1427
The strips of white cloth bear the emblems of the artist and publisher.

710. 77. *Teppōzu inaribashi minato jinja,* Masts beside Inari Bridge and the Harbor Shrine at Teppōzu
2/1857
Reference: Suzuki 541.
A1295, 50.1428

711. 79. *Shiba shimmei zōjōji,* Pilgrims and priests at Zōjō Temple and the Shimmei Shrine in Shiba
7/1858
Reference: Suzuki 543.
A1296, 50.1429

712. 82. *Tsuki no misaki,* Tea house at the Promontory of the Moon near Takanawa
8/1857
three-color embossed cartouche
Reference: Suzuki 546.
A1297, 50.1430

713. 83. *Shinagawa susaki,* The Benten Shrine at Susaki in Shinagawa
4/1856
Reference: Suzuki 547
Publication: Ficke 1920, 875, $10 (MA: "uncut, have with blue streak").
A1298, 50.1431

714. 84. *Meguro jijigachaya,* The Old Man's Teahouse in Meguro
4/1857
Reference: Suzuki 548.
A1299, 50.1432

715. 88. *Ōji takinogawa,* The Waterfall River at Ōji
4/1856
Reference: Suzuki 552.
A1300, 50.1433

716. 90. *Saruwakachō yoru no kei,* Evening view of the theater district in Saruwakachō with shadows cast by passers-by
9/1856
Reference: Suzuki 555.
Provenance: Bunri
A1301, 50.1434
Second state with large moon, cloud under noon.

717. 91. *Ukiji akiba no keidai,* Autumn foliage on the precincts of Akiba Shrine at Ukiji
8/1858
four-color cartouche
Reference: Suzuki 556.
Provenance: Jacquin
Publication: Jacquin 483, $12.50.
A1302, 50.1435

718. 92. *Mokuboji uchikawa gozensaibatake,* The fields for growing hors d'oeuvres at Mokubo Temple along the Uchi River
12/1857
Reference: Suzuki 557.
A1303, 50.1436

719. 93. *Niishuku no watashi,* The Niishuku Ferry
2/1858
Reference: Suzuki 558.
A1304, 50.1437

720

*720. 95. *Kōnodai tonegawa fūkei,* View of Kōnodai, the Hill of the Wild Goose, beside the Tone River
5/1856
three-color cartouche
Reference: Suzuki 560.
Provenance: unidentified Japanese collector's seal
A1305, 50.1438

721. 96. *Horie nekozane*, The river between the villages of Horie and Nekozane
2/1856
Reference: Suzuki 561.
Publication: perhaps May 473, $3.75.
A1306, 50.1439

722. 97. *Onagigawa gohonmatsu*, Five Pines on the Onagi River
7/1856
Reference: Suzuki 562.
A1307, 50.1440

723. 98. *Ryōgoku hanabi*, Fireworks at Ryōgoku Bridge
8/1858
Reference: Suzuki 563.
A1308, 50.1441
An early impression with light around bursting fireworks.
PLATE 181.

724. 98. *Ryōgoku hanabi*, Fireworks at Ryōgoku Bridge
8/1858
Reference: Suzuki 563.
A1309, 50.1442
A later impression with the sky dark.
PLATE 182.

725. 99. *Asakusa kinryūzan*, Snow at the entrance gate to Kinryūzan Temple in Asakusa
Reference: Suzuki 564.
A1310, 50.1443

726. 100. *Yoshiwara nihonzutsumi*, The Nihon Embankment leading to the Yoshiwara
4/1857
Reference: Suzuki 565.
A1311, 50.1444

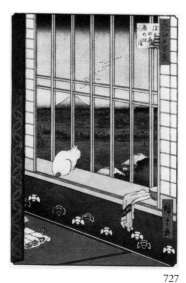

727

*727. 101. *Asakusa tambō tori no machi mōde*, Farmers' festival procession through the fields near Asakusa from a window in the Yoshiwara
11/1857
embossing, four-color cartouche
Reference: Suzuki 566.
A1312, 50.1445

728. 102. *Minowa kanasugi mikawashima*, Cranes by Minowa and Kanasugi on Mikawa Island
Intercalary 5/1857
embossing, three-color cartouche
Reference: Suzuki 567.
Provenance: unidentified Japanese seal
A1313, 50.1446

729. 106. *Fukagawa kiba*, Snow at the lumber yards in Fukagawa
8/1856
two-color cartouche
Reference: Suzuki 571.
Provenance: unidentified Japanese seal
A1314, 50.1447

730. 107. *Fukagawa susaki jūmantsubo*, Eagle over the Hundred-thousand *Tsubo* Plain beyond Susaki in Fukagawa
Intercalary 5/1857
traces of gloss on beak and claws, two-color embossed cartouche
Reference: Suzuki 572.
A1315, 50.1448

731. 108. *Shibaura no fūkei*, View of plovers at Shiba Bay
2/1856
Engraver: Hori Kan
with mica and white spattered on waves, two-color embossed cartouche
Reference: Suzuki 573.
A1316, 50.1449

732. 109. *Minami shinagawa samezu kaigan*, The shore of Edo Bay at Samezu south of Shinagawa
2/1857
embossed cartouche
Reference: Suzuki 574.
A1317, 50.1450

733. 111. *Meguro taikobashi yūhi no oka*, Snow on Twilight Hill by the Drum Bridge in Meguro
4/1857
three-color cartouche
Reference: Suzuki 576.
A1318, 50.1451

734. 112. *Atagoshita yabukōji*, Snow at Yabukōji in Lower Atago
12/1857
two-color cartouche
Reference: Suzuki 577.
Publication: Ficke 1920, 896, $40 (MA: "uncut").
A1319, 50.1452

735. 113. *Toranomongai aoizaka*, Waterfall by Aoi Slope outside the Tiger Gate of Edo Castle
11/1857
Reference: Suzuki 578.
Provenance: Bunri
A1320, 50.1453

*736. 114. *Bikunibashi setchū*, The boar meat restaurant at Bikuni Bridge in the snow
10/1858
with mica on bridge, two-color cartouche
Reference: Suzuki 579.
A1321, 50.1454

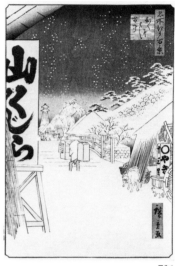

736

737. 115. *Takata no baba*, Archery target at the race course at Takata
2/1857
with mica on target and tree, embossing on target, two-color cartouche
Reference: Suzuki 580.
A1322, 50.1455

738. 117. *Yushima tenjin sakaue chōbō*, View from the top of the slope of the Tenjin Shrine in Yushima
4/1856
Reference: Suzuki 582.
A1323, 50.1456

739. 118. *Ōji shōzoku enoki ōmisoka no kitsunebi*, The ceremonial gathering of foxes on New Year's Eve at the nettle tree near the Inari Shrine at Ōji
9/1857
three-color cartouche
Reference: Suzuki 583.
A1324, 50.1457
The print is popularly known as the Fox Fires at Ōji.
PLATE 202.

*740. *Fuyu sumidagawa no yuki,* Winter snow on the Sumida River
Series: *Shiki edo meisho,* Famous places in Edo in the four seasons
ca. 1834
Signature: Hiroshige ga
Publisher: Kawashō
Censorship seal: kiwame
medium panel, 357 × 119
Reference: Matsuki 629; Suzuki 152, 4.

A993, 50.1126

From a series of four with appropriate, but unsigned, *kyōka* poems published by Kawaguchi Shōzō.

The Ledoux impression of this print is printed from different blocks and may be a contemporary copy.

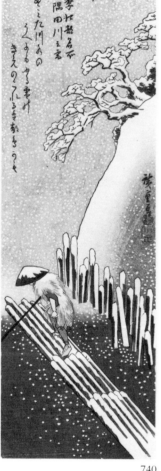

740

Nos. 741–744 are from the same series and have the same signature and format.

741. *Asakusa kinryūzanshita azumabashi uchū no bō,* View of Azuma Bridge in the rain below Kinryūzan Temple
Series: *Tōto meisho,* Views of famous places in the eastern capital
1830s
Signature: Hiroshige ga
Publisher: Fujioka
Censorship seal: kiwame

medium panel, 375 × 132, with variation up to 9 mm. within set
Reference: Matsuki 611; Suzuki 152, 4.
Provenance: Appleton
Publication: Appleton 88, $32.50.

A991, 50.1124

From a series of twenty panel pictures of Edo published by Fujokaya Hikotarō (Shōgendō) in the mid and late 1830s.

The pictures were printed two to an *ōban* sheet and there is a trace of the adjacent picture at the left.

*742. *Umeyashiki manka no zu,* Plum trees in full blossom at the plum garden at Kameido
ca. late 1830s
Artist's seal: Ichiryūsai
Censorship seal: kiwame
embossing
Reference: Suzuki 152, 2.
Provenance: Blanchard
Publication: Blanchard 255, $12.50.

A995, 50.1128

The picture shows traces of the adjacent panel to the left.

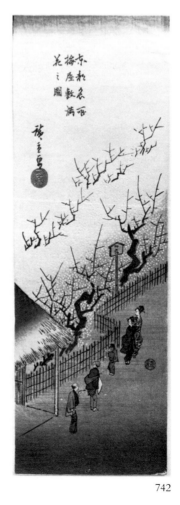

742

743. *Susaki kaihin shiohigari no zu,* Gathering shellfish at low tide on the beach at Susaki
ca. late 1830s
Artist's seal: Ichiryūsai
Reference: Suzuki 152, 6.

A996, 50.1129

Trace of adjacent print at left. Red on figures and roofs touched in by hand over faded color.

*744. *Asukayamashita haru no kei,* Spring view at the foot of Asuka Hill
ca. late 1830s
Artist's seal: Ichiryūsai
Publisher: Shōgendō
Reference: Suzuki 152, 7.

A998, 50.1131

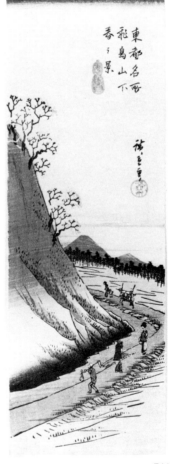

744

745. *Takanawa tsukiyo no zu,* Full moon at night at Takanawa
Series: *Tōto meisho,* Famous places in the eastern capital
ca. 1840
Signature: Hiroshige ga
Artist's seal: Ichiryūsai
Publisher: Yamaguchiya Tōbei
Censorship seal: kiwame
medium panel, 369 × 97

Reference: Matsuki 620; Suzuki 153, 3.

A992, 50.1125

From a series of nine panel prints with the series title in semicursive script.

746. *Gotenyama hanami,* Viewing cherry blossoms on Goten Hill
Series: *Tōto meisho,* Famous places in the eastern capital
ca. 1841
Signature: Hiroshige
medium panel, 350 × 111
Reference: Matsuki 638; Suzuki 153, 6.
Provenance: Blanchard
Publication: Blanchard 262, $7.50.

A994, 50.1127

From a set of ten, published by Kawaguchi Shōzō with a tile-shaped red title cartouche within the picture.
Traces of the adjacent picture are visible at the right.
The paper size seems slightly smaller than half a sheet of standard *ōban* paper. The print is untrimmed vertically but measures only 350 mm., whereas no. 741, also untrimmed, measures 375 mm.

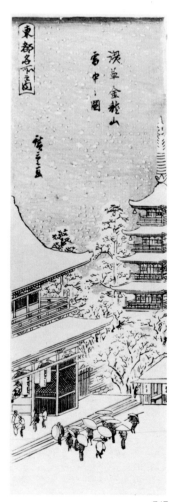

747

*747. *Asakusa kinryūzan setchū no zu,* Snow at Kinryūzan Temple in Asakusa
Series: *Tōto meisho no uchi,* Famous places in the eastern capital
ca. 1840–1841
Signature: Hiroshige ga
Publisher: Yamadai
medium panel, 344 × 114
Reference: Suzuki 153, 3.

A997, 50.1130

From a series of ten panel prints with a tile-shaped red cartouche, published by Yamadai, an otherwise unknown publisher.

748. *Ueno no bōsetsu,* Evening snow at Ueno
Series: *Edo hakkei,* Eight views of Edo
mid 1840s
Signature: Hiroshige
Publisher: Jōshūya Kinzō
Censorship seal: Mura
quarter block, 107 × 166
Reference: Suzuki 150, 7.

A1085, 50.1218

*749. *Mitate ukifune sumidagawa no watashi,* Ferry boat on the Sumida River in snow, an allusion to the *Ukifune* chapter
Series: *Edo murasaki meisho genji,* Famous places in Edo matched with chapters of the *Tale of Genji*
mid 1840s
Signature: Hiroshige ga
Publisher: Maruya Kyūshirō
Censorship seal: Yoshimura
ōban, 342 × 234
Reference: Matsuki 571; Suzuki 179, 2.

A1092, 50.1225

From a series of pictures of women at famous places in Edo, with a shell-shaped cartouche, and a descriptive text on either side of the title above.

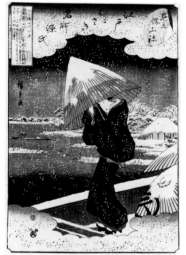

749

750abc. *Kasumigaseki*
Series: *Tōto meisho,* Famous places in the eastern capital
Signature: ōju Ichiryūsai Hiroshige hitsu
Artist's seal: Ichiryūsai
Publisher: Tsutaya Kichizō kō, Minamidemmachō itchōme
Censorship seal: kiwame
ōban triptych, 363 × 722

A1117, 50.1250

From a series of three-panel views of Edo, several with aerial perspective.

Nos. 751–814 are from the same series. Information repeats unless otherwise indicated.
The set of 55 prints of *ōban* format was begun around 1833 as a joint publication between the publishers Takenouchi Magohachi (Hoeidō) and Tsuruya Kiemon (Senkakudō) and was completed in 1834. At this time it was published as a set with frontispiece, titlesheet, and covers. Each print has a seal after the name of the station with a descriptive subtitle. Six early prints in the series were re-engraved and are known in two different versions, others are known in different states and distinct printing variations.

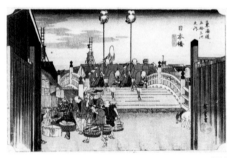

751

*751. 1. *Nihonbashi asa no kei,* Morning view of Nihon Bridge. First version with dogs at right
Series: *Tōkaidō gojūsantsugi no uchi,* Fifty-three stations of the Tōkaidō Road
ca. 1833
Signature: Hiroshige ga
Publisher: Takemago, Tsuruki
Censorship seal: kiwame
225 × 350, with variation in set up to 12 mm.
Reference: Suzuki 254.
Provenance: Matsuki

A655, 50.788

752. 1. Morning view of Nihon Bridge. First version

A655A, 50.788A

Unrecorded state lacking blue clouds in sky.

206

*753. I. *Nihonbashi gyoretsu furidashi,* A procession sets out at Nihon Bridge. Second version with large crowd
Artist's seal: Take
Provenance: May
Publication: May 1918, 154, $15.

A656, 50.789

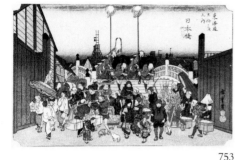

753

754. 2. *Shinagawa hi no de,* Sunrise at Shinagawa. First version with road meeting bottom border
Publisher: Senkakudō, Hoeidō
Censorship seal: trimmed
Reference: Suzuki 256.
Provenance: Matsuki

A657, 50.790

755. 3. *Kawasaki rokugō watashi,* The Rokugō Ferry at Kawasaki. First version with raft at left
Publisher: Senkakudō, Hoeidō
Censorship seal: trimmed
Provenance: Matsuki

A658, 50.791

756. 3. *Kawasaki rokugō watashi,* The Rokugō Ferry at Kawasaki. Second version, without the raft at left
Publisher: Take
Reference: Suzuki 259.

A659, 50.792

757. 4. *Kanagawa dai no kei,* The hill at Kanagawa. First version with small boats, lacking posts in water
Publisher: Hoeidō
Reference: Suzuki 260.

A660, 50.793

758. 5. *Hodogaya shimmachibashi,* Shimmachi Bridge at Hodogaya
Publisher: Senkakudō, Hoeidō
Reference: Suzuki 261.

A661, 50.794

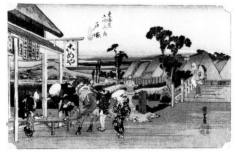

759

*759. 6. *Totsuka motomachi betsudō,* The alternate route from central Totsuka. First version with rider dismounting
Publisher: Tsuruki, Takemago
Reference: Suzuki 262.
Provenance: Matsuki

A663, 50.796

*760. 6. *Totsuka motomachi betsudō,* The alternate route from central Totsuka. Second version with man mounting horse
Publisher: Take
Reference: Suzuki 263.

A662, 50.795

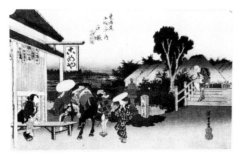

760

761. 7. *Fujisawa yugyōji,* Yugyō Temple at Fujisawa
Publisher: Hoeidō
Provenance: Matsuki

A664, 50.797

762. 8. *Hiratsuka nawatemichi,* The Nawate Road at Hiratsuka
Publisher: Hoeidō, Senkakudō
Reference: Suzuki 265.
Provenance: Matsuki

A665, 50.798

763. 9. *Ōiso tora ga ame,* Tora's rain at Ōiso
Publisher: Takenouchi han
Provenance: Matsuki

A666, 50.799

764. 10. *Odawara sakawagawa,* Fording the Sakawa River at Odawara. Second version with two men on left bank and blue mountain
Publisher: Hoeidō
Reference: Suzuki 267.
Provenance: Matsuki

A667, 50.800

765. 11. *Hakone kosui zu,* The lake at Hakone
Publisher: Hoeidō
Reference: Suzuki 269.

A668, 50.801

766. 12. *Mishima asagiri,* Morning mist at Mishima
Publisher: Hoeidō
Reference: Suzuki 270.
Provenance: Matsuki

A669, 50.802

767. 13. *Numazu tasogare no zu,* Twilight at Numazu
Publisher: Hoeidō
Reference: Suzuki 271.
Provenance: unidentified collector's seal

A670, 50.803

768. 14. *Hara asa no fuji,* Fuji in the morning from Hara
Publisher: Takenouchi
Reference: Suzuki 272.
Provenance: Matsuki

A671, 50.804

769. 15. *Yoshiwara hidari fuji,* Fuji at the left near Yoshiwara
Publisher: Hoeidō
Reference: Suzuki 273.

A672, 50.805

M. Ainsworth bought an impression of this print at the Blanchard sale, lot 393, for $12.50. It was probably not this impression as the catalogue describes it as a "splendid impression, splendid condition," which this is not.

770. 16. *Kambara yoru no kei,* Evening snow at Kambara
Artist's seal: Takenouchi
Provenance: Matsuki

A673, 50.806

The second state of the print with the legs of the figure at the right cleared and the sky dark on the horizon.

PLATE 49.

771. 17. *Yui satta mine,* Fuji from the peak of Satta near Yui
Publisher: Hoeidō han
Reference: Suzuki 276.
Provenance: Happer (?)

A674, 50.807

772. 18. *Okitsu okitsugawa,* Wrestlers fording the Okitsu River
Publisher: Tsuruki, Takemago
Reference: Suzuki 277.
Provenance: Matsuki, Metzgar
Publication: Metzgar 109, $25.

A675, 50.808

773. 19. *Ejiri mio embō,* Distant view of the promontory of Mio from Ejiri
Publisher: Hoeidō
Reference: Suzuki 278.
Provenance: Matsuki

A676, 50.809

774. 20. *Fuchū abegawa,* Fording the Abe River at Fuchū
Publisher: Hoeidō han
Reference: Suzuki 279.
Provenance: Matsuki

A677, 50.810

775. 21. *Mariko meibutsu chaya,* The tea house at Mariko
Publisher: Takemago, Tsuruki
Reference: Suzuki 281.
Provenance: Matsuki

A678, 50.811

Second state with the place name corrected.

776. 22. *Okabe utsunoyama*, Utsu Mountain at Okabe
Publisher: Senkakudō
Reference: Suzuki 282.

A679, 50.812

777. 23. *Fujieda jimba tsugitate*, Changing porters and horses at Fujieda
Publisher: Tsuruki, Takemago
Reference: Suzuki 283.

A680, 50.813

778. 23. *Fujieda* . . .
Publisher: Tsuruki, Takemago
Provenance: Matsuki

A680A, 50.813A

A slightly better, earlier impression than no. 777.

779. 24. *Shimada ōigawa sungan*, The Suruga bank of the Ōi River at Shimada
Publisher: Hoeidō

A681, 50.814

PLATE 42.

780. 24. *Shimada* . . .
Publisher: Hoeidō

A681A, 50.814A

Late impression of the preceding.

781. 25. *Kanaya ōigawa engan*, The Tōtomi bank of the Ōi River at Kanaya
Publisher: Takenouchi
Reference: Suzuki 285.

A682, 50.815

782. 26. *Nissaka sayononakayama*, The crying rock at Sayononaka Mountain near Nissaka
Publisher: Tsuruki, Takemago
Reference: Suzuki 286.

A683, 50.816

783. 27. *Kakegawa akibayama enchō*, Distant view of Mt. Akiba from Kakegawa
Publisher: Hoeidō han
Reference: Suzuki 287.

A684, 50.817

784. 28. *Fukuroi dechaya no zu*, Outdoor tea stall at Fukuroi
Publisher: Senkakudō, Hoeidō embossing

A685, 50.818

785. 29. *Mitsuke tenryūgawa no zu*, Morning mist on the Tenryū River near Mitsuke
Publisher: Hoeidō
Reference: Suzuki 290.

A686, 50.819

Second state with the horizontal lines in the background removed.

786. 30. *Hamamatsu fuyugare no zu*, Winter desolation at Hamamatsu
Publisher: Hoeidō
Reference: Suzuki 291.

A687, 50.820

Unrecorded first state of the print with the trees at the left printed from the key block rather than two grey color blocks.

PLATE 187.

787. 31. *Maisaka imagire shinkei*, The Imagire Promontory from Maisaka
Publisher: Hoeidō
Reference: Suzuki 292.

A688, 50.821

788. 32. *Arai watashibune no zu*, Ferry boats at Arai
Publisher: Takemago
Reference: Suzuki 293.
Provenance: Matsuki

A689, 50.822

788A. 32. *Arai* . . .

A689A, 50.822A

Faded impression of preceding.

789. 33. *Shirasuka shiomizaka no zu*, The Ocean-view Slope near Shirasuka
Publisher: Hoeidō
Reference: Suzuki 294.

A690, 50.823

790. 34. *Futagawa sarugababa*, The Sarugababa rest stop at Futagawa
Publisher: Hoeidō
Reference: Suzuki 295.
Provenance: Matsuki

A691, 50.824

791. 35. *Yoshida toyokawa no hashi*, The bridge on the Toyo River at Yoshida
Publisher: Hoeidō
Reference: Suzuki 296.

A692, 50.825

792. 36. *Goyu tabibito tomeonna*, Women stopping travellers at Goyu
Publisher: Takenouchi
Engraver: Horikō Jirobei
Printer: Surishi Heibei
Reference: Suzuki 297.

A693, 50.826

First state of the print with the publisher's name Takenouchi han in the circle at the right.
The names of the printer and engraver are given on the strips hanging from the rafter in the entrance to the inn at the right. Other strips read *Gojūsanshuku Tōkaidō tsuzukiga, Ichiryūsai zu*, "A set of pictures of the 53 stations on the Tōkaidō Road by Ichiryūsai."

793. 37. *Akasaka ryōsha shōfu no zu*, Travellers and hostesses at an inn at Akasaka
Publisher: Hoeidō
Reference: Suzuki 298.

A694, 50.827

M. Ainsworth bought a "fine impression" of this print "in splendid condition" at the Blanchard sale, lot 415, for $10. It was probably not this print.

794. 37. *Akasaka* . . .

A694A, 50.827A

Late impression of the preceding.

794A. 37. *Akasaka* . . .
Publisher: Takemago

A694B, 50.827B

Faded impression of no. 793.

795. 38. *Fujikawa bōbana no zu*, Procession at a boundary marker near Fujikawa
Publisher: Takemago
Reference: Suzuki 299.

A695, 50.828

796. 39. *Okazaki yahagi no hashi*, The Yahagi Bridge at Okazaki
Publisher: Hoeidō
Reference: Suzuki 300.
Provenance: Metzgar
Publication: Metzgar 137, $22.50.

A696, 50.829

797. 40. *Chiryū shūka umaichi*, The horse market in the fourth month at Chiryū
Publisher: Hoeidō
Reference: Suzuki 301.
Provenance: Matsuki

A697, 50.830

Second state of the print without the grey whale-like mountain at the right.

798. 41. *Narumi meibutsu arimatsu shibori*, Shops selling Arimatsu tie-dyed fabric, a famous product of Narumi
Publisher: Hoeidō han
Reference: Suzuki 302.

A698, 50.831

First state of the print with words *Takenouchi shimpan*, 'new publication of Takenouchi,' and the diamond-shaped seal of the artist on the cloth awning of the store at the left.

799. 42. *Miya atsuta shinji*, Religious horse races at the Atsuta Shrine in Miya
Publisher: Hoeidō
Reference: Suzuki 303.
Provenance: Metzgar
Publication: Metzgar 1916, 142, $10.

A699, 50.832

800. 43. *Kuwana shichiri watashiguchi*, The landing entry of the seven *ri* ferry at Kuwana
Publisher: Hoeidō
Reference: Suzuki 304.
Provenance: Matsuki

A700, 50.833

801. 44. *Yokkaichi miegawa*, Breeze on the Mie River near Yokkaichi
Publisher: Hoeidō
Reference: Suzuki 305.

A701, 50.834

First state of the print with the shading on the cloak of the man at the right.

802. 45. *Ishiyakushi ishiyakushiji*, The Stone Yakushi Temple at Ishiyakushi
Publisher: Hoeidō
Reference: Suzuki 306.

A702, 50.835

First state of the print with the blue mountain.

803. 46. *Shōno hakuu*, Light rain at Shōno
Publisher: Hoeidō han
Reference: Suzuki 307.
Provenance: Matsuki

A703, 50.836

First state of the print with the words Takenouchi and *gojūsantsugi* on the umbrella.

PLATE 179.

804. 46. *Shōno hakuu*, Light rain at Shōno
Publisher: Hoeidō han
Reference: Suzuki 307.

A704, 50.837

Second state of the print with only traces of the words on the umbrella. Dark shading on the tips of the bamboo.

PLATE 180.

805. 47. *Kameyama yukibare*, Clear weather after snow at Kameyama
Publisher: Hoeidō
Reference: Suzuki 308.
Provenance: Matsuki

A705, 50.838

806. 48. *Seki honjin hayadachi*, Early departure from the main camp at Seki
Publisher: Hoeidō
Reference: Suzuki 309.
Provenance: Matsuki

A706, 50.839

The hanging placards at the left advertise the cosmetic *Senjokō*.

807. 49. *Sakanoshita fudasute mine*, The peak of Fudesute Mountain from Sakanoshita
Publisher: Hoeidō
Reference: Suzuki 310.
Provenance: Matsuki
Publication: probably Blanchard 427, $11 (catalogue: "splendid impression, fine condition").

A707, 50.840

807A. 49. *Sakanoshita . . .*
Publisher: Hoeidō.

A707A, 50.840A

Slightly faded impression of preceding.

808. 50. *Tsuchiyama haru no ame*, Spring rain at Tsuchiyama
Publisher: Hoeidō
Reference: Suzuki 311.
Provenance: Matsuki

A708, 50.841

809. 51. *Minakuchi meibutsu kampyō*, Drying strips of gourd, a famous product of Minakuchi
Publisher: Hoeidō
Reference: Suzuki 312.
Provenance: Matsuki

A709, 50.842

810. 52. *Ishibe megawa no sato*, Megawa village near Ishibe
Publisher: Hoeidō

Reference: Suzuki 313.
Provenance: Matsuki

A710, 50.843

811. 53. *Kusatsu meibutsu tateba*, The Ubumochiya Restaurant serving local rice cakes at Kusatsu
Publisher: Takemago
Reference: Suzuki 314.
Provenance: Matsuki

A711, 50.844

811A. 53. *Kusatsu . . .*

A711A, 844A

812. 54. *Ōtsu hashirii chamise*, The Running Well Teahouse at Ōtsu
Publisher: Hoeidō
Reference: Suzuki 315.

A713, 50.846

First state of the print with mountain at the right and grey in the middle distance.

813. 54. *Ōtsu . . .*
Publisher: Hoeidō
Reference: Suzuki 315.
Provenance: Metzgar
Publication: Metzgar 158, $15.

A712, 50.845

Second state of the print without the mountain at the right and blue in the middle distance.

814. 55. *Keishi sanjō ōhashi*, The great bridge over the Kamo River at Sanjō in Kyōto
Publisher: Hoeidō
Reference: Suzuki 316.
Provenance: Matsuki

A714, 50.847

815

*815. *Katase shichimenzan yori umibe o miru*, Looking out at Enoshima and the sea from Mt. Shichimen near Katase village
Series: *Tōkaidō no uchi enoshimaji*, The route to Enoshima off the Tōkaidō Road
ca. 1834
Signature: Hiroshige ga
Publisher: Takenouchi Magohachi (Hoeidō)
Censorship seal: kiwame
ōban, 227 × 352
Provenance: Field

A715, 50.848

Only two pictures in this rare group are known.

Nos. 816–869 are from the same series and have the same series title, signature, publisher and format.

Fifty-four prints from the set of fifty-five (lacking no. 19, Ejiri), published by Maruya Seibei and called the Marusei Tōkaidō, after the publisher, or the *Reisho* Tōkaidō, since the title is written in the squared calligraphic script called *reisho* in Japanese.

Most surviving impressions of prints in this series are fine, suggesting that few were printed. Whether the set was unpopular, the blocks were lost by fire, or the publisher failed is uncertain, but the Marusei Tōkaidō is one of only two of Hiroshige's twenty Tōkaidō sets in horizontal *ōban* format, and contains some fine designs. Several of Hiroshige's preliminary drawings for pictures in the set survive. The censorship seals appear in pairs: Muramatsu, Fuku on nos. 816-825; Mera, Watanabe on nos. 826–829, 831, 833–869. There are no censorship seals on nos. 830 and 832.

816. 1. Nihonbashi. Mt. Fuji from Nihon Bridge.
Series: *Tōkaidōgojūsantsugi*, The fifty-three stations of the Tōkaidō Road
ca. 1850
Signature: Hiroshige ga
Publisher: Marusei han shiba shimmei mae
ōban, 217 × 347, with variation up to 9 mm. within series
Reference: Suzuki 152; UTK 14, 111.
Provenance: Ficke
Publication: Ficke 1920, 765, $7.50.

A787, 50.920

817. 2. Teahouse by the harbor at Shinagawa
Reference: UTK 112.
Provenance: Blanchard
Publication: Blanchard 1916, 438, $15.

A788, 50.921

818. 3. The Rokugō Ferry at Kawasaki
Reference: UTK 113.
Provenance: May
Publication: May 934, $12.50.

A789, 50.922

819. 4. Teahouses on the hill by Kanagawa
Reference: UTK 114.
Provenance: May
Publication: May 934, $12.50.

A790, 50.923

820. 5. Bridge on the Katabira River at Hodogaya
Reference: UTK 115.

A791, 50.924

821. 6. Totsuka
Reference: UTK 116.
Provenance: May
Publication: May 936, $15.00.
A792, 50.925

The composition is very close to Mochizuki, no. 26 of the Kisokaidō (catalogue no. 1033).

822. 7. Fujisawa
Reference: UTK 117.
Provenance: Blanchard
Publication: Blanchard 1916, 443, $7.
A793, 50.926

The print is unnumbered in the title cartouche.

823. 8. Hiratsuka
Reference: UTK 118.
Provenance: May
Publication: May 938, $12.50.
A794, 50.927

824. 9. The hut of the poet Saigyō at the Rising Snipe Marsh at Ōiso
Reference: UTK 119.
Provenance: Ficke
Publication: Ficke 1920, 773, $7.50.
A795, 50.928

825. 10. Fording the Sakawa River at Odawara
Reference: UTK 120.
A796, 50.929

826

*826. 11. Travelling by torchlight at night at Hakone
Reference: UTK 121.
Provenance: unidentified Japanese collector's seal on verso
A797, 50.930

827. 12. Mishima
Reference: UTK 122.
Provenance: Bunshichi Kobayashi (Hosukaku seal on verso)
A798, 50.931
PLATE 43.

828. 13. Mt. Fuji from Numazu
Reference: UTK 123.
A799, 50.932

829. 14. Mt. Fuji from Hara
Reference: UTK 124.
Provenance: May
Publication: May 943, $15.
A800, 50.933

830. 15. Mt. Fuji on the left at Yoshiwara
Reference: UTK 125.
Publication: May 944, $12.50 or Ficke 1920, 779, $25.00.
A801, 50.934

831. 16. Ferry boat on the Fuji River at Kambara
Reference: UTK 126.
Provenance: Matsuki
A802, 50.935

832. 17. Shellfish restaurant at Yui
Reference: UTK 127.
Publication: May 946, $7.50 or Ficke 1920, 781, $17.50.
A803, 50.936

833. 18. Off-shore view of Kiyomi Barrier and Temple at Okitsu
Reference: UTK 128.
Provenance: Ficke
Publication: Ficke 1920, 782, $17.50 (MA: "quality").
A804, 50.937

834. 20. Travellers arriving by night at Fuchū
Reference: UTK 130.
Provenance: Blanchard
Publication: Blanchard 1916, 456, $15.
A805, 50.938

835. 21. Snow at Mariko
Reference: UTK 131.
A806, 50.939

836. 22. Utsu Mountain near Okabe
Reference: UTK 132.
Provenance: May
Publication: May 950, $7.50.
A807, 50.940

837. 23. Rain at Fujieda
Reference: UTK 133.
Provenance: May
Publication: May 951, $7.50.
A808, 50.941

838. 24. Fording the Ōi River at Shimada
Reference: UTK 134.
Provenance: May
Publication: May 952, $7.50.
A809, 50.942

839. 25. Distant view of the Ōi River from the slope leading to Kanaya
Reference: UTK 135.
Publication: May 953, $7.50 or Ficke 1920, 789, $7.50.
A810, 50.943

840. 26. The stone which cries at night on Sayononaka Mountain near Nissaka
Reference: UTK 136.
Provenance: May
Publication: May 954, $25.
A811, 50.945

841. 27. The alternate route to Akiba Mountain at Kakegawa
Reference: UTK 137.
A812, 50.945

842. 28. Kites from Kakegawa flying over Fukuroi
Reference: UTK 138.
Provenance: Ficke
Publication: Ficke 1920, 792, $15.
A813, 50.946

843. 29. Ferry boats on the Tenryū River near Mitsuke
Reference: UTK 139.
Provenance: Matsuki
A814, 50.947

844. 30. Rough sea at Hamamatsu
Reference: UTK 140.
Provenance: May
Publication: May 955, $40.
A815, 50.948

845. 31. Loading ships at Maisaka
Reference: UTK 141.
Publication: May 956, $12.50 or Ficke 1920, 795, $7.50.
A816, 50.949

846. 32. Distant view of Mt Fuji from Arai
Reference: UTK 142.
Provenance: Ficke
Publication: Ficke 1920, 796, $45.
A817, 50.950

847. 33. The Oceanview Slope at Shirasuka
Reference: UTK 143.
Provenance: Ficke
Publication: Ficke 1920, 797, $10.
A818, 50.951

848. 34. Travellers at Sarugababa near Futagawa
Reference: UTK 144.
Provenance: Matsuki
A819, 50.952

849. 35. The Tennō Festival procession on the 15th day of the 6th month at Yoshida
Reference: UTK 145.
Provenance: Matsuki
A820, 50.953

The publisher's mark appears within the picture on this print, instead of in the lower right margin.

850. 36. The Plain of Motono along the old road at Goyu
Reference: UTK 146.
Publication: perhaps May 962, $10.
A821, 50.954

851. 37. Inns at Akasaka
Reference: UTK 147.
Provenance: Matsuki

A822, 50.955

852. 38. Procession at Fujikawa
Reference: UTK 148.
Provenance: unidentified Japanese
collector's mark on verso

A823, 50.956

853. 39. The Yahagi River at Okazaki
Reference: UTK 149.
Provenance: Matsuki

A824, 50.957

854. 40. Porters at Chiryū
Reference: UTK 150.
Provenance: Matsuki

A825, 50.958

855. 41. Shops selling Arimatsu tie-dyed
cloth at Narumi
Reference: UTK 151.
Provenance: Matsuki

A826, 50.959

The publisher's mark appears on the box
at the right.

856. 42. Nezame village, The Seven-*ri*
Ferry and the entrance gate to the
Atsuta Shrine at Miya
Reference: UTK 152.
Provenance: Ficke
Publication: Ficke 1920, 806, $17.50.

A827, 50.960

857. 43. The Seven-*ri* ferry boat ap-
proaching Kuwana
Reference: UTK 153.
Provenance: Ficke
Publication: Ficke 1920, 807, $40.

A828, 50.961

Clouds printed without outline in sky.
PLATE 199.

858. 44. The pilgrim route to Ise meeting
with the main road at Hinaga village
near Yokkaichi
Reference: UTK 154.
Provenance: Ficke
Publication: Ficke 1920, 808, $30.

A829, 50.962

859. 45. Travellers at Ishiyakushi
Reference: UTK 155.
Provenance: May
Publication: May 969, $7.50.

A830, 50.963

860. 46. Bonfire at Shōno
Reference: UTK 156.
Provenance: May
Publication: May 970, $5.

A831, 50.964

861. 47. Castle moat at Kameyama
Reference: UTK 157.

A832, 50.965

862. 48. Snow at Seki
Reference: UTK 158.

A833, 50.966

863. 49. Pilgrims at Sakanoshita
Reference: UTK 159.
Provenance: May
Publication: May 973, $5.

A834, 50.967

864. 50. River at Tsuchiyama
Reference: UTK 160.
Provenance: Matsuki
Publication: May 974, $2.50 or Ficke
1920, 814, $10.

A835, 50.968

865. 51. The beautiful pine trees at Mt.
Hiramatsu near Minakuchi
Reference: UTK 161.
Provenance: Ficke
Publication: Ficke 1920, 815, $20.

A836, 50.969

866. 52. Inn at Ishibe
Reference: UTK 162.
Provenance: Matsuki

A837, 50.970

Publisher's mark colored in at lower left.

867. 53. View of Lake Biwa from the
landing of the Yabase Ferry
Reference: UTK 163.

A838, 50.971

868. 54. Shop selling religious folk paint-
ings at Ōtsu
Reference: UTK 164.
Provenance: Matsuki

A839, 50.972

869. 55. The mountains on the east of
Kyōto from Sanjō Bridge
Reference: UTK 165.

A840, 50.973

Nos. 870–927 are from the same series
and have the same date, signature, pub-
lisher, censorship seal, format, technique,
and reference with exceptions noted.
Series: *Gojūsantsugi meisho zue*, Pictures of
famous places of the fifty-three stations
A complete but uneven set of 55 *ōban*
published by Tsutaya Kichizō in the 7th
and 8th months of 1855, commonly known
as the Vertical Tōkaidō.

870. 1. *Nihonbashi shinonome no kei*, Clouds
of dawn at Nihon Bridge
7/1855
Signature: Hiroshige hitsu
Publisher: Tsutaya Kichizō
Censorship seal: aratame
ōban, 342 × 222 with variation up
to 5 mm. within set
Reference: Suzuki 159.

A1192, 50.1325

871. 2. *Shinagawa gotenyama yori ekichū o
miru*, The station of Shinagawa from
Goten Hill

A1193, 50.1326

872. 3. *Kawasaki tsurumigawa namamugi
no sato*, Namamugi Village beside
the Tsurumi River at Kawasaki

A1194, 50.1327

873. 4. *Kanagawa dai no chaya kaijō mi-
harashi*, View of the ocean from the
teahouses at Kanagawa

A1195, 50.1328

874. 5. *Hodogaya sakaiki tateba kamaku-
rayama embō*, Distant view of the
Kamakura Mountains from the rest
house by the boundary tree at Ho-
dogaya

A1196, 50.1329

875. 6. *Totsuka yamamichi yori fuji chōbō*,
Distant view of Mt. Fuji from the
mountain road in Totsuka

A1197, 50.1330

876. 6. *Totsuka . . .*

A1197A, 50.1330A

A late impression of 875.

877. 7. *Fujisawa nanki no matsubara hidari
fuji*, Mt. Fuji at the left from the
pine forest of Nanki at Fujisawa
Publication: perhaps Blanchard 368,
$3.

A1198, 50.1331

878. 8. *Hiratsuka banyūgawa funawatashi
ōyama embō*, Distant view of Mt.
Ōyama from the ferry on the Banyū
River at Hiratsuka
Publication: Blanchard 368, $3.

A1199, 50.1332

879. 9. *Ōiso shigitatsusawa saigyōan*, The
hut of the poet Saigyō at the Snipe
Rising Marsh in Ōiso
Publication: Blanchard 368, $3.

A1200, 50.1333

880. 10. *Odawara kaigan ryōsha*, Fisher-
men on the beach at Odawara

A1201, 50.1334

881. 11. *Hakone sanchū yakō no zu*, Trav-
elling at night through the Hakone
mountains

A1202, 50.1335

882. 12. *Mishima mishima daimyōjin ichi
no torii*, The first entrance gate to
the Daimyōjin Shrine at Mishima

A1203, 50.1336

883. 12. *Mishima . . .*

A1203A, 50.1336A

A duplicate impression.

884. 13. *Numazu ashigarayama fuji yuki-
bare*, Mt. Fuji and Mt. Ashigara
from Numazu in clear weather after
a snowfall
Provenance: Happer and two uni-
dentified Japanese seals on recto

A1204, 50.1337

885. 14. *Hara ashitakayama fuji chōbō*, Mt.
Fuji and Mt. Ashitaka from Hara

A1205, 50.1338

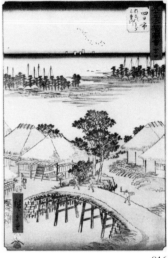

924. 52. *Ishibe ryosha tomarikyaku,* Guests at an inn at Ishibe

A1243, 50.1376

925. 53. *Kusatsu kusatsu kara yabase wa michi no yumi to tsuru,* The bow and bowstring routes from Kusatsu to Yabase

A1244, 50.1377

Yabase is across Lake Biwa from Kusatsu. The lake route was straight, like a bow string; the land route was long and curved, like a bow.

926. 54. *Ōtsu miidera kannondō yori ōtsu no machi kosui chōbō,* View of Lake Biwa and the town of Ōtsu from the building dedicated to the Kannon at Mii Temple
8/1855

A1245, 50.1378

927. 55. *Kyō sanjō ōhashi,* The great bridge at Sanjō in Kyōto
8/1855

A1246, 50.1379

Nos. 928–930 are from the same series. From a set of 55 prints originally designed and published by Ezakiya Tatsuzō and Ezakiya Kichibei just before the government required publishers to affix the marks of individual censors on their prints in the middle of 1842. The blocks changed hands around this time, and later impressions have added censorship seals and often the mark of the publisher Yamadaya Shōjirō. The series title is written in semi-cursive or running *gyōsho* script and the set is known in Japan as the *Gyōsho Tōkaidō.*

928. 38. *Fujikawa yamanaka shuku shōka,* Shops selling hemp rope bags at Yamanaka station near Fujikawa
Series: *Tōkaidō gojūsantsugi no uchi,* The Fifty-three Stations of the Tōkaidō Road
ca. 1841–1842
Signature: Hiroshige ga
Censorship seal: Hama
aiban, 194 × 317, with variation up to 6 mm. in set
Reference: Suzuki 158; UTK 14, 93 (first state).

A898, 50.1031

Second state with the publisher's mark in the lower left margin removed and the censorship seal added beside the signature.

929. 16. *Kambara iwafuchi yori fujikawa o miru zu,* View of the Fuji River from Iwafuchi near Kambara
Reference: UTK 14, 71.

A899, 50.1032

Third state with the censor's seal added lower left and the mark of the first publisher Etatsu removed from the left margin.

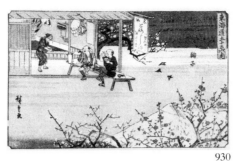

930

*930. 21. Restaurant at Mariko

A900, 50.1033

Second state with the seal of the publisher Ezaki removed from beneath the place name, but lacking the censorship seal.

Nos. 931–986 are from the same series and have the same series title, format, date, signature, publisher and censorship seal. The complete set of 56 *chūban,* or half-block, prints published by Sanoya Kihei with a 31-syllable *kyōka* poem printed on each picture. They are mostly late impressions.

931. 1. Fuji from Nihon Bridge
Series: *Tōkaidō gojūsantsugi,* The Fifty-three Stations of the Tōkaidō Road
ca. 1840
Signature: Hiroshige ga
Publisher: Sanoki
Censorship seal: kiwame
chūban, 156 × 210, with variation in set up to 3 mm.
Reference: Suzuki 160.

A841, 50.974

The poem on this print is by Kawanoya Yukihisa.

932. 2. Shinagawa

A842, 50.975

Poem by Kasōtei Tomoyori.

933. 3. Kawasaki

A843, 50.976

Poem by Haruzono Shizuki.

934. 4. Kanagawa

A844, 50.977

Poem by Shōhontei Atsumi (?).

935. 5. The Boundary Tree rest house at Hodogaya

A845, 50.978

Poem by Yūkakutei Chiyoko.

936. 6. Totsuka

A846, 50.979

Poem by Yūchikukan Itchō.

937. 7. Fujisawa

A847, 50.980

Poem by Shōginbō Kiyokaze.

938. 8. Ferryboats on the Banyū River at Hiratsuka

A848, 50.981

Poem by Ashiwara Mitsukuni.

939. 9. Ōiso

A849, 50.989

Poem by Fuyūtei Mitsunari.

940. 10. Odawara

A850, 50.983

Poem by Shigenoto Hinamasa.

*941. 11. Travelling by torchlight at Hakone

A851, 50.984

Poem by Fūkien Mitsuharu.

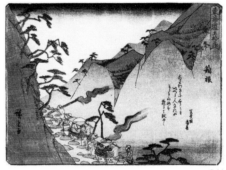

941

942. 12. Snow at Mishima

A852, 50.985

Poem by Motokawa Ishime.

943. 13. Fuji from Numazu

A853, 50.986

Poem by Tōuntei Okiho.

944. 14. Fuji from Hara

A854, 50.987

Poem by Suzugaki.

945. 15. Fuji on the left from the road through the rice fields at Yoshida

A855, 50.988

Poem by Eijudō Kanenobu.

946. 16. Fuji from Kambara

A856, 50.989

Poem by Baikōkyo.

947. 17. Crossing the Yui River

A857, 50.990

Poem by Yūkitei Hinahata.

948. 18. Fording the Okitsu River

A858, 50.991

Poem by Toshigaki Maharu.

949. 19. Fuji from Ejiri

A859, 50.992

Poem by Hanagaki Yasuko.

950. 20. Full moon at the licensed quarter at Nichōmachi in Fuchū

A860, 50.993

Poem by Kogetsurō Hamako.

951. 21. Utsu Mountain near Okabe

A861, 50.994

Poem by Shimputei Mitsuyo.

952. 22. The restaurant at Mariko

A862, 50.995

Woodblock prints of landscapes and actors are pasted on the walls of the teahouse, together with an advertisement for the face powder Senjokō.
The poem is by Shōembō Shibamori.

953. 23. Fording the Seto River at Fujieda
A863, 50.996
Poem by Seishitsu Masumi.

954. 24. Fording the Ōi River at Shimada
A864, 50.997
Poem by Shinsentei Hiroki.

955. 25. Preparing to ford the Ōi River at Kanaya
A865, 50.998
Poem by Sekiguchi Toshifuru (?).

956. 26. Slope at Nissaka
A866, 50.999
Poem by Yamatoen Kotozakura.

957. 27. Bridge at Kakekawa
A867, 50.1000
Poem by Naruo Shimakage (?).

958. 28. Fukuroi
A868, 50.1001
Poem by Hōrindō Hinazumi.

959. 29. The ferry on the Tenryū River near Mitsuke
A869, 50.1002
Poem by Asanebo Okikane.

960. 30. Hamamatsu
A870, 50.1003
Poem by Ki no Hiromochi.

961. 31. Imagire and ferry boats near Maisaka
A871, 50.1004
Poem by Tōjitsuen Hinasuki.

962. 32. Boat landing at Arai
A872, 50.1005
Poem by Chōkatei Namine.

963. 33. The Oceanview Slope at Shirasuka
A873, 50.1006
Poem by Shigenoto Hinamasa.

964. 34. Rain at Futagawa
A874, 50.1007
Poem by Tōhōgaki Matsuya.

965. 35. Bridge at Yoshida
A875, 50.1008
Poem by Hanagaki Shishin.

966. 36. Porters at Goyu
A876, 50.1009
Poem by Magomegaki Koharu.

967. 37. Moon at Akasaka
A877, 50.1010
Poem by Naruto Shizumaru.

968. 38. Snow at Fujikawa
A878, 50.1011
Poem by Tokiwaen Shigemi.

969. 39. Yahagi Bridge at Okazaki
A879, 50.1012
Poem by Chitose no Matsuhiko.

970. 40. Tea houses at Chiryū
A880, 50.1013
Poem by Kyōkatei Manegoto.

971. 41. Shops selling tie-dyed fabric at Narumi
A881, 50.1014
Poem by Kahōbō Nemachi.

972. 42. Gate of the Atsuta Shrine at Miya
A882, 50.1015
Poem by Matsunoya Mitsutoshi.

973. 43. The Tomita clan restaurant at Kuwana
A883, 50.1016
Poem by Munenoto Onimaru.

974. 44. Bridge at Yokkaichi
A884, 50.1017
Poem by Midorian Matsutoshi.

975. 45. Accounting house at Ishiyakushi
A885, 50.1018
Poem by Tomogaki Matsura.

976. 46. Shōno
A886, 50.1019
Poem by Uranoto Kanko.

977. 47. Kameyama
A887, 50.1020
Poem by Sanhatei Shizuyama.

978. 48. Government post at Seki
A888, 50.1021
Poem by Morinoya Mikage.
The curtains are decorated with the artist's diamond seal.

979. 49. Lay-down-the-brush Mountain at Sakanoshita
A889, 50.1022
Poem by Shimpūtei Hatsuka (?).

980. 50. Rain at Tsuchiyama
A890, 50.1023
Poem by Shibanoto Kusame.

981. 51. Inn at Minakuchi
A891, 50.1024
Poem by Baikadō Nerikata.
The inns are named Sanoya and Utagawaya after the artist and publisher.

982. 52. Inn at Ishibe
A892, 50.1025
Poem by Zukintei Suzukake.

983. 53. Restaurant at Kusatsu
A893, 50.1026
Poem by Shibaguchiya Okazumi.

984. 54. Lake Biwa from Ōtsu
A894, 50.1027
Poem by Tokiwaen Matsunari.

985. 55. Sanjō Bridge in Kyōto
A895, 50.1028
Poem by Tsurunoya Matsukado.

986. 56. Imperial Palace in Kyōto
A896, 50.1029
Poem by Kōsuitei Kōriko.

987.1–53 (two lacking, one duplicate):
Series: *Tōkaidō,* The Tōkaidō Road
ca. 1850
Signature: Hiroshige ga
Publisher: Tsutaya Kichizō
Censorship seals: Hama, Kinugasa
chūban, ca. 165 × 228
A897, 50.1030. 1–53.

Fifty-two prints from the set of fifty-four in *chūban,* or half-block format, published by Tsutaya Kichizō, ca. 1850. The prints are rather late impressions trimmed along or within borders and pasted into a Japanese-style album.

Each print is numbered in Japanese and the Japanese numbering is followed here. Nos. 10 (Hara) and 14 (Odawara) are missing in the album.

Shimada and Kanaya are included on one print, making an even 54 pictures in the series, probably to allow for printing two to an *ōban* block.

Suzuki points out that there is a pattern in the appearance of censorship seals on the prints:
Hama and Kinugasa, nos. 1–10, 21–30
Murata and Mera, nos. 11–20, 31–54.

1. Dawn at Nihon Bridge
2. Yatsuyama Hill at Shinagawa
3. Rokugō Ferry at Kawasaki
4. The hill tea houses and Lower Asama at Kanagawa
5. Katabira Bridge and Shimmachi at Hodagaya
6. Totsuka
7. Yotsuya rest stop and the junction of the Ōyama Road at Fujisawa
8. Kōraiji, Ōyama, and Fuji Mountains from Hiratsuka
9. Oyurgi beach and Koiso near Ōiso
11. Izu Bay from the Hakone mountains
12. Mishima
13. Mt. Ashigara and the slopes of Mt. Fuji from Numazu
15. Fuji on the left from the old market place near Yoshiwara
16. Ferries on the Fuji River at Kambara
17. The Kurasawa rest house near Satta Pass at Yui
18. Shiohama Beach and Kiyomi Barrier near Okitsu
19. Rain at Koyoshida Bridge at Ejiri
20. The Abe River cake shop at Fuchū
21. Distant view of Mt. Utsu in snow, with the *tororo* soup shops at Mariko
22. The pass at Mt. Utsu and the cake shops at Okabe
23. The ford at the Sato River near Fujieda

24. The Ōi River between Shi-
 mada and Kanaya
25. Mt. Mugen and the night-
 crying rock on Mt. Sayo-
 nonaka near Nissaka
26. Shrine gate at Kakekawa
27. Fukuroi
28. Ferry boats on the Tenryū River
 near Mitsuke
29. Bonfire at Hamamatsu
29A. Another impression with
 darker colors, tipped in facing
 no. 29
30. Imagiri in Tōtomi Province
 from Maisaka
31. Ships sailing to the govern-
 ment checkpoint at Arai
32. The Seaview Slope at Shira-
 suka
33. The Sarugababa rest house fa-
 mous for cakes wrapped in oak
 leaves, at Futagawa
34. Bridge over the Toyo River at
 Yoshida
35. Inns at Goyu
36. Crescent moon at Akasaka
37. The Yamanaka rest stop at
 Fujikawa
38. Yahagi Bridge at Okazaki
39. Early summer horse market at
 Chiryū
40. Tie-dyed cloth shops at Ari-
 matsu village near Narumi
41. Gate of the Atsuta Shrine at
 Miya
42. Landing of the Seven-*ri* Ferry
 for Kuwana
43. Juncture of the pilgrim road
 to Ise at Yokkaichi
44. Ishiyakushi
45. Accounting house and relay
 station at Shōno
46. Government camp at Kame-
 yama
47. The hillock one *ri* from Seki
48. The mountain where the old
 painter threw down his brush
 near Sakanoshita
49. Mt. Suzuka near Tsuchiyama
50. Inns at Minakuchi
51. Restaurant at Mekawa Village
 near Ishibe
52. Juncture of the Kiso and Tōkai
 Roads at the Kusatsu River
53. Mts. Hie, Hira and Karasaki
 from the Matsumoto Ferry at
 Ōtsu
54. Sanjō Bridge in Kyōto

*988. 47. Rain at Kameyama
 Series: *Gojūsantsugi,* Fifty-three Sta-
 tions
 Intercalary 2/1852
 Signature: Hiroshige ga
 Censorship seal: Hama, Magomi
 chūban, 217 × 166
 Reference: Suzuki 160.
 A901, 50.1034

From a set of 56 half-block prints published
by Muraichi in the early 1850s, known as
the *Figure Tōkaidō,* since the human figures
are so conspicuous in the designs.

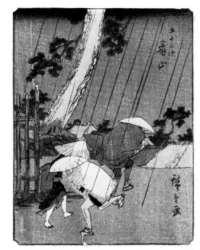

988

989. Series: *Ikō hiroshige tōkaidō yōkyō to
 narita dōchū,* Intermediate Tōkaidō
 Stations and Views on the Narita
 Highway (from) Original Drawings
 made by Hiroshige
 1919
 The complete set of 20 prints, pub-
 lished by Shōkichi Sakai, after
 drawings of ca. 1834 by Hiroshige
 in the Kazuo Takahata collection in
 Yokohama. The prints are in the
 original mats and cloth portfolio
 with title and block-printed facsim-
 ile of a Hiroshige watercolor of Mt.
 Fuji on the cover and a pamphlet
 with explanatory text by the pub-
 lisher and an English summary and
 brief table-of-contents by the
 American collector J. S. Happer.
 Since the pictures were not pub-
 lished during Hiroshige's lifetime,
 the series title was not finalized, but
 the pictures fall into five distinct
 groups: 4 of a series of rest stops
 between stations on the Tōkaidō
 Road, 4 of a series of views of
 Kanazawa, 3 views of the Kamakura
 area, 5 of the pilgrim route to Ōyama,
 and 4 of the pilgrim route to Narita,
 east of Edo. Series and picture titles
 vary, but all prints in the set have
 the same date, signature, artist's
 seals, publisher, engraver, format
 and provenance. The impressions
 are uniformly very fine.
989.1. Full moon at Takanawa
 Series: *Gojūsantsugi yōkyō ma no shuku
 tateba,* Interesting rest stops at towns
 between the fifty-three stations of
 the Tōkaidō Road
 Signature: Hiroshige ga
 Artist's seal: Ichiryūsai

Publisher: Sakai kōkodō kaihan
Engraver: Koike tō
Printer: Komatsu Sōtoku
ōban, 219 × 344, with variation up
to 7 mm. within set
Provenance: Takahata (blue printed
seal beneath publisher's mark)
 A.1362. 1–20, 50.1495.1–20

989.2. Bridge at Tsurumi
 Series: Interesting rest stops . . .
 A1362.2, 50.1495.2

989.3. *Sugita umezakari,* Plum trees in full
 bloom at Sugita
 Series: *Tōkaidō no uchi kanazawaji,*
 The route to Kanazawa off the Tō-
 kaidō Road
 Censorship seal: kiwame
 A1362.3, 50.1495.3

989.4. *Kanazawa ichiranzan hakkei kochōbō,*
 Prospect of the eight views of Kan-
 azawa from One View Mountain
 Series: *Tōkaidō no uchi,* The Tōkaidō
 Road
 Artist's seal: Ichiryūsai
 A1362.4, 50.1495.4

989.5. *Nōkendō hakkei embō,* Distant pros-
 pect of the eight views of Kanazawa
 from the Nōkendō
 Series: *Tōkaidō no uchi kanazawaji,*
 The route to Kanazawa off the Tō-
 kaidō Road
 A1362.5, 50.1495.5

989.6. *Kanazawa suzumegaura ryokaku yū-
 sen,* Sightseeing boats for travellers
 on Sparrow Bay at Kanazawa
 Series: *Tōkaidō no uchi,* The Tōkaidō
 Road
 A1362.6, 50.1495.6

989.7. *Sakaigi,* The boundary tree
 Series: Interesting rest stops . . .
 A1362.7, 50.1495.7

989.8. *Sōshū kamakura tsurugaoka,* Entrance
 to the Hachiman Shrine at Tsuru-
 gaoka in Kamakura, Sagami Prov-
 ince
 Series: *Tōkaidō no uchi,* The Tōkaidō
 Road
 A1362.8, 50.1495.8

989.9. Yuigahama
 Series: *Tōkaidō wakiji kamakura mōde
 no uchi,* Pilgrimage to Kamakura on
 a branch route of the Tōkaidō Road
 A1362.9, 50.1495.9

989.10. *Sōshū enoshima,* The Island of En-
 oshima in Sagami Province
 Series: *Tōkaidō no uchi,* The Tōkaidō
 Road
 A1362.10, 50.1495.10

989.11. Pilgrims at night at Kagetori
 Series: Interesting rest stops . . .
 A1362.11, 50.1495.11

989.12. *Yotsuya oiwake*, The junction of the pilgrim road at Yotsuya
Series: *Tōkaidō wakiji ōyama mōde no uchi*, Pilgrimage to Ōyama on a branch route of the Tōkaidō Road
A1362.12, 50.1495.12
PLATE 95.

989.13. Ferry at Tamura
Series: Pilgrimage to Ōyama (as no. 12)
A1362.13, 50.1495.13
PLATE 96.

989.14. Hills at Koyasu
Series: *Gojūsantsugi wakiji ōyama-kaidō no uchi*, The road to Ōyama, a branch route of the fifty-three stations
A1362.14, 50.1495.14
PLATE 97.

989.15. *Ōyama ōtaki*, The great waterfall at Ōyama
Series: *Tōkaidō wakiji*, A branch route of the Tōkaidō Road
A1362.15, 50.1495.15
PLATE 98.

989.16. *Ōyamadera*, Pilgrims at the temple on top of Mt. Ōyama
Series: *Gojūsantsugi no uchi wakiji*, A branch route of the fifty-three stations
A1362.16, 50.1495.16
PLATE 99.

989.17. Salt kilns at Gyotoku
Series: *Shimōsa narita dōchū*, Along the Narita Road in Shimōsa Province
A1362.17, 50.1495.17

989.18. *Tonegawa barabaramatsu*, Scattered pine trees along the Tone River
Series: *Shimōsa narita dōchū*, Along the Narita Road in Shimōsa Province
A1362.18, 50.1495.18

989.19. Meadows on Kogane Plain
Series: Narita Road
A1362.19, 50.1495.19

989.20. Rain at Imba Marsh
Series: Narita Road
A1362.20, 50.1495.20

Nos. 990–999 are from the same series and have the same date, signature, censorship seal and format, except when noted otherwise.
The complete set of ten prints, published by Kawaguchi Shōzō.

990. *Yodogawa*, Passenger boat by moonlight on the Yodo River
Series: *Kyōto meisho no uchi*, Famous views of Kyōto
ca. 1834
Signature: Hiroshige ga
Artist's seal: Ichiryūsai

Publisher: Eisendō han
Censorship seal: kiwame
ōban, 221 × 354, with variation up to 7 mm. in set
Reference: Suzuki 325.
A911, 50.1044

The first state, with the publisher's mark in blue in the right margin.
In the second state, the publisher's mark is removed.

991. *Gionsha setchū*, Snow at the shrine at the Gion district of Kyōto
Artist's seal: Ichiryūsai
Reference: Suzuki 326.
A912, 50.1045

Third state with the name of shrine, Kan-jinin, engraved in reserve, and the publisher's mark in the right margin removed.

992. *Arashiyama manka*, Cherry trees in full blossom at Arashiyama
Publisher: Kawaguchi han
Reference: Suzuki 327.
A909, 50.1042

993. *Tadasugawara no yūdachi*, Evening rain on the banks of the Tadasu River
Reference: Suzuki 328.
Provenance: Jacquin
Publication: Jacquin 466, ill., $87.50.
A914, 50.1047

Early impression with the lines of rain printed to the top edge over dark brown.

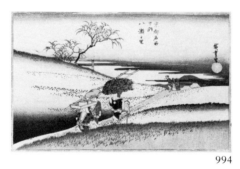

994

*994. *Yase no sato*, Yase Village
Publisher: Kawaguchi han
Reference: Suzuki 329.
A910, 50.1043

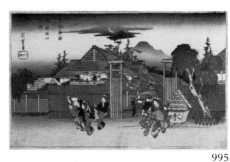

995

*995. *Shimabara deguchi no yanagi*, Crescent moon over the willow at the exit from the Shimabara licensed quarters
Publisher: Kawaguchi han
Reference: Suzuki 330.
Provenance: Happer authentication seal on verso
A913, 50.1046

996. *Tsūtenkyō no momiji*, Autumn leaves at Tsūten Bridge
Publisher: Kawaguchi han
Censorship seal: trimmed
Reference: Suzuki 331.
A908, 50.1041

997. *Kiyomizu*, Viewing the cherry blossoms around Kiyomizu Temple from the Ukamuse tea house
Artist's seal: Ichiryūsai
Publisher: Eisendō han (partly trimmed)
Censorship seal: partly trimmed
Reference: Suzuki 332.
A915, 50.1048

Early impression with publisher's mark in margin.

998. *Shijōgawara yūsuzumi*, Enjoying a cool summer evening along the Kamo River at Shijō in Kyōto
Publisher: Kawaguchi han
Reference: Suzuki 333.
A916, 50.1049

999. *Kinkakuji*, Kinkaku Temple
Publisher: Eisendō
Reference: Suzuki 334.
Publication: probably May, 148, $15.
A907, 50.1040

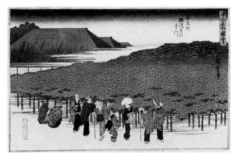

1000

*1000. *Anryūmachi naniwaya no matsu*, The pine tree at the Naniwaya Restaurant at Anryūmachi
Series: *Naniwa meisho zue*, Pictures of famous places in Osaka
ca. 1834
Signature: Hiroshige ga
Publisher: Eisendō
Censorship seal: kiwame
ōban, 223 × 351
Reference: Suzuki 165, 9; TNM 3576.
A1088, 50.1221

From a set of 10 published by Kawaguchi Shōzō.
Early impression with borders printed with imitation gold flecks.

Nos. 1001–1003 are from the same series and have the same format.

*1001. *Sōshū shichirigahama*, Enoshima Island from Shichiri Beach in Sagami Province
Series: *Honchō meisho*, Famous places in Japan
ca. 1832
Signature: Ichiryūsai Hiroshige ga
Artist's seal: Ichiryūsai
Publisher: Shōgendō (Fujiokaya Hikotarō)
207 × 343
Reference: Suzuki 445.
A652, 50.785

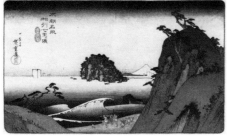

1001

1002. *Satta fuji*, Mt. Fuji from the pass at Satta
Signature: Hiroshige ga
Artist's seal: Ichiryūsai
Publisher: Fujihiko
Censorship seal: kiwame
ōban, 219 × 346
Reference: Suzuki 442.
A654, 50.787

The first three prints in the set were published around 1832, the remaining twelve in the late 1830s.

1003. *Sunshū fujikawa watashibune no zu*, The ferry boats on the Fuji River in Suruga Province
late 1830s
Signature: Ichiryūsai Hiroshige ga
Artist's seal: Utagawa
Publisher: Shōgendō (Fujiokaya Hikotaro)
210 × 342
Reference: Suzuki 451.
A653, 50.786

Nos. 1004–1085 are from the same series. The complete set of seventy pictures of *ōban* format begun by Keisai Eisen in 1835 and finished by Hiroshige in the late 1830s. The series was originally undertaken by the publisher Takenouchi Magohachi (Hoeidō) but concluded by Iseya Rihei (Iseri, Kin-judō). Hiroshige's prints have uniform series titles. The series titles on Eisen's pictures vary from print to print. The Hiroshige signature and title, *Kisokaidō rokūjūkutsugi no uchi*, Sixty-nine Stations on the Kisokaidō Road, are cited only the first time (no. 1017) they appear on the set. In the case of Eisen, the catalogue cites only variations from the title given in catalogue no. 1004.

Keisai EISEN

1004. 1. *Nihonbashi yuki no akebono*, Snowy New Year's dawn at Nihon Bridge
Series: *Kisokaidō tsuzuki no ichi*, A set of pictures of the Kisokaidō Road
1835
Publisher: Takenouchi Hoeidō han, Take
Censorship seal: kiwame
ōban, 222 × 347 with variations in set up to 10 mm. (larger variations noted)
Reference: Suzuki 335.
A716, 50.849

This is the first state of the print with the artist's signature, the publisher's name, and the character for sheep, the cyclic sign for the year 1835, on the umbrella.
In the second state the name of the publisher Iseri appears on the large umbrella and his emblem appears on the smaller umbrella at the center (UTK 15, 1).
Late impressions lack the name of the artist.

1005. 2. *Itabashi no eki*, Itabashi station
Publisher: Hoeidō, and another unread seal printed in blue
Reference: Suzuki 336.
A717, 50.850

Second state of the print with the artist's name and the Takenouchi seal removed, and the emblem on the pack horse changed to that of the new publisher Iseya Rihei.

1006. 3. *Warabi no eki todagawa watashi*, Ferry on the Toda River at Warabi Station
Publisher: Hoei
Reference: Suzuki 337.
A718, 50.851

Second state of the print with the artist's signature and one publisher's mark removed.

1007. 4. *Urawa shuku asamayama embō*, Distant view of Mt. Asama from Urawa Station
Series: *Kisoji no eki*, Stations of the Kiso Road
Reference: Suzuki 338.
Publication: perhaps Metzgar 659, $12.50.
A719, 50.852

Second state with signature and publisher's marks removed and the mark of Iseri on the cinch belt of the pack horse.

1008. 5. *Ōmiya shuku fuji enkei*, Distant view of Mt. Fuji from Ōmiya station
Publisher: Hoeidō
Reference: Suzuki 339.
A720, 50.853

Second state with the signature and one of the publisher's marks removed.

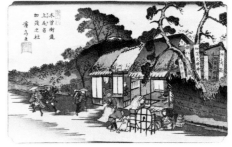

1009

*1009. 6. *Ageo shuku kamo no yashiro*, Kamo Shrine at Ageo station
Signature: Keisai ga
Publisher: Takenouchi han
Reference: Suzuki 340.
A721A, 50.854A

First state with the artist's signature.

1010. 6. *Ageo* . . .
Reference: Suzuki 341.
A721, 50.854

Second state with the signature removed.

1011. 7. *Okekawa shuku kōgen no kei*, View of the open country near Okekawa Station
Publisher: Hoeidō
Reference: Suzuki 342.
Provenance: unidentified collector's mark on verso
A722, 50.855

Second state with the signature removed.

1012. 8. *Fukiage fuji embō*, Distant view of Mt. Fuji from Fukiage
Signature: Keisai ga
Publisher: Hoeidō, Takenouchi
Reference: Suzuki 343.
A723A, 50.856A

First state with signature and Takenouchi seal.

1013. 8. *Fukiage* . . .
Publisher: Hoeidō
Reference: Suzuki 343.
Provenance: Matsuki
A723, 50.856

Second state with artist's signature and third publisher's seal removed.

1014. 9. *Kumagaya shuku hatchōzutsumi no kei*, View of the Hatchō embankment at Kumagaya Station
Series: *Kiso dōchū*, Along the Kiso Road
Signature: Eisen ga

Publisher: Takenouchi shimpan
Reference: Suzuki 344.
Provenance: Matsuki

A724, 50.857

1015. 10. *Fukaya no eki,* Night at Fukaya
Station
Publisher: Hoeidō hammoto
216 × 332
Reference: Suzuki 346.

A725, 50.858

Second state of the print with the signature and one seal removed, but with the houses in the background.
(A false state is reproduced as Suzuki 346 with a new signature added.)

1016. 11. *Honjō shuku kannagawa watashi-ba,* The ferry on the Kanna River at Honjō Station
Series: *Kisoji no eki,* Stations on the Kiso Road
Reference: Suzuki 348.

A726, 50.859

This print seems never to have been signed.

Utagawa HIROSHIGE

1017. 12. Shimmachi
Series: *Kisokaidō rokujūkutsugi no uchi,* Sixty-nine Stations on the Kiso-kaidō Road
late 1830's
Signature: Hiroshige ga
Publisher: Kinjudō
Censorship seal: kiwame
Reference: Suzuki 349.
Provenance: Matsuki

A727, 50.860

PLATE 44 (color).

Keisai EISEN

1018. 13. *Kuragano shuku karasugawa no zu,* The Karasu River at Kuragano Station
Signature: Eisen ga
Publisher: Takenouchi Hoeidō.

A728A, 50.861A

First state with signature.

*1019. 13. *Kuragano shuku . . .*
Publisher: Takenouchi Hoeidō
Reference: Suzuki 350.

A728, 50.861

Second state with signature removed.

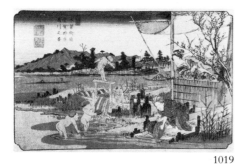

1019

1020. 13. *Kuragano shuku . . .*

A728B, 50.861B

Third state with signature and seals removed.

Utagawa HIROSHIGE

1021. 14. Takasaki
Signature: Hiroshige ga
Artist's seal: Ichiryūsai
Publisher: Hoeidō
Reference: Suzuki 351.
Provenance: Matsuki

A729, 50.862

Keisai EISEN

1022. 15. Snowy twilight at Itabana
Publisher: Iseri
Reference: Suzuki 352.

A730, 50.863

This print is never signed.

Utagawa HIROSHIGE

1023. 16. Annaka
Artist's seal: Ichiryūsai
Publisher: Kinjudō
Reference: Suzuki 353.

A731, 50.864

PLATE 45 (color).

1024. 17. Matsuida
Artist's seal: Ichiryūsai
Publisher: Kinjudō

A732, 50.865

Keisai EISEN

1025. 18. Sakamoto
Publisher: Iseri
Reference: Suzuki 355.

A733, 50.866

This print is never signed.

Utagawa HIROSHIGE

1026. 19. Karuizawa
Artist's seal: Tōkaidō
Publisher: Takenouchi

A734, 50.867

PLATE 46.

Keisai EISEN

1027. 20. *Kutsukake no eki hiratsukahara uchū no kei,* Rain on the Plain of Hiratsuka near Kutsukake station
Publisher: Takenouchi
Reference: Suzuki 357.
Provenance: Matsuki

A735, 50.868

Second state with the signature and printed publisher's name removed.
An impression in the British Museum lacks the rain block.

1028. 21. *Oiwake shuku asamayama chōbō,* View of Mt. Asama from Oiwake Station
Signature: Keisai ga
Publisher: Takemago, Take
212 × 334
Reference: Suzuki 358.

A736, 50.869

1028A. 21. *Oiwake . . .*
Signature: Keisai ga
Publisher: Kinjudō

A736A, 50.869A

Same as preceding, colors different, emblem on pack horse changed to that of Iseya Rihei.

Utagawa HIROSHIGE

1029. 22. Odai
Artist's seal: Ichiryūsai
Publisher: Kinjudō
Reference: Suzuki 359.

A737, 50.860

Keisai EISEN

1030. 23. Blind men brawling at Iwamurata
Series: *Kiso dōchū,* Along the Kiso Road
Publisher: Takenouchi
Censorship seal: kiwame

A738, 50.871

Second state with signature removed.

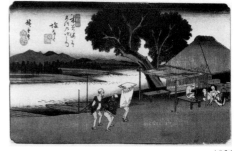

1031

Utagawa HIROSHIGE

*1031. 24. Shionada
Artist's seal: Ichiryūsai
Publisher: Kinjudō
Reference: Suzuki 361.
Provenance: Metzgar
Publication: Metzgar 666, $85 pl. XVIII (catalogue: "Exceedingly rare and beautiful in this printing. A great treasure").

A739, 50.872

Unrecorded second state with broken lower right corner of publisher's seal.

1032. 25. Yawata
Artist's seal: Utagawa
Publisher: Kinjudō
225 × 358
Reference: Suzuki 362.
Provenance: Matsuki

A740, 50.874

1033. 26. Full moon at Mochizuki
Artist's seal: Ichiryūsai
Publisher: Kinjudō
with overprinting on the moon
Reference: Suzuki 363.

A741, 50.874

Unrecorded second state with break on the blue block on the horse's blanket.

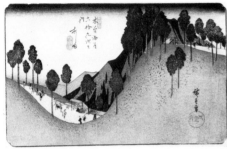

1034

*1034. 27. Ashida
Artist's seal: Ichiryūsai
Publisher: Kinjudō, Iseri (emblem)
Censorship seal: kiwame
Reference: Suzuki 364.

A742, 50.875

1035. 28. Full moon at Nagakubo
Artist's seal: Ichiryūsai
Publisher: Kinjudō, Iseri (emblem)
Censorship seal: kiwame
Reference: Suzuki 365.

A743, 50.876

First state with the mountains behind the bridge.

1036. 29. Snowy pass at Wada
Artist's seal: Ichiryūsai
Publisher: Kinjudō
Censorship seal: kiwame
Reference: Suzuki 366.

A744, 50.877

1037. 30. Inn at Shimosuwa
Artist's seal: Ichiryūsai
Publisher: Kinjudō han
Censorship seal: kiwame
Reference: Suzuki 367.

A745, 50.878

Keisai EISEN

1038. 31. *Shiojiritōge suwa no kosui chōkei*, View of Lake Suwa from Shiojiri Pass
Signature: Eisen ga
Publisher: Takenouchi, Hoeidō, Take
Censorship seal: kiwame
Reference: Suzuki 368.

A746, 50.879

First state with the signature.

Utagawa HIROSHIGE

1039. 32. Full moon at Seba
Artist's seal: Ichiryūsai
Publisher: Kinjudō
Reference: Suzuki 369.

A747, 50.880

1040. 33. Woodcutters resting at Motoyama
Artist's seal: Ichiryūsai
Publisher: Kinjudō, Iseri (emblem)
Reference: Suzuki 370.

A748, 50.881

1041. 34. Inn at Niekawa
Artist's seal: Ichiryūsai
Publisher: Kinjudō hammoto, Iseri (emblem)
Engraver: Matsushima Fusajirō tō
Printer: Surikō Matsumura Yasugorō, Kameta Ichitarō
Censorship seal: kiwame
Reference: Suzuki 371.
Provenance: Matsuki, Metzgar
Publication: Metzgar 673, $12.50.

A749, 50.882

The name of the publisher is on the signboard of the inn and the names of the engraver and printers on the boards hanging at the left, along with the name of the cosmetic manufacturer Sakamoto and his product Senjokō.

1042. 34. Inn at Niekawa
Provenance: unidentified collector's seal on verso

A749A, 50.882A

A duplicate impression.

Keisai EISEN

1043. 35. *Narai shuku meisanten no zu,* The Oroku comb shop at Narai Station
Signature: Eisen ga
Publisher: Takenouchi, Hoeidō hammoto, Take
Reference: Suzuki 372.

A750A, 50.883A

First state with the signature, with the block for the mountain at the left omitted, and a printed pattern in pink and grey on the slopes of the central peak.

PLATE 194.

1044. 35. *Narai shuku . . .*
Publisher: Takenouchi, Hoeidō hammoto, Take
Reference: Suzuki 373.
Provenance: unidentified collector's mark on verso

A750, 50.883

Second state with the artist's name removed and new grey blocks for the mountains at the left.

PLATE 195.

1045. 36. *Yabuhara toriitōge suzuri no shimizu,* The Inkslab Spring at Torii Pass near Yabuhara

Publisher: Hoeidō
Reference: Suzuki 375.

A751, 50.884

Unrecorded third state, with the signature removed and the additional color block on the mountain, but lacking the poem by Bashō on the rock at the left.

Utagawa HIROSHIGE

1046. 37. Mist at Miyanokoshi
Artist's seal: Ichiryūsai
Publisher: Kinjudō
Reference: Suzuki 376.
Provenance: Metzgar
Publication: Metzgar 674, $37.50.

A752, 50.885

The famine and economic disruption in the late 1830s caused many peasant families to desert the land on which they were tenant farmers. Free movement was illegal in the Edo period, and many of the flights and migration had to be surreptitious, as in this picture of a family fleeing under cover of night.

1047. 38. Government barrier at Fukushima
Artist's seal: Ichiryūsai
Publisher: Kinjudō, Take, emblem
Reference: Suzuki 377.
Provenance: Matsuki

A753, 50.886

1047A. 38. Government barrier at Fukushima

A753A, 50.886A

Faded impression of preceding.

*1048. 39. Waterfall at Agematsu
Artist's seal: Ichiryūsai
Publisher: Kinjudō
Reference: Suzuki 378.

A754, 50.887

Second state, lacking the spatter of *gofun* on the waterfall.

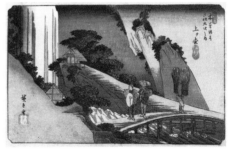

1048

1049. 40. Rain at Suhara
Artist's seal: Ichiryūsai
Publisher: Kinjudō
Reference: Suzuki 379.
Provenance: Matsuki

A755, 50.888

Keisai EISEN

1050. 41. *Nojiri inagawabashi enkei,* Distant view of the bridge on the Ina River at Nojiri
Series: *Kisojieki,* Stations on the Kiso Road
Signature: Eisen ga
Publisher: Takenouchi, Hoeidō
Censorship seal: kiwame
Reference: Suzuki 380.

A756A, 50.889A

The first state of the print with the artist's signature, before the birds by the bridge were removed and the color blocks altered to make the area beneath the bridge resemble Mt. Fuji.

1051. 41. *Nojiri inagawabashi enkei,* Distant view of the bridge on the Ina River at Nojiri
Series: *Kisojieki,* Stations on the Kiso Road
Publisher: Takenouchi, Hoeidō
Censorship seal: kiwame
Reference: Suzuki 381.

A756, 50.889

Second state with the signature and birds under the bridge removed, the cliffs printed green and grey.

1052. 41. *Nojiri . . .*
Publisher: Takenouchi, Hoeidō
Reference: Suzuki 381.
Publication: perhaps May 523, $5.

A757, 50.890

Second state with signature removed, the cliffs printed in blue and grey.

Utagawa HIROSHIGE

1053. 42. Mitono
Artist's seal: Ichiryūsai
Publisher: Kinjudō
Reference: Suzuki 382.
Provenance: May
Publication: May 523, $10.

A758, 50.891

1054. 43. Tsumakago
Artist's seal: Ichiryūsai
Publisher: Kinjudō
Reference: Suzuki 383.
Provenance: Spaulding

A759, 50.892

Keisai EISEN

1055. 44. *Magome shuku tōge yori embō no zu,* Distant view from the pass near Magome Station
Publisher: Takemago, Hoeidō
Reference: Suzuki 385.
Provenance: Rouart

A760, 50.893

Second state with the signature of Eisen removed and large mountain at center.

1056. 44. *Magome . . .*
Publisher: Takemago Hoeidō
Reference: Suzuki 385.

A760A, 50.893A

Later impression lacking some overprinting.

Utagawa HIROSHIGE

1057. 45. Ochiai
Artist's seal: Ichiryūsai
Reference: Suzuki 386.
Provenance: May
Publication: May 523, $5.

A761, 50.844

Second state lacking the publisher's mark lower left, printed with green on the banks, and only the upper tip of the mountain.

1058. 46. Nakatsugawa
Artist's seal: Ichiryūsai
Publisher: Iseri (emblem)
Reference: Suzuki 387.

A762, 50.895

Second design for this station, the first showing three porters walking in the rain.

*1059. 47. Snow at Ōi
Artist's seal: Ichiryūsai
Publisher: Kinjudō
Reference: Suzuki 388.

A763, 50.896

Second state without the spattered *gofun,* and without the shading on sky and mountains.

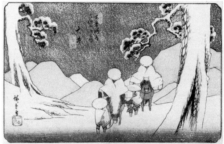

1059

1060. 48. Ōkute
Artist's seal: Ichiryūsai
Publisher: Kinjudō
Reference: Suzuki 389.
Provenance: Happer authentication seal on verso

A764, 50.897

1061. 49. Hosokute
Artist's seal: Ichiryūsai
Publisher: Iseri (emblem)
Reference: Suzuki 390.
Provenance: unidentified collector's mark and price $1.00 on verso

A765, 50.898

1062. 50. Inn at Mitake
Artist's seal: Ichiryūsai
Publisher: Iseri (emblem)
Reference: Suzuki 391.

A766, 50.899

1063. 51. Fushimi
Publisher: Iseri (emblem)
Reference: Suzuki 392.

A767, 50.900

1064. 52. Ferry boats at Ōta
Artist's seal: Ichiryūsai
Publisher: Iseri (emblem)
Reference: Suzuki 393.

A768, 50.901

Keisai EISEN

1065. 53. *Unuma no shuku inuyama yori embō,* Distant view from Dog Mountain at Unuma Station
Signature: Eisen ga
Publisher: Takenouchi, Hoeidō
Reference: Suzuki 394.

A769, 50.902

First state with signature, two publisher's marks, and bands of blue by distant shore.

Utagawa HIROSHIGE

1066. 54. Procession at Kanō
Publisher: Iseri (emblem)
Reference: Suzuki 395.
Provenance: Matsuki

A770, 50.903

Keisai EISEN

1067. 55. *Kōdo nagaekawa ukaibune,* Cormorant fishing boats on the Nagae River near Kōdo
Series title: *Kisoji no eki,* Stations on the Kiso Road
Reference: Suzuki 397.

A771, 50.904

Second state with the signature of Eisen and publisher's seal removed.

Utagawa HIROSHIGE

1068. 56. Mieji
Artist's seal: Ichiryūsai
Publisher: Iseri (emblem)
Reference: Suzuki 398.
Provenance: Matsuki

A772, 50.905

1069. 57. Akasaka
Artist's seal: Ichiryūsai
Publisher: Iseri (emblem)
Reference: Suzuki 399.

A773, 50.906

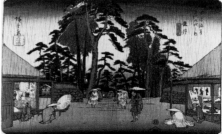

1070

*1070. 58. Rain at Tarui
Artist's seal: Ichiryūsai
Publisher: Iseri (emblem)
Reference: Suzuki 400.
Provenance: Matsuki

A774, 50.907

Woodblock prints are pasted on the walls of the teahouses and the mark of the publisher appears on a wall at the left.

1071. 59. Teashop at Sekigahara
Artist's seal: Tōkai
Publisher: Iseri (emblem)
Reference: Suzuki 401.
Provenance: unidentified collector's mark on verso

A775, 50.908

1072. 60. Boundary marker at Imasu
Artist's seal: Ichiryūsai
Publisher: Iseri (emblem)
Reference: Suzuki 402.
Provenance: Matsuki

A776, 50.909

1073. 60. Imasu
Publisher: Iseri (emblem)
Reference: Suzuki 402.

A776A, 50.909A

A duplicate impression.

1074. 61. The Kameya, or Turtle Inn at Kashiwabara
Publisher: Iseri (emblem)
Reference: Suzuki 403.
Provenance: unidentified collector's mark on verso

A777, 50.910

1075. 62. Samegai
Artist's seal: Ichiryūsai
Publisher: Iseri (emblem)
Reference: Suzuki 404.

A778, 50.911

1076. 63. Inns at Bamba
Publisher: Iseri (emblem)
Reference: Suzuki 405.
Provenance: Matsuki

A779, 50.912

1077. 64. Lake Biwa from Toriimoto
Artist's seal: Ichiryūsai
Publisher: Takenouchi, Iseri (emblem)
Reference: Suzuki 406.

A780A, 50.913A

An early impression.

1078. 64. Lake Biwa . . .
Artist's seal: Ichiryūsai
Publisher: Takenouchi, Iseri (emblem)
Reference: Suzuki 406.

A780, 50.913

A later impression with printing variations.

1079. 65. Takamiya
Artist's seal: Ichiryūsai
Publisher: Iseri (emblem)
Reference: Suzuki 407.

A781, 50.914

1080. 66. Bridge at Echikawa
Artist's seal: Ichiryūsai
Publisher: Iseri (emblem)
Reference: Suzuki 408.
Provenance: Matsuki

A782, 50.915

1081. 67. Boat bridge at Musa
Artist's seal: Ichiryūsai
Publisher: Iseri (emblem)
Reference: Suzuki 409.
Provenance: Matsuki, Metzgar
Publication: Metzgar 684 and 20.

A783, 50.916

Musa is the 67th subject in the series, but all impressions of the picture have a printed number 66, duplicating the number of the previous print.

1082. 68. Cherry blossoms at Moriyama
Publisher: Iseri (emblem)
Reference: Suzuki 410.

A784, 50.917

1083. 69. *Kusatsu oiwake,* The crossroads at Kusatsu
Artist's seal: Ichiryūsai
Publisher: Iseri (emblem)
Reference: Suzuki 411.

A785, 50.918

Misnumbered 68 on the picture.

1084. 70. The Kanaya or Gold Inn at Ōtsu
Publisher: Iseri (emblem)
Reference: Suzuki 412.
Provenance: Matsuki

A786, 50.919

Many of the banners hanging from the buildings give the names and emblems of the artist and publisher.

1085. 70. The Kanaya or Gold Inn at Ōtsu
Publisher: Iseri (emblem)

A786A, 50.919A

A duplicate impression.

1086. *Tōto shinagawa,* Full moon over tea houses beside the bay at Shinagawa in the eastern capital
Series: *Nihon minato zukushi,* Harbors of Japan
late 1830s
Signature: Hiroshige ga
ōban, 221 × 347
Reference: Suzuki 166, 5.

A988, 50.1121

Second state lacking publisher's mark and censorship seals. From a set of eleven prints published by Maruya Seijirō.
The lanterns read Marusei, Ichiryūsai and Hiro.

1087. *Echigo kamewaritōge,* Kamewari Pass in Echigo Province
Series: *Sankai mitate sumō,* Mountains and Seas Compared to Wrestlers
8/1858
Signature: Hiroshige ga

Publisher: Yamadaya Shōjirō, Minami Temma 2
ōban, 220 × 346
Reference: Suzuki 166, 7; TNM 3593.

A1087, 50.1220

From the set of twenty landscapes, Hiroshige's last work in the horizontal *ōban* format. Early impression with three-color cartouche.

Baiso GENGYO

1088. Frontispiece with title *Dainihon rokujūyoshū meisho zue,* Pictures of famous places in the sixty-odd provinces of greater Japan, and table of contents
9/1856
Signature: Gengyo sho
Publisher: Koshimuraya Heisuke han
Censorship seal: aratame
ōban, 363 × 244
embossing and blue-green ground

A1122, 50.1255

Utagawa HIROSHIGE

Nos. 1089–1157 are from the same series and have the same series title, signature, publisher, format, technique and reference. The complete set of 69 landscapes in vertical *ōban* format published by Koshimuraya Heisuke between 7/1853 and 3/1856. Each picture has the series and picture titles in the upper right, the signature Hiroshige hitsu below, and an abbreviated form of the publisher's name, Koshihei. They also bear marks of censorship which appear in these combinations: Mera-Watanabe, nos. 1089–1097, 1100, 1110; Murata-Kinugasa, nos. 1098–99, 1102–1104, 1108–1109, 1111–17; Fuku-Muramatsu, no. 1105; Hama-Magomi, nos. 1118–1119, 1121–24; aratame, nos. 1120, 1125–57. Several of the pictures were engraved by Hori Take (nos. 1089–92, 1097–1100, 1102–3, 1107, 1109–17, 1121–22, 1129, 1154–55). When the set was completed, a frontispiece with a title and a table of contents was designed by Hiroshige's friend Baiso Gengyo, listing the pictures by district in geographical order (no. 1088). This order has been followed here.

1089. 1. *Arashiyama togetsukyō,* The Moon Crossing Bridge at Arashiyama in Yamashiro Province
Series: *Rokujūyoshū meisho zue,* Pictures of famous places in the sixty-odd provinces
7/1853, pink title cartouche
ōban, 346 × 233, with variation up to 9 mm. within set
Reference: Suzuki 167.

A1123, 50.1256

1090. 2. *Tatsutayama tatsutagawa*, Tatsuta River and Tatsuta Mountain in Yamato Province
7/1853, purple title cartouche
Provenance: Happer authentication seal on verso

A1124, 50.1257

1091. 3. *Makigata otokoyama*, Otoko Mountain at Makigata in Kawachi Province
7/1853, pink cartouche

A1125, 50.1258

1092. 4. *Takashinohama*, Takashi Beach in Izumi Province
7/1853, pink cartouche

A1126, 50.1259

1093. 5. *Sumiyoshi deminohama*, Demi Beach at Sumiyoshi in Settsu Province
7/1853, pink cartouche

A1127, 50.1260

1094. 6. *Ueno*, Castle at Ueno in Iga Province
7/1853, two-color cartouche
Engraver: Hori Ta

A1128, 50.1261

1095. 7. *Asakumayama tōge no chaya*, Tea-houses at the pass on Mt. Asakuma in Ise Province
7/1853, pink cartouche
Engraver: Hori Ta

A1129, 50.1262

1096. 8. *Hiyoriyama toba minato*, Mt. Hiyori and Toba Bay in Shima Province
7/1853, yellow cartouche
Engraver: trimmed

A1130, 50.1263

1097. 9. *Tsushima tennō matsuri*, Lantern ships at the Tennō Festival at Tsushima near Nagoya in Owari Province
7/1853, light purple cartouche

A1131, 50.1264

1098. 10. *Hōraiji sangan*, Hōrai Temple in the steep mountains in Mikawa Province
8/1853, pink cartouche

A1132, 50.1265

1099. 11. *Hamana no ko horie kanzanji hikusa no hosoe*, The narrow inlet of Hikusa by Kanzan Temple on Hamana Lake at Horie in Tōtomi Province
8/1853, pink cartouche

A1133, 50.1266

1100. 12. *Mio no matsubara*, Mt. Fuji from the pine grove at Mio in Suruga Province
7/1853, pink cartouche

A1134, 50.1267

1101. 13. *Saruhashi*, The Monkey Bridge in Kai Province
8/1853, blue cartouche

A1135, 50.1268

1102. 14. *Shuzenji tōjiba*, Hot springs near Shuzen Temple in Izu Province
8/1853, yellow cartouche

A1136, 50.1269

1103. 15. *Enoshima iwaya no kuchi*, Entrance to the cave at Enoshima Island in Sagami Province
8/1853, purple cartouche

A1137, 50.1270

*1104. 16. *Sumidagawa yuki no ashita*, Snowy morning on the Sumida River in Musashi Province
8/1853, yellow cartouche

A1138, 50.1271

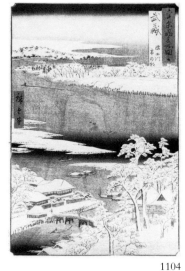

1104

1105. 17. *Asakusaichi*, The year-end festival at Asakusa in Edo
10/1853, yellow cartouche and bands of cloud in sky

A1139, 50.1272

1106. 18. *Kominato no ura*, Bay at Kominato in Awa Province
8/1853, pink cartouche

A1140, 50.1273

1107. 19. *Yasashigaura tsūmei kujūkuri*, Yasashi Bay, also known as Ninety-nine *Ri* Beach in Kazusa Province
8/1853, pink cartouche

A1141, 50.1274

1108. 20. *Chōshi no hama sotoura*, The outer bay at Chōshi Beach in Shimōsa Province
8/1853, yellow cartouche

A1142, 50.1275

1109. 21. *Kashima daijingū*, The great shrine at Kashima in Hitachi Province
8/1853, orange cartouche

A1143, 50.1276

1110. 22. *Biwako ishiyamadera*, Ishiyama Temple and Lake Biwa
7/1853, brown cartouche and cloud beneath moon

A1144, 50.1277

1111. 23. *Yōrō no taki*, Yōrō waterfall in Mino Province
8/1853, embossing and pink cartouche

A1145, 50.1278
PLATE 87.

1111A. 23. *Yōrō no taki . . .*
8/1853, late impression with embossing and red cartouche, the waterfall entirely blue

A1145A, 50.1278A
PLATE 88.

*1112. 24. *Kagowatashi*, The basket ferry in Hida Province
8/1853, brown cartouche

A1146, 50.1279

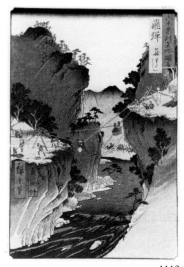

1112

1113. 25. *Sarashina tagoto no tsuki kyōdaiyama*, Mirror Stand Mountain and the moon reflected in the rice fields at Sarashina in Shinano Province
8/1853, pink cartouche

A1147, 50.1280

1114. 26. *Harunayama setchū*, Snow at Mt. Haruna in Kōzuke Province
8/1853, pink cartouche

A1148, 50.1281

1115. 27. *Nikkōzan urami no taki*, The back-view waterfall in the Nikkō mountains in Shimōzuke Province
8/1853, yellow cartouche

A1149, 50.1282

1116. 28. *Matsushima fūkei tomiyama chōbō no ryakuzu*, View of Matsushima with a distant prospect of Mt. Tomi in Michinoku Province
8/1853, pink cartouche

A1150, 50.1283

1117. 29. *Mogamigawa tsukiyama embō*, Distant view of Moon Mountain from the Mogami River in Dewa Province
8/1853, pink cartouche

A1151, 50.1284

1118. 30. *Gyosen kareiami*, Fishing boats netting flounders in Wakasa Province
9/1853, green cartouche
Engraver: Hori Kosen

A1152, 50.1285

1119. 31. *Tsuruga kebi no matsubara*, The pine forest of Kebi at Tsuruga in Echizen Province
9/1853, orange cartouche

A1153, 50.1286

1120. 32. *Kanazawa hakkei no uchi hasunoko no isaribi*, Fishing by torchlight on Lotus Lake, one of the eight famous places in Kanazawa in Kaga Province
9/1853, blue cartouche

A1154, 50.1287

1121. 33. *Taki no ura*, The beach with the waterfall by Hawknest Rock in Noto Province
9/1853, pink cartouche

A1155, 50.1288

1122. 34. *Toyama funabashi*, The bridge of boats at Toyama in Etchū Province
9/1853, pink cartouche

A1156, 50.1289

1123. 35. *Oyashirazu*, The Oyashirazu Promontory in Echigo Province
9/1853, yellow cartouche
Engraver: Hori Kosen

A1157, 50.1290

1124. 36. *Kanayama*, Entrance to the gold mines at Kanayama in Sado Province
9/1853, pink cartouche

A1158, 50.1291

1125. 37. *Kagamizaka*, Mirror Slope with the stone arch in Tamba Province
12/1853, yellow cartouche

A1159, 50.1292

1126. 38. *Amanohashidate*, Amanohashidate Peninsula in Tango Province
12/1853, pink cartouche
Engraver: Hori Sōji

A1160, 50.1293

1127. 39. *Iwaidani iwaya kannon*, The cave temple of Kannon in the Iwai Valley
12/1853, yellow cartouche

A1161, 50.1294

1128. 40. *Kajikoyama*, Cherry and pine trees on Mt. Kajiko in Inaba Province
12/1853, pink cartouche
Engraver: Hori Kosen

A1162, 50.1295

1129. 41. *Ono ōyama embō*, Distant view of Ōyama near Ono in Hōki Province
12/1853, yellow cartouche
Provenance: Happer authentication seal on verso

A1163, 50.1296

1130. 42. *Taisha hotohoto no zu*, Mist at the *hotohoto* festival at the great shrine in Izumo Province
12/1853, pink cartouche
Engraver: Hori Sennosuke

A1164, 50.1297

1131. 43. *Takatsuyama shiohama*, The Salt-maker's Beach near Mt. Takatsu in Iwami Province
12/1853, yellow cartouche
Engraver: Hori Sōji

A1165, 50.1298

1132. 44. *Takibi no yashiro*, The Floating Shrine of the Torch off the coast of Oki Province
12/1853, yellow cartouche
Engraver: Hori Kosen

A1166, 50.1299

1133. 45. *Maiko no hama*, Pine trees at Maiko Beach in Harima Province
12/1853, yellow cartouche

A1167, 50.1300

1134. 46. *Yamabushidani*, Rain in the Yamabushi Gorge in Mimasaka Province
12/1853, yellow cartouche

A1168, 50.1301

Second state lacking the additional horizontal rainblock beside the cartouche.
PLATE 108.

1135. 47. *Tanokuchi kaigan yugasan torii*, The stone gate of Yuga Temple on the beach at Tanokuchi in Bizen Province
12/1853, yellow cartouche

A1169, 50.1302

1136. 48. *Gokei*, The Go Gorge in Bitchū Province
12/1853, pink cartouche

A1170, 50.1303

1137. 49. *Abumon kannondō*, Temple of Kannon at Abumon in Bingo Province
12/1853, pink cartouche
Engraver: trimmed

A1171, 50.1304

1138. 50. *Itsukushima sairai no zu*, Festival at the Itsukushima Shrine in Aki Province
12/1853, orange cartouche

A1172, 50.1305

1139. 51. *Iwakuni kintaibashi*, The Brocade Bridge at Iwakuni in Suō Province
12/1853, yellow cartouche
Engraver: Hori Sennosuke

A1173, 50.1306

1140. 52. *Shimonoseki*, Ships in harbor at Shimonoseki in Nagato Province
3/1856, yellow cartouche

A1174, 50.1307

1141. 53. *Wakanoura*, Cranes flying over Waka Bay in Kii Province
9/1855, embossing, pink cartouche
Printer: Suri Sadaka

A1175, 50.1308

1142. 54. *Goshikinohama*, Five Color Beach in Awaji Province
9/1855, pink cartouche
Engraver: Hori Tomo

A1176, 50.1309

1143. 55. *Naruto no fūha*, Whirlpool and waves at Naruto in Awa Province
9/1855, yellow cartouche
Provenance: Happer authentication seal on verso

A1177, 50.1310

1144. 56. *Zōzusan embō*, Distant view of Elephant Head Mountain in Sanuki Province
9/1855, yellow cartouche
Engraver: Hori Sōji

A1178, 50.1311

1145. 57. *Saijō*, Geese over Saijō in Iyo Province
9/1855, embossing, yellow cartouche
Engraver: Hori Sōji

A1179, 50.1312

1146. 58. *Kaijō katsuozuri*, Fishing for bonito off the coast of Tosa Province
9/1855, pink cartouche

A1180, 50.1313

1147. 59. *Hakozaki kaichū no michi*, Hako Promontory in Chikuzen Province
9/1855, yellow cartouche
Engraver: Hori Sōji

A1181, 50.1314

1148. 60. *Yanase*, The weir in the shallows at Yanase in Chikugo Province
9/1855, yellow cartouche

A1182, 50.1315

1149. 61. *Rakandera shitamichi*, The road below the Rakan Temple in Buzen Province
12/1854, with mica, grey cartouche

A1183, 50.1316

1150. 60. *Minozaki*, Mino Promontory in Bungo Province
4/1856, with mica, yellow cartouche

A1184, 50.1317

1151. 63. *Nagasaki inasayama*, Inasa Mountain at Nagasaki in Hizen Province
5/1856, yellow cartouche

A1185, 50.1318

1152. 64. *Gokanoshō*, Tree bridge at Go-kanoshō in Higo Province
3/1856, pink cartouche
A1186, 50.1319

1153. 65. *Yuzu no minato obi ōshima*, Yuzu Bay on the island of Obi in Hyūga Province
3/1856, yellow cartouche
A1187, 50.1320

1154. 66. *Sakurajima*, Cherry Island in Ōsumi Province
3/1856, yellow cartouche
A1188, 50.1321

1155. 67. *Bōnoura sōkenseki*, The twin sword rocks in Bō Bay in Satsuma Province
3/1856, yellow cartouche
A1189, 50.1322

1156. 68. *Shisaku*, Snow at Shisaku in Iki Province
3/1856, pink cartouche
A1190, 50.1323

1157. 69. *Kaigan yūbare*, Clear evening with a rainbow over the sea in Tsushima Province
3/1856, three-color cartouche
A1191, 50.1324
PLATE 54 (color).

Nos. 1158-1194 are all from the same series and have the same date, signature, publisher, format, technique and reference.

1158. *(Fuji) meisho sanjūrokkei*, Thirty-six views of Mt. Fuji from famous places
4/1859
Signature: shōdai Ichiryūsai Hiro-shige-ō iga
Artist's seal: Hiro
Publisher: Tsutaya Kichizō
Censorship seal: aratame
ōban, 333 × 220
embossing
Reference: Suzuki 167.
A1325, 50.1458

Decorative title page with table of contents and explanatory text by Santei Haruma, sealed Santei, for the complete set of 36 views passed for censorship in 4/1858, but published posthumously. The prints are listed in the order given in the table of contents.

1159. 1. *Tōto ichikokubashi*, Fuji from Ichi-koku Bridge in the eastern capital
Series: *Fuji sanjūrokkei*, Thirty-six views of Mt. Fuji
4/1858
Signature: Hiroshige ga
Publisher: Tsutaya Kichizō
ōban, 337 × 220, with variation up to 4 mm. within set
Reference: Suzuki 167.
A1326, 50.1459

1160. 2. *Tōto surugachō*, Street musicians outside the Echigoya clothing store at Surugachō at the beginning of the New Year
A1327, 50.1460

*1161. 3. *Tōto sukiyagashi*, The Sukiya Bank of the moat of Edo Castle in the eastern capital
A1328, 50.1461

1161

*1162. 4. *Tōto tsukuda oki*, Ships moored off Tsukuda Island in the eastern capital
A1329, 50.1462

1162

1163. 5. *Tōto ochanomizu*, The bridge at Ochanomizu in the eastern capital
A1330, 50.1473

1164. 6. *Tōto ryōgoku*, Pleasure boat near Ryōgoku Bridge in the eastern capital
A1331, 50.1464

1165. 7. *Tōto sumidagawa tsutsumi*, Cherry trees in blossom on the bank of the Sumida River in the eastern capital
A1332, 50.1465

1166. 8. *Tōto asukayama*, Cherry trees in blossom at Asuka Hill in the eastern capital
A1333, 50.1466

1167. 9. *Zōshigaya fujimi chaya*, The tea-house with the view of Mt. Fuji at Zōshigaya
A1334, 50.1467

1168. 10. *Tōto meguro yūhigaoka*, Maple trees at Twilight Hill at Meguro in the eastern capital
A1335, 50.1468

1169. 11. *Kōnodai tonegawa*, The Hill of the Wild Goose by the Tone River
A1336, 50.1469

1170. 12. *Musashi koganei*, Cherry trees in blossom at Koganei in Musashi Province
A1337, 50.1470

1171. 13. *Musashi tamagawa*, The Tama River in Musashi Province
A1338, 50.1471

1172. 14. *Musashi koshigaya zai*, The countryside at Koshigaya in Musashi Province
A1339, 50.1472

1173. 15. *Musashi noge yokohama*, The villages of Noge and Yokohama in Musashi Province
A1340, 50.1473

1174. 16. *Musashi hommoku no hana*, Cherry trees in blossom in Hommoku in Musashi Province
A1341, 50.1474

1175. 17. *Sōshū miura no kaijō*, The sea off the Miura Peninsula in Sagami Province
A1342, 50.1475

1176. 18. *Sagamigawa*, Rafts on the Sagami River
A1343, 50.1476

1177. 19. *Sōshū shichirigahama*, Enoshima and the Seven-*ri* Beach in Sagami Province
A1344, 50.1477

1178. 20. *Sōshū enoshima iriguchi*, The entrance gate on Enoshima Island in Sagami Province
A1345, 50.1478

1179. 21. *Hakone no kosui*, The lake at Hakone
A1346, 50.1479

1180. 22. *Izu no sanchū*, Waterfall in the mountains of Izu
A1347, 50.1480

1181

*1181. 23. *Suruga satta kaijō*, Waves off the Satta Pass in Suruga Province

A1348, 50.1481

1182. 24. *Suruga mio no matsubara*, The pine forest of Mio in Suruga Province

A1349, 50.1482

1183. 25. *Tōkaidō hidari fuji*, Mt. Fuji on left along the Tōkaidō Road

A1350, 50.1483

1184. 26. *Sunen ōigawa*, Fording the Ōi River between Suruga and Tōtomi Provinces

A1351, 50.1484

1185. 27. *Ise futamigaura*, The married rocks in Futami Bay in Ise Province

A1352, 50.1485

*1186. 28. *Shinshū suwa no mizuumi*, Lake Suwa in Shinano Province

A1353, 50.1486

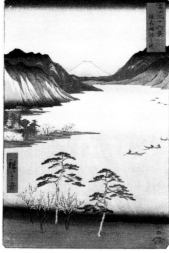

1186

1187. 29. *Shinano shiojiritōge*, Shiojiri Pass above Lake Suwa in Shinano Province

A1354, 50.1487

1188. 30. *Kai misakagoe*, Misaka Pass in Kai Province

A1355, 50.1488

1189. 31. *Kai ōtsukinohara*, Autumn flowers on the Ōtsuki Plain in Kai Province
Publication: perhaps May 1034, $3.75.

A1356, 50.1489

1190. 32. *Kai inumetōge*, The Dog's-eye Pass in Kai Province

A1357, 50.1490

1191. 33. *Shimōsa koganehara*, Ponies on Kogane Plain in Shimōsa Province

A1358, 50.1491

1192. 34. *Kazusa kuroto no ura*, Kuroto Bay in Kazusa Province

A1359, 50.1492

1193. 35. *Kazusa rokusozan*, Cryptomeria on Mt. Rokuso in Kazusa Province

A1360, 50.1493

1194. 36. *Bōshū hoda no kaigan*, The coast near Hoda in Awa Province

A1361, 50.1494

Nos. 1195-1203 are from the same series and have the same series title, publisher and format, except when noted otherwise. From a half-block series of thirty-six prints published by Sanoya Kihei.

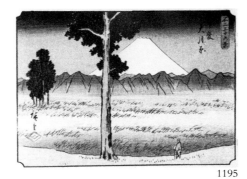

1195

*1195. *Kai ōtsukihara*, Ōtsuki Plain in Kai Province
Series: *Fuji sanjūrokkei*, Thirty-six views of Mt. Fuji
early 1850s
Signature: Hiroshige
Artist's seal: Hiro
Publisher: Sanoki
Censorship seals: Muramatsu, Fuku
chūban, 163 × 232, with variation up to 9 mm. within set
Reference: Suzuki 168, 29.

A1068, 50.1201

1196. *Tōto surugadai*, Fuji from Surugadai in the eastern capital
12/1852
Signature: Hiroshige ga
Censorship seals: Murata, Kinugasa

A1069, 50.1202

1197. *Tōto suidōbashi*, Suidō Bridge in the eastern capital
Signature: Hiroshige ga
Censorship seals: Mera, Watanabe

A1070, 50.1203

1198. *Kai yumeyama urafuji*, Fuji from behind at Mt. Yuma in Kai Province
12/1852
Artist's seal: Hiro
Censorship seals: Kinugasa, Murata

A1071, 50.1204

1199. *Hakone sanchū kosui*, Fuji from the mountain lake at Hakone
Artist's seal: Hiro
Censorship seals: trimmed
Provenance: Bunshichi Kobayashi (Hosūkaku seal on verso)

A1072, 50.1205

1200. *Suruga satta mine*, Fuji from Satta Peak in Suruga Province
Signature: Hiroshige ga
Censorship seals: trimmed
Provenance: Bunshichi Kobayashi

A1073, 50.1206

1201. *Sagami shichirigahama fūha*, Fuji between high waves from Shichiri Beach in Sagami Province
Artist's seal: Hiro
Censorship seals: Fuku, Muramatsu
Reference: Suzuki 168, 23.

A1074, 50.1206

*1202. *Sagamigawa*, Fuji from the Sagami River
Signature: Hiroshige ga
Censorship seals: Mera, Watanabe
Reference: Suzuki 168, 18.

A1075, 50.1208

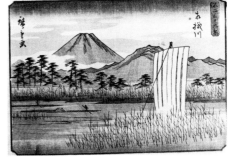

1202

(after Utagawa Hiroshige)

*1203. *Sagamigawa*, Fuji from the Sagami River
late 19th or early 20th century
Signature: Hiroshige ga

A1076, 50.1209

Keyblock proof impression without title cartouche or borderline of a modern facsimile of no. 1202.

1203

*1204abc.
Zusō hakoneyama, Full moon in the Hakone mountains between Izu and Sagami Provinces
Sōshū enoshima, The grotto at Enoshima Island in Sagami Province
Sunshū satta mine, The promontory of Satta in Suruga Province
mid 1830s
Artist's seal: Hiroshige
Censorship seal: kiwame (on center panel)
undivided triptych on ōban sheet, 264 × 375
Reference: Suzuki 169.

A1100, 50.1233

From an untitled series of six landscapes printed three to an ōban sheet with titles imitating seals before the Chinese couplet on each picture. Unpublished drawings are also known for five other landscapes in this format.

1205. Ujigawa hotarugari no zu, Catching fireflies on the Uji River
Series: Shokoku meisho, Famous places in the provinces
ca. late 1830s
Signature: Hiroshige ga
Publisher: Dansendō
fan, 238 × 292

A1101, 50.1234

From a fan seller's sample book with binding holes at right.

PLATE 53.

1206. Snow on the upper reaches of the Fuji River
ca. early 1840s
Signature: Hiroshige hitsu
Artist's seal: Ichiryūsai
Publisher: Sanoya Kihei
vertical ōban diptych, 734 × 245
Reference: Suzuki 153.

A1121, 50.1254

PLATE 47 (color).

Nos. 1207-1212 are from the same series and have the same date, signature and format.
Six prints from the first set of eight views of Lake Biwa published jointly by Takenouchi Magohachi (Hoeidō) and Yamamoto Heikichi (Eikyūdō) in the early 1830s. The series title is in a red vertical cartouche; the picture title and the canonical poem for each print are on an adjacent square panel with a wavy printed pattern in imitation of a poem sheet.

*1207. Karasaki yau, Evening rain on the Karasaki Pine

1204

Series: Ōmi hakkei, Eight views of Lake Biwa
early 1830s
Signature: Hiroshige ga
Publisher: Eikyūdō
ōban, 225 × 350, with variation up to 3 mm. within set
Reference: Suzuki 317.

A924, 50.1057

Fine, although not early impression, with the tree dark at the top and right.

1207

1208. Hira bōsetsu, Evening snow on Mt. Hira
Publisher: Eikyūdō
Reference: Suzuki 318.
Provenance: Rouart
Publication: Rouart 1922, 238.

A923, 50.1056

Early impression with the nearer mountains dark above lacking the band of grey at the foot of Mt. Hira at the left, the dotted row in the center middle distance, and before the break in the borderline at the lower left.

PLATE 48.

1209. Ishiyama shūgetsu, Autumn moon at Ishiyama
Publisher: Hoeidō
Censorship seal: kiwame
Reference: Suzuki 319.

A925, 50.1058

Good but rather late impression with the mountains at the left off-register.

PLATE 76.

1210

*1210. Awazu seiran, Haze on a clear day at Awazu
Publisher: Hoeidō han
Reference: Suzuki 321.

A928, 50.1061

1211. *Yabase kihan,* Returning sails at Yabase
Publisher: Eikyūdō han
Reference: Suzuki 323.

A927, 50.1060

1212. *Mii banshō,* Evening bell at Mii Temple
Publisher: Take
Censorship seal: kiwame
Reference: Suzuki 324.
Publication: perhaps Metzgar 691, $22.50.

A926, 50.1059

The second color version of the print. The earliest impressions are printed entirely in shades of grey.

1213. *Mii banshō,* Evening bell at Mii Temple
Series: *Ōmi hakkei,* Eight views of Lake Biwa
mid 1840s
Signature: Hiroshige ga
Publisher: Sanoya Kihei
Censorship seal: Yoshimura
quarter block, 104 × 164
Reference: Suzuki 174.

A1086, 50.1219

Nos. 1214-1221 are from the same series and have the same series title, date, signature and format.
Complete set of eight prints from a quarter-block series of pictures, each ca. 115 × 170, within fan-shaped borders and title written in formal script, each with the canonical poem. The pictures have green or pink color added by hand along the edges, perhaps from earlier mounting. The publisher's mark appears only on two prints, Yabase and Awazu, showing that the pictures were printed on two *ōban* sheets.

1214. *Karasaki yau,* Night rain at the Karasaki Pine
Series: *Ōmi hakkei,* Eight views of Lake Biwa
ca. early 1830s
Signature: Hiroshige ga
Artist's seal: Utagawa
with pink edge
Reference: Suzuki 173.

A1093, 50.1226

PLATE 77.

1215. *Awazu seiran,* Haze on a clear day at Awazu
Artist's seal: Hiro
Publisher: Shimizu
Censorship seal: kiwame
with green edge

A1094A, 50.1227A

PLATE 81.

1216. *Hira bōsetsu,* Evening snow on Mt. Hira
with green edge

A1099, 50.1232

PLATE 84.

Probable arrangement of sheet with green edges.

Hira	Awazu
Mii	Ishiyama

Probable arrangement of sheet with pink edges.

Katata	Yabase
Seta	
Karasaki	

1217. *Ishiyama shūgetsu,* Autumn moon at Ishiyama
with green edge

A1098, 50.1231

PLATE 82.

1218. *Mii banshō,* Evening bell at Mii Temple
Artist's seal: Yūsai
with green edge

A1095, 50.1228

PLATE 83.

1219. *Yabase kihan,* Returning sails at Yabase
Artist's seal: Yūsai
Publisher: Shimizu
Censorship seal: kiwame
with pink edge

A1097, 50.1230

PLATE 80.

1220. *Katata rakugan,* Descending geese at Katata
Artist's seal: Hiro
with pink edge

A1096, 50.1229

PLATE 78.

1221. *Seta sekishō,* Evening glow at Seta
with pink edge

A1094, 50.1227

PLATE 79.

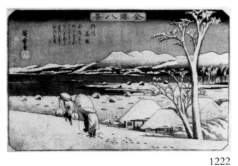

1222

*1222. *Uchikawa bōsetsu,* Evening snow by the Uchi River
Series: *Kanazawa hakkei,* Eight views of Kanazawa
ca. 1835–1836

Signature: Hiroshige ga
Artist's seal: Ichiryūsai
Publisher: Shiba Echihei
Censorship seal: kiwame
ōban, 225 × 353
Reference: Suzuki 431.
Publication: probably May, 929, $40.

A929, 50.1062

1223. *Nojima sekishō,* Evening glow at Nojima
Series: *Kanazawa hakkei,* Eight views of Kanazawa
Signature: Hiroshige ga
Artist's seal: Ichiryūsai
Publisher: trimmed
Censorship seal: trimmed
224 × 355
Reference: Suzuki 436.

A930, 50.1063

Two prints from the set of eight published by Echimuraya Heisuke (Echihei). Each print contains a classical poem. The publisher's mark and censorship seal are in the right margin.

Nos. 1224-1231 are from the same series and have the same series title, signature, format and size, except where noted otherwise.
The complete set of eight, with double vertical title cartouches and *kyōka* poems within the picture area, printed on two *ōban* sheets.

1224. *Ottomo kihan,* Returning sails at Ottomo
Series: *Kanazawa hakkei,* Eight views of Kanazawa
ca. 1840
Signature: Hiroshige ga
quarter block, 110 × 169, with variation up to 11 mm. within set
Reference: Suzuki 174, 1.

A1083, 50.1215

Poem by Kakei.

1225. *Susaki seiran,* Haze on a clear day at Susaki

A1081, 50.1214

Poem by Shimajo.

1226. *Shōmyō banshō,* Evening bell at Shōmyō Temple

A1080, 50.1213

Poem by Hekikai.

1227. *Nojima sekishō,* Evening glow at Nojima

A1077, 50.1210

Poem by Shūtō.

1228. *Hirakata rakugan,* Descending geese at Hirakata

A1078, 50.1211

Poem by Kikujo.

1229. *Seto shūgetsu,* Autumn moon at Seto

A1079, 50.1212

Poem by Chiyojo.

1230. *Uchikawa bōsetsu,* Evening snow at Uchikawa

A1084, 50.1217

Poem by Kazen.

1231. *Koizumi yau,* Night rain at Koizumi

A1082, 50.1215

Poem by Keisha.

Nos. 1232-1237 are from the same series and have the same date, signature, publisher, censorship seal and format.
The complete set of six with the series title in a red cartouche above the publisher's mark and censorship seal in the right margin. The names of the river and province are given within the picture, followed by the canonical classical poem on that Tama River. The set is fine and uniform. Five of the prints were bound together at one time.

*1232. The poet Toshiyori viewing bush clover and the autumn moon at the Noji Tama River in Ōmi Province
Series: *Shokoku mutamagawa,* The Six Tama Rivers in the provinces
ca. 1835-1836
Signature: Hiroshige ga
Artist's seal: Utagawa
Publisher: Tsutaya Jūzaburō
Censorship seal: kiwame
ōban, 223 × 345, with variation up to 2 mm. within set
Reference: Suzuki 176, 1.

A918, 50.1051

Poem by Toshiyori.

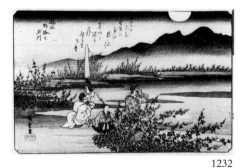

1232

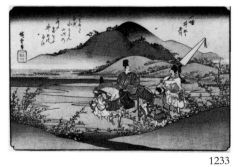

1233

*1233. The poet Shunzei stopping his horse in the ford to admire the yellow *yamabuki* flowering at the Ide Tama River in Yamashiro Province

Artist's seal: Ichiryūsai

A919, 50.1052

Poem by Fujiwara no Shunzei.

*1234. Travelling priests beside the Kōya Tama River in Kii Province
Artist's seal: Ichiryūsai
white spattered on the water in the river
Provenance: Spaulding

A921, 50.1054

Poem by Kōbō Daishi, the founder of the temple at Mt. Kōya.

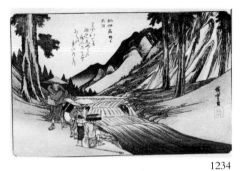

1234

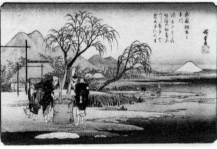

1235

*1235. Women pounding cloth beside the Chōfu Tama River in Musashi Province
Artist's seal: Ichiryūsai

A920, 50.1053

Poem by Fujiwara no Teika.

*1236. Women fulling cloth beside the Tōi Tama River in Settsu Province
Artist's seal: Yūsai

A917, 50.1050

Poem by Sagami.

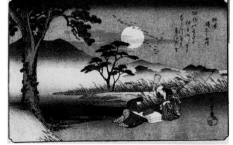

1236

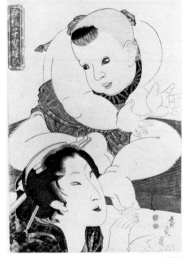

1237

*1237. Travellers watching plovers at the Noda Tama River in Michinoku
Artist's seal: Ichiryūsai

A922, 50.1055

Poem by the priest Nōin.

1238. Temple page on bridge by waterfall. The Kōya Tama River in Kii Province
Series: *Mutamagawa no uchi,* The six Tama Rivers
ca. early 1830s
Signature: Hiroshige ga
medium panel, 378 × 129
Reference: Suzuki 176.

A999, 50.1132

From a set of six panel prints with canonical poems originally published by Kawaguchi Shōzō and apparently reissued by Fujiokaya Hikotarō. This impression bears the mark of neither publisher.

1239

*1239. Woman and child clapping hands
Series: *Imayō kodakara asobi,* Modern children's games
ca. 1820
Signature: Hiroshige ga
Publisher: Iwatoya Kisaburō
Censorship seal: kiwame
ōban, 363 × 251
Reference: Suzuki 178 (series).
Provenance: Happer (?)

A1105, 50.1238

Possibly unrecorded. Suzuki lists four subjects in this early series, and one of his brief descriptions may correspond to this picture. The set is a continuation of a set by Utamaro II, *Shichihenge kodakara asobi,* also published by Iwatoya, ca. 1810, one subject of which is reproduced in TNM 2055.

Nos. 1240-1255 are from the same series and have the same date, signature, publisher and format.
The complete set of 16 prints, the first of Hiroshige's nine sets of illustrations of scenes in the play *Kanadehon chūshingura,* published by Izumiya Ichibei. The play has eleven acts, but Hiroshige includes pictures of six separate episodes in the final act. The set has decorative printed borders with the circular emblem of the chamberlain Yuranosuke. The set is exhaustively described in Stewart 250-55.

1240. Act 1. Lady Kaoyo approaches Ashikaga Tadayoshi
Series: *Chūshingura*
mid 1830s
Signature: Hiroshige ga
Publisher: Edo Shiba Senichi han
ōban, 231 × 355, with variation up to 5 mm. within set
Reference: Suzuki 183.
A934, 50.1067

1241. Act 2. Tonase watches Rikiya and Konami as Honzō and Wakasanosuke meet in the background
A935, 50.1068

1242. Act 3. Honzō presents gifts for Moronao
A936, 50.1069

1243. Act 4. Riki Rikiya watches Konami arrange flowers as Ono Kudayū approaches in the corridor
A937, 50.1070

*1244. Act 5. Sadakurō robs Yoichibei
A938, 50.1071

1244

1245. Act 6. Hunters grieving over Yoichibei's death as Kampei receives Yagorō and Goemon
A939, 50.1072

1246. Act 7. Yuranosuke feigns drunkenness at the Ichiriki Teahouse in Kyōto
A940, 50.1073

1247. Act 8. Tonase and Konami journey to find Rikiya
A941, 50.1074

1248. Act 9. Honzō commits suicide, and Yuranosuke sets off to complete his vengeance
A942, 50.1075

1249. Act 10. The *rōnin* disguised as police visit Amagawaya Gihei to test his loyalty
A943, 50.1076

1250. Act 11, no. 1. Preparations for the night attack
A944, 50.1077

1251. Act 11, no. 2. Breaking into Moronao's mansion during the night attack
A945, 50.1078

1252. Act 11, no. 3. The capture of Moronao during the night attack
A946, 50.1079

1253. Act 11, no. 4. The *rōnin* are halted on their way to Sengaku Temple by retainers of the lord of Sendai
A947, 50.1080

1254. Act 11, no. 5. The *rōnin* are forbidden to cross Ryōgoku Bridge on their way to Sengakuji Temple
A948, 50.1081

1255. Act 11, no. 6. The *rōnin* enter the precincts of Sengaku Temple to burn incense to their former lord
A949, 50.1082

Nos. 1256-1267 are from the same series and have the same series title, publisher, format, and censorship seal, except where noted otherwise.
The complete set of twelve prints, published by Aritaya Seiemon at Shimmeimae in Shiba.
The second of Hiroshige's nine sets of illustrations for the drama *Chūshingura.*
The printed borders on this set have the circular emblem of the chamberlain Yuranosuke against a background of bamboo.

1256. Act 1. Wakasanosuke confronts Moronao before the entrance to the Hachiman Shrine in Kamakura
Series: *Chūshingura*
mid 1840s
Publisher: Aritaya, Shiba Shin
Censorship seal: Mura
ōban, 225 × 348, with variation no more than 2 mm. within set
Reference: Suzuki 183.
A950, 50.1083

1257. Act 2. Konami brings tea to Rikiya as Honzō cuts the branch of a pine in front of Wakasanosuke
A951, 50.1084

1258. Act 3. Kampei chases a group of ruffians away from Okaru before the Shōgun's palace
A953, 50.1086

1259. Act 4. Yuranosuke swears revenge outside his master's mansion in Edo
A954, 50.1087

1259A. Act 4. Yuranosuke swears revenge
. . .
A954A, 50.1087A
A duplicate impression.

*1260. Act 5. Sadakurō counts the stolen gold
A955, 50.1088

1260

1261. Act 6. Kampei returns home as Okaru is leaving for Kyōto
A956, 50.1089

1262. Act 7. Yuranosuke plays the fool at the Ichiriki teahouse in Kyōto
A957, 50.1090

1263. Act 8. Tonase and Konami pass Mt. Fuji on their way to find Rikiya
A958, 50.1091

1264. Act 9. Honzō prepares to commit suicide to atone for his complicity in Enya's death
A959, 50.1092

1265. Act 10. One of the *rōnin* prepares to seize Osono, Gihei's temporarily estranged wife, and cut off her hair
A960, 50.1093

1266. Act 11. The night attack on Moronao's mansion
A961, 50.1095

1267. Act 11, no. 2. The *rōnin* remeet at the harbor at Takanawa to make their way toward Sengaku Temple
A952, 50.1085
The rendezvous is described in the square cartouche beside the series title.

Nos. 1268-1270 are from the same series and have the same signature, publisher, censorship seal and format.

1268. 1. *Sanshi o tomonaite tokiwa gozen hyōrōsu,* Tokiwa Gozen flees with her three children in the snow
Series: *Yoshitsune ichidai zue,* A pictorial biography of Yoshitsune
ca. 1834–1835
Signature: Hiroshige ga
Publisher: Senkakudō
Censorship seal: kiwame
ōban, 230 × 342, with variation up to 8 mm. within set.
Reference: Suzuki 185, 1.

A931, 50.1064

Plate 1 from the set of 16 published by Tsuruya Kiemon (Senkakudō), only ten of which are presently known.

1269

*1269. 6. *Ise no saburō ga kakurega ni yadorite ushiwakamaru shujū no keiyakusu,* Ise no Saburō visits Ushiwakamaru in hiding and swears his fealty

A932, 50.1065

1270. 7. *Ushiwakamaru hisoka ni kiichi hōgen ga hisho o miru,* Ushiwakamaru reads Kiichi Hōgen's secret scrolls
Provenance: Happer (?)

A933, 50.1066

1271

*1271. *Gojō no hashi senningiri,* Benkei attacking Ushiwakamaru at Gojō Bridge to obtain his thousandth sword
Series: *Ushiwaka zue,* Pictures of the young Yoshitsune
ca. 1850
Signature: Hiroshige ga
Publisher: Ibaya Senzaburō

Censorship seals: Magomi, Hama
fan, 223 × 291

A1102, 50.1235

From a fan seller's sample book with binding holes at right.

1272. Eggplants
ca. 1850s
Artist's seal: Ichiryūsai
Publisher: Unidentified
173 × 257
with lacquer on eggplants
Unrecorded
Provenance: Rouart

A1102A, 50.1235A

An unusual subject, format and technique. The picture may have been published as a fan print.

1273. 7. Hakoomaru leaves the temple
Series: *Soga monogatari zue,* Illustrations for the Tale of the Soga Brothers
mid 1840s
Signature: Hiroshige ga
Publisher: Ibaya Senzaburō
Censorship seal: Muramatsu
ōban, 342 × 229
Reference: Suzuki 187, 7.

A1091, 50.1224

From a series of 30 pictures with accompanying text by Ryūkatei Tanekazu, 28 of which are presently known.

Nos. 1274-1275 are from the same series and have the same series title, date, signature, publisher, censorship seals, format and approximate size.
Designed in imitation of a classical painted hand scroll, with quotations from Lady Murasaki's novel.
Only the first five pictures of the series are presently known.

1274. Court couple; illustration to *Hahakigi,* Chapter 2
Series: *Genji monogatari gojūyonchō,* The fifty-four chapters of the *Tale of Genji*
Intercalary 2/1852
Signature: Hiroshige ga
Publisher: Iseya Kenkichi, Akasaka
Censorship seals: Fuku, Muramatsu
ōban, 213 × 348
Reference: Suzuki 187, 2.

A1089, 50.1222

1275

*1275. Prince Genji sees young Murasaki; illustration for *Wakamurasaki,* Chapter 5
Reference: Suzuki 187, 5.

A1090, 50.1023

1276abc. *Sumidagawa yuki no zu,* Snow on the Sumida River
Series: *Edo meisho shiki no nagame,* Views of the four seasons at famous places in Edo
ca. 1850
Signature: Hiroshige ga
Publisher: Maruya Jimpachi
Censorship seals: Yoshimura, Muramatsu
ōban triptych, 360 × 749
Reference: UTK 2, 58–60.

A1114, 1119, 50.1252, 1257

The winter triptych from series of four seasons.

*1277abc. *Tsukuda no kihan,* Returning sails at Tsukuda Island
Series: *Meisho edo hakkei,* Eight views of famous places in Edo
mid 1840s
Signature: Hiroshige ga
Publisher: Jōshūya Kinzō
Censorship seal: Muramatsu
chūban triptych, 255 × 552
Reference: Suzuki 181.

A1116, 50.1249

Only six of the eight subjects in the set are presently known. The poem in the cartouche is by Sochō; the banners in the background are for the Sumiyoshi festival on Tsukuda Island.

1278. Women crossing the Ōi River
ca. mid 1830s
Signature: Hiroshige ga
Publisher: Sanoki, Kikakudō han
Censorship seal: kiwame
ōban, 263 × 382

A1118, 50.1251

Panel of horizontal triptych.

1279. *Ōtsue no bonodori,* Figures from Ōtsu folk paintings performing a religious dance
ca. 1850
Signature: Hiroshige gihitsu
Publisher: Maruya Jimpachi (emblem, Shiba Shin)
Censorship seals: Fuku, Muramatsu
ōban, 253 × 365
Reference: TNM 3191.

A1120, 50.1253

Second state of a fan print, published in horizontal ōban format with background of blue and grey clouds.

1280ab. *Ōjidō kitsune no yomeiri,* A fox wedding procession on the road to Ōji
ca. 1840s
Signature: Hiroshige gihitsu
Publisher: Tsutaya Kichizō

1277

1282

1284

1285

two right panels of an ōban triptych,
370 × 500

AIII5, 50.1248

1281. Turtle swimming in water weeds
ca. 1830s
Signature: Hiroshige hitsu
Publisher: Maruya Seibei
Censorship seal: kiwame
chūban, 227 × 173
printed in grey with traces of added
color on upper and lower edges

AIII3, 50.1246

The Chinese descriptive title, which seems
to read "Green water and green old im-
mortal" must refer to the turtle.

*1282. Otafuku and Fukusuke kneeling be-
fore a hanging scroll of Mt. Fuji
3/1858
Signature: Hiroshige hitsu
Publisher: Yamadaya
ōban, 371 × 252
Reference: Apparently unrecorded
Provenance: Unidentified Japanese
collector's seal on verso

AII06, 50.1238

The printed inscription is a list of the ages
of people born in the earth and water signs
who will enter a period of good fortune on
the 8th day of the 5th month.

1283. Shōki, the demon queller
ca. 1850
Signature: Hiroshige hitsu
Artist's seal: Ichiryūsai
Censorship seals: Murata, Mera
large panel, 375 × 172

AII07, 50.1240

PLATE 116.

*1284. Clams, fish, tongue-cut sparrow,
female Bodhidharma and view of
Arashiyama in Kyōto
Untitled series of harimaze, or as-
semblage prints
7/1858
Signature: Hiroshige, Tōkai, Ichi-
ryūsai
Artist's seals: Hiro, Ichiryūsai
Publisher: Moriya Jihei
aiban, 227 × 338

AII08, 50.1241

*1285. Badger, tea kettle, Mt. Fuji
Untitled series of harimaze, or as-
semblage prints, in imitation of stone
rubbings
ca. 1850s
Signature: Ichi
Artist's seals: Ichiryūsai, Andō, Hi-
roshige
aiban, 344 × 231
engraved in reserve

AII09, 50.1242

1286. Cuckoo and woman with iron
cauldron on head
1830s
Signature: Hiroshige hitsu
Publisher: Yamamoto
⅓ block, 255 × 125
Reference: TNM 3167.

AIII0, 50.1243

Traces of adjacent prints at left and right.
Poem by Toshigaki Maharu.

1287. Goyu kyūseki yamamoto kansuki kokyō,
The remains of the former dwelling
of Yamamoto Kanouke at Goyu
late 19th century
Signature: Hiroshige
Artist's seal: Ichiryūsai
Publisher: Kobayashi Bunshichi
(with plover numbered 4)
small, 173 × 112
Reference: Suzuki 169.

AIIII, 50.1244

Copy of a section of one sheet of an 18-
print assemblage series of views of Japan.

1288. Asazuma dancer in boat beneath
willow
ca. 1840s
Signature: Hiroshige ga
Artist's seal: Hiro
narrow panel, 330 × 78

AIII2, 50.1245

Trace of adjacent print at right.

1289. Peacock and peonies
1830s
Signature: Hiroshige hitsu
Artist's seal: Ichiryūsai
Publisher: Jakurindō
Censorship seal: kiwame
large panel, 383 × 178
embossing and areas without out-
line
Reference: TNM 3487; Ledoux 41;
V and I 6, 243; Blanchard (cover);
Matsuki 301.

AI000, 50.1133

The inscription in formal Chinese script says that the peony is the fragrance of wealth and nobility. It is signed Yūsai, one of the artist's secondary names.

There are two accepted states or versions of this print. The first with the mark of censorship, the seal of the publisher Jakurindō and the seal Ichiryūsai after the artist's signature, is reproduced in Ledoux, *Hokusai and Hiroshige,* 41 and V and I 6, 243. The second, without the seals and with entirely new color blocks, is reproduced on the cover of the Blanchard sale catalogue, 1916. The colors of the Ainsworth impression match the patterns of the Blanchard print, but close comparison shows that they are printed from yet a different set of blocks and there also seem to be unacceptable differences on the keyblock, particularly on the lower right character in the inscription. The seals on the Ainsworth impression are obviously a modern addition, and since the keyblock seems identical with the Ledoux print, except for the extension of the edge of the rock at the center bottom, it may represent a second state of the original version. The Blanchard print would then be a second version, possibly contemporary, since the color blocks seem to be engraved with more care and sensitivity than those of the Ainsworth print. What seems to be another impression of the Ainsworth print is reproduced in the Matsuki catalogue, no. 301.

1290. Sparrows and winter-flowering camellia in snow
1830s
Signature: Hiroshige hitsu
Artist's seal: Utagawa
Publisher: Sanoki
large panel, 385 × 178
embossing and areas without outline

A1001, 50.1134

Second state with the mark of the publisher Jakurindō removed, lacking the overprinted color at the bottom of the print.
The Chinese poem above says:
Crows and kites contend for food, sparrows squabble for nests.
Alone I stand by the pool in the wind and snow at evening.
Impressions of the first state are reproduced in Hillier, *Vever* 863; Suzuki 181; and UZ 4, pl. 15 in color.

(after Utagawa Hiroshige)

1291. Swallows, peach blossoms and full moon
late 19th century (?)
Signature: Hiroshige hitsu
Artist's seal: Ichiryūsai
large panel, 371 × 171

with embossing and areas without outline
Reference: TNM 3489; Vever 861; Ledoux 42.

A1002, 50.1135

The poem, a Chinese couplet, is sealed by Hiroshige's relative, the priest Ryōshin. A flowery paraphrase is included in Ledoux 42 where an impression of the second state of the original print is reproduced.
Impressions of the first state are reproduced in Hillier, *Vever* 861, and elsewhere.
Many contemporary copies of bird-and-flowers were produced in the mid-19th century, but the engraving, printing, and paper of this print seem later.

1292. Bunting on branch of cherry blossoms
1830s
Signature: Hiroshige ga
Artist's seal: Ichiryūsai
large panel, 382 × 170
with embossing and areas without outline
Reference: UT 12, 129.
Provenance: Jacquin (?)
Publication: Jacquin 541, $75(?).

A1003, 50.1136

First state with the seal of the calligrapher Ryōshin after the Chinese couplet upper left. Impressions of the second state without the seal are reproduced in TMC 3492 and Hillier, *Vever* 860. The collector purchased an impression of this print in the Jacquin sale, but this impression is not mounted on *velin* paper like the other Jacquin prints and may have been a later purchase.

PLATE 60.

1293. Copper pheasant among pine shoots on hillside in snow
1830s
Signature: Hiroshige hitsu
large panel, 373 × 159

A1004, 50.1137

Second state with new color blocks, the mark of the publisher Jakurindō and the censorship seal removed, and snow in the sky. In the first state, reproduced in Hillier, *Vever* 862, there is no snow and the pheasant is perched on a steep green hillside.

*1294. *Hagoshi no tsuki,* Moon through the leaves
Series: *Tsuki nijūhakkei no uchi,* 28 views of the moon
1830s
Signature: Hiroshige hitsu
Publisher: Jakurindō
Censorship seal: kiwame
large panel, 385 × 173
Reference: Suzuki 97; UT 12, 129.

A1064, 50.1197

First state of the print with the mark of the publisher Jakurindō. Chinese couplet.

1294

1295. Dragon in clouds
1830s
Signature: Hiroshige hitsu
Artist's seal: Ichiryūsai
Censorship seal: kiwame
large panel, 372 × 172
spattered color

A1065, 50.1198

PLATE 66.

1296. Pheasant on rock amid chrysanthemums
1830s
Signature: Hiroshige hitsu
Publisher: Sanoki han
large panel, 375 × 167
yellow ground
Reference: TNM 3490 (1st state).
Provenance: Hayashi

A1005, 50.1138

Second state with the mark of Jakurindō, the original publisher and the censorship seal removed from the end of the 17-syllable verse on the fragrance of chrysanthemums.

1297. White heron flying over irises
1830s
Signature: Hiroshige hitsu
Artist's seal: Hiroshige
large panel, 376 × 171
with embossing, areas without outline, and blue ground
Reference: TNM 3491; V and I 6, 246; Suzuki 183 (copy).

A1006, 50.1139

Second state with veins on the petals of the iris; early impressions have more shading and over-printing on the background.
The Chinese couplet about the white heron is in the calligraphy of Hiroshige's relative Ryōshin.

1298. Parrot on flowering crabapple tree
1830s
Signature: Hiroshige hitsu
Publisher: Jakurindō han

Censorship seal: kiwame
large panel, 382 × 173
areas without outline
Reference: UT 12, 127; TNM 3494.

A1007, 50.1140

An impression in the Tokyo National Museum has the mark of the publisher Sanoki and may have different color blocks.

1299. Crane, waves, and rising sun
1830s
Signature: Hiroshige hitsu
Publisher: Jakurindō
Censorship seal: kiwame
large panel, 388 × 178
with embossing and areas printed without outline
Reference: May 1918, 1132; Matsuki 300.

A1008, 50.1141

Possibly a copy; there seem to be differences, at any rate, on the blue color blocks of this impression and that reproduced in the catalogue of the May collection 1918, 1132. The water on the Matsuki impression seems very similar to the Ainsworth print.

*1300. Titmouse on camellia branch
1830s
Signature: Hiroshige hitsu
Artist's seal: Ichiryūsai
Publisher: Wakasaya
Censorship seal: kiwame
large panel, 372 × 177
Reference: TNM 3488 (2nd state);
Vever 871 (2nd state).
Provenance: Wakai

A1009, 50.1142

First state of the print with the publisher's mark and the printed outline around the edge of the flowers. The second state lacks the publisher's mark and the outline of the flowers is removed. The poem about camellias is sealed Kojin, 'the deceased,' or Furubito.

1300

1301. Bird in loquat tree
1830s
Signature: Hiroshige hitsu
Artist's seal: Ichiryūsai
Publisher: Jakurindō
Censorship seal: kiwame
large panel, 385 × 174
Reference: Genthe 79 (Jakurindō);
Dooman 219 (Sanoki); Crighton IV, 10 (Sanoki).

A1010, 50.1143

The seal before the Chinese couplet in seal script seems to read Ōatari, "great success." The picture is designed and printed in imitation of a Chinese stone-rubbing, with the picture engraved in reserve. A fine impression of another, seemingly earlier, state has a seal reading Kikakudō han after the artist's signature, and a seal reading Sanoya after the mark of censorship.

1302. Long-tailed blue bird and azaleas
1830s
Signature: Hiroshige hitsu
Publisher: Fujihiko
medium panel, 375 × 129

A1011, 50.1144

The poem speaks of azaleas on the mountain in the evening. Another impression with the seal Ichiryūsai instead of the seal of the publisher after Hiroshige's signature is reproduced in Rouart 1922, 695. The Rouart impression seems later, lacking the final flourish on the last character in the poem, but seems to have an additional grey leaf above the foliage at the right which was not inked on the Ainsworth impression.
PLATE 52 (color).

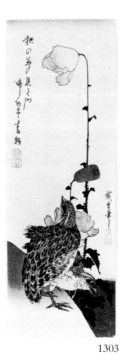

1303

*1303. Quail and poppies
1830s
Signature: Hiroshige ga
Artist's seal: Ichiryūsai
Publisher: Kawashō
Censorship seal: kiwame
medium panel, 375 × 126

A1012, 50.1345

The poet asks if the quail are seeing a dream of autumn.

1304. Pheasant on snowy pine branch
1830s
Signature: Hiroshige hitsu
Artist's seal: Ichiryūsai
Publisher: Kawashō
Censorship seal: kiwame
medium panel, 375 × 128
grey ground

A1013, 50.1146

An earlier impression with fewer breaks on the keyblock and grey shading on the tree trunks is reproduced in Suzuki 185.
An earlier impression also lacking grey shading is in Hillier, Vever 916.
The Chinese couplet in formal script is about snow.

1305. Cuckoo flying in rain
1830s
Signature: Hiroshige hitsu
Publisher: Shōeidō
Censorship seal: kiwame
medium panel, 371 × 127
Provenance: Metzgar

A1014, 50.1147

Signs of adjacent panel at left.

1306. Copper pheasant among bracken and pine shoots
1830s
Signature: Hiroshige hitsu
Artist's seal: Ichiryūsai
medium panel, 373 × 128

A1015, 50.1148

17-syllable poem about bracken.

1307. Small green birds and hydrangeas
1830s
Signature: Hiroshige hitsu
Publisher: Kawashō
Censorship seal: kiwame
medium panel, 374 × 128
embossing and pink ground

A1016, 50.1149

17-syllable poem about hydrangeas.
PLATE 50 (color).

1308. Bush warbler and wild chrysanthemums
1830s
Signature: Hiroshige hitsu
Artist's seal: Ichiryūsai
Publisher: Kawashō
medium panel, 374 × 127

A1017, 50.1150

31-syllable poem on the taihō, an imaginary bird.

*1309. Swallow on tendril of wisteria
1830s
Signature: Hiroshige hitsu
Publisher: Shōeidō
Censorship seal: kiwame
medium panel, 384 × 130
with embossing, areas without out-
line, and blue ground

A1018, 50.1151

An impression lacking the pink shading at
the top is reproduced in Hillier, *Vever* 914.
Another impression is reproduced in TMC
3511. 31-syllable poem by Hajintei on the
subject of wisteria.

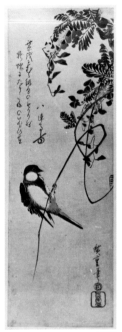

1309

1310. Yellow bird on mallow bush beside
a stream
1830s
Signature: Hiroshige hitsu
Artist's seal: Ichiryūsai
medium panel, 375 × 132
with embossing and blue ground

A1019, 50.1152

Other, similar impressions, are reproduced
in Suzuki 184, Hillier, *Vever* 906, and TMC
3524.

1311. Ducks in stream with reeds
1830s
Signature: Hiroshige hitsu
Artist's seal: Yūsai
Publisher: Kawashō
medium panel, 376 × 130
Reference: TNM 3521.
Provenance: Metzgar

A1020, 50.1153

1312. Sparrow and bamboo
1830s

Signature: Hiroshige hitsu; jussai
Tonarime
Artist's seal: Hiroshige
Publisher: Shōeidō
Censorship seal: kiwame
medium panel, 375 × 126
with embossing and areas without
outline

A1021, 50.1154

Poem by Hajintei. Hiroshige drew the bam-
boo.
The sparrow was drawn by Tonarime, "a
neighbor's girl," age 9 (or 10 in the Japanese
method of counting).
PLATE 61.

1313. Yellow bird and clematis
ca. 1830s
Signature: Hiroshige hitsu
Publisher: Kawashō
medium panel, 348 × 116

A1022, 50.1155

The engraving of the keyblock is harsh and
the form of the publisher's mark is unusual.
This may be a contemporary copy.
Printed mark at upper right to indicate
where picture should be cut from adjacent
panel.
Chinese couplet on clematis.

1314. Mandarin duck on snowy bank
1830s
Signature: Hiroshige hitsu
medium panel, 345 × 114

A1023, 50.1156

Trace of adjacent print at lower right.
An earlier impression with the seal Ichir-
yūsai after the artist's name, is reproduced
in Hillier, *Vever* 912.

1315. Cock and hydrangeas
1830s
Signature: Hiroshige hitsu
Publisher: Kawashō
medium panel, 344 × 114
Reference: TNM 3499.

A1024, 50.1157

17-syllable poem on hydrangeas.

*1316. Magpie and roses by stream
1830s
Signature: Hiroshige hitsu
Publisher: Kawashō
medium panel, 383 × 113
Reference: TNM 3499.

A1025, 50.1158

The Tokyo National Museum impression
lacks the blue behind the bird.

1317. Two swallows and iris
1830s
Signature: Hiroshige hitsu
Publisher: Kawashō
medium panel, 343 × 112
Reference: TNM 3503.

A1026, 50.1159

17-syllable poem on swallows.

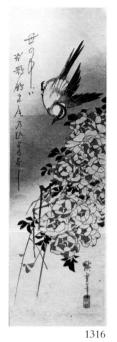

1316

1318. Bird on flowering cherry branch
1830s
Signature: Hiroshige hitsu
Publisher: Kawashō
medium panel, 335 × 109
Reference: TNM 3532.

A1027, 50.1160

17-syllable poem on wild cherry.

1319. Parrot on pine branch
1830s
Signature: Hiroshige hitsu
medium panel, 337 × 114

A1032, 50.1165

Chinese couplet.

1320. Swallows and wisteria
1830s
Signature: Hiroshige hitsu
Artist's seal: Ichiryūsai
medium panel, 335 × 115

A1033, 50.1166

17-syllable poem on swallows.

1321. Sparrow and bamboo
1830s
Signature: Hiroshige hitsu
Publisher: Kawashō
Censorship seal: kiwame
medium panel, 338 × 112

A1034, 50.1167

17-syllable poem on baby sparrow and
bamboo.

1322. Yellow bird and roses
1830s
Signature: Hiroshige hitsu
medium panel, 346 × 113

A1037, 50.1170

Perhaps a contemporary copy.
17-syllable poem.

1323. Magpie with mallow flowers
1830s
Signature: Hiroshige hitsu
Artist's seal: Ichisai
medium panel, 331 × 115
A1040, 50.1173
17-syllable poem on mallows.

1324. Copper pheasant flying in bamboo
1830s
Signature: Hiroshige hitsu
Publisher: Shōeidō
medium panel, 339 × 114
A1043, 50.1176
The Chinese characters read "Clear wind in the bamboo grove."

1325. Rabbits by stream in full moon
ca. late 1830s
Signature: Hiroshige ga
Publisher: Fujihiko
Censorship seal: kiwame
medium panel, 379 × 126
Reference: TNM 3528; UTK 11, 8 (color).
A1066, 50.1199
Traces of adjacent print at left.
Poem by Kawanoya Yukihisa.
The impression in the Tokyo National Museum is printed entirely in grey, except for the rabbits' eyes and seals, with much darker shading in the background and around the moon.
PLATE 51 (color).

1326. Deer by waterfall
ca. late 1830s
Signature: Hiroshige ga
Publisher: Shōgendō
medium panel, 372 × 129
Reference: Suzuki 187.
Provenance: Metzgar
A1067, 50.1200
31-syllable poem by Seifū.

1327. Bird and mallow flowers
ca. 1842
Signature: Hiroshige hitsu
Artist's seal: Ichiryūsai
Publisher: Sanoya Kihei (?)
Censorship seal: Taka
medium panel, 344 × 112
Reference: TNM 3508.
A1031, 50.1164

1328. Pair of plovers, waves and full moon
ca. 1842
Signature: Hiroshige hitsu
Artist's seal: Ichiryūsai
Publisher: Sanoya Kihei (?)
Censorship seal: Taka
medium panel, 345 × 113
A1035, 50.1168
Traces of an impression of 1329 at lower right.
17-syllable poem on plovers and moon.
An earlier version of the print with no moon and the birds closer to the waves is reproduced in Rouart 1922, 925.

1329. Mandarin duck and winter blooming camellias
ca. 1842
Signature: Hiroshige hitsu
Artist's seal: Utagawa
Publisher: Sanoya Kihei (?)
medium panel, 341 × 115
Provenance: Blanchard
Publication: Blanchard 1916, 544, $12.50.
A1041, 50.1174
17-syllable poem on mandarin ducks. Originally printed with an impression of 1328.

1330. Chrysanthemums
mid 1840s
Signature: Hiroshige hitsu
Censorship seal: Mera
medium panel, 327 × 103
A1030, 50.1163
17-syllable poem on chrysanthemums by Shōrin.

1331. Bird on flowering begonia
mid 1840s
Signature: Hiroshige hitsu
Artist's seal: Yūsai
Censorship seal: Tanaka
medium panel, 334 × 114
Provenance: Metzgar
A1036, 50.1169
17-syllable poem on begonia by Isō. Poet's seal effaced.

1332. Copper pheasant and mallow
3/1853
Signature: Hiroshige hitsu
Artist's seal: Hiro
Censorship seals: Mera, Watanabe
medium panel, 337 × 110
A1029, 50.1162
17-syllable poem. See 1333.

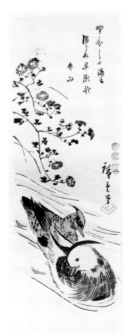
1333

*1333. Mandarin ducks swimming by wild chrysanthemums
3/1853
Signature: Hiroshige hitsu
Artist's seal: Hiro
Censorship seals: Mera, Watanabe
medium panel, 345 × 113
Provenance: Blanchard
Publication: Blanchard 1916, 554, $17.50.
A1038, 50.1171
Poem by Chikuzan. Originally printed on same sheet with 1334.

1334. Bird on cherry branch
3/1853
Signature: Hiroshige hitsu
Censorship seal: Mera, Watanabe
medium panel, 342 × 111
yellow ground
A1039, 50.1172
Poem by Chikuzan and trace of another impression of 1333 at left.

1335. Crane and pines by stream
2/1854
Signature: Hiroshige hitsu
Artist's seal: Ichiryūsai
Publisher: Tsutaya Kichizō
Censorship seal: aratame
medium panel, 344 × 110
A1028, 50.1161

1336. Sparrows and winter-blooming camellias in snow
2/1854
Signature: Hiroshige hitsu
Artist's seal: Ichiryūsai
Publisher: Tsutaya Kichizō
Censorship seal: aratame
medium panel, 341 × 116
A1042, 50.1175
Traces of adjacent print at right.

1337. Cuckoo, cherry petals, and full moon
1830s
Signature: Hiroshige hitsu
Artist's seal: Tōkaidō
narrow panel, 342 × 75
A1046, 50.1179
17-syllable poem on the cuckoo.

1338. Swallows and cherry blossoms
1830s
Signature: Hiroshige hitsu
Artist's seal: Ichiryūsai
panel from assemblage sheet, 315 × 93
yellow ground
A1047, 50.1180

1339. Bird on flowering branch
1830s

Signature: Hiroshige hitsu
Artist's seal: Hiro
narrow panel, 340 × 74
printed in grey
A1049, 50.1186

1340. Poppies in breeze
1830s
Signature: Hiroshige hitsu
narrow panel, 340 × 74
printed in grey

AI050, 50.1183

Poem on poppies by Yūzan.
Printed cutting mark at right.

1341. Bird on wisteria
1830s
Signature: Hiroshige hitsu
Publisher: Arisei Shiba Shin
narrow panel, 341 × 74
printed in grey

AI051, 50.1184

1342. Sparrows and narcissus
ca. 1840
Signature: Hiroshige ga
Publisher: Wakayo
narrow panel, 338 × 77

AI044, 50.1177

Cutting lines at left.

1343. Crane and autumn flowers
ca. early 1840s
Signature: Hiroshige hitsu
Artist's seal: Hiro
narrow panel, 347 × 78

AI045, 50.1178

1344. Adonis and New Year decoration
ca. 1840s
Signature: Ichiryūsai
Artist's seal: unread
narrow panel, 343 × 78, section of
an assemblage print; imitation of
stone-rubbing, engraved in reserve

AI048, 50.1181

1345. Crane and yellow yamabuki flowers
1830s
Signature: Hiroshige hitsu
Artist's seal: Ichiryūsai
chūban, 256 × 182
embossing
Reference: TNM 3554.

AI052, 50.1185

Traces of adjacent picture at left. Poem by
Nensha Tomiharu.

1346. Bird and platycodon (kikyō)
1830s
Signature: Hiroshige hitsu
Artist's seal: Ichiryūsai
chūban, 235 × 172

AI055, 50.1188

17-syllable poem on platycodon. Trace of
adjacent print at right.

1347. Bulbul on ivy tendril
ca.1850
Signature: Hiroshige hitsu
Artist's seal: Kakihan
Publisher: Yamajin han
Censorship seals: Kinugasa, Murata
chūban, 225 × 167

AI054, 50.1187

17-syllable poem on ivy.
Probably a reissue with added censorship
seals of a print designed in the 1830s.

1348. Cuckoo, iris and crescent moon
ca. 1850
Signature: Hiroshige ga
Publisher: Yamajin han
Censorship seals: Kinugasa, Morita
chūban, 225 × 164

AI053, 50.1186

Traces of adjacent print at right.
17-syllable poem on cuckoo.
The signature looks early and this may be
a republication with added censorship seals
of a print designed ca. 1830.

1349. Bats, full moon, and pilings
1830s
Signature: Hiroshige hitsu
Artist's seal: Utagawa
Publisher: Eijudō
1/3 block, 255 × 123
Provenance: Metzgar

AI063, 50.1196

PLATE 65.

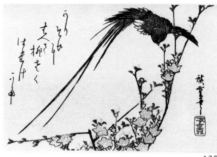

1350

*1350. Long-tailed fly-catcher and peach
blossoms
1830s
Signature: Hiroshige hitsu
Artist's seal: Ichiryūsai
1/4 block, 122 × 183
Provenance: Blanchard
Publication: Blanchard 1916, 518,
$20 ill. (MA: "splendid impression,
flawless condition").

AI056, 50.1189

17-syllable poem on peach blossom.

1351. Cuckoo and full moon
1830s
Signature: Hiroshige hitsu
Artist's seal: Ichiryūsai
small 1/4 block, 111 × 163

AI057, 50.1190

Cutting marks on lower edge.
17-syllable poem on cuckoo.

1352. Mandarin ducks
1830s
Signature: Hiroshige hitsu
small 1/4 block, 111 × 164

AI058, 50.1191

1353. Kingfisher and pampas grass
1830s
Signature: Hiroshige
small 1/4 block, 111 × 164

AI059, 50.1192

1354. Warbler on plum tree
1830s
Signature: Hiroshige
Artist's seal: Hiro
small 1/4 block, 110 × 164

AI060, 50.1193

1355. Swallow and iris
Signature: Hiroshige
small 1/4 block, 110 × 163

AI061, 50.1194

1356. Swallow and cherry branch
ca. late 1840s
Signature: Hiroshige hitsu
Publisher: Yamajin han
1/4 block, 164 × 111

AI062, 50.1195

Cutting marks above and signs of adjacent
print at left.
17-syllable poem on the swallow.

1357. Scorpion fish (kasago), isaki, and
ginger stalks
Untitled series of ten pictures of fish
ca. early 1830s
Signature: Ryūsai Hiroshige ga
Publisher: Eijudō
Censorship seal: kiwame
ōban, 249 × 362
with mica on fish
Reference: Suzuki 592.
Provenance: Hayashi

AI103, 50.1236

Second state, with the publisher's mark and
censorship seal added and the character Ichi
missing at the beginning of the artist's
signature.
In the first state, the picture was published
privately as part of a surimono-style poetry
album.
Kyōka poems by Nensha Tomiharu and
Shinsetsutei Satondo of Fujisawa in Sagami
Province.

1358. Grey mullet (bora), camellia, and
lotus root
Untitled series of ten pictures of fish
ca. early 1830s
Signature: Ichiryūsai Hiroshige ga
Publisher: Eijudō
Censorship seal: kiwame
ōban, 238 × 346
with mica on fish
Reference: Suzuki 593.
Provenance: Hayashi

AI104, 50.1237

Second state with added publisher's mark
and censorship seal.
Kyōka poems by Hinogaki Shirobune and
Toshinoto Haruki.

Utagawa HIROSHIGE II

1359. 44. *Yokkaichi*
Series: *Tōkaidō gojūsantsugi*, The Fifty-three stations of the Tōkaidō Road
2/1854
Signature: Shigenobu ga
Publisher: Yamajin han
Censorship seal: aratame
¼ block, 112 × 171

A1363, 50.1496

1360. Woman and children on Shichiri Beach near Enoshima
10/1854
Signature: Ichiyūsai Shigenobu ga
Publisher: Yamajin han
Engraver: Hori Taniyasu
ōban, 367 × 250

A1365, 50.1498

Panel of a triptych.

1361. *Shiba shimmei*, Snow at the Shimmei Shrine in Shiba
Series: *Edo meisho*, Famous places in Edo
10/1858
Signature: Shigenobu ga
Publisher: Yamaguchiya Tōbei
ōban, 212 × 343

A1364, 50.1497

1362. *Katata rakugan*, Descending geese at Katata
Series: *Ōmi hakkei*, Eight views of Lake Biwa
2/1859
Signature: nisei Hiroshige ga
Publisher: Fujikei
Engraver: Hori Kane
Censorship seal: aratame
ōban, 218 × 345

A1367, 50.1500

Canonical poem upper left.

*1363. *Kashū kanazawa daijōji*, Mist at Daijō Temple at Kanazawa in Kaga Province
Series: *Shokoku meisho hyakkei*, One hundred views of famous places in the provinces
ca. 1859
Signature: Hiroshige ga
Publisher: Uoei (trimmed)
Censorship seal: trimmed
ōban, 337 × 221

A1373, 50.1506

*1364. *Sōshū shichirigahama*, Waves at Shichiri Beach in Sagami Province
5/1859
two-color cartouche

A1374, 50.1507

1365. *Sado kinzan okuana*, Deep shafts in the gold mines on Sado Island
11/1859
Publisher: Uoei
with mica

A1375, 50.1508

1366. 19. Rain at Matsuchiyama
Series: *Edo meisho yonjūhakkei*, Forty-eight views of famous places in Edo
1/1861
Signature: Hiroshige ga
Publisher: Tsutaya Kichizō
Censorship seal: aratame
chūban, 226 × 166

A1376, 50.1509

For other prints by Hiroshige II see catalogue nos. 695, 1375.

1367. *Imadobashi matsuchiyama*, Snow at Imado Bridge and Matsuchi Hill
Series: *Tōto sanjūrokkei*, Thirty-six views of the eastern capital
8/1861
Signature: Hiroshige ga
Publisher: Sōto (trimmed)
ōban, 212 × 343

A1369, 50.1502

Nos. 1368–1370 are from the same series of ninety prints published by Uoya Eikichi between 1859 and 1864, and have the same series title, signature, publishers, format and size.

1368. *Zōjōji asagiri*, Morning mist at Zōjō Temple
Series: *Tōto sanjūrokkei*, Thirty-six views of the eastern capital
1861
Signature: Hiroshige ga
Publisher: Sōto
Censorship seal: aratame
ōban, 342 × 230
three-color cartouche
Provenance: J.S. Happer authentication seal on verso

A1370, 50.1503

1369. *Ueno kiyomizudō manka*, Cherry trees in full blossom at the Kiyomizu Hall in Ueno
Series: *Tōto meisho*, Famous views of the eastern capital
2/1862

Signature: Hiroshige ga
Publisher: Izumiya Ichibei (Senichi)
Censorship seal: aratame
ōban, 207 × 337
printed mostly in shades of blue

A1368, 50.1501

Nos. 1370 and 1371 are from the same series and have the same series title, date, signature and publisher.

1370. *Yoroi no watashi*, Rain at the Yoroi Ferry
Series: *Edo meisho zue*, Pictures of famous places in Edo
8/1863
Signature: Hiroshige ga
Publisher: Fujikei
Engraver: Hori Chō
Censorship seal: aratame
ōban, 338 × 228

A1371, 50.1504

From a series of landscapes with explanatory text above published between 1861 and 1864, seventy-one of which are presently known.

1371. Sunrise at Susaki
Series: *Edo meisho zue*, Pictures of famous places in Edo
8/1863
Signature: Hiroshige ga
Publisher: Fujikei
ōban, 328 × 220

A1372, 50.1505

Utagawa HIROSHIGE III

*1372. The stone monument for Hiroshige erected on the precincts of the Akiba Shrine
4/1882
Signature: Ryūsai Hiroshige keihaku
ōban, 337 × 229
with mica and embossing

A1366, 50.1499

1363

1364

The monument was engraved with a sketch of Hiroshige in priests' robes holding a poem slip, and his last poem, both in the hand of Hiroshige III. The biography and eulogy of the artist at the right was composed by Hiroshige III, but written by the calligrapher Ayaoka. The inscription has been translated in Strange, *The Colour-Prints of Hiroshige.*

1372

1373abc.
> *Akasaka karinōkyo okadode no zu*, The Emperor and Empress leaving the temporary palace at Akasaka in carriages
> Series: *Tōkyō meisho no uchi*, Famous Places in Tōkyō
> 4 November 1881
> Signature: Ōju Hiroshige
> Publisher: Hirano Denkichi
> ōban triptych, 357 × 707
> with aniline colors
>
> A1376A, 50.1509A

Utagawa HIROKAGE

1374. 16. *Ōji kitsunebi*, Fox fires at Ōji
> Series: *Edo meisho dōgizukushi*, Comic events at famous places in Edo
> ca. 1860
> Signature: Hirokage ga
> ōban, 336 × 218
> embossing
>
> A364, 50.497

The foxes have bewitched the farmer who thinks he is a lord being carried in a palanquin.

Many details are copied from a print by Hiroshige (see cat. no. 739).

PLATE 203.

1375.2

1375.42

GYŌSAI, HIROSHIGE II, KUNICHIKA, KUNISADA, KUNISADA II, KUNITSUNA, YOSHIKATA, YOSHIMORI, YOSHIMUNE, YOSHITORA, YOSHITOSHI, YOSHITSUYA, and KUNIYOSHI

Series: *Tōkaidō*, The Tōkaidō Road
(Some plates subtitled *meisho* or *meisho nouchi*, Famous places along the Tōkaidō Road.) A collaborative set designed by twelve leading Edo print designers and published jointly by at least 21 publishers, commemorating the journey of the Tokugawa shogūn from Edo to Kyōto to see the emperor. Sixty-five prints from the set are included in the album, but the last three stations of the Tōkaidō Road—Kusatsu, Ōtsu, and Kyōto—are missing. The last picture in the album is an unrelated panel from a Kuniyoshi whaling triptych published in the 1830's. All prints were published in 4/1863, except as noted.

The artist Kawanabe Gyōsai signed pictures for this set with his early names Kyōsai and Chikamaro.

ōban, 330 × 220

A540.1-66, 50.673.1-66

	ARTIST	SUBJECT	PUBLISHER	ENGRAVER
1375.1	KUNISADA	Nihonbashi	Etsuki	Katata Hori Tatsu(?)
*1375.2	Ichieisai YOSHITSUYA	Shimbashi, Shiba, Edo	Jōshūya	
1375.3	HIROSHIGE II	Zōjōji Temple, Shiba		
1375.4	Isshōsai YOSHIMUNE	Fudanotsuji, Motoshiba	Jōshūya	
1375.5	HIROSHIGE II	Ōkido, Takanawa	Enhiko	
1375.6	Shōjō CHIKAMARO	Cowbarn at Takanawa	Daikin	
1375.7	KUNISADA	Shinagawa	Enhiko	
1375.8	KUNISADA	Below Yatsuyama, Shinagawa	Kagishō	Hori Ōta Tashichi
1375.9	HIROSHIGE II	Ōmori	Daikin	
1375.10	HIROSHIGE II	Suzugamori	Daikin	
1375.11	HIROSHIGE II	Kawasaki	Marutetsu	
1375.12	HIROSHIGE II	Daishigawara	Daikin	
1375.13	KUNISADA	Kanagawa	Isekane	
1375.14	YOSHITORA	Kanagawa (foreign ships)	Sanotomi	
1375.15	YOSHITSUYA	Hodogaya	Jōshūya	
1375.16	YOSHITSUYA	Hodogaya, plate 2	Jōshūya	
1375.17	KUNISADA II	Totsuka	Sōto	
1375.18	YOSHIKATA	Fujisawa	Koshihei	
1375.19	HIROSHIGE II	Hiratsuka	Uoei	

1375.20	KUNITSUNA	Odawara	Kikuichi		
1375.21	HIROSHIGE II	Odawara	Itoshō		
1375.22	Ikkōsai YOSHIMORI	Hakone	Takichi		also an engraver
1375.23	KYŌSAI	Hunt in the Hakone mountains (signed Kyō Shōjō)	Marutetsu	Hori Daijirō	
1375.24	KUNISADA	Mishima	Sōto		
1375.25	KUNISADA	Numazu	Isekane		
1375.26	KUNISADA	Hara	Daikin		
1375.27	Ichieisai YOSHITSUYA	Yoshiwara	Tsujibun		
1375.28	HIROSHIGE II	Kambara	Marujin		
1375.29	HIROSHIGE II	Yui	Jōshūya		
1375.30	KYŌSAI	Okitsu (signed Shōjō Chikamaro)	Fukuchū		
1375.31	KUNITSUNA	Ejiri	Kikuichi		
1375.32	YOSHIMORI	Fuchū	Marutetsu		
1375.33	HIROSHIGE II	Mariko	Enhiko		
1375.34	YOSHIMORI	Okabe	Kinkyū		
1375.35	YOSHITORA	Fujieda	Enhiko		
1375.36	KUNITSUNA	Shimada	Marujin		
1375.37	YOSHIMORI	Kanaya	Fukuchū		
1375.38	KUNISADA	Nissaka	trimmed		
1375.39	KUNISADA	Kakegawa	Isekane		
1375.40	KUNITSUNA	Fukuroi	Koshihei		
1375.41	YOSHIMORI	Hamamatsu	Kinkyū		
*1375.42	Ikkaisai YOSHITOSHI	Maisaka	Kadokin	Hori Chō	
1375.43	KUNISADA	Arai	Isekane		
1375.44	Ichiransai KUNITSUNA	Shirasuka	Etsuki	Katata Hori Hei	
1375.45	Ichiō KUNICHIKA	Futagawa	Iseshō	Katata Hori Chō	
1375.46	HIROSHIGE II	Yoshida	Isekane		
1375.47	KUNISADA	Yoshida, pl.2	Daikin		
1375.48	Ichiransai KUNITSUNA	Goyu	Sōto 5/1863		
1375.49	YOSHITORA	Fujikawa	Sanotomi		
1375.50	Shōjō KYŌSAI	Okazaki	Fukuchū	Hori Daijirō	
1375.51	HIROSHIGE II	Chiryū	Ebirin	Matsushima Hori Masa	
1375.52	KUNICHIKA	Chiryū	Kagishō	Hori Ōta Tashichi	
1375.53	KUNITSUNA	Narumi	Sōto		
1375.54	YOSHITORA	Miya	effaced		
1375.55	CHIKAMARO	Aerial mirage at Kuwana	Marutetsu 5/1863		
1375.56	Ichieisai YOSHITSUYA	Yokkaichi	Tsujibun		
1375.57	Shōjō CHIKAMARO	Suzugayama, Sakanoshita	Daikin		
1375.58	Ichiō KUNICHIKA	Minakuchi	Koshihei	Katata Hori Chō	
1375.59	HIROSHIGE II	Ishiyakushi	Itoshō		
1375.60	KUNITSUNA	Shōno	Kikuichi		
1375.61	KUNISADA II	Kaneyama	Ebirin		
1375.62	KUNISADA II	Seki	Kinkyū	Matsushima Hori Masa	
1375.63	YOSHITORA	Sakanoshita	Sanotomi 5/1863		
1375.64	Ichieisai YOSHITSUYA	Tsuchiyama	Seibundō		
1375.65	Ikkeisai YOSHITOSHI	Ishibe	trimmed		
1375.66	Ichiyūsai KUNIYOSHI	Winch and whales	Sōshūya kiwame	left panel of a triptych, 1830s	

1376

Kobayashi KIYOCHIKA

*1376. Moonlight over a bridge beside a willow
ca. early 1880s
Signature: Kobayashi Kiyochika
ōban, 224 × 336
areas printed without outline

A553, 50.686

The margins with the date and picture title have been trimmed.

Kawanabe GYŌSAI

*1377. Crow on branch
ca. 1880s
Signature: Shōjō Gyōsai ga
Artist's seal: Gyōsai
ōban, 362 × 249
in imitation of brush painting

A547, 50.680

*1378. Crow in snow
ca. 1880s
Signature: Shōjō Gyōsai
Artist's seal: unread
ōban, 384 × 262
in imitation of stone-rubbing with black ground

A548, 50.681

*1379. Crows on a plum branch
ca. 1880s
Signature: Jokū Gyōsai zu
Artist's seals: Bankokuhi, Jokū
kakemono-e, 734 × 253
Reference: Crighton IV, 11.
Provenance: Ficke
Publication: Ficke 1920, 390, $120 (ill.) (MA: "xx uncut, flawless").

A549, 50.682

Jokū means "like the sky" or "like emptiness"; *bankokuhi* means "fly over all the nations."

An excellent example of engraving in imitation of brush painting.

1377

1378

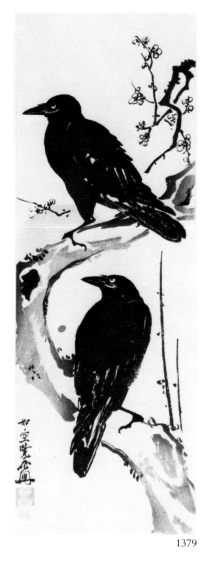

1379

Kojima SHŌGETSU, after KUNISADA

1380. Memorial portrait of Utagawa Hiroshige holding a brush and a poem sheet
ca. 1881
Signature: ōju Shōgetsu
Artist's seal: Shōgetsu
ōban, 373 × 234
embossing
Reference: Suzuki 86G; Mori 216.
A647, 50.780

The inscription at the right is a biography of the artist. The calligraphy at the left is a poem by an unidentified poet:

Kono fude mo azuma no hana ni kono okina,
This old man's brush is one of the flowers of the east.

Mizuno TOSHIKATA

1381. *Mushi no ne,* The sound of insects
Series: *Sanjūrokkesen,* Thirty-six fine poems
1890s
Signature: Toshikata
Artist's seal: Ōsai
Publisher: Akiyama Buemon
ōban, 368 × 248
A551, 50.684

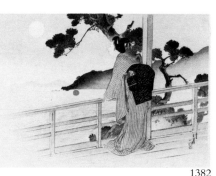

1382

*1382. Woman gazing at the moon
Series: *Imayō bijin,* Modern women
1890s
Signature: Shōsetsu Toshikata e
Artist's seal: Shōsetsu
Publisher: Akiyama Buemon
ōban, 249 × 369
A552, 50.685

Numbered *i* and probably the first plate in the series.

Yōshū CHIKANOBU

*1383. *Yomimono,* Reading
Series: *Edo nishiki,* Edo brocade
9/1902
Signature: Yōsai Chikanobu
Artist's seal: unread
Publisher: Matsuki Heikichi
ōban, 254 × 370
embossing and silver
A550, 50.683

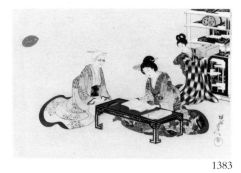

1383

1383A. 1. *Ōmi ishiyama shūgetsu murasaki shikibu,* Lady Murasaki viewing the autumn moon at Ishiyama by Lake Biwa in Ōmi Province
Series: *Setsugekka,* Snow, Moon and Flowers
2 August 1884
Signature: Yōshū Chikanobu hitsu
Artist's seal: *toshidama*
Publisher: Kobayashi Tetsujirō
Engraver: unread
ōban, 210 × 330
with aniline colors
A550A, 50.683A

SHŌUN

1384.
1-12 The complete set of 12 prints as issued with covers, printed title slip, and address labels of the publisher in English and Japanese. The pictures are sentimental half-length pictures of women against landscapes and interiors designed in a variety of painterly styles.
Series: *Shiki no nagame,* Views of the Four Seasons
December 1906
Signature: Shōun
Artist's seal: Shōun

Publisher: Matsuki Heikichi
238 × 353
 1. *Kado no nigiwai,* Noise at the gate
 2. *Umibe,* Seashore
 3. *Ohinasama,* Dolls
 4. *Fumiyomu setsu,* Reading
 5. *Harugasumi,* Spring mist
 6. *Mushi no setsu,* Insect season
 7. *Oagari,* Breakfast
 8. *Yūsuzu,* The cool of the evening
 9. *Ohanashi,* Conversation
 10. *Tsuki,* Moon viewing (With penciled annotation "lesbos revisited" in a western hand)
 11. *Hanamusume,* A bride
 12. *Yuki no watashi,* Ferry in the snow

A550B, 50.683B

after Itō JAKUCHŪ

1385. 1. Copper pheasant in snow
Series: *Itō Jakuchū shimpitsuga roku-mai no uchi,* Six genuine pictures by Itō Jakuchū
late 19th or early 20th century
Artist's seals: Jakuchū, another unread
278 × 393

A546, 50.679

This and the following prints are a series of black-printed facsimiles of a rare set of bird-and-flower prints by Jakuchū designed in imitation of stone-rubbing which were originally published in 1771. A set of the original prints is in the Riccar Art Museum in Tōkyō.

*1386. 2. Small green parrot on dried branch
Artist's seals: Jokin, azana Keiwa
318 × 264

A542, 50.675

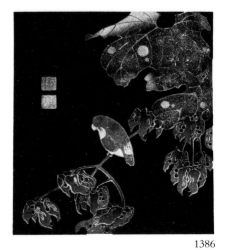

1386

1387. 3. Parrot and roses
Signature: Jokin
279 × 374

A544, 50.677

1388. 4. White parrot on perch
Artist's seals: Jokin, Jakuchū (last two characters unread)
circular on sheet, 278 × 317

A543, 50.676

1389. 5. Parrot on oak branch
Artist's seals: Jokin no in, Keiwa uji
274 × 393

A545, 50.678

1390. 6. Swallow and camellia
Artist's seals: unread
318 × 263

A541, 50.674

1391

Helen HYDE

*1391. Japanese mother and child
1901
Signature: Helen Hyde
circular, on thin Japan paper
332 × 367

A570, 50.703

Signed, numbered 98, and annotated "Copyright 1901 by Helen Hyde" in pencil.

Hashiguchi GOYŌ

1392. Young geisha applying lip rouge
9/1920
Signature: Goyō ga
vertical, 413 × 282
with embossing and yellow mica ground

A558, 50.691

*1393. Woman combing her hair
3/1920
Signature: Goyō ga
Artist's seal: Hashiguchi Goyō
vertical, 456 × 342
embossing and silver mica ground

A559, 50.692

1393

1394. Woman fastening her underrobe
5/1920
Signature: Goyō ga
Artist's seal: Goyō
vertical, 481 × 147
embossing and yellow mica ground

A560, 50.693

1395. Evening moon over Kōbe
1/1920
Signature: Goyō ga
Artist's seal: GY
177 × 304

A561, 50.694

One of the artist's three landscape prints.

1396

Kawase HASUI

*1396. *Shiobara shiogama,* Shiogama hot
 spring, Shiobara
 autumn 1918
 Signature: Hasui
 Artist's seal: geometric emblem
 Publisher: Watanabe
 476 × 178

A556, 50.689

This and the following are among the artist's
earliest prints.

1397. *Shiobara arayuji,* The road at Arayu
 near Shiobara
 1918
 Signature: Hasui
 Artist's seal: geometric emblem
 Publisher: Watanabe
 186 × 477

A555, 50.688

One of the artist's first prints.

1398. *Matsushima katsurajima,* Raking pine
 needles at Katsura Island, Matsu-
 shima
 summer 1919
 Signature: Hasui
 Artist's seal: geometric emblem
 Publisher: Watanabe
 ōban, 258 × 390

A554, 50.687

1399. *Komagatagashi,* Horse cart and bam-
 boo poles on the Komagata Bank
 of the Sumida River
 Series: *Tōkyō jūnidai,* Twelve Tō-
 kyō themes
 summer 1919
 Signature: Hasui
 Artist's seal: geometric emblem
 Publisher: Watanabe
 ōban, 261 × 388

A557, 50.690

UNIDENTIFIED

1400. Promontory with sails
 1915
 Publisher: Watanabe
 ōban, 251 × 374

A562, 50.695

UNSIGNED

1401. Shōki, the demon queller
 probably late 19th or early 20th
 century
 302 × 231
 watercolor with opaque pigment on
 background

A1, 50.134

This drawing is a modern version of an
Ōtsu-e, a type of folk painting produced at
Ōtsu, a town near Kyōto on the Tōkaidō
Road, from the 17th to the 19th centuries.

After Nishimura SHIGENAGA

1402. Young man holding a fan
 Woodblock for a facsimile cut in
 the late 19th or early 20th century,
 together with an impression from
 the block printed in 1979
 321 × 416 (block)

A1377, 50.1510

On the back of the block is the outline for
a facsimile of a print by Masanobu of a
courtesan with a young attendant.

PLATE 215.

242

Japanese Prints from Sources other than the Ainsworth Bequest

Yōshū CHIKANOBU

Nos. 1–12 are from an untitled series of historical subjects published by Fukuda Shōjirō between 1898 and 1899. Nos. 1 and 3 are unsigned, but the other prints are signed Yōshū Chikanobu; many are sealed, Yō.

1. Sasaki Tadatsuna and Kajiwara Genta crossing the Uji River
 January 1898
 Engraver: Hori Ei tō
 ōban, 209 × 330, with variation up to 4 mm. within set
Source unknown, 43.295

2. Komatsu Naidaijin Shigemori admonishing his father Kiyomori
 January 1898
 Engraver: Hori Ei tō
Source unknown, 43.294

3. Murakami Yoshimitsu beating off three attackers
 January 1898
Source unknown, 43.290

4. Hino Oshin swinging on a bamboo
 February 1898
 Engraver: Hori Ei
Design copied from a woodblock print of Hino Kumawakamaru designed by Yoshitoshi in 1878.
Source unknown, 43.292

5. Hasebe Nobutsura fighting off spear men
 February 1898
 Engraver: Hori Ei
Source unknown, 43.296

6. Shizuka Gozen dancing before Minamoto no Yoritomo
 February 1898
Source unknown, 43.300

7. Kumagai and Atsumori at the battle of Ichinotani
 March 1898
Source unknown, 43.293

8. Kusunoki Masashige in a shower of arrows
 December 1898
 Engraver: Hori Ei
Source unknown, 43.301

9. Taira no Koremochi and the demon of Mt. Togakushi
 December 1898
Source unknown, 43.299

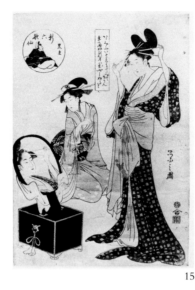

15

10. Yomota Tamba no Kami duelling with Katō Kiyomasa
 1898
Source unknown, 43.297

11. Oda Nobunaga leaping into flames to escape Yasuda Sakubei
 1898
Source unknown, 43.298

12. Nasu no Yoichi shooting the fan at the Battle of Dannoura
 January 1899
Source unknown, 43.291

17

Keisai EISEN

13. Spring rain
 ca. early 1820s
 Signature: Keisai Eisen ga
 Publisher: Wakasaya
 Censorship seal: kiwame
 ōban, 339 × 230
Gift of Charles F. Olney, 04.300

14. *Shinchi no ume,* Plum at Shinchi
 Series: *Ada kurabe imayō sugata,* A comparison of modern forms of charm
 ca. late 1820s
 Signature: Keisai Eisen ga
 Censorship seal: kiwame
 Publisher: Kawaguchiya Shōzō
 ōban, 360 × 242
Gift of Charles F. Olney, 04.301

Chōbunsai EISHI

*15. Courtesan standing before a mirror; illustration of a poem by Ōtomo Kuronushi
 Series: *Shin rokkasen,* A new version of the Six Immortal Poets
 ca. 1795
 Signature: Eishi zu
 Publisher: Nishimuraya Yohachi (Eijudō)
 Censorship seal: kiwame
 aiban, 320 × 221
 yellow background
 Reference: Brandt 228.
Gift of Mrs. F. F. Prentiss, 44.94

After FUJIMARO

16. Geisha and servant in snow
 ca. 1900
 Signature: Fujimaro hitsu
 Artist's seals: unread
 300 × 196, tipped onto larger sheet
Woodblock facsimile of a painting of the early 19th century; from an album.
Gift of Mrs. Hazel B. King, 38.3

Suzuki HARUNOBU

*17. *Hira bosetsu,* Evening snow on Mt. Hira
 Series: *Ōmi hakkei no uchi,* Eight views of Ōmi
 ca. 1764
 Unsigned
 Publisher: Okumura (?)
 hosoban, 313 × 139
 two-color print with pink and grey
 Reference: Keyes 73.

There are two states of the print, one with the signature Harunobu ga and the mark of a different publisher. An example of the other state is in the Museum of Fine Arts, Boston.

Gift of Mrs. F. F. Prentiss, 44.90

Utagawa HIROSHIGE

18. 47. Clear weather after snow at Kameyama
Series: *Tōkaidō gojūsantsugi no uchi*, Fifty-three stations of the Tōkaidō Road
ca. 1833
Signature: Hiroshige ga
Publisher: Hoeidō
ōban, 226 × 350

Duplicate of no. 805 in Ainsworth collection.

Gift of Mrs. F.F. Prentiss, 44.95

19. 5. Distant view of the Kamakura Mountains from the rest house by the boundary tree at Hodogaya
Series: *Gojūsantsugi meisho zue*, Pictures of famous places of the 53 stations (Vertical Tōkaidō)
7/1855
Signature: Hiroshige hitsu
Publisher: Tsutaya Kichizō
Censorship seal: aratame
ōban, 344 × 227
Reference: Suzuki 159.

This and the following prints are from the Vertical Tōkaidō, Hiroshige's last series of views along the highway between Edo and Kyōto. There is a complete set of these prints in the Ainsworth collection, nos. 870–927. Information on series title, date, signature, publisher, censorship seal, format and reference is the same on all prints in the series. Measurements differ only slightly and are not given here.

Source unknown, 00.6

20. 6. Distant view of Mt. Fuji from the mountain road in Totsuka
Source unknown, 00.9

21. 16. View of the Fuji River from Iwabuchi Hill near Kambara
Source unknown, 00.16

22. 18. The Satta Foothills from the Okitsu River at Okitsu
Bequest of Mary L. Mains, 65.40

23. 18. The Satta Foothills from the Okitsu River at Okitsu
Source unknown, 00.15

24. 20. The second block of the Miroku licensed quarter by the Abe River at Fuchū
Source unknown, 00.7

25. 33. The Oceanview Slope at Shirasuka
Source unknown, 00.8

26. 37. Yajirō mistakes Kitahachi for a fox and beats him on the Nawate Road near Akasaka
Source unknown, 00.5

27. 40. The ancient site of the iris field at Yatsuhashi Village near Chiryū
Source unknown, 00.13

28. 43. The Seven-*ri* ferry boat approaching Kuwana
Source unknown, 00.12

29. 47. Lightning and rain at Kameyama
Source unknown, 00.11

30. 48. The junction of the pilgrim's road to Ise at Seki
Source unknown, 00.14

31. 51. Namatsu Plateau and the foothills of Mt. Matsu near Minakuchi
Source unknown, 00.17

32. 55. The great bridge at Sanjō in Kyōto
8/1855
Source unknown, 00.10

33. The Pine Tree of the Heavenly Cloak at Mio Bay near Ejiri
Series: From a *harimaze* Tōkaidō series
ca. late 1840s or early 1850s
Unsigned
335 × 510,
ishizuri-e, printed in reserve

A fragment of a larger print with several designs in different styles.

Source unknown, 00.4

34. *Yoshiwara yuki no asa*, Snowy morning at the Yoshiwara
Series: *Tōto meisho*, Famous places in the eastern capital
ca. 1850
Signature: Hiroshige ga
Publisher: Sanoya Kihei (Sanoki)
Censorship seals: Watanabe, Kinugasa
ōban, 220 × 339
Reference: Suzuki 136, 9.

Bequest of Mary L. Mains, 65.14

35. Otoko Mountain at Makigata in Kawachi Province
Series: *Rokujūyoshu meisho zue*, Pictures of famous places in the sixty-odd provinces
7/1853
Signature: Hiroshige hitsu
Publisher: Koshimuraya Heisuke (Koshihei)
Engraver: Hori Take
Censorship seals: Watanabe, Mera
ōban, 343 × 230
Reference: Suzuki 167.

This and the following two prints are duplicates of prints in the Ainsworth collection. Information on series, title, signature, reference, and format are the same as above.

Bequest of Mary L. Mains, 65.42

36. The Yōrō Waterfall in Mino Province
8/1853
Engraver: Hori Take
Censorship seals: Murata, Kinugasa with embossing on waterfall
Bequest of Mary L. Mains, 65.43

37. Amanohashidate in Tango Province
12/1853
Engraver: Hori Sōji
Censorship seal: aratame
Bequest of Mary L. Mains, 65.39

38. Inume Pass in Kai Province
Series: *Fuji sanjūrokkei*, Thirty-six views of Mt. Fuji
4/1858
Signature: Hiroshige ga
Publisher: Tsutaya Kichizō
ōban, 339 × 224
Reference: Suzuki 167.
Bequest of Mary L. Mains, 65.38

Utagawa HIROSHIGE II

39. *Ryōgoku nōryō*, Enjoying the evening cool at Ryōgoku
Series: *Edo meisho*, Famous places in Edo
2/1859
Signature: nisei Hiroshige ga
Censorship seal: aratame
ōban, 217 × 341
Source unknown, 43.288

Katsushika HOKUSAI

40. Enoshima in Sagami Province
Series: *Fugaku sanjūrokkei*, Thirty-six views of Mt. Fuji
early 1830s
Signature: Zen Hokusai Iitsu hitsu
Publisher: Eijudō
Censorship seal: kiwame
ōban, 252 × 377
Reference: UTK XIII, 27.
Gift of Mrs. F.F. Prentiss, 44.93

After Katsushika HOKUSAI

41. Courtesans of the Ōgi House viewing the moon
ca. 1900
Signature: Sōri aratame Hokusai ga
long surimono, 210 × 512

Facsimile reproduction of a surimono originally designed ca. 1799. An impression of the original in Indiana University Museum of Art is illustrated in *Hokusai et son temps*, Paris, 1980, fig. 18.

Gift of Mrs. Helen J. Collins, 00.52

Torii KIYONAGA

42. Three women strolling beside the
 Sumida River
 ca. mid-1780s
 Signature: Kiyonaga ga
 ōban, 384 × 249, center panel of a
 triptych.
 Reference: Hirano 848.
Gift of Mrs. F.F. Prentiss, 44.91

Utagawa KUNISADA

43. Actor as Umeomaru in the Car-
 riage-stopping scene of the play *Su-
 gawara denju*
 ca. 1850
 Signature: Kōchōrō Toyokuni ga
 Artist's seals: *toshidama*
 Publisher: Ebisuya
 Censorship seals: Muramatsu, Fuku
 ōban, 353 × 246, panel of a polyp-
 tych
Source unknown, 41.39

44. The wrestler Kurosaki Sakichi
 7/1854
 Signature: Toyokuni ga
 Publisher: Yamamotoya
 Censorship seal: aratame
 ōban, 367 × 253
Source unknown, 43.289

MASAARI

45. Boys playing with dolls
 Series: *Jūnikagetsu yōdō asobi,* Twelve
 months with children's games
 1780s
 Signature: Masaari ga
 Publisher: Eijudō
 chūban, 215 × 156
 Provenance: Laurent
From a set of 12, printed two to one *aiban*
sheet.
Gift of Genevieve Brandt, 42.79

Yōsai NOBUKAZU

46. *Rei,* Etiquette. Minamoto no Yoshi-
 ie and Abe no Sadatō in the battle
 of Kawasaki
 Series: *Sono omokage sugata no ea-
 wase,* Memories of the past in pic-
 tures
 March 1903
 Signature: Yōsai Nobukazu
 Publisher: Maki Kinnosuke
 ōban, 372 × 249
Source unknown, 43.286

After Tōshūsai SHARAKU

*47. Sakata Hangorō III as Fujikawa Mi-
 zuemon
 Series: Untitled series of half-length
 portraits of actors in kabuki per-
 formances of 5/1794

ca. early 20th century
Signature: Tōshūsai Sharaku ga
Publisher: emblem of Tsutaya Jūza-
burō
Censorship seal: kiwame
ōban, 366 × 253
mica background
A deceptive facsimile reproduction.
Source unknown, 00.129

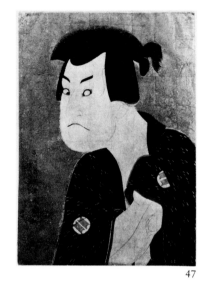

47

Momokawa SHIKŌ

48. The courtesan Okaru and the cham-
 berlain Yuranosuke in a scene from
 Act 7 of *Kanadehon chūshingura*
 ca. 1798
 Signature: Shikō ga
 Publisher: Murataya
 pillar print, 621 × 142
 Provenance: Laurent
Shikō was a name used by Eishōsai Chōki
on prints published in the late 1790s and
early 1800s.
Gift of Genevieve Brandt, 40.44

Itō SHINSUI

49. Kneeling nude
 Spring 1922
 Signature: Shinsui saku
 Artist's seal: Itō
 Publisher: Watanabe Shōzaburō
 409 × 247
 with embossing and extensive use
 of *baren*
Numbered on verso 125 from an edition of
200.
Gift of Mrs. Malcolm McBride, 39.18

Utagawa TOYOKUNI

50. Young woman with a cat
 ca. early 1810s
 Signature: Toyokuni ga
 Publisher: Hagiwara
 Censorship seal: undeciphered
 ōban, 356 × 229
Gift of Mrs. Helen J. Collins, 00.1

Kitagawa UTAMARO

51. Woman looking through a piece of
 transparent silk cloth
 Untitled series of bust portraits of
 women
 mid-1790s
 Signature: Utamaro hitsu
 Publisher: Yamaguchiya Chūsuke
 ōban, 370 × 249
 Reference: Shibui 71, 1, 3; Shōga-
 kukan 400.2.
Elisabeth Lotte Franzos Bequest, 58.49

52. 3. Feeding mulberry leaves to the
 silkworms
 Series: *Joshoku kaiko tewaza gusa,* A
 woman's occupation of raising silk-
 worms
 late 1790s
 Signature: Utamaro hitsu
 Publisher: Tsuruya Kiemon (em-
 blem)
 ōban, 386 × 250
 Reference: Shibui 138,1,3; Shōga-
 kukan 105.3.
From a series of 12 pictures that Suzuki
dates 1799.
Gift of Mrs. F.F. Prentiss, 44.92

after UTAMARO

53. Two women by cistern
 late 19th or early 20th century
 Signature: Utamaro hitsu
 nagaban, 506 × 198
Modern facsimile.
Gift of Mrs. Helen J. Collins, 00.51

Hiroshi YOSHIDA

54. Evening in a Hot Spring
 1939
 Signature: Hiroshi Yoshida (pencil),
 Yoshida (brush)
 Artist's seal: Hiroshi
 Engraver: Yoshida
 Printer: Yoshida (*jizuri* seal in upper
 left margin)
 247 × 378
Unrecorded in the catalogue of Yoshida's
prints (*Yoshida hiroshi hanga ten,* Riccar Mu-
seum, Tokyo, 1976).
Purchased from American College Society
of Print Collectors, 39.69.

Ichimōsai YOSHITORA

55. *Kikuzuki,* The Chrysanthemum
 Festival
 Series: *Gosekku no uchi,* The Five
 Annual Festivals
 1/1854
 Signature: Kinchōrō Yoshitora ga
 Publisher: Maruya Jimpachi
 Censorship seal: aratame
 ōban, 349 × 252
Gift of Genevieve Davis Olds, 33.34

UNSIGNED

56. Ca. 144 images of Amida Buddha
 1047
 Unsigned
 On four sheets of paper measuring
 approximately 355 × 260, 350 ×
 240, 240 × 240 and 100 × 30
 uncolored stamped design

Four fragments cut from larger sheets of
stamped images that were inserted into a
statue of Amitabha Buddha at the Jōruri
Temple in Kyōto in 1047.

Friends of Art Fund, 51.47

57

*57. Sze-ma Kuang saves a playmate
 from drowning in a water jar
 Series: Untitled album of uncolored
 pictures in Kanō style
 ca. early or mid-18th century
 oval, 251 × 338

Possibly designed by, or after a design by,
Tachibana Morikuni.

Gift of Mrs. F.F. Prentiss, 44.89

58. The lovers Oshun and Dembei
 early 1800s
 Publisher: Ihiko
 pillar print, 609 × 117

Possibly by Banki, a pupil of Utamaro,
who designed other pillar prints issued by
this publisher.

Elisabeth Lotte Franzos Bequest, 58.50

59. Dancer holding a lacquer box
 ca. mid-19th century
 narrow panel, 305 × 61

Possibly a fragment of a *harimaze* sheet.

Gift of Miss Genevieve Brandt, 40.43

*60. *Yonaoshi namazu no nasake,* The
 kindness of the catfish in restoring
 the world
 1855
 ōban, 361 × 249

Catfish rescuing survivors of the great
earthquake that struck Edo during the Ansei
period.

Source unknown, 43.287

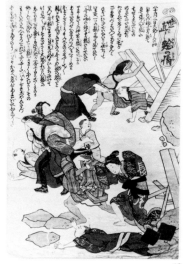

60

Index of Artists

The numbers refer to catalogue numbers

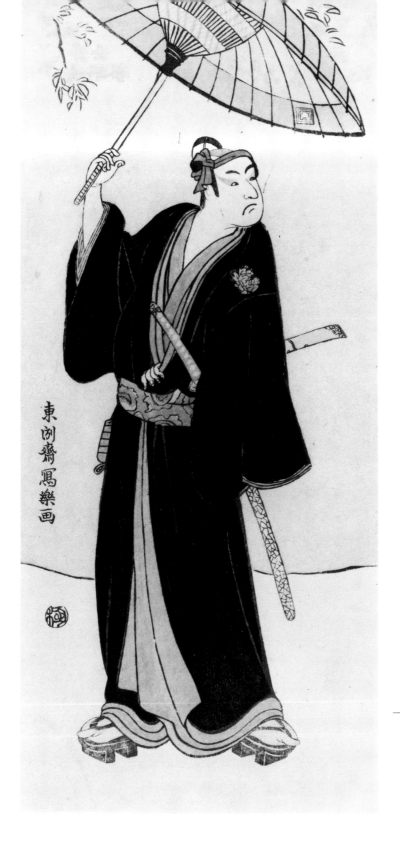

東洲齋寫樂画

III. *Appendices*

IDENTIFICATION OF TRADITIONAL ORGANIC COLORANTS EMPLOYED IN JAPANESE PRINTS AND DETERMINATION OF THEIR RATES OF FADING

Robert L. Feller, Mary Curran and Catherine Bailie[a]

A.1 INTRODUCTION

The investigation that will be described here was undertaken on behalf of the Allen Memorial Art Museum to provide information concerning the potential rate of fading of traditional organic colorants found in Japanese prints. This undertaking was supported in part by a portion of the funds provided by the National Endowment for the Arts to enable the museum to inspect and catalogue its collection of prints and to survey the needs for their conservation. Because of the long-term interest that the Research Center on the Materials of the Artist and Conservator has had concerning the potentially damaging effects of light on museum collections, the project was expanded further than originally commissioned.

Roger and Keiko Keyes (consultants), who in 1979 undertook the cataloguing and technical examination of the Ainsworth collection of Japanese prints in the Allen Art Museum, had long been aware that many Japanese prints in collections throughout the world are now in seriously faded states. Keiko Keyes, particularly, urged both the curatorial staff of the Museum and the scientists at the Research Center to seek information on the rate of fading of traditional colorants used in the prints. Among the questions that needed to be answered were: What colorants used in these prints are especially sensitive to light? How rapidly will they fade? Finally, are such pigments to be found in the prints in the collection of the Allen Art Museum? At the beginning of this project, the Keyes knew of no decisive information available which would answer these questions. Accordingly, a portion of the grant to the Museum was assigned to obtain this information, vital to the care and preservation of prints executed in this time-honored art form.

A.2. PLAN OF INVESTIGATION

In order to obtain the desired information concerning the sensitivity of the traditional Japanese colorants to light, the authors first had to obtain a number of authentic samples of these materials. Two—*ai* (indigo) and *beni* (safflower red)—were obtained from Keiko Keyes in the form of dry pigments as well as strips of paper on which they had been painted. Two others, *aigami* (dayflower blue) and *enju* (Japanese pagoda tree), were provided through the kindness of the distinguished collectors, Dr. and Mrs. James B. Austin of Pittsburgh. Other colorants of interest to this work were available from the collection of the National Gallery of Art Pigment Bank maintained at the Center; the lightfastness of pigments such as carmine, natural and synthetic alizarin, Prussian blue, turmeric and gamboge, for example, had already been investigated on a number of occasions in the past, some more extensively than others.

It was necessary to determine whether such pigments could be identified in a print and, if so, whether they could be proven to exist in prints of the Ainsworth collection. The spectrophoto-metric reflectance curves of the authentic samples of both *aigami* (dayflower) and *ai* (indigo) proved to be sufficiently characteristic that they can be detected and distinguished when these blue pigments are used alone or in mixtures with a yellow or red. *Beni* (safflower) fluoresces under near-ultraviolet radiation and has a sufficiently characteristic spectrophotometric reflectance curve that it, too, can be identified with reasonable confidence. With this information, we were able to show that these three colorants were indeed present in representative prints from the collection that were sent to the Center for examination. The measurement of spectral reflectance curves is a "non-destructive" method of analysis; no sample needs to be taken. A detailed description of the methods used to measure the spectral reflectance curves of various areas on the prints, by simply placing the particular colored area at the viewing port of the instrument, is given in the addendum section.

Finally, using samples of dyeings and paint-outs of traditional colorants, as well as small areas of two prints of the 1800s kindly provided to the laboratory for this purpose, fading tests were conducted under a bank of fluorescent lamps and the observed rate of fading of the samples compared with the International Standards Organization's blue-wool fading standards. The results showed that at least seven of the traditionally-employed colorants are indeed fugitive. *Beni* (safflower) and *aigami* (dayflower blue) were found to be especially sensitive to light.

A formal report on the initial investigation was presented to the Allen Art Museum on Dec. 18, 1980.[1] The basic findings on lightfastness were also published in 1981 in the preprints of a meeting of the International Council of Museums' (ICOM) Committee for Conservation.[2] Since then, the work has been extended to include studies on (a) the fading of some of the same colorants applied as textile dyes, (b) the general ineffectiveness of ultraviolet filters in preventing fading, and (c) the direct measurement of fading in two inexpensive prints of the 1800s.

B. CONCERNING THE TRADITIONAL COLORANTS

1. Pigments

The coloring materials that artists employ fall into two principal chemical classes: inorganic (mineral) and organic compounds. The latter are usually complex substances based on carbon along with hydrogen, oxygen, and perhaps nitrogen or sulfur. The compounds can be subclassified further, if so desired, into those of natural or of synthetic origin. With regard to long-term durability, it is generally recognized that the mineral pigments tend to be highly stable. In contrast, the organic-based coloring materials, particularly those traditionally derived from various natural vegetable or animal sources, tend to exhibit moderate to poor lightfastness. The Japanese printmaker employed both inorganic and organic colorants, but our chief concern here will be with the traditional natural organic materials, for these have long been considered to be the least stable of the various colorants used.

[a] Research Center on the Materials of the Artist and Conservator, Mellon Institute, Carnegie-Mellon University, Pittsburgh, Pa.

A coloring agent is particularly useful to the artist if it stays where he puts it (does not "run") and does not tend to wash away or to dissolve into the paint vehicle or a protective varnish. In order to immobilize a colorant based on soluble dyestuffs, the dyer of cloth has traditionally reacted his coloring matter with mineral-based "mordanting" agents which will precipitate or otherwise insolubilize the colored chemical substance. The painter traditionally has insolubilized dyestuffs by a process called "laking": the soluble colorant is absorbed on a relatively colorless but porous mineral, or is coprecipitated with an otherwise colorless mineral. Colorants attached to inorganic colorless minerals in this way are known as "lakes." There are also organic-based coloring agents that are, or can become, insoluble in themselves and thus do not require laking; indigo is such an example.

Because the authors cannot be certain of the exact nature of many of the colored materials traditionally used by the Japanese printmaker, we will employ the general term "colorant" in this text without attempting to define more precisely whether the coloring matter is based on a lake, an insoluble organic substance, or perhaps a mixture of either a mineral pigment and an organic-based colorant or two organic-based colorants. Mixtures were often used—a yellow with a blue to make green—or a red with a blue to make purple, for example. In such cases, one of the two colorants may fade more rapidly than the other, leaving a highly distorted color balance in the picture. The reader may

recall that the color in the foliage of European tapestries is frequently found as blue today; it is probable that it was originally green but that the yellow dye used in mixture with the blue has completely faded away. One may expect greens and purples in many Japanese prints to suffer similar changes in hue as one component fades in time more rapidly than the other.

A further factor affecting the color of Japanese prints is the color of the paper. Inks are more or less transparent, depending in part on the concentration and in part on the light-absorption characteristics of the colorants used. The result is that the hue of the paper can affect the printed color. Papers frequently yellow with age, even in the dark. Moreover, as the colorants themselves fade, more and more of the color of the paper is able to show through, further affecting a change in appearance. When it was possible to do so, we have measured the color of the unprinted paper in order to aid in our analysis and identification of the colorants.

A paint or printing ink is based on a colorant dispersed in a binder or vehicle combined with a solvent. Unfortunately, we cannot say much about the binder at this time, for that used in traditional Japanese prints is not well documented. It was frequently a water-dispersible material, possibly based on a rice-starch paste.

For the sake of clarity throughout this report, we shall use the term "color" to apply to the perceived color; it is the visual effect, that which the eye sees. The term "colorant" applies to the coloring matter or material used to create the color perceived.

The authors are not familiar with the history of Japanese printmaking but can refer to the comments of Arthur Davison Ficke in order to provide some idea of the dates involved.[3] Ficke says that the black and white period of Japanese printmaking changed after about 1700 with the introduction of red lead ("tan"). He further states that, about 1710, citrine and yellow were introduced and, by 1715, "beni," the red made from Carthamus tinctorius L., the Beniband plant. Hand-coloring prevailed up to about 1742; then green and red (*beni*) colors printed from blocks appeared in the period of 1742–64. After that date multi-colored prints began to appear, extending up to the present time. Ficke considered a fifth period, 1806–1858, to mark the close of the great era of figure-prints, although it was the time of the outstanding landscape prints of Hokusai and Hiroshige. From this brief summary, one learns that the inquiry concerning lightfastness will be concerned primarily with colorants available in the eighteenth century.

Table I presents a list of some of the principal coloring agents that one may expect to find in traditional Japanese prints.[4,5] To the best of our knowledge, all the organic colorants in this list tend to be fugitive, with alizarin, indigo and Prussian blue the most stable of the series, perhaps even possessing what might be considered "intermediate" lightfastness.[b] Information concerning the lightfastness of eleven in this list of organic-based colorants has been obtained as a result of the present investigations, summarized principally in Tables IV and V.

Although inorganic pigments tend to be stable, brief mention should be made of the fact that some of these can also readily change in appearance. Three deserve comment. Red lead and white lead can discolor owing to the chemical reaction of these pigments with sulfides in the atmosphere, causing them to darken owing to the formation of black lead sulfide. Ficke mentions, for example, that the white—this would probably have been lead white—had turned black on some of Hiroshige's works.[3]

In what may be a reference to the darkening of red lead by sulfides but which also may be a reference to the darkening of

TABLE I

Some Traditional Japanese Colorants

Japanese Name	Typical or Nominal Color	Source (Common Name)
Organic Colorants		
Beni[1]	red or pink	Carthamus tinctorius (Safflower)
Ukon[1]	yellow	Curcuma longo (Turmeric)
Ai[1]	blue	Polygonum tinctorium (Indigo)
Aigami[1]	blue	Commelina communis (Dayflower, lily family)
Zumi	mustard yellow	Malus Sieboldii or Pyrus Toringo
Shio	yellow	Garcinia morella (Gamboge)
"Yen Chih"	red	Mirabilis Jalapa L.
Suo	red	Caesalpina sappan L. (Red bud)
Kariyasu	yellow	Miscanthus tinctorius (Miscanthus)
Enju	yellow	Styphnolobium japonicus (Jap. pagoda tree)
Kihada	yellow	Phellodendron amurense (Jap. yellow wood)
Yama-momo	yellow	Myrica rubia
Kusa-ai	green	Combination of yellow with indigo
Bero-ai	blue	Prussian blue
Enji	crimson lake	Traditionally, a carminic acid colorant from cochineal insect
Akane	red	Rubia akane and tinctorum; pseudopurpurin- and alizarin-based colorants
Inorganic Colorants		
Enpaku[2]	white	Lead white
Gofun	white	Clam-shell white
Shu[2]	vermilion	Mercuric sulfide
Tan[2]	orange	Red lead
Benigara	iron oxide red	"Red Shell"
Kio or Sekio	yellow	Orpiment, "Stone Yellow"

[1] Mrs. Keyes considers these four to be the organic colorants of principal concern with respect to exposure to light. The present study did not include *ukon* (turmeric), but prior experience with this material indicates that it is fugitive. Cloth dyed with ukon proved to be very fugitive.

[2] As noted in the text these can darken.

[b] The characterization of colorants with respect to their being in a class of lightfastness designatable as "fugitive," "intermediate" or "excellent" is discussed in Section E.

vermilion upon exposure to light, Ficke states in another passage, "The rich orange color of Koriusai and Shunshō, and the delicate pink used by Harunobu, Kiyonaga and Shunshō, are transformed in the course of time to a rusty black . . ." Vermilion (mercury sulfide) is able to darken owing to its transformation into a black form, a physical rather than chemical alteration. Articles by Gettens[6] and Feller[7] discuss in considerable detail the phenomenon of the blackening of vermilion caused by exposure to light. In 1964, the authors noted a set of Japanese-prepared vermilion pigments that had been kept in glass jars in a showcase in the hallway outside the conservation laboratory of the Fogg Art Museum of Harvard, perhaps placed there by Edward Forbes in

TABLE II

Summary of the Results from the Examination of Prints in the Collection

Prints of the 1820s —	
	Print 416 — (print in excellent condition; possibly unfaded?)—the blue of the water is based on indigo. Area (b)*
	Print 410 — the blue in sky and the water is based on *aigami* (b; b1,2). See Figure 9.
	Print 411 — the blue of the water is *aigami* but the color is more pale than in 410 (b).
Prints of the 1850s —	
	Print 1113 — (print essentially unfaded?)—red in both calligraphic panels at top right is probably *beni* (r1,2). See Figure 8.
	Print 1111 — (print considered by Mrs. Keyes perhaps to have undergone an intermediate degree of fading)—red signature panels at top right: basically the same spectrophotometric curves as 1113 but paler hues; also more pale than red cloud which fluoresces strongly under near-ultraviolet radiation. Probably *beni* (r1,2,3).
	Print 323 — (a print which has, in the opinion of Mrs. Keyes, faded somewhat since 1972)—the purples of the kimono appear to be red plus *aigami;* a paler hue has the same curve shape as the darker one (with little less blue and more red in it). The darker one is a slightly more blue-purple (p1,2).
	Print 479 — the red curves are not distinctive enough to learn much, but fluorescence in the red kimono at the far left figure suggests *beni* (r). See Figure 8.
	Print 194 — the blue in the left-most figure is *aigami* and the purple in the figure on the extreme right is based on a mixture of red and *aigami* (b; p1,2).
	Print 288 — the pale blue seems to be *aigami;* the red fluoresces strongly and therefore may be *beni* (safflower) (see Figures 8, 9) (b1,2,3; 1r1,2). The purple appears to be a mixture of red and *aigami* (p1,2). The green apparently is a yellow plus indigo, as seen in Figure 10 (g1,2).
	Print 290 — the blue of the kimono at far left appears to be indigo (see Figure 10); the purple showing at the neck of the lady at the left, a mixture of red and indigo (b1,2; p1,2).

* Locations of the areas measured are noted in the illustrations that accompanied the Final Technical Report submitted to the Allen Art Museum on Dec. 18, 1980, Reference 1. The particular area is designated by a letter or a number: (b2) is blue area 2; (r3) is red area 3; p, purple. See example of the marked copies of the prints in Figure 14.

the 1930s; all had turned black at the outer wall of the jars where they had been exposed to the light. The samples were labeled: *Shu* (akaguchi, deep), *Shu* (kiguchi, orange) and *Shu* (kodai, burnt).

2. *Traditional Dyes*

Although our specific concern is with the colorants in prints, it is of some interest to review the natural coloring agents traditionally used in the dyeing of cloth. Schraubstadter[5] notes that the dyeing of cloth was a fine art when the first prints were made and, hence, the colorants used in treating cloth were likely to have been employed initially in printmaking, both the mineral and vegetable. Later on, cochineal, imported from China, was substituted for *beni*. Sometime after its discovery date of 1704, Prussian blue was imported from Holland and used in many cases in place of indigo.

At an international symposium on the conservation and restoration of cultural property held in Tokyo and Tsukuba, Japan, in November of 1978, Hayashi presented a paper on the plant dyes used in ancient Japanese textiles. Therein the sources and chemical composition of common dyestuffs were described.[8] Professor Hayashi's list of yellow dyestuffs include:

Kihada, Phellodendron amurense var. suberosum (Rutaceae). The dye constituent is berberine, which has an intense yellow fluorescence under near-ultraviolet radiation.
Woren, Coptis japonica (Ranunculaceae). The dye constituent here is also berberine.
Kariyasu, Miscanthus tinctorius and Arthraxon hispidus (both belonging to Graminae). The dye constituents are anthraxin and related flavonoids (mainly luteolin glycosides).
Ukon (Japanese turmeric), Curcuma domestica (Zingiberaceae). The dye constituent is curcumin, the only yellow dye not requiring a mordant to fix it on cloth. This apparently fluoresces as well as berberine-based colorants.
Kuchinashi, Gardenia jasminoides (Rubiaceae). The dye constituent is crocin.
Enju, Sophora japonica (Leguminosae). The dye constituent is rutin (quercetin glycoside).
Haze or *Haji* (Japanese sumack) Rhus succedanea (Anacardiaceae). The dye constituent is fustin.

The red dyestuffs are:

Alkane, Rubia akane (Rubiaceae), Japanese Madder. The dye constituent is pseudopurpurin, which is yellow-orange but becomes red when mordanted with alkali.
Seiyo-akane, Rubia tinctorum (Rubiaceae). The dye constituent is alizarin.
Benibana, safflower, Carthamus tinctorius (compositae). The two dye constituents are carthamin and carthamon.
Suwo (Brazil wood, originated in Malaya, India), Caesalpinia sappan (Leguminosae). The dye constituent is brazilein, which is a yellowish brown color but becomes scarlet red when mordanted by alum.

The only violet dye reported was:

Murasaki or *Shikon*, Lithospermum erythrorhizon (Borraginaceae). The dye constituent is shikonin, a derivative of naphthoquinone.

The major blue dye is:

Ai, Polygonum tinctorium (Polygonaceae). The dye constituent is indigotin (indigo). Besides this plant, there are Strobilanthes flaccidifolium (Acanthaceae) and Isatis sp. (Cruciferae), the main dye constituent of which is also indigotin. *Aigami* does not appear in Hayashi's list of dye's used on cloth.

The major brown to black dyes are tannins. There are several plant sources for the tannins, but it is impossible to distinguish them at this time.

C. DETERMINATION OF CHARACTERISTIC SPECTRAL REFLECTANCE CURVES AND MEASUREMENT OF RATE OF FADING WITH KNOWN SAMPLES OF TRADITIONAL JAPANESE ORGANIC COLORANTS

1. *Preparation of Samples of Known Colorants*

Mrs. Keyes kindly provided the initial samples. *Beni* (safflower red) was received as a brushed-out specimen on a strip of paper; a small piece was cut out for exposure tests. The sample of *aigami* (dayflower blue) was received as a paper pad saturated with the colorant, a time-honored way in which dyes and lake pigments have been supplied to the artist. A small piece was cut off, and suspended in distilled water; the extracted blue coloring matter was then brushed on filter paper. The *ai* (indigo) was received in the form of a solid cake; a fragment was broken off, ground and dispersed in water and applied to filter paper.

A second sample of *aigami* (dayflower blue) was prepared by Dr. and Mrs. James Austin to demonstrate how the colorant could be readily obtained from the plants growing in their garden simply by crushing the flower petals directly onto a piece of filter paper. The result was a beautiful intense blue.

Dr. Austin also brought to the laboratory a spire of flowers from a tree blossoming nearby which he said was known as the Japanese pagoda tree. We extracted the petals and stamens separately in hot distilled water, brushing each resulting solution onto filter paper. Although we are not certain that this is the traditional technique for preparation of the colorants, the stamen extract yielded a bright clean yellow, and that from the petals, a somewhat darker yellow. The Japanese name for the yellow colorant from the pagoda tree is *enju*.

The test samples on filter papers were exposed 3½ inches below a bank of fluorescent lamps in a room maintained at 70°F (21.1°C) and at 65% relative humidity. The International Standards Organization's blue-wool standards (ISO R105, BS1006:1971) were exposed along with the colorant samples to monitor the rate and extent of fading. (Use of these fading reference standards is discussed in Section E.) Initially, and at intervals during the exposures, the samples were removed for spectrophotometric reflectance measurements. The results are illustrated in Figures 1 to 7. As fading occurred, the reflectance increased.

2. *Spectral Curve Characteristics and Changes on Fading*

Figures 1 and 2 illustrate the changes that took place in the spectral reflectance curves of the two samples of *aigami* (dayflower blue) as fading occurred. The crushing of the petals had deposited the greatest amount of colorant on the filter paper (Figure 2); this is indicated by the lower reflectance than that of the colorant extracted from the paper pad (Figure 1). Both samples exhibit a characteristic absorption pattern in the region of low reflectance: a major absorption peak at 585 nanometers (nm) and a major shoulder at 630 nm and minor shoulder at about 550 nm. Because absorptions are additive, these curve characteristics will appear regardless of whether the colorant is mixed with other colorants such as a yellow or a red and will provide a unique fingerprint for identifying the presence of this colorant.

Figure 3 shows the changes that took place in the spectral reflectance curve of *ai* (indigo). The shape of the curves in the absorption region of 660–700 nm remains much the same even though the short-wavelength reflectance region tends to shift towards the green in the course of fading. Figure 4 illustrates a curve which the authors regard as typical of indigo, exhibiting a somewhat higher reflectance at 700 nm than found in Figure 3. However, the differences seen here are not uncommon in samples of a natural dyestuff such as this. The reader can readily see by comparing Figures 1 and 2 with Figures 3 and 4 that there would be no difficulty in distinguishing between these two blue colorants.

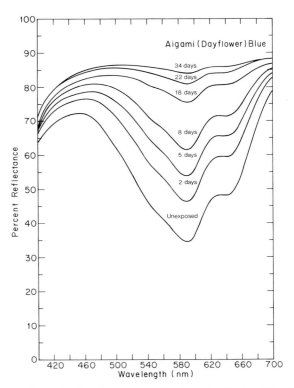

Figure 1. Spectral reflectance curves of pale wash of *Aigami* (dayflower blue) exposed for a total of 34 days (9 million lux hours) under "soft white" fluorescent lamps.

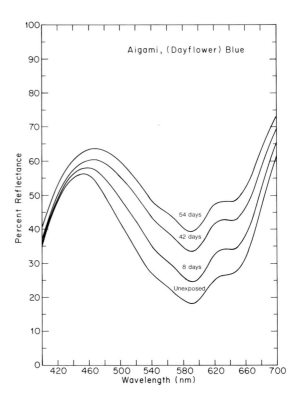

Figure 2. Spectral reflectance curves of higher concentration of *Aigami* (dayflower blue) than in Figure 1 exposed for a total of 54 days (14.3 million lux hours) under "soft white" fluorescent lamps.

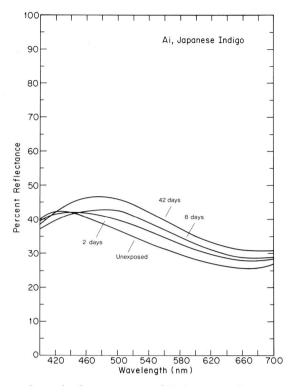

Figure 3. Spectral reflectance curves of *Ai,* Japanese indigo, exposed for a total of 42 days (12 million lux hours) under "soft white" fluorescent lamps.

The spectral reflectance curve of safflower red is not as unmistakable, although the general curve shape, the location of the absorption maximum, and the fact that the colorant fluoresces under near-ultraviolet radiation can make its identification a reasonably certain matter. If one were to measure the spectral sensitivity of emission and the spectral emission curve of the fluorescence of safflower red under near-ultraviolet radiation, as we have reported in the case of madder and of Indian yellow[9], the characterization of *beni* could be firmly established with this additional objective measurement, one again that does not require the taking of a sample. Figure 5 indicates that, in the course of fading, the pigment loses some of the sharpness of the slight reflectance peak at 450 nm. The curve shape of this pigment is not sufficiently distinctive that one would have a high degree of confidence in using the curve as a sole means of identifying *beni* in a print. However, as we have said, the fact that the safflower-based colorant also fluoresces under 365 nm ultraviolet radiation is a useful supplementary characteristic that warrants a high degree of confidence in our current identifications in the Ainsworth collection.

The curves of the two extracts from the flowers of the Japanese pagoda tree, *enju,* shown in Figures 6 and 7, are not sufficiently distinct to be used for identification purposes. The coloring matter proved to be very fugitive indeed.

The above described investigations, carried out on samples of known composition, convinced us that, if the spectral reflectance curves of colorants in actual prints could be measured, these three colorants—safflower red and particularly the *aigami* and indigo blues—could be identified with considerable confidence even in a faded condition. These preliminary studies also convinced us that the three colorants were markedly sensitive to fading upon exposure to light.

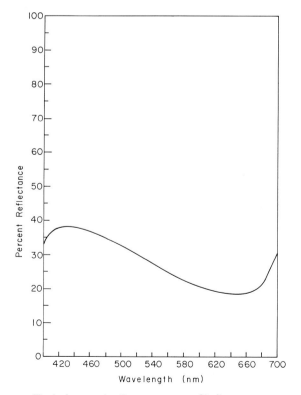

Figure 4. Typical spectral reflectance curve of indigo.

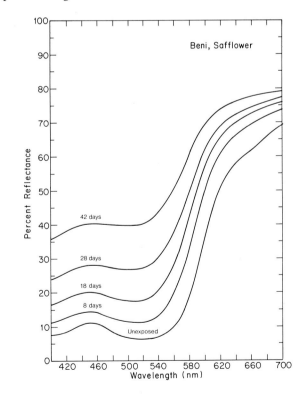

Figure 5. Spectral reflectance curves of *Beni* (safflower) exposed for a total of 42 days (12 million lux hours) under "soft white" fluorescent lamps.

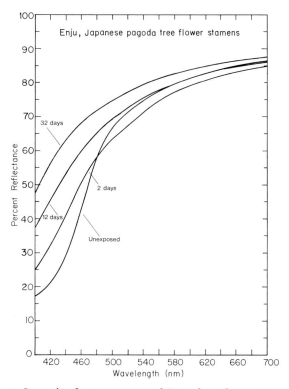

Figure 6. Spectral reflectance curves of *Enju*, from flower stamens of Japanese pagoda tree, exposed for a total of 32 days (9 million lux hours) to "soft white" fluorescent lamps.

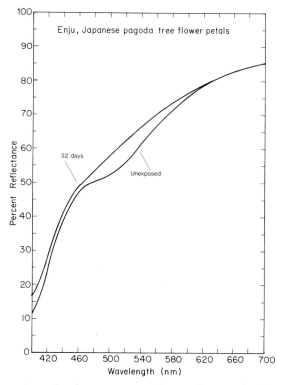

Figure 7. Spectral reflectance curves of *Enju*, from petals of Japanese pagoda tree, exposed for a total of 32 days (9 million lux hours) to "soft white" fluorescent lamps.

D. IDENTIFICATION OF AIGAMI (DAYFLOWER), INDIGO AND SAFFLOWER RED IN SPECIFIC PRINTS

Having shown that three very fugitive and commonly encountered colorants in traditional Japanese prints can be identified with considerable confidence simply by measuring their spectral reflectance curves and by observing the tendency of the red to fluoresce, attention was turned to the possibility of identifying these particular colorants in the prints of the Ainsworth collection. The effort to measure the spectral reflectance curves of various reds, blues, violets and greens in the prints was successful; we are able to report the presence of these three colorants, which readily tend to fade upon exposure to light, in a representative set of ten prints in the collection. The measured spectral reflectance curves, some examples of which can be seen in Figures 8, 9, and 10, permit the colorants to be identified by reference to the curves of known specimens, shown in Figures 1, 3 and 5, and by observation of the fluorescence of the red.

Details of the methods used to measure the spectral reflectance curves on the prints themselves are described in the addendum. Because of the generally small size of areas of uninterrupted color that were to be found in a typical print, the Small-Area-View (SAV) Color-Eye® was usually used to obtain the reflectance data; the circular measurement-port on this instrument is only ¼" in diameter. The reflectance was measured every 20 nm across the visible spectral region of wavelengths (400–700 nm) relative to a barium sulfate (white) standard. Owing to the fact that most of the colored areas were not completely opaque, a sheet of Millipore® filter paper was placed behind each print to provide a standard white-reflecting background behind the prints. This material has a reflectance of 100.5 relative to usual barium sulfate standard.

Because the prints are generally on an off-white background (perhaps the paper has discolored in many cases owing to age), the curves were frequently altered by the yellowness of the paper. Nevertheless, this was not sufficient to obscure the characteristic absorption peaks of the two blue pigments and certain mixtures thereof. Figure 9, for example, shows a typical result in which area b2 in the sky of print 410, now an olive grey owing to the discoloration of the paper, can still be identified as having once been a blue or bluish-grey made with *aigami*.

Table II presents a summary of the pigment identifications in ten prints in the collection. Complete data on all measurements are reported in the Final Technical Report submitted to the Allen Art Museum.[1]

Aside from the identification of the various colorants, it is hoped, through the availability of these records of spectral reflectance, that someone at a future date might be able to detect a change in the reflectance in these particular prints, especially if fading should occur to an appreciable extent. Accurate and confident measurement of the extent of a color change between these present measurements and a time five to ten years hence is not an easy task, but we believe that the achievement of such an objective is possible with reasonable success.[9,10]

E. DETERMINATION OF LIGHTFASTNESS

1. *Concerning the Specification of Lightfastness*

The International Standards Organization's Recommendation R105 on Lightfastness: While we are all reasonably familiar with materials that fade and realize, moreover, that some textiles and paints tend to fade very rapidly and that others are highly resistant to change, the characterization of the relative lightfastness of materials remains a challenging task even for the scientist. The difficulties arise because the rate at which a material fades depends not only on the particular coloring matter involved but also on

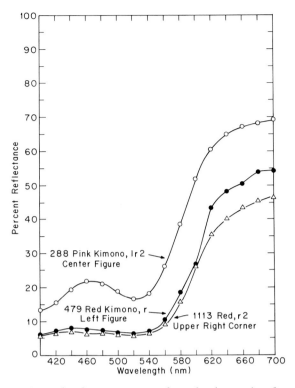

Figure 8. Spectral reflectance curves of a red colorant that fluoresces under near-ultraviolet radiation (*Beni?*). Measurements made with the Model D-1 Color-Eye® spectrophotometer.

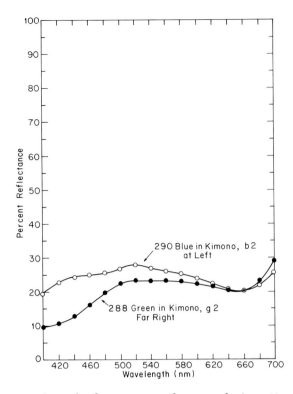

Figure 10. Spectral reflectance curves for areas of prints 288 and 290 based on indigo or mixtures with indigo. Measurements taken with the Kollmorgen-Leres "Trilac" instrument and computed from the MASK program.

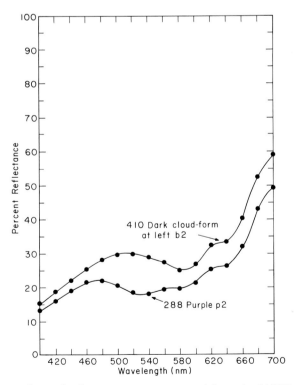

Figure 9. Spectral reflectance curves, computed from the MASK program, for a blue cloud form in the sky at left and a purple in kimono in prints 410 and 288, colorants based on or containing aigami. See Figure 14 for areas that were measured in print 288. The formerly blue area b2 is now, as recorded here, an olive grey owing to the discoloration of the paper.

whether it is associated with other substances such as mordants and whether it is mixed with ultraviolet-absorbing or photochemically-active pigments. Fading also depends on the concentration of the coloring matter and on the vehicle or binder with which it may be associated.

The complexities of this situation have been somewhat circumvented by the textile chemists who have developed a series of standard dyeings that fade at a known rate. These lightfastness standards are simply placed alongside of an unknown material to be tested and, after a period of exposure to daylight or to a source of artificial illumination, one simply states whether the material under test has faded faster, equal to, or less than the rate of one of the standard dyeings. The International Standards Organization (ISO), for example, supplies a series of eight blue-dyed wool cloths, each one of which has been designed to fade at about half the rate of the preceding standard in the series. These are known as the blue-wool fading (or lightfastness) standards and are described in ISO Standard R105. English-speaking colleagues can most readily obtain a copy of this standard in the form of British Standard BS1006:1971.[11,12,13]

The simplest way to specify the lightfastness of various materials is to take a sample of a dyed cloth or test panel of paint, place it side by side with a set of the ISO blue cloths, expose them to a light source and, after a period of time, report whether the particular colored sample under test has faded at much the same rate as one of the eight ISO standards. Standard No. 1 is the most fugitive; No. 8, the most stable.

If one wishes to be a bit more objective in describing the extent of fading, various standards organizations have issued sets of five pairs of grey patches, each pair of which differs in contrast throughout a series of five major steps. The first pair is identical (geometric grey scale contrast 5; unchanged) and the last (contrast No. 1) shows considerable difference in the lightness between

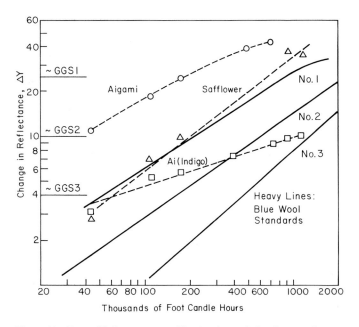

Figure 11. Rate of fading, measured by the change in luminous reflectance (ΔY), of samples of *Aigami* (dayflower), *Beni* (safflower) and *Ai* (indigo) under "daylight" fluorescent lamps, compared with the equivalent change in ISO R105 blue-cloths Nos. 1, 2 and 3.

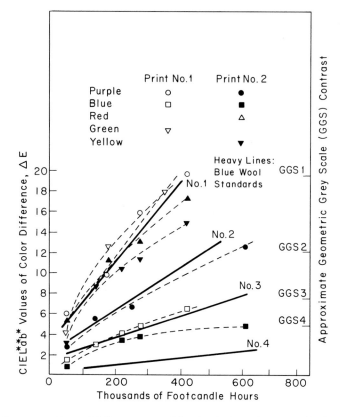

Figure 12. Rate of fading, measured by the CIE L*a*b* units of color difference (ΔE), of seven colorants in two prints, taken from an illustrated Japanese book of about 1800, kindly donated for these studies by Mrs. Keyes. Illumination: "daylight" fluorescent lamps.

the two patches. Known as the geometric grey scale, this simple device is readily available as British Standard BS2662.[14] The American Association of Textile Chemists and Colorists and the American Society for Testing Materials also specify virtually the same standard. Using this series of grey patches, one can objectively state, as the result of a visual comparison between the exposed and unexposed portions of an unknown material and an inspection of both exposed and unexposed portions of one of the blue cloths, that the unknown colored material being tested and a particular blue cloth have both faded to the same geometric grey scale (GGS) contrast. The contrast between faded and unfaded portions in a particular case may have been equivalent to GGS step 4, let us say. If such were the case, this information would convey the fact that very little fading had taken place because grey scale step 4 (GGS 4) is considered to be a "just perceptible change." If, on the other hand, one stated that the standard and test piece had changed to GGS 1, this information would establish the fact that considerable fading had taken place.

For those workers who do not possess elaborate color-measuring equipment, the International Standards Organization intended that the degree of fading of test samples would be reported by visually comparing the extent of fading that took place in any given test with one of the steps in the geometric grey scale. If color-measuring equipment is available, one can report the degree of fading in terms of the total color difference, a mathematically-calculated unit usually designated ΔE.[15] Because there are many different equations that have been devised to try to represent the visual evaluations of color difference (none is perfect), one must always specify the particular equation being used. This laboratory has regularly used an equation recommended by the Commission Internationale de l'Eclairage known as the CIE L*a*b* equation for color difference. However, we have also found that measurement of the change in luminous reflectance, signified by ΔY, will give results nearly as useful for our purposes.[13b]

In view of the existence of these internationally-recognized standards, we have chosen to report the lightfastness of various samples of the dyed or painted-out colorants in terms of the ISO R105 blue cloth that fades at approximately the same rate. Thus, we report in Figure 11 that the *beni* (safflower) fades at the same rate as blue cloth No. 1 as measured by the change in the luminous reflectance, ΔY. In Figure 12, measurements of ΔE for blue cloths Nos. 1 to 4 and the particular colorant samples are compared, again allowing us to report the lightfastness of the various colored areas of the prints in relationship to the rate of color change in one of the standard blue cloths. For convenience, the approximate location of the geometric grey scale changes is also indicated in the two figures.

A Practical Standard of Lightfastness for Conservators: Because variations in the concentration of the colorant, the kind of mordant or laking material, and the type of vehicle or substrate have such a profound effect on the rate at which a colorant apparently fades, the Center has recommended that the lightfastness of artists' colorants be referred to simply in terms of three broad classes, specified in Table III. The first classification would be considered *fugitive*; such materials would be expected to exhibit noticeable color change in no more than 20 years of normal exposure to light under museum or household conditions. Materials that might be expected to last more than 100 years without much change (more specifically: 100 years of exposure at an annual level of about 100,000 footcandle hours, or approximately 1 million lux, per year) could be considered to be of *excellent* lightfastness; those in between would be considered to exhibit *intermediate* lightfastness.[16] One can, of course, classify the lightfastness of various test pieces as being equivalent to one of the eight ISO blue-wool fading standards, but we consider that there would be far less disagreement over the precision and

TABLE III

Proposed Standard Classifications of Photochemical
Stability for Materials in Conservation[16]

Class	Classification	Intended Useful Lifetime	Approximate Equivalent Standard of Photochemical Stability
C	Unstable or Fugitive	less than 20 years	ISO R105 Class 3 or less
B	Intermediate	(20–100 years)	(Between Class 3 and 6)
A	Stable or Excellent	greater than 100 years	Greater than ISO R105 Class 6

TABLE IV

Lightfastness of Some Traditional Colorants

Pigment	Approximate ISO R105 (BS1006:1971) Lightfastness Grade	Protection Afforded by Ultraviolet Filter
Synthetic-Alizarin Lake (Control)	4 to 5	some
Indigo	3 to 4	some
Gamboge, Garcinia Morella	2 to 3	some
Carmine Lake (Carminic Acid Lake)	1 to 2	little if any
Safflower Red, Carthamus Tinctorius (Beni)	1*	little if any
Turmeric, Curcuma Longo	1	little if any
Dayflower Blue, Commelina Communis (Aigami)	<1*	some

Test exposures were made on samples, dispersed in water and painted out on Whatman filter paper, placed 3½″ from General Electric HO "daylight" fluorescent lamps (rated color temperature 6250°K) in a room maintained at 70°F (21°C) and 50% RH. Of the total irradiance between 320 and 700 nm, about 3 to 4% was determined to be in the near-ultraviolet (320–400 nm). Those marked with an asterisk (*) were exposed under "soft white" fluorescent lamps (rated color temperature 3025°K; ultraviolet 3 to 7%).

reliability of such measurements if the test material were simply placed in one of three classifications: fugitive (unstable), intermediate, or excellent (stable).

Details of the determination of the lightfastness of representative organic colorants that might be found in Japanese prints will be reported in the following sections. In nearly every case there is no question that the colorants described are fugitive.

E2. The Traditional Organic Colorants

Based on the spectrophotometric data from the experiments shown in Figures 1, 2, 3 and 5, the rate of fading of the brushed-out traditional colorants under a bank of "soft white" fluorescent lamps was compared to the rate of fading of the first few ISO R105 blue-wool cloths, measured as the change in the luminous reflectance of the specimens, ΔY. The rated color temperature of the "soft white" lamps is 3025°K; ultraviolet emission, 3–7% of the total radiation in the ultraviolet-plus-visible range.

The results are shown in Figure 11. The Y value reported here (capital Y or "cap Y") is the colorimetric measurement known as the CIE tristimulus Y value. The reader will recall that colors can be specified in terms of the amount of red, green and blue-colored lights that can be mixed to duplicate the color. This is essentially what the tristimulus X, Y, Z values in the CIE system of colorimetric specifications represent. The net color change, usually designated as ΔE, can be based on any number of mathematical equations involving the changes in X, Y, and Z taken together. However, in the case of monitoring the changes in the blue cloths, the authors have found that the change in the luminous reflectance, (ΔY) gives satisfactory results.[13b] We have monitored the fading of the colorants in the present investigation both ways, using ΔY in Figure 11 and ΔE in Figure 12. The results will not be precisely the same by these two methods, but when comparing materials of widely different degrees of lightfastness, one can demonstrate with considerable confidence whether a given test sample possesses either fugitive (having a lightfastness equal to or less than ISO R105 blue-wool standard 3), intermediate, or excellent lightfastness (greater than ISO R105 standard 6).

Over the years this laboratory has investigated the lightfastness of a number of other pigments that are related to the present question. Most extensively studied have been alizarin and carmine lakes, but we also have prior data on the behavior of indigo, gamboge, turmeric and quercitron. Table IV sums up the information that we have on the principal colorants that one can expect to find in Japanese prints, essentially as reported in a brief communication in 1981.[2]

One can see that most of the traditional colorants are very fugitive indeed and will be little protected under ordinary gallery conditions of exposure through the use of an ultraviolet filter. Under slightly different light sources, conditions of temperature and humidity, and concentrations or type of colorant, the lightfastness classifications given in Table IV may change by one grade, or possibly two, in the ISO series of eight standards. Nonetheless, the general conclusion is that nearly all of these colorants are very sensitive to light, tending to fade markedly (to a geometric grey scale contrast greater than 2) in less than two million footcandle hours (about 20 million lux hours) of illumination similar to diffuse daylight through window glass.

E3. Fading of Cloth Dyed with Traditional Materials

Several samples of silk dyed by Mr. Seiju Yamazaki, Director of the Institute of Vegetable Dyeing, Takasaki City, Gumma Prefective, were kindly provided by Professor Kôzô Hayashi. Small specimens were used for tests of lightfastness. The dyes, their mordants, and their classification with respect to lightfastness are listed in Table V.

The important conclusions to these studies is that ukon and beni proved to be very sensitive to light when applied in the traditional manner of dyeing cloth. All samples, save a brown-colored suwo, fell in the "fugitive" classification, exhibiting a lightfastness no better than ISO R105 blue-cloth No. 3.

Reviewing Padfield and Landi's work on a number of dyes that can be related to the present question, one finds turmeric (curcuma tinctoria) being rated as equivalent to an ISO R105 class 1 dye; likewise, orchil (red from lichens), sanders wood, young fustic (wood of Rhus cotinus), annatto (seed pods from Bixa orellana), gardenia (G. Flordia), tesu (flowers of Butea frondosa).[17] Of the dyeings that exhibited reasonable lightfastness, quercitron was rated between ISO class 3 and 4; cutch about the same. Indigo exhibited a lightfastness between 4 and 5 on cotton in their tests; higher, when dyed on wool. The point to be made in citing this work is to provide further evidence that the traditional natural dyestuffs are well known to be fugitive.

TABLE V

Fading of Representative Dyed Cloths

Color	Raw Plant Dyes	Mordanted by	ISO R105 Light-fastness Classi-fication
Yellow	*Ukon* (Curcuma root stock)	citric acid	<1
Yellow	*Enju* (Sophora flower bud)	aluminum acetate	3*
Red	*Beni* (Carthamus flowers)	citric acid	1
Red	*Suwo* (Caesalpinia wood)	aluminum acetate	3*
Brown	*Suwo* (Caesalpinia wood)	aluminum acetate and ferric acetate	4
Violet	*Shikon* (root of Lythospermum erythrorhyzon)	aluminum acetate	3
Violet	*Shikon* (root of Lythospermum erythrorhyzon)	aluminum acetate and lime	3
Brown (?)	*Yama-momo***	alum	2*
Yellow	*Kariyasu***	alum	2*

* Scarcely any protection to these dyeings was provided by an ultraviolet filter when fading carried out under "daylight" fluorescent lamps.
** Most of the samples in this table were kindly supplied by Prof. Hayashi, but these two dyeings were carried out at Pittsburgh with materials and directions supplied by Mrs. Keiko Keyes. Perhaps if they had been dyed by an experienced Japanese craftsman, the lightfastness would be one or two grades higher.

E4. *Fading of Colorants in Actual Prints*

Two small prints, taken from a Japanese illustrated book published about 1800, were kindly donated to the Center by Mrs. Keiko Keyes to be used to determine the fugitive character of colorants in actual prints of the period.

Each print was wrapped completely in household aluminum foil. An area of about 3 square inches was cut out of the foil where an exposed color could be visually compared to an unexposed area. In order to fade only a small portion of this total area of the print, a flap of aluminum foil was placed over the cut-out area, overlapping onto the large piece of foil that covered the print. A small window was cut in this flap to expose just a small area of color to the light, about ¼″ × ¼″. Because the flap was firmly taped in place (hinged) to the overall covering foil, this procedure made it possible to examine the faded versus the adjoining unfaded portion periodically, simply by lifting up the hinged flap with its ¼″ × ¼″ opening, taping it shut again after inspection, and thereby not losing the location of the area being exposed.

Small areas of various colors in the prints were thus selected and exposed to high-output "daylight" fluorescent lamps in a room held at 50% RH and about 70°F (21.1°C). A set of blue-wool standards (BS1006: 1971) was placed beside the prints and exposed at the same time. The progress of fading was measured on the Small-Area-View SAV Color-Eye® and, from the tristimulus values thus determined, the CIE L*a*b* color differences (ΔE) were calculated.

Figure 12 shows the increase in the color differences (ΔE) with exposure time for each colorant area in the prints and compares them with the color change experienced by the blue-wool standards. It can be seen that the colorant areas selected are indeed fugitive. Only one was more lightfast than blue-wool No. 3 and at that only slightly better.

Analysis of the spectrophotometric reflectance curve indicated that the blue in print No. 1 contained *aigami* (dayflower). By 400 hours, the sample was considerably faded. This exposure is equivalent to no more than 550,000 footcandle hours. If this print were to be exposed on a gallery wall illuminated for eight hours a day at 25 footcandles (about 250 lux), the blue would be seriously faded in less than ten years. As seen in Figure 12, this blue—perhaps *aigami* mixed with carbon black—is one of the more stable colorants in the two prints.

Following these initial tests, additional unexposed areas of the prints were selected and the prints re-exposed, this time under an efficient ultraviolet filter that removed most of the radiation of wavelength below 400 nm. The results, summarized in Table VI, indicate that little if any protection was gained by placing the prints under an ultraviolet filter. This important conclusion is further discussed in the following section.

This investigation has shown that six different areas of color in these two prints contained fugitive colorants. A seventh, apparently based on indigo, was scarcely more stable. Moreover, the rate of fading of these under normal exhibition conditions is not likely to be significantly improved by the use of filters that remove most of the ultraviolet radiation.

Because very small areas of the prints were only partially faded, the prints were returned to Mrs. Keyes in relatively good condition; the change in some of the test areas was scarcely noticeable.

E5. *Ineffectiveness of Ultraviolet Filters*

Daylight entering a museum through window glass or the illumination from ordinary fluorescent lamps freqently contains a portion of the total radiation which is in the ultraviolet, usually the near ultraviolet, region. This radiation, which cannot be seen by the human eye, is very energetic with respect to potential photochemical harm. Of the total radiation emitted by such sources in both the visible and ultraviolet regions of the spectrum (310 to 700 nm [nanometers]), sometimes as much as 7% will be in the ultraviolet, that is, radiation below 400 nanometers. In the fluorescent lamps used in the fading experiments described herein, the percentage fell between 3 and 7%. Because of this fact, it has become the custom of many institutions to exhibit prints, drawings, textiles and similar materials under plastic ultraviolet filters.[18] It is well known, however, that materials that are particularly susceptible to exposure are frequently highly sensitive to radiation in the visible region and are not primarily sensitive to the ultraviolet.[19] Thus, as has been stated many times, the use of an ultraviolet filter may result in very little protection whatsoever. This seems to be particularly true of many of the most sensitive colorants found in the traditional Japanese print.

As mentioned in Section E.4, Table VI, none of the seven colored areas of the two prints received significant protection from the use of an ultraviolet filter. The dyed cloths reported in Table V also were scarcely protected. In another series of tests, a paint based on cochineal carmine was found to fade practically at the same rate regardless of whether it was protected by an ultraviolet filter or not. The same was found true of carmine oil paints and water colors exposed under diffuse daylight-through-window-glass on the wall of an art gallery for more than three years: practically no protection at all was given to this pigment by the use of an ultraviolet filter.

Colorants of particular interest in this work that may receive some benefit from ultraviolet filters are, first of all, indigo, which tests indicated might fade at a rate only about a third as much if it is protected by a filter. We have also observed that Prussian blue and alizarin will usually receive some benefit from the use of ultraviolet filters, although we do not have quantitative data to offer at this time.

The tests to verify these findings have not been elaborate. However, the limited number of measurements that have been made thus far confirm an opinion that has long been held by conservators and conservation scientists: in the case of very fugitive colorants, the use of ultraviolet filters tends to offer little protection against fading under normal museum conditions of illumination by diffuse daylight and fluorescent lamplight. This is not to say that the precaution of using ultraviolet filters should not be taken in order to do everything possible to protect the paper and vehicles as well as the colorants from potential damage. Nonetheless, one must not be lulled into thinking that the use of ultraviolet filters will all but eliminate the danger of fading. Visible light can also cause a significant degree of fading in many materials; this is expected to be especially true in those that exhibit the greatest tendency to fade.

There are a number of plastic sheets and foils available on the market designed to filter out ultraviolet radiation; most are very satisfactory. The accepted definition of the ultraviolet region refers to those radiations of shorter wavelength than 400 nm; a more or less ideal ultraviolet filter would thus be one that removed all radiation below 400 nm. The absorbing substances used to filter out radiation do not possess a sharp on-again, off-again ability to transmit certain wavelengths and to remove others, however. Instead, most filters remove a few percent of the radiation on the edge of the visible region; their transmission then sharply falls to a point of very low percentage at, let us say, about 390 nm, perhaps further tapering off, transmitting ever decreasing amounts of the ultraviolet radiation, down to possibly 380 nm. The precise shape of the curve of spectral transmission of such filters will vary with the thickness of the filter, the concentration of the filtering compound that is in the transparent sheeting and the particular chemical substance that has been used to filter the ultraviolet radiation. One might say that an "ideal" ultraviolet filter would cut off very sharply at about 400 nm, transmitting better than 90% of the visible radiation greater than 410 nm and less than 1% of the radiation below 390 nm. This describes more or less the characteristics of the practically colorless filters manufactured for this purpose by many companies.

There is another filtering material that many museums find convenient to use: this type removes some of the blue visible radiation, with the result that the plastic is ever-so-slightly yellow. In a sense, this type removes just a bit more of the potentially damaging radiation, that is the shorter wavelengths of the visible, blue, region of the spectrum. Whereas it might be considered somewhat more protective to use this just-slightly-yellow ma-terial, the point that we wish to make in the connection with the care of Japanese prints can be demonstrated with the type of filter that removes primarily radiations below 400 nm. In discussing the effects of attempting to use an ultraviolet filter, we have been referring to the effectiveness of the first type, the practically colorless filters, rather than the slightly yellow kind. Nonetheless, if either type had been used in such studies, we are confident that the essential findings would have been much the same.

F. CONCLUSIONS

This investigation has shown that *aigami* (dayflower) and *ai* (indigo) can be identified positively in Japanese prints without taking samples, simply by measuring the spectral reflectance curves of specific areas of the prints. Because of its fluorescence and reasonably distinctive spectral reflectance curve, safflower red (*beni*) can also be identified with considerable assurance. In the future, the identification of *beni* can be made with even greater confidence if its spectral-fluorescence characteristics were to be measured.

Fading tests on known samples of these three colorants have shown that they fall in the fugitive class of lightfastness, or very close to it, characterized as having a tendency to fade equivalent to or less than ISO R105 blue-wool cloth No. 3. *Aigami* fades more rapidly than the most fugitive of the blue-wool standards (cloth No. 1) and *beni* fades just as rapidly as blue-wool cloth No. 1. The lightfastness of indigo is just slightly better, equivalent to somewhere between blue-wools 3 and 4. *Aigami* and *beni* will fade noticeably in about 50,000 footcandle hours (500,000 lux hours) and fade drastically in less than 200,000 footcandle hours (2 million lux hours) of exposure to illumination similar to that emitted by "soft white" fluorescent lamps (3025°K).

These particular colorants were detected in every one of the ten prints examined from the collection of the Allen Art Museum. Five prints were shown to contain the very fugitive blue—*aigami*; four apparently contained safflower (*beni*) red and three cases involved indigo. Five examples of a purple made with one of these fugitive blues were found and two greens made with indigo and a yellow.

Even if the exposure standard recommended by the Museum Exchange subcommittee of the United States-Japan Conference on Cultural and Educational Interchange (CULCON)[20] is followed, in which it is recommended that materials highly sensitive to light be exhibited to the extent of no more than 5,000 footcandle hours of exposure per year, prints that contain the traditional colorants *aigami* and *beni* can be expected to fade noticeably in ten years under these reasonably cautious restrictions. If such prints were to be exhibited every museum day throughout the year at levels of illumination of only 5 footcandles, it is predicted that these areas of color may noticeably fade in no more than 200 weeks of exhibition. This will certainly disrupt the harmony and balance of colors, for it is expected that other areas of the print, based on more stable colorants, will not fade as readily.

In the course of this investigation, the lightfastness of more than a dozen natural-dye colorants traditionally used in Japan was determined: seven pigments, reported in Table IV and nine dyed cloths, reported in Table V. Only two were significantly more lightfast than the ISO R105 blue-cloth No. 3, and these scarcely more than one step better. The basic fact of the high sensitivity of these materials to light seems well established, although other investigators will undoubtedly wish to verify, confirm and refine specific details. The findings place the traditional Japanese print among the most light-sensitive of materials that a museum or gallery may have in its collection. Certainly works containing such fugitive colorants should be displayed only for a limited time at the lowest possible levels of illumination.

TABLE VI

Lightfastness of Colorant Areas in Two Prints Taken from Japanese Book of About 1800. Ratings as to Blue-Wool Standard Fading Classes 1 to 4 (ISO R105; BS1006:1971)

	Print #1		Print #2	
	No Protection	Under Ultraviolet Filter*	No Protection	Under Ultraviolet Filter*
Purple Area	<1	1**	2	2
Blue Area	3	3	3-4	3
Red Area			1	1-2
Green Area	<1	1-2		
Yellow Area			1-2	2-3

* Efficient ultraviolet filter that transmits less than 70% at a wavelength of 400 nm and 5% at 390 nm.
** The rating number means that this colorant area of the print faded at the same rate as ISO blue-wool standard No. 1.

G. ACKNOWLEDGMENTS

Special appreciation goes to Keiko Keyes for her encouragement of these studies and to her and to Dr. James B. Austin for samples of authentic materials. Technical advice on color measurement was kindly supplied by Ruth Johnston-Feller who also arranged for use of the computational program MASK through the courtesy of the Ciba-Geigy Corporation, Ardsley, N.Y. David Encke measured the light intensities and assisted in setting up the easel system on which the prints were mounted for spectrophotometric measurements.

The authors particularly wish to thank Dr. Kôzô Hayashi of the Research Institute of Evolutionary Biology, Tokyo and Mr. Seiju Yamazaki, Director of the Institute for Vegetable Dyeing, Takasaki, for their kindness in providing authentic samples of several traditional dyes and dyeings. Through Mrs. Keyes, Mr. Iwataro Oka also supplied the project with several plant materials from which dye extracts were made.

The project designed to identify the presence of *aigami, ai* and *beni* in representative prints of the collection was supported by a grant from the Oberlin cataloguing project sponsored by the National Endowment for the Arts, using matching funds arranged through the efforts of Mrs. Keyes. The extensive work of characterizing known colorants and measurement of their rates of fading was carried out as part of the general research program of the Research Center on the Materials of the Artist and Conservator, an undertaking that receives its basic support through the generosity of the Andrew W. Mellon Foundation.

NOTES

1. Feller, R. L. and Bailie, C. W. (1980), *Final Technical Report: Identification and Rate of Fading of Some Traditional Organic Colorants Employed in Japanese Prints,* to the Allen Art Museum from the [Research] Center on the Materials of the Artist and Conservator, Mellon Institute, Pittsburgh, Pa. 15213.

2. Feller, R. L. and Johnston-Feller, R. M. (1981), "Continued Investigations Involving the ISO Blue-Wool Standards of Exposure," Paper 81/18/1, Sixth Triennial Reunion, ICOM Committee for Conservation Meeting, Ottawa, Canada.

3. Ficke, A. D. (1915), *Chats on Japanese Prints,* Unwin, London.

4. Yoshida, T. and Yuki, R. (1966), *Japanese Print Making,* Charles E. Tuttle, Rutland, Vermont.

5. Schaubstadter, C. (1948), *Care and Repair of Japanese Prints,* Idlewild Press, Cornwall-on-Hudson, New York.

6. Gettens, R. J., Feller, R. L. and Chase, W. J. (1972), "Vermilion and Cinnabar," *Studies in Conservation,* 17, No. 2, 45–69.

7. Feller, R. L. (1967), "Studies of the Darkening of Vermilion by Light," Report and Studies in the History of Art, National Gallery of Art, Washington, D.C., 99–111.

8. Hayashi, K. (1979), "Chemical Procedure for the Determination of Plant Dyes in Ancient Japanese Textiles," in *International Symposium on the Conservation of Cultural Property,* 1978, Tokyo National Research Institute of Cultural Properties, 39–50. Through the courtesy of Dr. John Winter of the Freer Gallery of Art the following publications have come to our attention since this project was completed: Kashiwagi, M. and Yamazaki, S. (1982), "The Lightfastness of Traditional Vegetable Dyes," *Scientific Papers on Japanese Antiques and Art Crafts,* Tokyo National Research Institute of Cultural Properties, 27, 54–65; in Japanese. Hiraoka, A. (1982), "Spectrophotometric Characteristics of Ancient Yellow Papers and their Fading Behaviors," *ibid.,* 27, 66–72.

9. Feller, R. L. (1968), "Problems in Reflectance Spectrophotometry," IIC-1967 London Conference on Museum Climatology, London, International Institute for Conservation of Historic and Artistic Works, 257–269.

10. Johnston, R. M. and Feller, R. L. (1963), "The Use of Differential Spectral Curve Analysis in the Study of Museum Objects," *Dyestuffs,* 44, No. 9, 1–10.

11. British Standard 1006:1971, *Methods for the Determination of the Colour Fastness of Textiles to Light and Weathering.* This 37-page pamphlet essentially represents the principal aspects of International Organization for Standardization Recommendation R105: I, Part II. Pamphlets describing the standard practice (BS1006:1971), the geometric grey scale (see reference 14) and the small cards comprised of strips of all eight cloths were available from TALAS, 104 Fifth Avenue, New York, NY, 10011. If presently unavailable from this source, write to the American National Standards Institute, 1430 Broadway, New York, NY, 10018.

12. Feller, R. L. (1978), "Further Studies on the International Blue-Wool Standards for Exposure to Light," Paper 78/18/2, Fifth Triennial Reunion, ICOM Committee for Conservation Meeting, Zagreb, Yugoslavia. Available from International Centre for Conservation, Via di San Michele, 13, 00153 Rome, Italy.

13. a. Feller, R. L. and Johnston-Feller, R. M. (1978), "Use of the International Standards Organization's Blue-Wool Standards for Exposure to Light. I. Use as an Integrating Light Monitor for Illumination Under Museum Conditions," AIC Preprints of Papers Presented at the Sixth Annual Meeting, Forth Worth, Texas, 73–80.
 b. Feller, R. L. and Johnston-Feller, R. M. (1979), "Use of the International Standards Organization's Blue-Wool Standards for Exposure to Light. II. Instrumental Measurement of Fading," AIC Preprints of Papers Presented at the Seventh Annual Meeting, Toronto, Ontario, Canada, 30–36.

14. British Standard BS2662:1961, Available from British Standards Institution, Two Park Street, London, W1, England.

15. Judd, D. B. and Wyszecki, G. (1975), *Color in Business Science and Industry,* 3rd ed., J. Wiley, New York, 313–30.

16. Feller, R. L. (1975), "Speeding Up Photochemical Deterioration," *Bulletin Institut royal du Patrimoine artistique,* 15, 135–50.

17. Padfield, T. and Landi, S. (1966), "The Light Fastness of the Natural Dyes," *Studies in Conservation,* 11, 181–93.

18. Feller, R. L. (1964), "Control of the Deteriorating Effects of Light Upon Museum Objects," *Museum,* 17, No. 2, 57–98.

19. McLaren, K. (1956), "The Spectral Regions of Daylight Which Cause Fading," *J. Society Dyers & Colourists,* 72, 86–99.

20. Japan Society (1980), *Report of the Study Group on Care of Works of Art in Traveling Exhibitions of the Museum Exchange Subcommittee of the United States-Japan Conference on Cultural and Education Interchange,* New York.

1. Measuring Large Matted Japanese Prints with the Color-Eye®

To facilitate easy movement and handling of the color-measuring instrument, the Kollmorgen Small-Area-View (SAV) Model D-1 Color-Eye® was placed on a typewriter table equipped with locking wheels. After the instrument was standardized in the usual manner in the specular-component-included (SCI) mode, the sample holder and its spring support were removed from the sample-viewing port and a piece of black construction paper, with a hole cut in it for the light beam to pass through, was taped over the port area to prevent any sharp edges of metal on the instrument from abrading the print.

An artist's easel was used to support the prints. Weights were taped to the supporting legs of the easel to keep it firm and free from tipping forward. Several layers of large filter-paper sheets were strapped to a pressed-wood support using bands of chromatography filter-paper strips. The sheets of filter paper served to cushion the back of the matted print. A two-inch-deep trough of glassine paper was likewise strapped around the pressed-wood support near the bottom to hold and protect the bottom of the hinged mat and its print. The support panel thus prepared was securely clamped upon the easel.

The SAV Color-Eye® requires only a ¼″-diameter area for color measurement. Before measuring an area of color in a print,

a Xerox® copy was made. By measuring from the top, left-hand border, it was possible to specify the exact area of the print that was measured. The spot was also marked on the photocopy. Before attaching the print and its mat to the support, six pieces of Millipore® filter paper were placed between the print and the backing mat board. Because the prints tended to be translucent (at incomplete hiding), all measurements were made with the print having this white background, which has a measured reflectance of 100.5 relative to the usual barium sulfate standard. The cover of the matted print was folded back and the print and its matte-board support were then tucked into the glassine trough; the print and its Millipore® backing was held in place on the support with filter-paper strips, as shown in Figure 13. The print thus supported on the easel could be adjusted up and down, and the Color-Eye® on its moveable table could be moved sideways, to align the print with the port of the instrument. When everything was in proper position, the wheels on the table were locked, and a soft black cloth draped around the print and port area in order to reduce stray light in case the print was not perfectly tight against the measurement port.

The measurements thus carried out resulted in no damage to the prints. At some date in the future, they can be remeasured in the same locations. Copies of all prints showing the measured areas are available in the Final Technical Report submitted to the Allen Art Museum in 1980.[1] An example of such a record, marked where both the small-area-view (SAV) and the larger ("mask") areas have been measured, is shown in Figure 14.

Figure 13. The Model D-1 SAV Color-Eye® with a print on its supporting easel in place for measurement.

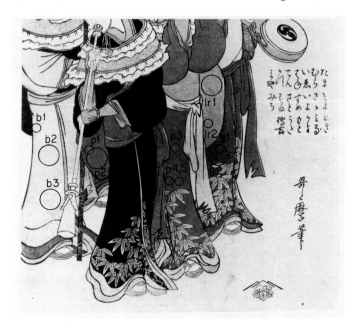

Figure 14. Illustration of the photocopied detail of print 288 with areas marked, for the record, where measurements were taken with the small-area-view (SAV) Color-Eye® and larger Leres "Trilac" instrument fitted with ½″-diameter "mask." Similar records were made of all prints in which the spectral reflectance measurements were taken.

2. *Measuring Large Matted Japanese Prints with the Trilac® Spectro-
photometer*

The Center's Kollmorgen-Leres Trilac® recording spectropho-
tometer has an especially-modified removable metal section which
holds spring supports for both the standard and sample. After
standardizing the instrument in the usual manner, this section
was removed so that the print in its supporting mat could be
placed in a vertical position firmly against the measuring port of
the instrument and adjusted in position so that a specific area of
the print could be measured. The specular-component-adjusting
wedge, which is screwed onto the sphere, is normally held in
place with a special screw that has sharp knurled edges. Because
this was considered potentially dangerous to the prints, the wedge
was removed and measurements made with specular component
excluded (SCE). Rather than replacing the screw in the hole, the
opening was covered with black electrical tape. The sliding cover,
which usually protects the standard and sample ports from light,
was also removed and a soft black cloth draped over the sample
and port area to eliminate stray illumination. Because the prints
have practically no gloss, it was considered that measurements
in the SCE mode would be much the same as measurements
made with the specular component included (SCI).

Areas of relatively uniform color in the prints that one might
wish to measure are generally smaller than the two-inch-diameter
port of the Trilac® instrument. For this reason, a black mask
with a ½″-diameter opening in it, made from flexible paper-
backed aluminum foil painted with black optical paint, was taped
over the sample port. With the barium sulfate reference-white
plaque taped to the "standard" port, the Trilac® was ready to
measure the spectral reflectance of specific areas of the prints.
The instrument bench has a pressed-wood board securely fastened
to it, which extends out beyond the viewing ports. This served
as a table upon which to rest the support on which the prints
were placed for measurement purposes.

Unlike the Color-Eye®, the Trilac® has no periscopic peephole
with which to align the sample in the proper position. The back
of the print and its support, not the front, is all the operator
could see. Because of this, a large 16″ × 16″ piece of glass, bound
with tape to cover the edges, was used to support the print.
First, a Xerox® copy on clear plastic was made of the print. This
transparent copy was taped to the back of the glass and, thus
supported, was positioned at the sample port so that the area to
be measured could be lined up with the ½″ port. By using a
bench jack, the bottom edge of the glass was raised or lowered
to the desired height; for alignment in the horizontal direction,
marks were made at the bottom edge of the glass to show the
position of the bench jack. Its position thus aligned, the glass
support could be returned to exactly the same position even
though the operator would no longer be able to see the sample
port. The print was carefully placed on the front of the glass
panel so that the bottom and one edge of the mat would permit
it to be exactly lined up with its Xerox® transparency on the
other side of the glass. The edges of the mat assembly were
gently held in place with strips of filter paper. Millipore® filter
paper was inserted behind the print for a standard white back-
ground. The glass support with the print now taped to its front
was placed back where it had been during the alignment and
held firmly there for the measurement. A soft black cloth, draped
over the easel and other paraphernalia at the end of the instrument,
excluded stray light. The use of a Xerox®-copy transparency
mounted on the rear removed the problem of guesswork con-
cerning the area of the print being measured. Figures 9 and 10
show the results of a measurement using the MASK computer
program; this computational program gives the reflectance values
one would expect to measure if the normal 2″ ports had been
employed rather than the black mask with its ½″-diameter
opening.

Details of the exact areas measured on ten prints in the collection
and the data relating to thirty-eight spectrophotometric meas-
urements can be found in the Final Technical Report, "Identifi-
cation and Rate of Fading of Some Traditional Organic Colorants
Employed in Japanese Prints" on file at the Allen Art Museum.

Bibliography

AIC I — Gunsaulus, Helen C., *The Clarence Buckingham Collection of Japanese Prints: The Primitives*. Chicago, The Art Institute of Chicago, 1955.

AIC II — Gentles, Margaret O., *The Clarence Buckingham Collection of Japanese Prints, volume II: Harunobu, Koryūsai, Shigemasa, their Followers and Contemporaries*. Chicago, The Art Institute of Chicago, 1965.

Amsterdam — van Rappard-Boon, Charlotte, *Catalogue of the Collection of Japanese Prints, Part I. The Age of Harunobu*. Amsterdam, Rijksmuseum, 1977.

Appleton — *Catalogue of . . . Japanese Colour Prints . . . of Colonel H. Appleton. . . .* London, Sotheby, Wilkinson & Hodge, June 20–23, 1910.

Appleton — *The Important Collection of the Work of Hiroshige . . . formed by Colonel H. Appleton. . . .* New York, Walpole Galleries, May 17 and 19, 1920.

Baske — *The Yamada Baske Collection. . . .* New York, American Art Association, May 2, 1928.

Berlin — *Japanese Color Prints. A Collection from Berlin, Germany*. New York, Walpole Galleries, January 31, February 1, 2, 1923.

Binyon and Sexton — Binyon, Laurence, and Sexton, J. J. O'Brien, *Japanese Colour Prints*. London, 1923, reprinted 1960 et seq.

Blanchard — *Illustrated Catalogue of the Notable Collection of Japanese Color Prints . . . of Mrs. John Osgood Blanchard. . . .* New York, American Art Association, April 5–6, 1916.

Borie — *Japanese Color Prints. The Important Collection of Mrs. A. Borie. . . .* New York, Walpole Galleries, May 1–2, 1919.

Brandt — Brandt, Klaus J., *Hosoda Eishi 1756–1829, der japanische Maler und Holzschnittmeister und seine Schuler*. Stuttgart, 1977.

Bremen — *Japanese Color Prints . . . from the Art Museum, Bremen*. New York, Walpole Galleries, April 1, 1922.

Crighton — Crighton, Robin A., *The Floating World: Japanese Popular Prints 1700–1900*. London, Victoria and Albert Museum, 1973.

Danckwerts — *Catalogue . . . of Japanese Colour Prints formed by the late W. O. Danckwerts. . . .* London, Sotheby, Wilkinson & Hodge, July 21–24, 1914.

Dooman — *Japanese Color Prints. The Collection of Dr. Isaac Dooman. . . .* New York, Walpole Galleries, February 11–12, 1924.

Ficke — Ficke, Arthur Davison, *Chats on Japanese Prints*. London, 1915.

Ficke 1920 — *Illustrated Catalogue of an . . . Important Collection of . . . Japanese Color Prints . . . the Property of A. D. Ficke*. New York, American Art Galleries, February 10–11, 1920.

Ficke 1923 — Ficke, Arthur Davison, "The Prints of Kwaigetsudō." *The Arts*, IV, August 1923, 95–119.

Ficke 1925 — *The Japanese Print Collection of Arthur Davison Ficke*. New York, Anderson Galleries, January 29–30, 1925.

Field — *Illustrated Catalogue of Japanese and Chinese Color Prints. The Collection of the Late Hamilton Easter Field*. New York, American Art Association, December 6–7, 1922.

Field and Laurent — *Japanese Color Prints . . . from the Portfolios of Hamilton Easter Field and Robert Laurent*. New York, Walpole Galleries, April 9–10, 1920.

Fuller — *Japanese Prints . . . the Noted Collection of Gilbert Fuller, Boston. . . .* New York, Parke-Bernet Galleries, November 20, 1945.

Gale — Hillier, Jack, *Catalogue of the Japanese Paintings and Prints in the Collection of Mr. and Mrs. Richard P. Gale*. 2 vols., London, for the Minneapolis Institute of Arts, 1970.

Genthe — *400 Japanese Color Prints Collected by Arnold Genthe*. New York, Anderson Galleries, January 22–23, 1917.

Getz — *150 Rare Japanese Color Prints Collected by Professor John Getz*. New York, Anderson Galleries, January 14, 1925.

Goncourt — Goncourt, Edmond de, *Hokusai*. Paris, 1896.

Gookin — *Catalogue of . . . Japanese Colour Prints, the Property of Frederick William Gookin*. London, Sotheby, Wilkinson & Hodge, May 23–24, 1910.

Hall	*Chinese Snuff Bottles, Japanese Books, Colored Prints . . . Collected by Mr. Trowbridge Hall.* New York, American Art Galleries, April 22, 1921.
Harmsworth	*The Important Collection of Japanese Color Prints Formed by R. Leicester Harmsworth . . . withdrawn from the Victoria & Albert Museum, South Kensington.* New York, J. C. Morgenthau, April 27, 1939.
Hayashi	*Dessins, estampes, livres illustrés du Japon, réunis par T. Hayashi.* Paris, Hôtel Drouot, June 2–6, 1902.
Henderson and Ledoux	Henderson, Harold and Ledoux, Louis V. *The Surviving Works of Sharaku.* New York, 1939.
Higuchi	Higuchi, H. et al., *Ukiyoe bunken mokuroku—ukiyoe no ryūtsū shushū kenkyū happyō no rekishi*, 2 vols. Tokyo, 1972.
Hillier, *Hokusai*	Hillier, Jack, *Hokusai: Paintings, Drawings and Woodcuts.* London, 1955.
Hillier 1966	Hillier, Jack, *Japanese Colour Prints.* London, 1966.
Hillier 1970	Hillier, Jack, *Suzuki Harunobu. An Exhibition of his Colour-prints and Illustrated Books on the Occasion of the Bicentenary of his Death in 1770.* Philadelphia Museum of Art, September 18–November 22, 1970.
Hillier, *Vever*	See Vever
Hirakawa	*Japanese Color Prints by the Great Masters Collected by the Expert Kenkichi Hirakawa of Tokyo.* New York, American Art Galleries, March 12–13, 1917.
Hirano	Hirano, Chie, *Kiyonaga: A Study of his Life and Works.* Cambridge (Mass.), for the Museum of Fine Arts, Boston, 1939.
Jacquin	*Rare and Valuable Japanese Colour Prints, The Noted Collection formed by a Distinguished French Connoisseur of Paris.* New York, Walpole Galleries, January 17–22, 1921.
Jenkins	Jenkins, Donald, *Ukiyo-e Prints and Paintings: The Primitive Period, 1680–1745.* Chicago, The Art Institute of Chicago, 1971.
Kawaura 1925	*K. Kawaura Collection of Japanese Prints.* New York, American Art Association, November 30–December 1, 1925.
Keyes 1972	*Suzuki harunobu zensakuhin mokuroku* (A Catalogue of the Single-Sheet Woodblock Prints by Suzuki Harunobu). In *Zaigai hihō suzuki harunobu*, Tokyo, 1972.
Keyes and Mizushima 1973	Keyes, Roger S., and Mizushima, Keiko, *The Theatrical World of Osaka Prints.* Philadelphia Museum of Art, 1973.
Keyes 1976	Keyes, Roger S., "Wide-Eyed as an Owl: Japanese Woodblock Prints from the Mary A. Ainsworth Collection." *Apollo,* CIII, February 1976, 94–97.
Kobayashi	Kobayashi, Tadashi et al., "Fūzokuga to ukiyoe," in *Nihon bijutsu zenshū,* XXII, Tokyo, 1979.
Lane	Lane, Richard, *Images from the Floating World.* Oxford, 1978.
Ledoux 1942	Ledoux, Louis V., *Japanese Prints of the Primitive Period in the Collection of Louis V. Ledoux.* New York, 1942.
Ledoux 1945	Ledoux, Louis V., *Japanese Prints by Harunobu and Shunshō in the Collection of Louis V. Ledoux.* New York, 1945.
Ledoux 1948	Ledoux, Louis V., *Japanese Prints, Bunchō to Utamaro, in the Collection of Louis V. Ledoux.* New York, 1948.
Ledoux 1950	Ledoux, Louis V., *Japanese Prints, Sharaku to Toyokuni, in the Collection of Louis V. Ledoux.* Princeton, 1950.
Link 1977	Link, Howard A., *The Theatrical Prints of the Torii Masters: A Selection of Seventeenth and Eighteenth-century Ukiyo-e.* Riccar Art Museum, Tokyo, and Honolulu Academy of Arts, Honolulu, 1977.
Matsuki	*Japanese Color Prints . . . brought together by . . . Bunkio Matsuki.* New York, Anderson Galleries, January 19–20, 1920.
May	*Illustrated Catalogue . . . Rare and Valuable Japanese Color Prints formed by . . . the late Frederic May.* New York, American Art Galleries, May 6–10, 1918.
Metzgar 1916	*Mr. Judson D. Metzgar's Noteworthy Collection of Rare Japanese Color Prints.* New York, American Art Galleries, November 13–14, 1916.
Metzgar 1919	*Illustrated Catalogue of the Collection of Japanese Color Prints, the Property of Mr. Judson D. Metzgar, of Moline, Illinois.* New York, American Art Galleries, May 15–16, 1919.
Michener	Link, Howard, (with Jūzō Suzuki and Roger S. Keyes), *Primitive Ukiyo-e from the James A. Michener Collection in the Honolulu Academy of Arts.* Honolulu, 1980.
Mori	*Ukiyo-e Paintings, Japanese and Chinese Color-Prints. The S. H. Mori Collection.* New York, American Art Association, December 9–10, 1926.
Morse	Morse, Peter (with Roger Keyes), *Katsushika hokusai sakuhin mokuroku* (A Catalogue of the Single-sheet Woodblock Prints of Katsushika Hokusai). In *Zaigai hihō katsushika hokusai.* Tokyo, 1972.
Morse 1951	*Japanese Prints. A Selection from the Charles J. Morse and Jared K. Morse Collection.* Hartford, Wadsworth Atheneum, March 14–April 29, 1951.
NBZ	*Nihon bijutsu zenshū.* See Kobayashi.
NHBZ	*Nihon hanga bijutsu zenshū,* 8 vols. Tokyo, 1961–62.

Noguchi	Noguchi, Yone, *The Ukiyo-e Primitives*. Tokyo, 1933.
Oberlin	"The Mary A. Ainsworth Bequest of Japanese Prints and Books." *AMAM Bulletin*, VII, Spring 1950, 61–73.
Oshima 1923	*Japanese Color Prints Collected by . . . K. Oshima. . . .* New York, Anderson Galleries, February 26–27, 1923.
Oshima 1926	*Oriental Collection . . . of Kano Oshima. . . .* New York, American Art Association, March 18–19, 1926.
Paine	Paine, Robert T., "Japanese Prints of Birds and Flowers by Masanobu and Shigenaga." *Oriental Art*, n.s., IX, 1, Spring 1963, 22–34.
Riccar	*Utagawa Kuniyoshi 1797–1861*. Tokyo, Riccar Art Museum, November 23–December 24, 1978.
Robinson 1961	Robinson, B. W., *Kuniyoshi*. London, Victoria and Albert Museum, 1961.
Robinson 1979	Robinson, B. W., *Kuniyoshi 1798–1861, une collection particulière*. Geneva, Museum of Art and History, December 8, 1978–February 25, 1979.
Rouart	*Illustrated Catalogue of Japanese Color Prints . . . of the late Alexis Rouart. . . .* New York, American Art Association, February 6–7, 1922.
Russell	*Japanese Color Prints . . . of Robert Howard Russell*. New York, Walpole Galleries, February 9–10, 1922.
Sato	*An Important Collection of . . . Color Prints . . . of Shotaro Sato. . . .* New York, Anderson Galleries, March 9–10, 1916.
Schmidt	Schmidt, Steffi, *Katalog der chinesischen und japanischen Holzschnitte im Museum für Ostasiatische Kunst Berlin*. Berlin, 1971.
Schraubstadter	*The Notable Collection of . . . Japanese Color Prints . . . of Carl Schraubstadter. . . .* New York, American Art Association, 1921.
Seidlitz	Seidlitz, Woldemar von, *A History of Japanese Prints*. London, 1910.
Shibui	Shibui, Kiyoshi, *Ukiyoe zuten, XIII, Utamaro*. Tokyo, 1964.
Shibui 1933	Shibui, Kiyoshi, *Ukiyoe naishi*, 2 vols. Tokyo, 1933.
Shōgakukan	*Ukiyoe shūka III* (Prints by Kitagawa Utamaro in the Museum of Fine Arts, Boston). Tokyo, 1978.
Spaulding	*Illustrated Catalogue of Japanese Color Prints . . . of Messrs. William S. and John T. Spaulding*. New York, American Art Association, November 16–18, 1921.
Springfield 1968	Dailey, Merlin C., with Mary Ann Dailey and Hideo Sekiguchi, *The Raymond A. Bidwell Collection of Prints by Utagawa Kuniyoshi 1789–1861*. Springfield (Mass.), Museum of Fine Arts, 1968.
Stern	Stern, Harold P., *Master Prints of Japan: Ukiyo-e Hanga*. New York, 1969.
Stewart	Stewart, Basil, *Subjects Portrayed in Japanese Colour-Prints: A Collector's Guide to All the Subjects Illustrated Including an Extensive Account of the Chushingura and Other Famous Plays. . . .* New York and London, 1922. Reprinted New York, Dover Publications, 1979.
Suntory	Suntory Museum of Art, *Kisō no gaka utagawa kuniyoshi*. Tokyo, 1971.
Suzuki	Suzuki, Jūzō, *Utagawa Hiroshige*. Tokyo, 1970.
TNM	*Illustrated Catalogues of the Tokyo National Museum. Ukiyo-e Prints*, 3 vols. Tokyo, 1960–63.
Ukiyoe shūka IX	*Ukiyoe shūka*, IX (Minneapolis Institute of Arts, Portland Art Museum, Allen Memorial Art Museum Oberlin College, Achenbach Foundation for Graphic Arts, Cleveland Museum of Art). Tokyo, 1981.
UT	*Ukiyoe taisei*, 12 vols. Tokyo, 1930–1931.
UTK	*Ukiyoe taikei*, 17 vols. Tokyo, 1975–77.
UTS	*Ukiyoe taika shūsei*, 20 vols. Tokyo, 1931–1932.
UZ	*Ukiyoe zenshū*, 6 vols. Tokyo, 1956–1958.
Van Caneghem	*Rare and Valuable Japanese Color Prints . . . of Julio E. Van Caneghem* New York, Walpole Galleries, March 2–3, 1921.
Vever	Hillier, Jack, *Japanese Prints and Drawings from the Vever Collection*, 3 vols. New York and London, 1976.
V and I	Vignier, Charles, and Inada, Hogitarō, *Estampes japonaises . . . exposées au Musée des Arts Décoratifs . . .*, 6 vols. Paris, 1909–14. (Vols. 5–6 by MM. Vignier and Lebel.) Reprinted in 2 volumes, Geneva, Minkoff Reprint, 1973.
Walpole	*A Small but very Fine Private Collection of Japanese Color Prints. . . .* New York, Walpole Galleries, June 14, 1920.
Waterhouse	Waterhouse, D. B., *Images of Eighteenth-Century Japan*. Toronto, 1975.
Wright	*The Frank Lloyd Wright Collection of Japanese Antique Prints. . . .* New York, Anderson Galleries, January 6–7, 1927.
Yoshida	Yoshida, Teruji, *Harunobu zenshū*. Tokyo, 1942.
Yoshida	Yoshida, Teruji, *The Life and Works of Tōshūsai Sharaku*. Tokyo, 1957.